Movers and Shapers 2
Irish Visual Art 1940-2006

VERA RYAN, born in 1953, grew up in Rathdowney, County Laois. She was educated in the Dominican Convent, Eccles Street, University College Dublin and Trinity College. Although a qualified solicitor since 1978, she has always worked in the visual arts and has taught art history at the Crawford College, Cork since 1981. She has been a member of various boards, including the board of the National College of Art and Design (1983-1987) and the Irish Museum of Modern Art (1997-2000). Widely published in books and catalogues, she contributed to *Tony O'Malley* (Scholar Press 1996). She has one son.

For Will Smyth and Tom O'Byrne with love

Movers and Shapers
Irish Visual Art 1940-2006

Vera Ryan

The Collins Press

Published in 2006 by
The Collins Press
West Link Park,
Doughcloyne,
Wilton,
Cork

British Library Cataloguing in Publication Data

Ryan, Vera
Movers and Shapers 2
1. Art, Irish - 20th century 2. Cultural animators -
Ireland - Interviews 3. Artists - Ireland - Interviews
I. Title
709.4'15'09045

ISBN-10: 1905172036
ISBN-13: 978-1905172030

Typesetting: The Collins Press

Font: RotisSerif, 11pt

Printed in Malta

Contents

Acronyms and Abbreviations

AGM	Annual General Meeting
AIB	Allied Irish Banks
CEO	Chief Executive Officer
CAS	Cork Arts Society
CIAS	Contemporary Irish Art Society
CIÉ	Córas Iompar Éireann
CRT	Cultural Relations Committee
CTT	Córas Tráchtála Teo
DCU	Dublin City University
DIT	Dubin Institute of Technology
EEC	European Economic Community
ENO	English National Opera
ESB	Electricity Supply Board
EU	European Union
GNP	Gross National Product
GPA	Guinness Peat Aviation
GPO	General Post Office
IELA	Irish Exhibition of Living Art
IGS	Irish Georgian Society
IMMA	Irish Museum of Modern Art
IRA	Irish Republican Army
IRSP	Irish Republican Socialist Party
KAGS	Kilkenny Art Gallery Society
KDW	Kilkenny Design Workshop
MoMA	Museum of Modern Art (New York)
MST	*Movimento dos Sem-Terra* (The Landless Movement of Brazil)

NAIDA	National Agricultural Industrial
NCAD	National College of Art & Design
NCEA	National Council for Educational Awards
NIHE	National Institute of Higher Education
NIVAL	National Irish Visual Arts Library
OPW	Office of Public Works
PMPA	Private Motorists Protection Association
RA	Royal Academy
RDS	Royal Dublin Society
RHA	Royal Hibernian Academy
RHK	Royal Hospital Kilmainham
RTÉ	Radio Telefís Éireann
SADE	Sculpture and Drawing Exhibition
SJ	Society of Jesus
TCD	Trinity College Dublin
TD	Teachtaire Dáil
UCC	University College Cork
UCD	University College Dublin
UDA	Ulster Defence Army
UDC	Urban District Council
UVF	Ulster Volunteer Force
VEC	Vocational Educational Committee

Titles and abbreviations in the text:
The Crawford Gallery is an abbreviation of the Crawford Municipal Art Gallery. The Crawford College is an abbreviation of Crawford College of Art and Design.
The Hugh Lane is an abbreviation of the Dublin City Gallery, the Hugh Lane. It was formerly the Hugh Lane Municipal Gallery of Modern Art. The Municipal Gallery is an abbreviation of this.
The Irish Exhibition of Living Art is abbreviated to *Living Art.*

Acknowledgements

I would like first and foremost to thank the interviewees who participated in this volume. Their patience and generosity is much appreciated. Sadly, Gordon Lambert and John Kelly died before publication. Without Catherine Marshall's help and inspiration it would not have been possible to interview Gordon. I am deeply indebted to her and to Tony Lyons. Thanks also to Anita Delaney. Without Mairead Breslin Kelly's support the interview with John Kelly could not have been brought to completion. Warm thanks to Mairead.

Mavis Arnold, Katherine Beug, Dr Paul Caffrey, Angela Eastwood, Jenny Haughton, Julie Kelleher, Dr Roisín Kennedy, Antoinette Murphy, Dr Paula Murphy, Eric Pearce, Norah Ring, Professor Anngret Simms, Marcella Senior, Pat Taylor and George Vaughan were most helpful in various ways and I thank them. In the Arts Council, I thank Bernadette O'Leary, Michelle Hoctor and Siobhan Comer who were also generous with their help. The support of Marie Bourke, Leah Benson and Adrian le Harivel in the National Gallery is similarly appreciated.

Dr Brendan Murphy, Brendan Goggin, Sarah Morey and the Arts Committee in CIT facilitated financial support without which publication would not have been possible. I am very grateful to them. In the Crawford College of Art and Design I thank many colleagues, especially the principal Geoff Steiner Scott, Dr Stuart White, Dr Julian Campbell, Trish Brennan, Joe O'Neill, Denis Lynch, Mary Cronin, Triona Crowley, Bella Whelan, Denis Kearney, Martin Lynch and Paddy Rice. Noel McMorran was, once again, immensely helpful with the photographs and I am indebted to him.

Three libraries – the Crawford College library, NIVAL at the

National College of Art and Design and The Irish Times library – were indispensable to this book. In the Crawford library I thank Margaret Kenneally, Francis Moore and Martin Hazel for unstinting professionalism. I thank Edward Murphy, whose pioneering project, the National Irish Visual Arts Library at NCAD, has made research so much more accessible and I thank Donna Romano. In *The Irish Times* I thank Irene Stevenson, Esther Murnane, Peter Thursfield and the editor, Geraldine Kennedy.

I am grateful to Anne Kearney at the *Irish Examiner,* Peter Thursfield of *The Irish Times* and Peter Murray at The Crawford Gallery. In the Cork Arts Society I wish to thank Niall Foley and Charlo Quain.

Intellectual and moral support from friends and colleagues Hilary O'Kelly and William Gallagher made a significant difference to this volume and I am, once again, deeply indebted to them. Nuala Fenton and the Fenton Gallery team – Ita Freeney, Sibil Montague and Helena Tobin – have been unfailing supporters. I thank Helena in particular for her sustained help with the technology. Jennifer Mathews Lynch was similarly efficient, obliging and cordial.

I would like to thank all my family and Cormac, Peigín and Neil Smyth. The hospitality of the Deering family in Terenure made the production of this volume very special and I thank Shay, Ro, Paul, John and Mark.

I sincerely thank the dedicatees of *Movers and Shapers 2* for practical help, ideas and gracious tolerance.

Introduction

Tennessee Williams' play *The Glass Menagerie* (1944) opens with a caveat to the audience on memory. This wonderful play is about a son's recollections of life with his mother and sister, a life so painful in its lack of opportunity that the young man fled. But he could not flee his memories, which sprang up, lay in wait, haunted or overwhelmed him in ways so unpredictable and powerful that their dramatisation is an acknowledgement of their huge presence in his psyche.

The nature of memory has been an intensive focus of interest across many disciplines in recent years. Historians, psychologists, neuroscientists, philosophers, biographers, film-makers and artists have different ways of exploring memory and different vocabularies in doing so. In the context of the visual arts in Ireland, painter Hughie O'Donoghue[1] has explored paternal family histories in relation to war memory, notably in *Crossing the Rapido* (1998-2003). In the *Venice Biennale* (2005) Ronan McCrea showed lens-based work which explores the spaces between individual and collective memory, sometimes using a motif from Grimm's fairy tales. Girlhood has been important in Alice Maher's work. In Padraig Trehy's short film *My First Motion Picture* (2004)[2] the child's absorption of family stories about himself is narrated in the first person, as if remembered.Willie Doherty's mid-career retrospective False Memory (2002-2003)[3] explored memory's strangely elusive nature, with a strong political consciousness. *Ghost Ship* (1999) by Dorothy Cross[4] suggested the haunting nature of memory.

In an art historical context, if it is agreed that Vasari was the first art historian of the modern period, then we meet the question of how and what we remember, and want remembered, in the first classic art history text, *Lives of the Painters, Sculptors and Architects* (1550). In

reaction to it Michelangelo, then in his seventies, asked Condivi to write his biography. Condivi's account is seen[5] as reflecting Michelangelo's scorn for Vasari's statement that the artist was trained in the Ghirlandaio workshop. The message is that a genius like Michelangelo, primarily a sculptor, would not be formed by mere workshop experience. In the second edition of *Lives* (1568), by which time Michelangelo was dead, Vasari quoted from documentation proving Michelangelo's apprenticeship. Banking records have since been researched to confirm it.[6] This case is seen as representing the triumph of documentation over the authentic but mercurial voice of the artist and the vagaries of word of mouth. However, maybe the memories Michelangelo had of the Ghirlandaio workshop made him need to forget he was there.

How, under particular circumstances and stimuli, we remember or forget certain things is indicative of personal and social values and pressures. Memory is not static; we exercise it and it is stimulated and revived, or falls into abysses in all sorts of ways, for all sorts of reasons. We often remember and share memories for pleasure, not just for the record. But perhaps there is so much interest in memory now because the nature of memory as a collective value is changing, as it was when the printed book was coming to the fore in Vasari's time.

Quite apart from incapacitating neuro-degeneration situations, we may now be forgetting the importance of practising the business of remembering. As television came into this culture over 40 years ago, the compulsory memorising of poetry at school had begun to decline. Now, with mobile phones, even telephone numbers are seldom retained in human memory. In the imaginative and practical domains, the reduced use of personal memory brings the danger of atrophy.[7] Critics of the computer warn that using computers as memory surrogates may be a serious danger, not only to the imaginations and skills of those who use them from an early age but for society as a whole. The capacity to build social values is linked with collective memory.

The forms by which collective memory is transmitted are also

clearly changing. Collective memory was traditionally constructed, agreed and transmitted around the proverbial hearth. The function of group storytelling was partly taken over by radio, then television. Books, magazines and television documentaries now fulfil some of the roles of collective memory construction. The increasing dominance of modern technological media truncates traditional notions of storytelling and creates other memory. Mocumentary films and reality television increasingly challenge assumptions around authenticity and the role of primary experience in narrative modes.

Yet the gap that has opened up between technical modes of memory transmission and traditional storytelling creates room for projects like the present one, where there is a combination of conversational style and book form. A major motivation in continuing the interviews begun in 2001 and published in 2003 as *Movers and Shapers – Irish Visual Art since 1960* was, once again, to try and give a sense of some of the individuals who have been, and are, important players. Once again, a cross-section of artists, educators, administrators, collectors and writers are valued for their roles as innovators, witnesses and participants. Their subjectivity, and the interviewer's, is overt. There are many understandings of subjectivity. But inevitably, the consciousness that memory and subjectivity were morphing into history had varied yet determining effects on how participants in the project remembered.

Based on the oral history model, which usually operates within concepts of memory as primarily retentive, the interview process was dialogic. The dialogic process was less chronologically directed than would appear in the final interviews, since we do not remember chronologically. On rare and self-evident occasions, the interview process was triggered by photographic and documentary material viewed together by interviewer and interviewee. Each interviewee was invited to check and agree what was to be published and through the process of agreement, many interviews had a strongly collaborative evolution. In that sense, the interviews would not be the same if presented on television or sound recordings. Disappointingly – because of its capacity to attune the ear to nuances within

master narratives – gossip[7] was frequently elided by interviewees.[8]

Through this process of singling out well-known individuals for extended interview, *Movers and Shapers 2*, like *Movers and Shapers* (2003) is partly an attempt to contextualise and complement the chroniclings of artistic production and its infrastructure during the period. The tremendous research into Irish art during the last 30 or 40 years makes it timely perhaps and potentially useful to present an empirical and non-synopsising model at this stage. One of the pleasures for the interviewer on a full reading is the cumulative impact of the interviews as a collectivity. Perhaps a theoretical positioning may be appropriate later.

Two politicians but no gallerists were interviewed for *Movers and Shapers* (2003). The position is reversed in this compilation: John Taylor, who started Taylor Galleries in Dublin in 1978, and Jamshid Mirfenderesky, who opened the Fenderesky Gallery in Belfast in 1984, are leading Irish gallerists. Jamshid Mirfenderesky reflects on his experiences: 'When I opened the Gallery ... the situation was still pretty bad and most of the artists that started to show with me ... were interested in reflecting the society in which we were living ... That fortunately or unfortunately came to an end. Fortunately because the situation in many respects is better now, but unfortunately because at that time there was a great deal of comraderie.'

Speaking of an earlier time and remembering one of his favourite artists John Taylor says: 'It was customary to introduce a buyer to the artist. I remember saying to Nano Reid "This collector has just bought your painting". Nano said in a voice that sounded like a female version of Cyril Cusack 'Did you buy that ... that's funny ... I couldn't imagine anyone buying that". She could not have been less commercial.' The art market expanded enormously since John Taylor began working with Leo Smith in 1964. Contemporary Irish art had not begun to sell well at auction. A new first generation market for contemporary Irish art developed within a few decades. Gallerist David Hendriks died in 1983, six years after Leo Smith, and the enormous contribution which these two men made to the development of the visual arts in Ireland echoes throughout the volume. Artist John Kelly's account of a student

seeing the files from the Hendriks Gallery thrown into a skip on St Stephen's Green gives much room for thought.

If the co-ordinates of the art world are the artist and his/her place of work/training, the exhibition venue, the collector and the writer, the shortage of collectors, especially non-corporate ones, 35 years ago seems very striking now. Frances Ruane has been art advisor to Allied Irish Banks for 25 years and in her interview gives real insight into the issues involved in corporate collecting. The Arts Council were then important collectors. As Arts Council director Mary Cloake points out in her interview, they will be returning to collecting very soon, after quite a pause. The Office of Public Works have been long-term steady buyers and the Friends of the National Collections and the Contemporary Irish Art Society collected to donate to under-funded institutions. Some of the greatest and some of the most civic collectors of the generation born before the establishment of the Arts Council in 1951 have passed away. Don Carroll, George Dawson, R.R. Figgis, Basil Goulding, Gwladys McCabe, Neil Monahan for the Bank of Ireland, Stanley Mosse, Michael Scott and Leo Smith formed collections which had various fates. But Gordon Lambert lived long enough to see a dream come true with the opening of The Irish Museum of Modern Art in May 1991. His unconditional gift of a collection built up since the mid 1950s helped realise that patriotic dream. Interwoven with his work in the Irish biscuit industry was his belief in the many roles art could play. His sense that art could participate in bringing North and South closer was important in the '60s and '70s. 'I was born before the Border was imposed. I have thought and acted on an all-Ireland basis ever since.'

Patrick Scott was born during the birth pangs of the Irish State. His anecdotes about being an artist in Dublin during and after the Second World War and his involvement with various art groups, particularly the Irish Exhibition of Living Art, both communicate vivid images of his life and are historically important. Like John Kelly, and indeed so many other Irish artists, he was involved with theatre at a creative level. Living and working in the same city, these two artists tell parallel stories. Achieving different levels of

prominence in differing circumstances, each artist's account is illuminated by the other's.

Bruce Arnold too gives glimpses of the mid-century Dublin he experienced and loved when he came from England to study in Trinity College. There 'were a lot of people who came from abroad in Trinity at that time ... properly abroad; Rhodesia, South Africa, that kind of thing. It was full of English and full of colonials.' As he says, an English settler in Ireland, one inclined to articulate his observations, was unusual then. His collecting developed from having a commercial gallery, the Neptune Gallery. His major publications on Orpen, Jellett and Jack Yeats are part of the acceleration in scholarship on Irish art in the last 35 years. But his earlier art criticism may prove to be no less important, challenging, as it did, many of the decisions of members of the establishment.

Despite everything – authoritarianism, emigration, censorship and poverty – the view that Dublin was a serious centre of artistic vitality in the later years of de Valera's leadership is endorsed in these interviews. But de Valera's own county, Clare, still seemed to represent 'authentic' Ireland, where folk and musical traditions survived. It was in Clare that English-born, Harvard-educated Barrie Cooke settled in 1954, finding his way to Clare through a series of significant and fascinating connections, not least a letter of introduction to Professor Delargy, founder and director of the Irish Folklore Commission, who was holidaying in Clare. 'At that time no artist in Ireland lived in the country.' But Barrie Cooke did and does. His interview is an often amusing account of how volunteerism was actively practised in the creative world of Kilkenny. 'Brian [Boydell] said "you must call and see Peggy and Hubert Butler". I called and I liked them very much. Peggy was the main mover around the Kilkenny Art Gallery Society. She wanted me to join KAGS. I was cautious. I said I might not give a talk. She said "you might not be asked" ...'

The memories of Kilkenny Design Workshops (1963-1988) shared with us by Barrie Cooke and Pat Scott remind us of the personalities involved when the first State-owned design consultancies took off in Kilkenny. The great Bill Walsh, who had been a student in Kilkenny

College and who founded the Workshops is described: 'Bill Walsh was an extraordinary man. Kilkenny Design was a semi-state body but it was the only one I've come across where the board were not political appointees. They were appointed by Bill Walsh, at least in the early years', recalls Pat Scott, a board member for eighteen years.

In *Movers and Shapers* (2003) quite a few people from one institution, in that case the Arts Council, were interviewed. In *Movers and Shapers 2*, a number of the interviewees have had an involvement with the National Gallery. In 1980, 34-year-old Homan Potterton was the youngest director to take up office. He gives a very good picture of his strategy as director, his imaginative purchases of twentieth-century paintings, his own prodigious research and his presentations of current research on Irish art. His interview perhaps more than others attests to a narrow nationalism still surviving into the 1980s. 'Being told you didn't belong to your heritage when you were working your guts out for Ireland was painful,' he explains.

In the mid 1960s scholar Hilary Pyle was a young blonde working in the library of the National Gallery. Her book on James Stephens had just come out, and her pioneering research on Jack Yeats was beginning. Her interview allows great insight into aspects of her research experience. 'Some people tried to dissuade me at first. They seemed to feel that the Yeats they knew might be misunderstood.' She gives a vivid account of social conditions at the time.

'When I got married I still worked in the Gallery. I should have left, that was the rule in the public service in 1969; a woman had to resign when she married. James White said to me "What are your plans, are you going to have a family?" I said I had no idea. "Anyway," he said, "how do I know you are married?"– even though he had been at our wedding! ... So I continued to work in the Gallery.'

Marriage to an Irishman in 1973 brought Frances Ruane to Ireland. The changes that had happened in the intervening years allowed her to become the first education officer in the National Gallery. The new cultural democracy was beginning. Her observations of Irish life influenced her writing on Irish art. 'There's a myth that the Irish are very friendly ... I thought Irish people were very secretive ... In Ireland

... you find out by an indirect route. This quality was so much to the forefront of my thinking at the time that it made its way into my writing. For example, in *The Delighted Eye* (1980), I was describing Irish art as suggestive ... Irish art was grey and misty, not in sharp focus; Paddy Collins' work is an example.'

Frances Ruane, like John Kelly, taught at the National College of Art and Design for many years. John had been a student there in the 1950s and evaluates the situation in his interview. Brian Maguire, appointed professor of Fine Art at NCAD in 2000, was a student there twenty years or so after John Kelly, in the last days of the old regime. Both held anti-establishment positions at different times. Brian's extraordinary work in empowering people outside the formal education system to make art is now at an international level. 'It's true I tend to focus on people whose voice is marginalised. The mentally ill, the homeless, the powerless are at significant times the doctors of the community. They heal the community from its arrogance and its avariciousness', he believes.

John Kelly's stories tell us about a whole generation of artists in a wry way: 'James McKenna arrived at the Municipal [Gallery] with his big wooden horse. He'd delivered it on the back of a horse and cart. This was for the Independent Artists. The attendants said he couldn't bring it upstairs. The floor boards were rotten, as was later proved. They wanted James to leave it in the hall. James got into a rage. He insisted that he would take it home. We all struggled out the door with the horse. But we persuaded James that it would look fantastic downstairs. We brought it back off the horse and cart and inside. It was called *The Red Horse for the People*. The twins were about five. James insisted that they sit up on the horse. Looking warily at the attendants one of them said to James "What will the people say?" "We are the people," thundered James.'

Leadership in earlier years may have come from enterprising individuals who went ahead to try and create good conditions for arts practitioners and broaden access to the arts. Mary Cloake's job as director of the Arts Council requires a particular overview of the Irish art scene. An openness to ideas characterises her approach. Her

sense of what art offers is broadly defined. 'The arts give you perspectives on the world ... Art can make people more critical. The arts communicate, they don't contain ... The arts communicate value and deal with identity. They can help in society's unity and society's diversity. That is why public money goes to the arts.'

The extraordinary changes which have happened in Ireland even in this century, not to talk of over the last 40 years, can make aspects of the past easily forgettable or unknown. What was the art world like before now? Was it better in some ways and worse in others? What were the people like? Maybe compilations such as this will help answer those kinds of questions.

VERA RYAN,
31 October, 2005

1. Hamilton, J., *Hughie O'Donoghue: Painting, Memory and Myth*, London, NY, 2004.
2. Director/Writer, Tréhy, P., Mendoza Films/RTÉ, 2004.
3. IMMA, *Willie Doherty False Memory*, 2002.
4. IMMA, *Dorothy Cross*, 2005.
5. Wilde, J., 'Michelangelo, Vasari and Condivi', pp. 1-17 in *Michelangelo Six Lectures by Johannes Wilde*, London, 1978.
6. Hirst, M. & Dunkerton J., *Making and Meaning/The Young Michelangelo*, London, 1995.
7. Shaughnessy, H. *The Irish Times*, 12 October 2004, p. 15.
8. Rogoff, I., 'Gossip as testimony: a postmodern signature' pp. 58-65 in *Generations and Geographies in the Visual Arts/Feminist Readings* (ed.), Pollock G., London, 1995.

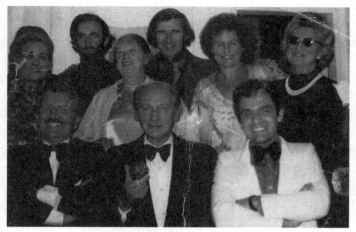

Back from left: Frankie Byrne,
James Colman, Brian O'Doherty and Barbara Novak his wife, Máirín
Lynch; middle: a friend; front: Gordon Lambert, Jack Lynch, Brian Ferran
at a pre-Rosc drinks party in Gordon's.

Gordon Lambert

Gordon Lambert was born at home in Rathgar, Dublin, in 1919 and educated at Sandford Park School, Rossal Public School in Lancashire and Trinity College Dublin. After obtaining a first class honours BA and B Comm. with Distinction, he qualified as a chartered accountant. He joined the firm of W. & R. Jacob and Co. Ltd. in 1944, subsequently becoming Managing Director and chairman. In 1977, he was appointed to Seanad Éireann by an Taoiseach. Uniquely for a southern senator, he was appointed to the Arts Council of Northern Ireland, in 1976. A sportsman of repute in hockey, badminton and golf, at the age of 35, through the stimulus of gifted friends, he started an art collection, through which a significant contribution to the promotion of peace and goodwill across class and political divides in Ireland was made. The Gordon Lambert Rooms, opened in the Irish Museum of Modern Art in 1999, honour his unconditional gift of this art collection to the nation. In 1999 he was conferred with an honorary doctorate by Trinity College. Gordon died on 27 January 2005.

VR: *How did IMMA get going, Gordon?*

GL: In 1984 when I learned that the late Basil Goulding's[1] collection was to be dispersed, as his successor to the chair of the Contemporary Irish Art Society, I put the item on the agenda for our next meeting. Together with Dorothy Walker, Pat Murphy, Campbell Bruce and other active members it was decided to write to the government to express our dismay. The large Tàpies which had been loaned to the Bank of Ireland and many other superb works were being acquired by the well-known galleries of Europe. The loss of these masterpieces caused an outcry. It stimulated the government to reconsider the establishment of an Irish museum of modern art. And I let it be known that I would donate my collection to help its fruition. I felt that would undoubtedly lead to other well-known collectors coming forward. I introduced corporate membership to the CIAS to help this objective.

Incidentally, I was on the board of the National Gallery since 1982. I wrote to Homan Potterton, director, saying that I thought the National Gallery should involve itself in an extension with a modern gallery. This was turned down by the board, who favoured the Municipal [Gallery] to provide this service. I argued that it was under the corporation and was only a city gallery. The National Gallery would not involve itself. So Haughey set up this committee.

When they were examining the issue of Kilmainham as a venue I had a visit from the Museum of Modern Art International Council. I was the only Irishman on the MoMA Council. On one of their European visits I persuaded them to come to Dublin. The Royal Hospital Kilmainham was functioning as a general cultural centre with Tony Ó Dálaigh as director.

I got Haughey's permission to hang part of my collection in Kilmainham and to entertain the MoMA visitors to a luncheon there, with the Minister for Education, Dr Michael Woods. MoMA's International Council voted $10,000 to the exhibition of drawings by Philip Guston in the Douglas Hyde Gallery [in 1989] as a gesture of thanks to me for making their visit to Ireland so

memorable. The fact that the MoMA visit took place at Kilmainham gave a boost to the RHK as a venue for the proposed international gallery of modern art.

VR: *Who was the chair of the Irish Museum of Modern Art committee?*

GL: Padraig O h-Uigínn. In 1987 he started discussions. He had enormous influence. He was Haughey's right-hand man. It was through him that I had the lunch arranged. The department of an Taoiseach paid for it. Brian Farrell came and raved about my collection. He gave me so much praise. I got Padraig O h-Uigínn to show Brian's letter to me to Haughey. There is no doubt about it, it had some influence. Haughey, of course, already had a reputation for the arts.

I was against the creation of a minister for the arts. It was better to report directly to the Taoiseach. By keeping the responsibility for the arts in the Taoiseach's office it is not affected by the demands of local politics.

VR: *Noel de Chenu put you on a par with Hugh Lane, who like you donated about the same number of works, approximately 300, to Ireland.*

GL: I was thrilled by Noel's remark. He was the Office of Public Works' architect responsible for the whole reconstruction of the RHK as a museum.

VR: *Australian artist Sidney Nolan also wanted to make a gift.*

GL: There were complications. I think it was tax. He was here in this house. In fact, I have a photo of him and Dorothy Walker, Jamie Boyd, his brother-in-law and myself. At that time he had given *The Wild Geese* (1989) to help to move the project along. These [6] paintings came. The other examples were to be of every year of his work. That fell through.

VR: *What do you think of his painting?*

GL: I think it's interesting. The finest thing was his show in the Royal Dublin Society [in 1973]. It was magnificent. He had never seen that work presented so well as featured in the magazine *The Arts in Ireland*.[2] An American woman, Princess

Evangeline Zalstem-Zalessky, one of the Johnsons of Johnson's Baby Oil, and her boyfriend, Charles Merrill, published the magazine. They were both leading lights in the Irish arts world while living here for about three years.

VR: *Was there anything in your collection that you could not part with in your gift to IMMA?³*

GL: A lovely little Kathy Prendergast. There is one Camille Souter that I didn't like to part with. She gave it to me as a gift for opening her joint exhibition, *2 Deeply, [100 paintings by Barrie Cooke and Camille Souter]* with Barrie Cooke, in the Carroll Building [in 1971]. Basil Goulding and myself organised it in aid of the Central Remedial Clinic.

VR: *Lady Valerie Goulding's project? You were very much in demand to sit on national boards in Ireland; weren't you invited to sit on the board of the National College of Art and Design?*

GL: Yes. Because of the extent of my involvement with the boards of the ESB, Dublin Tourism, Theatre Festival, and the Irish Ballet, some of which I had to relinquish when appointed to Seanad Éireann, I declined. In my letter, which Charlie Haughey acknowledged, I emphasised my desire for a museum of modern art.

VR: *You were a founder member of the Society of Designers of Ireland?*

GL: Yes. I launched the major exhibition entitled The Bowl at Kilkenny Design Centre in 1979 and subsequently the major exhibition of patchwork quilts in Fir House School, Tallaght, to encourage them and ceramics to be classified in the visual arts.

VR: *Earlier you argued for the importance of the Scandinavian report,* Design in Ireland *(1962). Were your visits to Sweden connected with that?*

GL: No, I was in Sweden a couple of times, on behalf of Jacob's. We were investigating a soup. The Scandinavian report was so critical, coming so close to the Taoiseach's application for full membership of the European Economic Community.

Frank Sutton was involved in publishing it. He was a very

underestimated contributor to the evolution of Córas Tráchtála, and in particular to Kilkenny Design.

When I worked for Jacob's and Irish Biscuits, I was the first member of staff outside the Jacob's family to be invited on to the board, in 1959. It coincided with the economic recovery in Ireland after

Left to right: Gordon Lambert, Margaret Downes and Frank Sutton.

the stagnation of the '50s and the appointment of Seán Lemass as taoiseach. My responsibilities included sales, advertising and public relations. This involved my membership of the National Agricultural Industrial Development Association, NAIDA, where we displayed our products. Jack Lynch's mother-in-law, Mrs O'Connor, ran the NAIDA exhibition in 3, St Stephen's Green, promoting Irish goods and fashion. I walked into one of their meetings and she said 'you're the next president of NAIDA'. She was a great patriot. She was a woman you couldn't refuse. As a new member of the Association of Advertisers, I was invited to give an address following the publication of the Scandinavian report in 1962. I helped to merge NAIDA with the Federation of Irish Industry in the Buy Irish Campaign.

Incidentally Jacob's pioneered the first Buy Irish Campaign in 1906. Look at the brochure.

VR: *The title* A Modest Appeal to the Irish People *has shades of Jonathan Swift.*

GL: NAIDA ran the St Patrick's Day parade. Haughey was Minister for Justice in 1964. I got to pin the shamrock on his lapel on the viewing stand at the General Post Office. The following year I had the same honour with Erskine Childers.

VR: *Mrs Childers looks very elegant in all these photos.*

GL: And still is. She walked over here the other day in a designer outfit and high heels. I persuaded her to take a taxi home.

VR: *Who dressed the Fianna Fáil women in the '60s and '70s?*

GL: I don't know. I think it was Irene Gilbert who dressed Rita Childers but Rita was a very good shopper. Rita chose designer clothes that she felt suited her. She had very good dressmakers. I knew Máirín O'Connor, Jack Lynch's wife, since my accountancy apprenticeship days, when we were a small group of keep-fit fanatics who played mixed hockey on Sundays.

VR: *Did you ever see Jack Lynch hurl?*

GL: Oh no. I didn't know Jack then.

VR: *This is a great group photo you have here, with Lynch holding a ball. Is it a hurling ball?*

GL: No, a cricket ball. A special cricket ball to commemorate my father's fifth hat trick in first-class cricket. He captained the Irish Cricket team for 26 years and scored 100 centuries. There is a photo of Jack Lynch and me leaning over Máirín's mother when she was very old. Jack and Máirín had no children. They cared for her and in a way she became their child.

VR: *Tell me about the great idea you had in the early '60s, to use radio and television to advertise Jacob's biscuits?*

GL: I must explain, because the Aer Lingus inaugural passenger flight to Cork on 16 October 1961 was a major step in my whole evolution from being a black and white accountant, to developing my whole marketing strategy. In February 1961 our advertising agent devised the radio programme, with the willing co-operation of Aer Lingus, based on the theme song, Frank Sinatra's 'Come fly with me'. Harry Thuillier recorded interviews with passengers aboard Irish international flights. This provided a weekly radio programme. Harry interviewed passengers, including members of the press, on the inaugural passenger flight to Cork.

Frankie Byrne was working for McConnell's advertising and I encouraged her to set up her own PR company with her

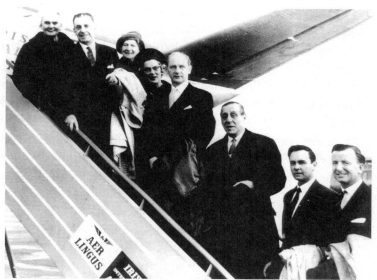

Aer Lingus inaugral flight to Cork 16 October 1961. Left to right: Mrs Lemass, An Taoiseach, Mrs Briscoe, Mrs Jack Lynch, Jack Lynch, Lord Mayor of Dublin Robert Briscoe, Paul Rowan and Gordon Lambert.

sister Esther. I asked her to think of a radio show which would appeal to women – the major purchasers of food products. She started *Dear Frankie*, with a resumé of women's columns from the national newspapers, coupled with Sinatra records. That with her unique throaty voice introduced a sizable bulk of correspondence from unhappy and lonely women. She became so well known. She spoke the commercial for Jacob's, always accompanied with a Sinatra song. I organised the inaugural Aer Lingus passenger flight in conjunction with the Dublin Junior Chamber of Commerce. Senator Mrs Jenny Dowdall, former Lord Mayor of Cork, drove up from Cork at my invitation to fly on that flight. I also organised the first passenger flight out of Cork on 16 October 1961, with the winners of the Jacob's Biscuit promotion together with sporting personalities – including Tony O'Reilly, Jim McCarthy, Andy Mulligan, Christy Ring and Christy

O'Connor. The party arrived in Dublin to a luncheon at Jacob's factory, hosted by Edward Bewley, company chairman.

When Irish television was about to be launched the following January I seized the opportunity to get Frankie B. to contact the editors of all the national newspapers. We got them to announce that Jacob's would be sponsoring the Irish Television Critics' Award. It seems hard to credit now, but in those days there were no such awards. It was supported by an Taoiseach, Seán Lemass, who was Guest of Honour at the presentations. I had great support from Seán Lemass after the flight to Cork. He wrote to congratulate me for initiating the Critics' Awards and when I was appointed to the board of ESB in 1964, he wrote and said it was the unanimous decision of the cabinet. In Seamus O Maitiu's history of W. & R. Jacob[4], he says that my career shadowed that of Lemass on the larger national canvas. In fact an employee dubbed me the "Lemass of Jacob's". Later the Lemasses moved up here to the corner house. There used to be a guard on their house. I felt very protected.

VR: Here is a lovely photo of Kathleen Lemass visiting Jacob's.

GL: That's Lily Dunne with her. Lily's brother Paddy later became Lord Mayor of Dublin.

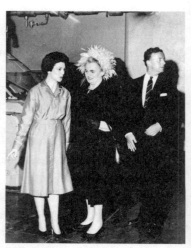

Having established a good relationship with the Junior Chamber of Commerce in 1962, I arranged a joint Jacob's meeting in Belfast. Jacob's had a depot there. I brought Paddy Hillery, then Minister for Industry and Commerce, who made a nice speech about co-operation. Brian Faulkner made a terrible speech. That was on the day that Nelson's Pillar was blown up [8

Lilly Dunne, Mrs Lemass and Gordon in Jacob's.

March 1966]. He got all the publicity! Erskine Childers wisely advised me not to have a toast to the Queen, which might have been divisive. It was very black then. So we had a buffet lunch to avoid toasts.

VR: *Were you actively political?*

GL: When Lynch had to fly back from America during the arms crisis [in 1970] Valerie Goulding rang me and said, 'do you want to join Fianna Fáil in support of Jack Lynch?' At 6am she collected a letter from me with my consent. She and I were appointed independent senators by Jack Lynch in 1977, together with Mary Harney and Seamus Brennan, only to learn that Independent senators appointed by Fianna Fáil have no role in leadership matters!

VR: *Tell me about being a member of the Northern Ireland Arts Council.*

GL: I had four Picasso etchings. I gave two [*Vollard Suite* etchings (1933)] to IMMA, one to the National Gallery and one to the Ulster Museum. The Ulster Museum had no Picasso. They were so pleased. I was adviser to the Northern Arts Councils before I went on the board of it. Ted Hickey[5] asked me to show my collection in the Ulster Museum. Subsequently I was put on the advisory committee to the Ulster Museum also. It was a much bigger affair than when my collection was shown in Wexford, in November 1976. It was at a time when the violence in the North was escalating. They praised me for having the courage to show it. I recall an incident crossing the Border. I was travelling to a meeting in Jacob's depot in Belfast. It was a time when a triptyque was necessary for cars crossing the border. I had a puncture and was late arriving at the custom's post. The officer said I could not go through as the post in Newry would be closed. I persisted, citing the importance of my meeting. The officer softened and said, 'You wouldn't be looking for Jim Figgerty, would you?'. 'Yes,' I said, to which he replied 'I'll phone Newry and arrange for your special admission as it is vital to find Figgerty to put the figs into the figrolls!'.

It's interesting to note that the other big food companies, Cadbury's and Rowntrees, like Jacob's, were also Quakers and avoided any connection with smoking or alcohol.

When I was asked to join Co-Operation North I declined because of my long association with Northern Ireland, where Jacob's biscuits were accessible to all shades of loyalty. I was born before the Border was imposed. I have thought and acted on an All-Ireland basis ever since. I'm Church of Ireland. The Archbishop of the Church resides in Armagh, in the same city as the Catholic representative of Rome.

VR: *You have a fabulous archive and a fabulous memory. Do you follow the auctions?*

GL: Not very well.

VR: *Now that contemporary art sells so well at auction, it can be hard on artists to see their work resold at high prices, when they were often paid very little.*

GL: You sound like Robert Ballagh.

VR: *I was at a lecture he gave yesterday [25 September 2003]. We must talk about Robert Ballagh,[6] seventeen of whose works you bought, but let's get back to auctions.*

GL: I only sold two works at auction, to test the market for the artist. Everything I bought had some connection with my life. My first portrait commission was of my mother, by Henry Robertson Craig. Some collectors are said to have destroyed that artist Schnabel, who used the broken plates. The work they buy is often put in crates in bank vaults and they don't even collect it. When Saatchi buys new artists everyone rushes to buy their work. I know for a fact that some collectors employ art dealers as buyers. They say, 'I'll sell your such and such and buy such and such'.

VR: *Does the portrait* Mother with Monty and Duke *(1958) capture her spirit?*

GL: It does. I didn't want a portrait as such. She was sitting in her chair, with two dogs and the portrait of my father was beside her. He died in 1956, she died in 1964. Robertson Craig's work went out of fashion. He painted me in *The Regatta* (1958/9). I

am sitting in the front of the boat. I gave the study to the National Gallery.

Mother and he got on very well. Harry was a charmer.

VR: *In general do the self-portraits[7] you commissioned reflect the range of figurative work in the Irish element of your collection?*

GL: Yes, to an extent. I got the idea of commissioning portraits from different artists in Cagnes-Sur-Mer, where I saw a collection of portraits of the collector by a variety of artists. I learnt that portraits are not about how the person wishes to be seen but how the artist sees them.

VR: *Tell me more about your parents, please.*

GL: My father [Robert] was a veterinary surgeon. He was the vet to Jacob's, Boland's and Guinness' horses. His father was also a vet. The entrance to the Lambert home, 'Mount Anthony', was on Rathmines Road, where eventually the Princess Cinema was built. My aunts used to ride on horseback around the grounds, and talked to the rebels in 1916. Portobello Bridge was a key position in 1916. Jacob's was occupied, but Thomas MacDonagh allowed the horses out to be watered. Much later, Jacob's was a venue for exhibiting a model of Dublin during 1916. At the other side of Rathmines Road was the entrance to the Leinster Cricket Club, where my father began his famous cricket career. My brother was a great rugby player, my father and brothers were great Lansdowne members. I used to be brought to rugby matches. I can still smell the cigars my father used to smoke.

My grandmother's family were the owners of the Shelbourne Hotel, the Jurys.

VR: *Are they written up in Elizabeth Bowen's book[8] on the Shelbourne?*

GL: Elizabeth Bowen mentions my great uncle, Charles Jury, but not my grandmother Agnes, who was his sister and married Robert Mitchell. Charles inherited the hotel. That's where I got the Charles from – Charles Gordon Lambert. He used to send me five shilling postal orders every birthday. My mother [Nora Mitchell] got married from Ailesbury House in 1907. The house is now the

Spanish Embassy. Her mother was a Jury, not to be confused with the Jurys of Dame Street, who were Catholic. My mother kept in touch by letter with Uncle Harry and Aunt Georgie Jury, who were Catholics. I have letters from Auntie Georgie.

VR: *You were the youngest of four brothers.*

GL: My older brothers and I were in Sandford Park. It was the first interdenominational school. Skeffington, Cruise O'Brien, the Solomons, Davis and Keating were there. Because of limitations in Protestant education we were sent to Rossall in Lancashire after that. Rossal was primarily classical. It was the only public school on the sea in England. A lot of Protestants North and South went there from Ireland. I travelled with the late Bishop Harvey of Kilkenny on the B and I Line. Ken Besson whose family owned the Hibernian Hotel [in Dawson Street] looked after me on another occasion. It was very Spartan. You had to have a cold bath every morning. Ever since that, up to relatively recently, I had a cold bath every morning. I hated leaving home; I said that on the Gay Byrne interview.

VR: *Tell me about that interview, Gordon.*

GL: I was fascinated at how much Gay Byrne brought out in me. It was a most relaxed and happy broadcast. It coincided with my sixty-seventh birthday and with the celebration of the annual Jacob's Awards that evening.

VR: *You came home to go to university?*

GL: I went to Trinity. A year after I was qualified as an accountant I was sent on approval to do the audit at Jacob's, where I met Harold Jacob. Edward Bewley, who was head of Jacob's Ireland then, offered me the job of assistant accountant at £300 a year. You see this photo of Maureen O'Hara, I was showing her the Jacob's Television Award designed by Richard Kingston.

It was the second award scheme, Texaco had the first. Robert Costelloe, Paul's brother, designed the radio award, which came later. He died suddenly in a car crash [in 1974]. Theo McNab redesigned it.

I had to go for an interview during the blackout in London.

Maureen's mother, Mrs FitzSimons, and the other two daughters were there. Margot got me into a hotel; I went down to Denham studios with them. Florrie, Maureen's other sister, was filming *Hotel Reserve*. A few weeks ago I looked at what was on television and *Hotel Reserve*, made in 1944, was on. I'd never seen it. So I watched it. It wasn't a great film, but it was very exciting for me. They lived in a house in Milltown opposite the golf club.

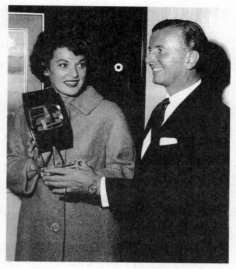

Maureen O'Hara and Gordon Lambert.

VR: *Was the location of Jacob's, at 28-30 Bishop Street until 1977, important to your evolution as a collector? It was two minutes from St Stephen's Green, then very near so many significant art places.*

GL: The move to Tallaght in all took ten years, during which we had to cope with the world commodity crisis, massive increases in materials prices, even an energy crisis. There was the merger with Bolands [in 1967], staff changes and union negotiations and so on.

When Jacob's was in Bishop Street I used to go to Robert Roberts in Grafton Street for lunch; baked beans on toast. There was a men's table. It was not an arty table, but Cecil King[9] was there. Cecil brought me up to the Dublin Painters' Gallery on [7] St Stephen's Green. Patrick Hennessy, Henry Robertson Craig, Barbara Warren and Beatrice Glenavy were showing there. That's how I got involved with Patrick Hennessy and Robertson Craig. They were always together. Hennessy was a very private person.

My mother and father and the Warrens were very friendly through Lansdowne Rugby Club. John Warren was a good friend of mine. He was killed in a car crash. I was with Nance Warren, their elder sister that night. We passed the car, I recognised the number. We left Nance home and John wasn't there. I knew the worst then. My mother had to break the news to the family. That was 1938.

VR: *You began your collection with a Barbara Warren.*[10] *When you started buying in 1954, would you have been able to afford to buy a Yeats?*

GL: No, that's why I didn't. I remember *My Beautiful, My Beautiful* (1953). Basil Goulding bought it for about £5,000 from Waddington's.

VR: *You believe it was Basil Goulding who inspired you to collect. Did you buy any of his collection sold through Hendriks and Dawson?*

GL: Yes, *Hats off for Camille* [Souter] (1976) by Patrick Scott.

It was through Basil that I began to look at the work of Camille Souter and Barrie Cooke and it was he who invited me to join the CIAS. He and Cecil King certainly influenced my early collection. I was greatly honoured when Basil invited me to succeed him as chairman of CIAS, which he founded in 1962 [or '63] 'to fill a void'. His foresight gave some Irish artists a permanent establishment in the public eye, that neither the government nor the corporation, nor even private patronage were willing to provide otherwise, at that time. Basil was endowed with a multiplicity of outstanding talents, which he used to the full with amiable gentility. In my opinion, he could be regarded as a conceptual artist himself. His imaginative use and indeed misuse of the English language can be compared to Joyce. To me his wordology or the way he mixed the alphabet was akin to an artist mixing his multicolour paints. The impetus which he gave through his unconquerable spirit and wit to what used to be the Cinderella of the arts in Ireland, the visual arts, should always be remembered.

VR: *I've heard his AGM speeches at Goulding Fertilisers were*

famous for their elegance and pithiness. Did you drive in from Rathfarnham every day to Jacob's?

GL: In the early days I cycled. The neighbours hired a garage to keep the bicycles and we got a tram in. There was one person who always got on the tram and the smell of his feet ... I remember a woman pointing out the church in Rathmines and saying it was as big as the Vatican.

VR: *There's great excitement this weekend with the launch of the Luas (4 and 5 July 2004).*

GL: We used to have local trains. Tod Andrews closed the Harcourt Street line. I remember Maureen O'Hara's father used to go on the train from Milltown into town. Quite a few people took that line into Jacob's. It wasn't so bad for me when the trams went. I had a Morris Minor by then.

We lived in a bigger house, 'Berehaven', down this road, built by Chris Murphy's widow. She was from Berehaven in Cork; Chris of Independent Newspapers. Chris was Martin Murphy's brother. Martin had lived in Dartry House and he had Easter egg hunts there for children. Eva Murphy, Chris' daughter, was about the same age as me.

VR: *Martin Murphy who caused trouble in the 1913 lockout?*

GL: I had to live with that later in Jacob's, who were involved in the Labour dispute then. Eva, Chris' daughter, was my first girlfriend. We were three and four. They lived next door to 76 Highfield Road, where I was born. Countess Markievicz lived further down on the same side. Erskine Childers was also a neighbour. Eva got married when she was seventeen. As very young children we appeared on the Gaiety stage together, as part of the Leggat Byrne dancing school.

VR: *Was she anything to the Eva Murphy whom Samuel Beckett's father is said to have loved and not allowed marry because he was Protestant and she Catholic?*

GL: She was Chris Murphy's sister and the aunt of my Eva. My mother was thinking of moving from Highfield Road. The Murphys were building the house up here on the grounds which

had been owned by the Jesuits, and had also included the Castle Golf Club. It was one of the first. It was the outstanding house of the time. Chris died and he left it in his will that his widow was to finish it. Pickering was the builder. She got involved with some actor and to everyone's surprise she married him. She moved to England, but before she moved she mentioned to my mother, who had been her next door neighbour in Highfield Road, that she was selling the house. I was about eighteen then. I got very excited about having a room to myself.

We lived in 'Berehaven' for ten years. During the War we grew vegetables on the lawn. We also had a vegetable plot on the golf links. My father, a vet and a cricket player, was not very interested in the house. The golf course was used by the whole family. My mother had been ladies captain of the Grange Golf Club. The year I won the Captain's Prize, in 1951, I moved up to this house [on Hillside Drive] with my parents. I had taken an option on this site. It was all wasteland. With O'Brien the builder who bought the land from the Jesuits, I designed the house. I lived with my parents and looked after them. There were very severe restrictions on building. This was the first bungalow after the war. The builder was so taken with my design, he built the house next door for his son like it. At one of my parties Harry Bernardo, of Bernardo Furs, connected with the Homes, was also so taken with the design that he built a similar one up the road.

VR: *The garden onto the golf course is lovely for the sculptures.*

GL: The sculptures are in IMMA now – the Michael Bulfin and the Gerda Frömel [*Mobile*, 1973] and others. I bought a Joe Butler. I am going to ask him to paint it now that I see the image on the Hallward invitation.[11] I saw the *Birth of Chú Chulainn* (1967) by Delaney in Hendriks and liked it, but didn't buy. Next time I saw it was over the entrance to the Lyric Theatre in Belfast. I stood on the balcony with Edward Delaney and said, 'If the proposed sponsor doesn't buy it, I will'. Edward Delaney arrived here with it. He chose the granite base for it. That influenced me in mounting the Gerda Frömel. It also influenced me in mounting the

Arp [*Oriflame* c. 1957-66). It's now on exhibition in Letterkenny [July 2004].

Birds in Flight by Oisín Kelly also has a granite base. To my great luck I received it as an award by Guinness Peat Aviation for Outstanding Contribution to the Arts [in 1988]. I was in company with Haughey (1981), Michael Scott (1982), James White (1983), Seamus Heaney (1984), Samuel Beckett (1986) and later Tim O'Driscoll. Tony Ryan was so helpful and encouraging. I went down to see him in Nenagh. GPA really operated from there, although their business was in Shannon. Maurice Foley has a place there.

After 'Berehaven' my mother referred to this bungalow as the matchbox. After they died I redesigned my parents' bedroom around the big Cecil painting. There was a huge wardrobe, a Victorian one, and a small fireplace. I closed that off. I got the idea of striped wallpaper for my study from Cecil. The day that Cecil died [7 April 1986] was the day after the Gay Byrne interview.

VR: You are a friend of Ulli de Breffny, who, like her late husband Brian de Breffny, has done great work for the arts.

GL: She did a hell of a lot. I used to go down to her home in Castleton Cox [in Co. Kilkenny]. It was very relaxing. Brian was so involved. I remember Michael Scott introduced me at an early *Rosc*. When Brian died [in 1989] she sold Castletown Cox and moved to Burlington Road. Her house is for sale now. It is a Victorian house and she decorated it with modern Irish art. Brian was a historian[12] really, but he was known mostly in the social world as the best dressed man in Ireland. I was nominated the third best; he, Charlie Haughey and myself

VR: *Who was your tailor Gordon?*

GL: Frank Gormley in Grafton Street. The other person he dressed was the singer Frank Patterson. Frank Gormley was married to Ursula Hough of The Rathmines and Rathgar Musical Society.

VR: *Did Sybil Connolly[13] ever advise you on your clothes?*

GL: No. I started the idea of the exhibition of Irish fashion with Elizabeth McCrum, Ted Hickey's wife. Sybil wanted me to go on

the International Council for MoMA. I went to the opening of the extension of MoMA with Sybil. It was amazing. They were curtseying to Sybil. She was royalty in New York. She was very friendly with Peggy and David Rockefeller. Beth Strauss was her best friend in New York. Sybil wasn't a member of the Council. She designed clothes for all those people; it's all in Robert O'Byrne's book.[14] It was Beth who nominated me to the International Council. In 1979 there was a trip with Beth, who was president of the New York Horticultural Society and her group, to Dublin. Sybil had this beautiful mews at the end of her garden in [71] Merrion Square. These special friends stayed there, they had greater freedom. I hosted a dinner party for them and invited Richard Wood from Cork. He and Peggy Rockefeller got on famously because Peggy was interested in cattle.

Owing to my ill health, I invited Beth to meet my friend Patrick J. Murphy, whom I nominated as my successor. My period as the only Irish member was 1980 to 1992.

The International Council for MoMA started in Winston Salem, North Carolina, the home of the first Arts Council in North America. Winston Salem is about the size of Limerick and it was a revelation to learn what they have done for the arts. The explanation is that some of the most capable and best-trained business people are involved. They claim that the investment by business in helping the arts has generated a twenty-fold return. Being on the International Council for MoMA helped me to promote Declan [McGonagle] and prominent curators to know more about Ireland. IMMA is a success through the hard work of the staff. The teamwork was stimulated by Declan. It should always be recorded that he established the international image of IMMA. It was tragic that he felt he couldn't stay.

VR: *Yes. Have you met the new director? Enrique Juncosa being Spanish and your mother's former home now being the Spanish Embassy will be of interest to him.*

GL: Not yet, but I am looking forward to it. We were fortunate to get a man of worldwide repute, and coming from the Renia Sofia in

Spain which I knew from my visits with the MoMA group.

There are 25 countries represented on the International Council. Buying had nothing to do with it. There were exhibitions. For every meeting in New York there was a special overseas meeting. We had three days somewhere. In New York I stayed in the Knickerbocker Club, right beside all the main hotels on Fifth Avenue. I used to bring films of *Rosc*, and catalogues and books with me and leave them there for them to read. They never regarded the reporting seriously until I came. Mrs Joanne Phillips of the Phillips Collection in Washington was president when they came to Ireland. There was nowhere of the standard to take the Rothko they would give.

On the International Council was James Johnson Sweeney. I became more friendly with him. He was so respected. I was disappointed he was taken so lightly. Michael Scott had the idea of *Rosc* but James got the paintings. Anywhere I went – Milan – Rome – anywhere - if I mentioned James Johnson Sweeney I was brought into the private room of the gallery.

VR: *You've been very supportive of publications on Irish art.*

GL: The book[15] by Roderick Knowles was criticised by Dorothy Walker for including his partner, Helena Zak. All the artists that have developed are included in that book. It should have been republished. I think Tim Pat Coogan's book *Ireland and the Arts* is very good.[16] It covers so many things, the atmosphere of the times and ideas like Patrick Collins being the successor

Left to right: Gordon Lambert, Betty Parsons and James Johnson Sweeney.

to Yeats. It mentions my part on the International Council and *Rosc*. I was involved with *Circa* [the contemporary art journal, begun in 1982].

Ann Reihill invited me to join the advisory committee of the *Irish Arts Review*, of which I have all the copies including the first eight rare copies. Ann married into the Dillon Malones. I knew Patrick through the Irish Management Institute. He was a very nice man. He died. Then she married John Reihill of Ted-castles. She had a wonderful collection down in 'Deepwell'. One of them was the original *Military Manoeuvres* (1891) by Richard Moynan. Bridgid Moynan was living in Killiney, in the Tower on Strand Road. She inherited Moynan's scrapbooks. I used to go down to the hut attached to it; it was referred to in the long lease as the bathing hut of the tower. I got to know her very well. She was living with Hilary Heron's father, James. He was a completely opposite personality, interested in golf. I used to play golf with him. Bridgid had the scrapbooks. 'I'm throwing these out, you can have them,' she said. I got all Moynan's scrapbooks, the study for *Military Maneouvres* included. I thought 'I'm not into collecting that period'. So I gave them to the National Gallery, in memory of Bridgid Moynan, his daugh-ter. I couldn't believe how well they looked. There was also an oil study of one of the paintings of the black man who featured in another Richard Moynan.

VR: *When did you get to know James White?*

GL: I'll tell you how I got to know James. He used to write criticism for *The Irish Times*. He was on the staff of Player's, the cigarette manufacturers. He was appointed to the Municipal [Gallery] the same day I was appointed director of Jacob's. I made the sugges-tion that I would like to introduce the Jacob's factory workers to see art, and James agreed. He said 'I must invite the Player's workers first'. So we had a Sunday for the Player's workers and then for Jacob's.

I got to know Aggie White. She and James lived in the flat of the Municipal when he was there. Behind every great man is

a great woman. She is a wonderful woman, a real complement to James. I met quite a few people through visiting James and Aggie in the flat in the Municipal, including Alice Berger Hammerschlag. I became a trustee of her Northern Ireland trust award [after she died in 1969].

James did a lot of good work in bringing people into the National Gallery. Homan Potterton never got the credit for what he did in conservation and storage. They blame Ethna Waldron for a lot, but she didn't inherit much in the Municipal in that line. A lot of the early modern pictures were presented by Basil Goulding of the CIAS. That had Fr O'Sullivan, Michael Scott, Stanley Mosse. Stanley bought a lot, before I ever became involved.

VR: *I see the catalogue of an exhibition Contemporary Art from Irish Industry, in 1966. You believed in having art in the industrial setting?*

GL: The art and industry exhibition was a very early effort to use art in public relations. In my travels in Sweden I saw works of art in the factory. They were subsequently presented to member of staff as awards, instead of bonuses. They bought paintings and displayed them first and then distributed them. That's why I introduced art to the new factory in Tallaght. People would come to the factory and say I created an atmosphere. I left some work there. I got them to buy the Deborah Brown and the Theo McNabs. I walked into Hendriks one day and saw this long series by Theo McNab. 'That's just the one,' I said. The boardroom was a long a narrow room. Not only that, I wanted something for a room you could have meetings in, and not be disturbed. They're perfect when you're thinking of problems. They've never had an adverse comment. On the other wall I put three abstracts by Ciarán Lennon. They would encourage discussion but not cause an adverse effect.

I had my own little dining room in Jacob's in Bishop Street, in which I entertained customers who used to come up to the Spring Show. They would prefer to have lunch in Bishop Street than in the hotels.

VR: *Showing the centres of manufacturing to the nation was a big thing then. Children were often brought there on their school tours and given lots of biscuits.*

GL: Yes. When I joined the board of the ESB they had very little communication with the rural community. I suggested they develop a lunch room on the roof. It materialised. The new offices were already built when I joined the board [in 1964]. I felt it was too straight a line – the whole vista of Georgian buildings from Holles Street to the mountains is staggered. They set up an art advisory committee – Fr Donal O'Sullivan, Ethna Waldron, George Dawson, Sam Stephenson and me, to record stages in the development of the ESB.

I had the privilege of meeting Henry Moore. Fr O'Sullivan was a great friend of Henry Moore's and got him over. He wanted to buy a Henry Moore for outside the building. It didn't happen. Moore said it wasn't suitable to his concept, because the only time the sun shone was 4pm in the afternoon. Subsequent to that Frank Morris was commissioned to do the lettering on the outside of the building. I later opened an exhibition of Henry Moore's prints in the Lad Lane Gallery.

VR: *You were on the advisory committee of the Municipal, too, from 1976-1991. What about the Albers in* Homage to the Square-Aglow *(1963) – the 1972 portrait you commissioned from Ballagh?*

GL: That's a pure coincidence. Ballagh didn't know that I was fond of Albers. Ethna Waldron was involved in buying that Albers for the Municipal. Albers withdrew all his work from the world galleries because he was annoyed at the lack of public appreciation. Denise René had some of his work. I bought a tapestry from her, woven in Aubusson. There were two Albers in Hendriks. Ethna Waldron bought one.[17] I bought the print; the little one I bought in New York.

VR: *Hendriks showed international stock almost from the time they opened.*

GL: I bought two Picasso etchings for £35 at the opening of Hendriks

in 1956. They are now selling at £20,000. This taught me that prints were good ways to buy international art. Every time I visited Paris I went to Galerie Proute, and Galerie Maeght. I bought the Braques in Galerie Maeght. Braque supervised all the printing himself. Braque's prints were in Hendriks during the '60s. George Dawson was specialising in Braque. That had an influence on me.

VR: *What led to the opening of David Hendriks' galleries, originally the Ritchie Hendriks Gallery, on 3 St Stephen's Green, like NAIDA?*

GL: The people who encouraged David Hendriks to open a gallery were Patrick Hennessy and Robertson Craig. They made a contact for him. It happened when Waddington was closing; that took a long time. Leo Smith made the remark that one gallery wouldn't close and another open. Waddington was the prime gallery before Leo Smith [of the Dawson Gallery] and Hendriks emerged. I bought some Micheal Farrell's and Colin Harrison's and some Pat Scott's from Leo Smith. He inherited a lot of artists from Waddington. I used to go into Waddington [on 8 South Anne Street] for frames and that sort of thing.

VR: *Was it hard for galleries to make a living then?*

GL: I had an uncle whom I met in Duke Street one day. I brought him along to the window of Waddington's where there were some Yeats. My uncle made the remark 'what's that? I could do better myself with a bucket of dirt and a mop'. That really describes the attitude of most people to contemporary art then. Waddington didn't show international art. Leo Smith didn't. A lot of credit goes to Cyril Barrett, S.J., who later brought the kinetic art exhibition to Dublin, to the Hendriks.

I met David Hendriks through Barbara Warren and Helen Watson of TCD, whose sisters were teachers in Kingston, Jamaica. She was in the bursar's office. He stayed with them in Dublin. He was doing a degree in Trinity; he wasn't sure what to do. Then he met Patrick Hennessy and Robertson Craig. His mother's name was Ritchie. He was David Williams when he came to Dublin.

Patrick Hennessy thought that Ritchie Williams wouldn't sound too good. Hendriks was where the money came from, on his mother's side. Vivette, his cousin, was Vivette Hendriks.

Patrick Hennessy and Robertson Craig introduced David to Madame Guinoiseau, who helped run the gallery for a while. She very much complemented David. She used to say he was pure Inca. She was a relation of one of the French politicians. She was a most attractive older lady, a dilettante of the arts, an amateur with a professional knowledge acquired at the Academie des Beaux Arts. She was the wife of Colonel de Waverin of the French Resistance and wished to earn a living in the post-war depression. I don't think David could afford to keep her on. Vivette then took over her role, until 1975.

VR: *Had Madame Guinoiseau run a gallery in Paris?*

GL: No. David was very much affected by Patrick Hennessy and Robertson Craig. Patrick Hennessy's patrons were the Vernons from Cork; she was the sister of the Duke of Westminster. They were very grand and very generous. They always bought Hennessy's. Hennessy lived off Elgin Road, with a mews studio. He showed in Agnew's, the most prestigious gallery in London. I bought the Hennessy *Yellow Ribbon* (c. 1956) in Agnews.

VR: *Did the Vernons buy in Hendriks?*

GL: No; only Hennessy and Robertson Craig. They began in the Guildhall and were selling well there and weren't dependant on the Irish market. The Dublin Painters' Gallery provided them with income also.

Vivette would have stayed. There were three reasons why Vivette went home. A broken romance was one. Her father died and she had to stay to look after her mother. The exchange rate and that sort of thing was another. A lot of money in Jamaica was Hendriks money. She couldn't live here in style. Robertson Craig did a lovely portrait of Vivette with a string of pearls. It went back to Jamaica. Incidentally, her father was known as the only man on the island to own a Rolls Royce.

VR: *In* Living with Art, David Hendriks[18] *there's a lot of comment*

about how compatible the Irish and the Jamaican temperaments are. You'd been there on a visit in 1954, but did you know that the first governor of Jamaica under British rule was the former commander of the garrison at Macroom in Cork, and the father of William Penn, founder of Pennsylvania and the Quakers?

GL: No, but an uncle of David and Vivette was the Jamaican High Commissioner to London in those days.

VR: *For one gallery to close and two to open was pretty amazing, given the economic climate of the 1950s. Had the Hendriks many key patrons?*

GL: Gladwys McCabe, a great collector of Patrick Hennessy and Robertson Craig, said to David 'do you know what you are doing? It will take you five years before you make it.' She has been underestimated. She promoted Patrick Collins. She was the wife of the famous fish shop; they used to say she was married to Fish McCabe. If my collection and hers were put together it would have been the best. She had Collins, Armstrong, Roberston Craig – he did a lovely portrait of her[19] – and Hennessy. She and Cecil King were great pals.

VR: *Did she buy Collins* Stephen Hero *(1950) in Hendriks?*

GL: She had that Collins before Hendriks opened.[20] Later on, when Collins left Hendriks, Norah McGuinness put down the window of her car and said 'what the blazes are you doing leaving Hendriks?'[21]

Then the Bairds, they bought from both galleries. They added a bit of glamour. He was in insurance, she was independent. They were very united. He did everything for her; all she had to do was look lovely. They wouldn't buy without each other.

VR: *Their art has been up for auction at Adam's (26 May 2004).*

GL: I remember *The Cat* (c. 1954) by Gerard Dillon was hanging over the kitchen door in their home in the Burnaby in Greystones. They were from the North, they had two very fine Colin Middletons. *Child Dreaming* was one. She gave my trust a drawing by Robert Ballagh of her husband holding a portrait of her. I

was the only friend she had in her last days. She wouldn't ring anyone else.

Maureen Hurley said the David Hendriks Gallery was much more social than anywhere else. She said she met all the artists there. David was very friendly with J.B. and Rhoda Kearney [from Cork]. They bought.

GL: Hendriks came to [16] Lavitt's Quay [in Cork, between 1971 and 1977] to show work. I went down several times with the Bairds. Some of my collection was shown in Lavitt's Quay. I always stayed in the Metropole.

VR: *I think all that art activity around the Cork Arts Society was influential on a whole group of Cork artists, some[22] of whom showed in Hendriks, which was beautiful; I mean 119 St Stephen's Green, the premises David Hendriks leased and moved to in 1965.*

GL: Yes. Diane Tomlinson, now a professional garden photographer, took charge of the framing and the framer was the son of Charles Lamb the painter. Diane and I had never met. David introduced us in the Arts Club. Diane's uncle's horse had won the Grand National and her grandmother was presented in Court in London. I met Diane when she was still living in 'Fairyhill', her family home. It was off Newtownpark Avenue, with a lot of ground; it's all built on now. Diane knew another cousin of David's when she was a nurse with her in St Thomas' Hospital in London. She returned to look after her grandmother. When she died, she lived on for a while with her father. I was often in the house. It was the first house I remember with red wallpaper; the drawing room had sapphire blue walls. Later Diane moved into a flat at the top of 65 Pembroke Road. Cecil lived in a flat quite near, on Pembroke Road. There again another great friend of Cecil's was Dr Thekla Beere. She had a flat in the same house. She taught me statistics when I studied for my commerce degree in Trinity and she made students believe that statistics was the most important element of a degree in commerce. I was a con-scientious student and she drove me into liking her because she

stated that I was her brightest student. She became secretary to Childers in Transport and Power – the first woman to hold such an office.

VR: *By the mid 1980s so many of that group had passed on – Patrick Hennessy in 1980, Basil Goulding in 1982, David Hendriks in 1983, Robertson Craig in 1984, and Cecil in 1986. And even though Hennessy had spent a lot of time during the last ten years of his life out of Ireland, wasn't there a huge loss to Irish art, a kind of a sea change?*

GL: Yes. It was to honour this that Diane Tomlinson and I gave *The Oracle* (1967) to the National Gallery. It had been a particular favourite of David's, and Hennessy and Harry Robertson Craig were the inspiration for the opening of the Hendriks Gallery, so we thought it appropriate to give a painting by Hennessy.

VR: *Would you compare your collection to some of your friends'?*

GL: George Dawson spearheaded the collection of prints by the modern masters such as Braque, which I tended to follow. Pat Murphy's is probably the largest and most varied collection, covering a much longer period. My collection has been referred to by Bruce Arnold as a tapestry of personal documents, a visual calendar of my years of collecting, including Irish contemporary art and international art and developments such as the kinetic phase. I was interested in the kinetic movement among South American artists, Soto, Cruz Diaz, Le Parc, Novoa and others. I carefully acquired given the limitations of my income. Basil's embraced some very expensive international contemporary art as well as Irish, which he selected and bought for himself and some wealthy friends of his. I did buy quite a few abroad. But the purchases generally were influenced by the major exhibitions which professionally emerged on the Irish art scene through *Rosc*, and progressive galleries like the Hendriks and the Trinity exhibitions.

Of course, I was stimulated by my visits to Cagnes-Sur-Mer, the *Venice Biennale*, *Documenta* and America, and by my friendships with so many Irish artists.

VR: *Your collection is special for lots of reasons; one being that mix of Irish and international artists. Tell me about the Milan connection.*

GL: Penelope Dickson ran the Studio Marconi in Milan. James Coleman had a studio there. I knew Penelope very well. She was the daughter of friends of Basil Goulding in Enniskerry. I had seen the Adami *Beauty Parlour* (1969/70) in the David Hendriks Gallery. I thought it was too important a painting to let out of Ireland. I thought I better go to Milan and see more of his work. So I flew from Nice to Milan. It was a tense flight during the Corsican problems. The wheels failed and we had to make an emergency landing, successfully thank goodness. I had dinner with Penelope and looked at the Adamis but couldn't see anything more important than *Beauty Parlour*.

VR: *Did Adami come over for the Italian Painting exhibition in Hendriks and in the Arts Council of Northern Ireland?*

GL: No, he didn't come to Ireland. I have a print of the Joyce portrait [1971]. I don't know why Penelope didn't come back. She and James [Coleman] had a son. She was a very alive, attractive, intelligent person. The way she sold paintings – Milan businessmen would ring her and say 'buy me such and such'. They just trusted her. James showed me around Milan and we visited the studio of Antonio Diaz.

VR: *How did David Hendriks source artists like Adami?*

GL: It all started with Cyril Barrett and Anne Crookshank. They wanted to get the kinetic and op exhibitions to Dublin. There was nowhere in Dublin to show them. David Hendriks was delighted to co-operate with them. Through my association with the arts in Northern Ireland I was aware of Anne Crookshank's wonderful collection, which she acquired for the Ulster Museum. I really got to know and admire her as a person with a great sense of humour during the kinetic exhibition, where one Japanese artist introduced an artwork which had bubbles pouring over the top and dissolving. She was very funny about the special soapsuds, a detergent ingredient that could only be

purchased in London. Crookshank was hilarious. And that episode and the other kinetic artists who participated in the show which no one else would touch, only David, led us all to look at art with new eyes.

VR: *The kinetic art exhibition in August 1967 had huge attendances – 4,000 – that is about the number of people who were working in Jacob's! But it cost a lot.*

GL: I suppose, but it was grant aided by the Arts Council[s]. It stimulated my interest in kinetic art, but the range of Italian artists emanated from Studio Marconi.

VR: *When asked much later to write about your favourite painting you chose your big Vasarely, Lant (1968). Eleven Vasarelys were shown in that Kinetic Art exhibition in Hendriks.*

GL: Many Irish people will know Lant from the cover of Henry Sharpe's *Art History and Appreciation*, the textbook. It is also on the cover of the full documentation of the OPW on the reconstruction of the RHK.

VR: *Did he and Denise René run a gallery together in Paris?*

GL: No, not exactly but Denise René regarded Vasarely as the senior artist and developed a huge market for his prints through her gallery on the left bank.

VR: *Was the large Vasarely one of your biggest financial stretches?*

GL: The Adami was a big stretch.

VR: *What are your thoughts when you look at that Vasarely now?*

GL: I am still dazzled by it. In retrospect I can assess how my early training in mathematics and accountancy unconsciously influenced me towards the development of my interest in kinetic art. My interest deepened as I studied his scientific approach to art and I admired his dedication to uplifting man's drab environment by his matchless knowledge of colour combination to pure and scientific architecture. I've said all that elsewhere. He was attracted by the speed and sophistication of machines which moved man into his new aesthetic environment. This foreshadowed computer art and on to digital art.

VR: *Your Soto Curvas Immateriales (1966) an op art piece, was on*

the front page of The Irish Times *on 7 November 1967.*

GL: It was the only work from an Irish collection shown in the first *Rosc*. James Johnson Sweeney selected it. Máirín Lynch used to refer to the Soto as 'the coat hangers'. At the Municipal[23] opening she said 'You put me in front of that bum,' meaning the Adami *Beauty Parlour.*

I bought the Soto from his studio in Paris. He won the prize at the *Venice Biennale* in 1964. Vasarely was shown in *Rosc '67*. I hankered after his permutation period. He has the discipline that is everlasting.

VR: *Did I hear you saying that at the opening of the Project Arts Centre [when it moved to East Essex Street in 1974][24] you bought some Irish paintings by very young artists?*

GL: I bought the Charles Tyrrell for £100 and I bought a Colin Harrison.

VR: *You, like the Hendriks, were interested in the promotion of Irish artists abroad.*

GL: I used to go occasionally for a weekend to Cannes in the south of France. I used to hire a Volkswagen and drive to Galerie Maeght. I was so interested in the exhibitions in Cagnes-Sur-Mer. Deborah Brown and Theo McNab were showing there in 1975. I walked to the top of the Castle Grimaldi and there in one of the most important rooms, on the main wall, was the fibre-

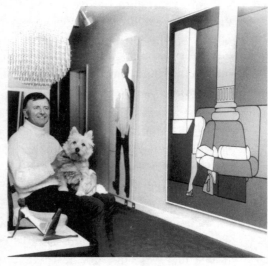

Gordon Lambert and his dog sitting opposite Beauty Parlour.

glass piece by Deborah and the black satin ones by Theo McNab, including the *Irish Elegy* (1971) that I have. It was stunning. To my mind it equalled any gallery wall I've seen. There were 40 countries represented. I was very proud to see the Irish flag flying. It was a bit tattered.

I went in 1981 and 1982. I never had such a good time as when I was on the jury in 1982. Blaithín de Sachy came with Gene Lambert. His paintings were of his period in hospital after he was crippled in a car accident. They were hung upside down; I corrected that. In 1981 the Charlie Tyrrells looked good but unfortunately didn't get a particular hanging. I felt one should be there for the hanging. It was such an unusual place – the castle, the rooms and the walls. The Irish formed a team. Blaithín was regarded as the official delegate of the artists represented. Every five years they have an exhibition of winners in previous festivals. I represented the Cultural Relations Committee on the jury that year. Graham Gingles was there, with his girlfriend who died of cancer soon after.

Blaithín having the car was certainly helpful. We had a riotous time. Seán McSweeney and his wife came one year, and Eithne Jordan and Michael Cullen. The governments had people select the painters, an international jury made the awards. It started in 1969. The aim of the festival was to compare the recent work by living painters of all nations. The only disappointment I had was that Gene Lambert took all sorts of photos and I have never seen them.

VR: *Was that Blaithín de Sachy of the Lincoln Gallery, administrator for Vincent Ferguson at Hendriks after David died?*

GL: Yes. I had great arguments with people in Dublin who denigrated Cagnes-Sur-Mer, as documented in my report to the CRC.

VR: *On what basis were they arguing?*

GL: That we should be going to Venice and *Documenta*. I didn't disagree with that but given the miserly grant – £1,500 – my idea was that artists could get seen in Cagnes-Sur-Mer and move on to Venice. That happened to an extent. We came back to the

Venice Biennale [in 1993]. On the night after the opening in Cagnes-Sur-Mer in 1982 we were invited by the French Minister for Culture to the Galerie Maeght, to an exhibition which included work by Anne [Madden] and Louis [le Brocquy]. Louis had shown in Cagnes-Sur-Mer in 1972 and lived locally.

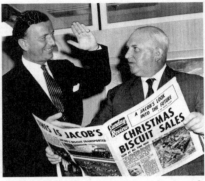

Gordon Lambert, MD, Jacob's, and Frank Sykes, Sales Manager, Jacob's, 1962.

VR: *Which work did you lend to A Sense of Ireland in 1980?*[25]

GL: The Michael Bulfin *Atom Smasher* (1969) and Aileen MacKeogh's[26] *Woodpiece* (1978). I sponsored Works on Paper at Angela Flowers on behalf of the CIAS and was allowed my contribution against tax liability, which was quite unknown in those days.

VR: *You achieved all this on a salary. For better or for worse, Gordon, you are seen as responsible for bringing the level of biscuit eating per capita at the time in Ireland to the same level as in England.*

GL: In Ireland we had a monopoly, 80 per cent of the market, until Bolands came in as competitors in 1957 and built a huge factory in Deansgrange. Jacob's had the reputation but it did very little advertising. It was known through commercial travellers. Travellers would notify customers that they were arriving in Limerick or wherever. In Limerick they stayed in 'The George'. They expected the customer to come to them. As an accountant I wrote a very serious note to the board of Jacob's. It might have led to my demise but instead they promoted me to commercial manager in charge of sales, advertising and distribution. I was the first person in private enterprise to assume the title of Marketing Director. Joe McGeough of Bórd Bainne says he was the first Marketing Director but that was in a public company.

VR: *Trade loyalty was a very practised virtue then, wasn't it? Per-*
haps the most famous advertisement you launched was 'How do
Jacob's get the figs into figrolls?' Which biscuits were your own
favourite?

GL: Raspberry and custard. The buyer from Altman's in New York
rated it as one of the world's best biscuits.

I used to bring home broken biscuits. My mother had
arthritis. She had a great friend who used to shop with her. One
day Mrs Austen went into the corner shop in Rathgar to get a
packet of cream crackers and came out with a packet of
Boland's. My mother was shocked. 'Oh Jenny,' she said 'you
must buy Jacob's.'

This sentimental recollection makes me reflect on the loy-
alty and support I have enjoyed not just from close friends but
from the whole spectrum of the human race, which has given
me a purpose in life. I was privileged to receive a gift of one of
his own paintings from Declan McGonagle.[27] I am so glad I
lived to learn of the takeover of Jacob's by Fruitfield, an Irish
company. In spite of my age and suffering from Parkinson's
Disease, which I wish to convey in this interview, I am able to
continue my interest in all these activities we discussed, thanks
to my many friends and my colleagues in IMMA.

In conversation, with the assistance of Catherine Marshall, Dublin, 28 August, 26
September, 27 September, 30 October, 31 October, 14 November and 5 December
2003, and 6 April, 5 July, 9 July and 1 October 2004.

1. In 1977 Gordon succeeded Sir Basil Goulding (1908-1982) as chair of CIAS.
Gordon was a member for over 40 years. CIAS, through the financial contri-
butions of its members, bought and donated art to over 40 institutions in Ire-
land, initially most notably the Municipal Gallery in Dublin (The Dublin City
Gallery, the Hugh Lane). In 2005/6, *Siar 50* at IMMA exhibited some CIAS art.

2. Walker, D., 'Sidney Nolan', *The Arts in Ireland no. 1, Vol. 2* 1973, pp. 34-44.

3. Marshall, C., 'A Quiet National Treasure: Gordon Lambert and the Making of
a Collection', *Irish Arts Review Yearbook* Vol. 15, 1999, pp. 71-80.

4. O Maitiu, S., *Celebrating 150 years of Irish Biscuit Making*, Dublin, 2001 p. 86.

5. Ted Hickey (1940-2005) was from County Wicklow and was educated at UCD and the London School of Film. Interested in music, he was a dynamic and much respected keeper of art in the Ulster Museum from 1974-1993. He later worked for the Arts Council of Northern Ireland on a part-time basis.

6. Ciaran Carty's *Robert Ballagh*, Dublin, 1986, contextualises the artist's practice well.

7. Robert Ballagh in 1972, Clifford Rainey in 1975, Adrian Hall in 1979, Pat Harris in 1980 and Brian Maguire in 1982 painted portraits of Gordon Lambert.

8. Bowen, E., *The Shelbourne*, London, 1951.

9. Waldron, E., 'Cecil King' *The Arts in Ireland*, January 1973.

10. Campbell, J., *Barbara Warren RHA a retrospective*, Dublin, 2002. Barbara Warren's portrait of David Hendriks is reproduced in *Living with Art David Hendriks*, McCrum, S. and Lambert, G., (eds.), Dublin, 1985.

11. *Couple* by Joe Butler in painted steel was on the invitation to *Summer at the Hallward, an exhibition of Painting and Sculpture by Gallery and Invited Artists'* at the Hallward Gallery, 65 Merrion Square, 14 July-27 August 2004. My thanks to Mary Tuohy at Hallward.

12. Baron Brian de Breffny, (1929-89) wrote *The Houses of Ireland* (with Rosemary ffolliott), 1975; *The Churches and Abbeys of Ireland*, 1976; *The Castles of Ireland*, 1977 and *The Synagogue*, 1978. He edited the *Irish Arts Review*, of which he was a founder, from 1984 to 1989 and edited *Ireland :A Cultural Encyclopaedia* (1983).

13. Sybil Connolly (1921-1998) had an Irish father and a Welsh mother and moved to Ireland aged fifteen. She went to London to study dress design, returning in 1940. Her solo career began in 1957, but her clothes had appeared in America by 1953. Jacqueline Kennedy wore a pleated linen dress by Sybil Connolly for her official White House portrait by Aaron Shikler (1970). See McCrum E., *Fabric and Form: Irish Fashion since 1950*, UK, 1996, p. 35.

14. O'Byrne, R., *After A Fashion: A History of the Irish Fashion Industry*, Dublin, 2000.

15. Knowles, R. (ed.), *Contemporary Irish Art*, Dublin, 1982.

16. Gordon Lambert wrote an essay 'A Matrix of Contemporary Irish Visual Art' pp. 198-205 in *Ireland and the Arts* (ed.) Coogan, T.P.

17. This painting was purchased by the Friends of the National Collections and presented to the Hugh Lane Municipal Gallery of Modern Art in 1970. From 1974, the Corporation gave the Municipal Gallery a purchasing grant.

18. *Living With Art, David Hendriks* has tributes from friends, family, artists, critics and collectors, and a history of the Gallery by Seán McCrum. That year,

the David Hendriks Memorial Exhibition was organised by *An Comhairle Ealaíon*/The Arts Council and the Arts Council of Northern Ireland. It travelled to Belfast, Derry, Dublin, Cork and Kilkenny.

19. Gwladys McCabe, neé Orr (1902-1989) married Michael McCabe in 1923. She was the first woman president of the United Arts Club. She studied at art college. Her own collection hung in her study. Apparently paintings she liked less well were hung in her husband's room. Mrs McCabe's daughter donated a portrait of her mother seated in the drawing room in her home, painted by Leo Whelan *c.* 1946, to the National Gallery. I am indebted to Sara Donaldson for correspondence, 7 March 2005. See also Donaldson, S., 'Followers of Fashion, Women's Dress in Nineteenth and Twentieth Century Painting', *Irish Arts Review* Spring 2005 pp. 58-59.

20. *Stephen Hero* was for sale at the Irish Exhibition of Living Art in 1950, for £36.15.

21. Collins' first one-person show was in the Ritchie Hendriks Gallery in 1956. He showed again there in 1959, and between 1961 and 1972 showed nine times with David Hendriks.

22. John Burke showed in 1974, 1976, 1980 and 1983, Vivienne Roche in 1980 and 1983, and Eilís O'Connell in 1981 and 1983.

23. *The Gordon Lambert Collection,* shown in The Municipal Gallery of Modern Art, 26 May to 25 June 1972.

24. I am indebted to Charlie Tyrrell for clarification on this matter. The office of *The Arts in Ireland* was in the same building as The Project Arts Centre for a while.

25. A Sense of Ireland London, Festival of the Irish Arts, 1 February-15 March 1980.

26. Aileen Mac Keogh (1952-2005) was an outstanding educationalist, administrator and artist. She was elected chair of IELA in 1984. She taught sculpture at NCAD and was integrally involved in the development of Temple Bar's cultural quarter. She was a pioneer of creative digital media in Ireland and produced two television series, *The Art Files* and *Profiles.* From 1997, she was head of the School of Creative Arts and the National Film School at Dún Laoghaire Institute of Art and Technology.

27. Declan McGonagle, first director of The Irish Museum of Modern Art, attended art college as a young man. See Ryan, V., *Movers and Shapers: Irish Art since 1960,* Cork 2003.

John Kelly in his studio in Henrietta Street, Dublin. Photo by Fergus Bourke.

John Kelly

Artist John Kelly, was born a twin in Dublin in 1932. He was educated in the Central Model School, Marlborough Street, Dublin, Bolton Street College of Technology, and the National College of Art. He exhibited widely from 1957 and won many awards, including the Cagnes-sur-Mer prize, the Oireachtas Award and the Carroll's Award at The Irish Exhibtion of Living Art (IELA). He has worked in theatre, and his play The Third Day *was produced in the Gate Theatre in 1961. He and Mairead Breslin married in 1962 and they have six daughters. He was a founder member of the Project Arts Centre and the Black Church Print Studio. He was a director of the Graphic Studio for ten years and taught at the National College of Art and Design (NCAD) from 1977 to his retirement. He was elected to the RHA in 1991 and became a member of* Aosdána *in 1996. John died on 26 March 2006.*

VR: *John, you've been unwell.*

JK: They told me I had a week to live. If I had six sons they'd carry the coffin but since I haven't I told my six daughters they would have to carry it. They all went out and bought black coats. One of them even measured the aisle of Dominick Street church to see how long it is. My great friend Austin Flannery OP would look after things. Gerry Davis[1] and Ulick O'Connor would be asked to say a few words.

But I knew I wasn't going to die.

VR: *Good for you.*

JK: My only regret is that I can't get down to the studio. It's on the top floor in Henrietta Street.

VR: *In Alice Hanratty's house?*

JK: Yes. I'd be lost without Alice. She has her own etching press in the room beside me. She's been an extraordinarily honest influence on printmaking. She's been so helpful to so many people. Her years of teaching, picketing the College [of Art], getting sacked, and teaching in other colleges – extraordinary. She has an extraordinarily high standard for her own work. I've never seen her do anything pretty. She's absolutely down to earth. Printmaking is great fun, but it's very hard work, winding huge heavy presses around and around. It's very tiring. I haven't printed for years. I must be there for over twenty years. I had a studio in [11] Capel Street. Gerry Davis owned a building and he let me use a room in it. Then he rented a space over Siopa na mBróg in Capel Street and he took a room for me. It was condemned and then Alice offered me a room.

On my last week on earth I was in an isolation ward on my own. I did self portraits. I used to get up at three in the morning. My daughter Lara brought me in drawing paper and charcoal. I did one portrait a night. I exhibited them in the Academy and they all sold. That was nice. Camille [Souter] rang me up and said 'I've just come from the Academy. I saw the most beautiful drawings'. That from Camille – she's a lovely person but she doesn't go around throwing out praise. I was thrilled. They were very

strange. There's a strange looking person looking back at me. Everyone says they are a great likeness. My hair turned completely grey. It went from light grey to a real dark slate grey. When I said to people 'my hair has gone grey', they said 'what are you talking about, you have been grey for years'.

VR: *You were elected to the [Royal Hibernian] Academy in 1991?*

JK: There was a knock on the door late one night and Carey Clarke was standing there. He told me I was elected. I was thrilled.

VR: *Was it great to be able to work in the studio every day?*

JK: I couldn't wait to get out of the College. I retired at 65, I'm 72 now. College was becoming less and less about finding the time to really deal with students. I used to spend a lot of time talking to them. It became very bureaucratic. I'd have a faculty meeting on Tuesday, a staff meeting on Wednesday, a planning meeting on Thursday. Gradually I found I'd walk back into the studio and not recognise the students. I found I was sitting in a big room with loads and loads of other art teachers sitting at endless meetings.

There were still very good students coming in but I don't think the College made the right demands on them. You couldn't fail a student. Other colleges were getting firsts in painting and firsts in sculpture and firsts in print. We were under pressure, at least in the print department. We were still demanding that they learn real skills. I felt that no matter where they went in the world they would be able to say 'I have a degree in printmaking from the National College of Art and Design in Ireland'. And they would be recognised as having skills. When I started looking at other colleges I saw they were determined to give their students high marks. The external examiners, particularly the English ones, had very different standards. The head of one college in England, a leading college, said he couldn't agree with my marks and that in his college a certain student was easily a first. I said 'That's no problem for me, but here this student would be rated as a 2:2'. He said 'In four years you are expecting too much'. Literally we had external assessors that I wouldn't accept as degree students.

VR: *Is art education becoming becoming a bit of an industry?*

JK: It is. The College starts off the academic year with the absolute certainty that it needs 175 or 275 students or whatever. It knows how many students it needs to have to run a viable core study; it used to be called Foundation. They do a little bit of everything; glass, painting, ceramics. By the end of the year the odd one has decided 'that's for me' – fashion or whatever – but the majority would be delighted to go into any department. At the end of the year they put their work up on the wall and the departments go around harvesting the students. Then there's a whole batch of people nobody wants. It's difficult to place students. You can't say 'you've been a terrific student, you've done what the course demands but your way of working doesn't suggest that you'd be manipulating ideas'. There was always a large number of people floating in the College, simply because there are not that many talented people in any one country. When you think there's our college in Dublin and a considerable one in Dún Laoghaire and another in DIT, one in Cork, another in Limerick, there are a lot of people who can't be the best. They are all recruiting. You can't reject a fourth-year student who has worked hard. You know the externs wouldn't give them a place if they were running a gallery but they had a first.

VR: *Were standards better in earlier years?*

JK: The College in the old days was a most peculiar place.[2] When I had spent a long time teaching and when I considered the difficulties the staff worked under, I realised how dedicated they were. The inspectors were employed by the Department of Education. Some of them had never painted in their lives. Some didn't keep up with trends in art. They saw no reason to look at anything that wasn't their own 'ism'. The teachers should be able to discuss the work of any major artist in the world. But the younger contemporaries were ignored by the inspectors. That passed on to the students, who grew up with very little interest in the development of modern art.

In Ireland we were years working in the darkness, where civil servants known as artists had given up looking at art and

went in on Monday and drew *The Discus Thrower*.

When I was a student our female models couldn't have pubic hair. I saw an amazing example of that when there were two girls, sisters, one of whom was a model, a lovely person. Her sister would collect her before the bell went at 9.30pm. They'd go home together. There was one evening when the model couldn't come. The sister came to give her apologies and said that if Professor MacGonigal didn't mind, she'd model for the evening. He waved to the screen and said 'you will find a dressing gown in there'. There were about fifteen students, male and female. She came out with the dressing gown on, she was on the raised rostrum, and threw off the gown. Poor old Mac nearly fell over himself trying to cover her. He looked as if he was trying to smother her. We discovered that she had committed the mortal sin of the Victorian school, she had pubic hair. That came from Ruskin. He pointed out that females in Greek art didn't have pubic hair. When he married his marriage broke up immediately. The poor wife was deformed, she had this growth. That's just one of the little things that made the College strange.

Mac was a very helpful teacher. He knew that if the archbishop of Dublin knew there were girls posing in the nude in Dublin, near the Dáil, we'd all be excommunicated. Mac was commissioned to do the occasional portrait, but was never the academic type portraitist. Nor was Keating. His painting was crude, he didn't smooth on the paint like cream. If the hands were expressionless, like pounds of Denny's sausages, if the nose was red, he'd lay on the paint as he saw it. The RHA painters were flatterers usually. George Collie did those wonderful fashionable portraits, very well painted, smooth as glass, as lifeless as waxworks. If you presumed to talk to these academic painters about Lucien Freud they wouldn't know what you were talking about. They would think, 'what a mess'. As for Francis Bacon, I am sure they would dismiss him as the greatest chancer. That's sad. Even if they didn't like the work, the painter was trying to tell you something about the person in front of you, give you some

insight. Bacon would talk non-stop to his sitters. With academic painters you get the feeling there's no real conversation going on. The last thing the painter wants is to talk to the sitter.

I did drawing classes with Domhnall Ó Murchadha. Domhnall never really made a great impression. I don't think Domhnall's own work was very good. It was very stiff. It was strange with sculpture in the College. Peter Grant, another interesting guy, again he was extremely traditional in his approach. He was a lovely guy. His work wasn't terribly adventurous. Michael O'Sullivan was a terrific teacher, a very imaginative guy, terrifically knowledgeable on mythologies, whether Irish or Greek. It comes out in his work. I think he was another casualty of the College and the scope they allowed younger teachers.

Herkner left at the outbreak of the Second World War and went back home to fight for his country. He fought at the Russian front. It must have been horrendous, but he survived it and at the end of the war he came back. Professor Romein left at the same time to defend Holland against the Germans. They came straight back, they had special permission; we were neutral. I did lettering with Romein and drawing with Herkner. A very kind, very gentle man, but lost in Ireland. I don't think he had any real friends in Ireland. We found a whole collection of his work in the basement of the RHA. It's rather stylised 1930s' mask-making.

There was a Breton model, Anton; he was a Breton nationalist. The Germans offered the Bretons a state of their own. It was easy enough to believe them when they came in and said 'we are going to train you to become the future government'. The Bretons couldn't resist the offer until one day they woke up and the Germans had vanished overnight from the seminary where they were training. The Bretons went down to the gate and saw the Allies coming up the road in tanks, so they all disappeared across the fields. They were wearing German uniforms. Anton made his way to Ireland in a fishing boat. His greatest danger was from the French underground.

We think of the Germans as being amazingly clever with

their secret police but sometimes they were very naïve. There was a German spy dropped in Northern Ireland, in full colonel's uniform. He'd heard everyone in Ireland hated the British so they would give him loads of information. He couldn't find anyone to tell him what he needed to find out. He walked around the place and eventually he met two guys on the road on the Border. 'Can you direct me to the city?' he asked. They said 'You go down the road, it's way down there', and they directed him to Dublin. He gave them a pound each. He regretted giving them the pound. 'They will tell everyone', he thought but they couldn't believe their luck and went off to the nearest pub. He walked all the way to Dublin. He felt there was something different. He had no idea what was going on. He stole clothes off a clothes-line to get out of German uniform. The Germans sent a guy to find him. This guy ran out of money and was rambling around Dublin. He went into the Abbey and they gave him a job as a strong man act in the interval. He was made up. He used to spy in the day and lift weights at night. All this I read in a book called *Spies in Ireland*.[3]

So Anton was in the College and this guy was in the Abbey. We never knew the extent of our neutrality. So many British sailors and airmen who strayed into Ireland were rapidly put on the train to Belfast and were back in Britain. Germans were put in the Curragh immediately.

The IRA were on the roofs of warehouses in Belfast to make a track with torches for the German bombers to come in. There were ordinary people living around the docks, people who worked in Harland and Woolf. It shows how anti-British an awful lot of people were. The clergy weren't anti-German, they saw the Germans as a strong wall against Communism.

Herkner was obviously a good designer, a good craftsman, as was Domhnall. Domhnall was sort of at the mercy of the Church. You couldn't say there was any member of the hierarchy who had any feeling for art. In Galway Cathedral there's a large ceramic of Padraig Pearse and maybe Christ standing side by side. That's an odd combination. It would be like finding a

painting in Spain of Franco and Jesus Christ.

Some of the architects[4] did try to wake up and show the Church what churches could be. I spent years on a church art committee with Richard Hurley and Austin Flannery, and maybe Patrick Pye. Richard Hurley and Liam McCormick were a few of them, trying to drag the hierarchy protesting and screaming into the twentieth century. They were still buying church art from Italy, still using female models for Christ, and putting on the little beard. Every Catholic house in Ireland had an oilograph from Italy with a figure who had a female face, and beautiful long curly hair. Christ had a pinkish face. Everyone knows he had long tapering fingers and long curly hair. The clergy referred to the place in Italy that made the Sacred Heart images as the Chamber of Horrors. There was not the slightest effort to bring in any serious art of religious images. The only name I could give you was Evie Hone. She wasn't that popular as a religious artist, despite what the books said. She tried to make images that were not steeped in honey and sentiment. Unlike France, you could not get a commission in Ireland where a great architect could go to a great artist and they were both equally honoured. In Ireland, the Parish Priest told you the images he wanted. If you said the sentiment is saccharine, it was goodbye. I know that Fr O'Sullivan did save the Rouault [*Christ and the Soldier, (1930)*] from obliteration in the Municipal Gallery.

In Holy Week the Church would cover up the statues in purple drapes. At the end of the week the triumphant Christ, who triumphed over death through the Resurrection should have been there. When they pulled off the cloth, what was hanging there? The Crucifixion, usually. It had always been there. No one would bother to remove it and replace it with a Resurrection. Logically and theologically it didn't make sense.

Before I retired colleges were becoming very unreal, with very little to do with the actual job of the fine artist when they come out of college. I often wondered was our problem that we need more educated teachers. We needed to be able to bring in

a really tough philosopher to talk to the students about thinking. In a way it was the younger women teachers coming in to the College who liberated the students. They were willing to discuss all ideas, sexual and emotional and all sorts of things. They had something to say. Louise Walsh and Alice Maher would be good examples. I can actually hear Alice's voice talking to the students, asking 'why did you do that?' instead of saying 'that's coming along nicely'. You might open a floodgate of personal fears if you asked 'why did you do that?'.

VR: *But it is hard to have a practice with enough commitment, and to teach with full commitment, and teaching doesn't work if you ration it, does it?*

JK: It's terribly difficult to do both. It's difficult for a number of reasons. In College you can have a large number of people and demand they think about something. I introduced a drawing block for first year called the narrative of painting. I'd go into Eason's on my way to work, buy every newspaper I could lay my hands on, all the English pulpy ones, *The Pigeon Carrier*, *The Messenger*, the *Cork Examiner*, the *Catholic Herald*, the *Skibbereen Eagle*, the lot. I'd talk about the story aspect and ask the students 'what does it mean to you? Some journalist has already told this story. What do you think it is about? Could you make images to tell this story?' For some reason this worked great. You wouldn't believe the difference in those drawings and the drawings they had in their portfolio when they applied: drawings of Auntie Mary, or Fido the dog by the fire. I'd say to them 'this is yesterday's history' – bicycles stolen, bombs going off, babies dying, celebrities getting married. The image was added to as the week went on. If they were lucky the story would run in the newspapers. If they looked back at their first drawing they would keep questioning it. By the end of the week they wouldn't recognise the drawing. I used to encourage them not to be afraid to go back over their drawing. They could possibly go back with a more profound resonance. Or the first image could click in a different direction. At the end of the week they

would all be pinned up. I would do my best to get them to take me through their drawings. It was great fun. They all worked in their own spaces in College, not together. I would discuss my own work, I would bring along my drawings as well. I would discuss how I saw them over time and how I saw images in different ways. But as you teach you realise that what will happen will be that someone will take over what you are saying. Fine. Now they've screwed it up for you, it's become distorted in their image and it's wrecked. It can make you wary about showing your own process. I wouldn't hold back. But it was difficult. Terribly difficult.

Your own creativity is part of your teaching. You go in every day and hand over interesting ideas. You can't keep distance. You see so much of the ones who didn't get involved. This person or that taught them about using paint but nothing about art; they were learning to 'perfect their technique'. You need to stand back from your work and from their work and still try to give them something. You are supposed to try to wake them up and get them thinking.

The teachers I had in the '50s went into the College with a genuine love of art and a love of technique and gradually discovered they couldn't paint out the Department of Education. They had to do what the Department of Education wanted them to do. The incident with Mac was sheer panic: him seeing himself losing his pension. There was that fear. In the College when I was a student you could walk into a room and see the whole class saying the Rosary. The '50s were terrible.

The shop under the stairs in Kildare Street sold paper, drawing pins, charcoal – that sort of thing. A couple of months ago Joe O'Connor had a terrific show in the Peppercanister Gallery, it was of footballers. He was an evening student with me. He studied medicine but left that and became a postman in England. I asked him why he did that and he said 'I'd start at 5am or 6am in the morning and the quicker I got it done the sooner I got to the studio'. He did classes at Chelsea School of

Art and Regent Street Polytechnic. He is a terrific painter.

VR: *He showed in the Project in 1970. Did you go to Cagnes-sur-Mer when you got an award there?*

JK: No. Earlier on I had exhibited in the Independents [and shared the prize] with Barrie Cooke, who showed those wonderful paintings of the salmon leaping. They were terrific.

VR: *Were you involved in the selection of the exhibitions in the Project?*

JK: Yes. This guy Jonathan Wade came in one day and he had paintings that were rather crude but there was no doubt that they had passion. Myself and maybe Michael Bulfin were selecting. I said 'you are not ready for a one-man show, we should take a couple of these and put them in a group show.' He was delighted. Years and years later I was doing the same thing and the fellow making the selection with me was Jonathan Wade. He told the guy who wasn't getting the show about his own application for a show. 'I've often looked back on the work I was going to show in that first one-man exhibition and was delighted I didn't show it', said Jonathan.

The director of the Arts Council was one Fr Donal O'Sullivan, SJ. He actually ran the Arts Council. Many people would disagree with what I am going to say but he ran it as he liked. He didn't like sculpture so they seldom bought sculpture. Fr O'Sullivan was the novice master at the Jesuit training college at Emo. Michael Kane hated Fr O'Sullivan. He used to swear Fr O'Sullivan had his own wine cellar in the Russell Hotel. I came across an article in a newspaper a couple of years ago and I rang Michael Kane and I read it out to him. The article was about Fr O'Sullivan having a long-standing affair with Graham Greene's long-standing girlfriend. There's a combination. I could hear Michael Kane howling with laughter at the other end of the phone. 'Jesus Christ I knew it all along ...' Graham Greene was most likely the best-known Catholic in Britain at the time, as well as being a novelist, of course. Fr O'Sullivan wore extraordinary clothes, a shot silk black waistcoat with black stone buttons. He

was extraordinarily elegant. James McKenna, who is now dead, was a great mask maker. He did that famous cabaret where the actors wore masks of all the Arts Council members in the Project basement first. Then it went to the Gate. He had a terrific mask of Fr O'Sullivan with his collar, saying 'I never drink'. Everyone knew the opposite was true. And 'I won't buy sculpture, I hate it'. He had George Dawson juggling scientific apparatus that blew up. George was a member of the Arts Council, and professor of genetics at TCD. James had a wonderful righteous angle.

VR: *Did you make those masks?*

JK: No. I made the masks for John Arden, the great English playwright, when he came to Dublin for *The Happy Haven*, a play about an old folks home at the Gate.

We had started the Independent Artists and the Project Arts Centre, some five or six of us. The one thing we could never do was see the director of the Arts Council. We never got beyond the hall. Mervyn Wall was a good writer – *No Trophies Raised* is very good. He wrote about the knights of Columbanus and was criticised for it. The director of the Arts Council before Fr O'Sullivan, Sean O Faolain, gave him a job as secretary of the Arts Council. We used to call him Mervyn Stonewall. He'd say 'the Reverend Father is not available at the moment, he's on retreat'. Mervyn sat in the front room in [70] Merrion Square and Fr O'Sullivan in the back room. The Arts Council had these two rather grotty rooms, now

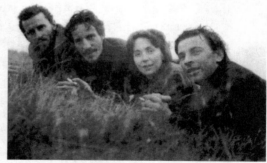

Left to right: Brian Bourke, John Kelly, Mairead Breslin and James McKenna at Pine Forest, Glencullen, 1962.

they have the whole house [and number 69]. The ones who controlled the whole art scene were Sir Basil Goulding, Fr Donal and Michael Scott. They handed out scholarships and awards to the right people, but only to the right people. I, at one stage, was recommended for the Macaulay (Fellowship) but Fr Donal O'Sullivan didn't want to give it to me, because, he said, I'd left school at thirteen and a half and the scholarship wasn't intended for someone to finish their education. Fr O'Sullivan wouldn't be interested in what religion you had. He was interested in how much money you had.

He was surrounded by the best people. Michael Scott was a great mate of Fr O'Sullivan's. James McKenna got fits of rage and would come out with terribly funny things. At the Independent Artists we were having a meeting about Arts Council finance and James hit the table with his fist and said 'I'm sick of Sir Basil Goulding and his fucking Dung dynasty.' At James' funeral the poet from Kildare said 'James is dead. Who will now be our conscience?'.

Group 65 at The Irish Times Gallery, Westmoreland Street, 1966. Left to right: Michael Kane, Charlie Cullen, Ron Watson, Marianne Heemskerk, John Kelly and John Breen. Photo by Fergus Bourke.

When we started the Project we made an application to the Arts Council for money to have slips of paper with lists of titles. We'd applied for £12 and they refused. Yet IELA[5] would get grants to bring work up North, they got fantastic grants. We didn't begrudge artists like Pat Scott, but we couldn't even get £12. IELA always took the exhibitions to Belfast. They never sold artists from the South in Belfast. But the reverse is true; Campbell, Armstrong, Dillon, O'Neill were all from the North and were the biggest sellers here.

We were hell-raisers, we made demands on the Municipal Gallery. We put on exhibitions, we decided who would hang. Tony Butler [in *The Irish Press*] referred to us as the armpit of Irish art – we were the dregs of the dregs – we were from the wrong side of the track. It was said humourously.[6]

When the Project was starting, we got two rooms off Colm Ó Briain's father who had a tool shop on [31] Lower Abbey Street – near the China Showrooms. He said he'd give them to us for nothing if we'd clear them out. We shifted tons of rubbish and painted the walls and put down lino and put up a sign. We all did physical labour for months. The Project gave Seamus Heaney his first poetry reading in the South. We put on first exhibitions for people whom the galleries wouldn't even open the door to, not alone refuse them.

VR: *Did you know Michael Byrne?*

JK: Michael Byrne was a great friend of mine. He was a strange guy, a great man. I honestly believe it was his own way of working that prevented him getting the recognition he certainly deserved. He didn't let anyone into his way of working. He started with little drawings, maybe a 4 inch drawing of little cubes. He'd then make a larger drawing identical to the smaller one – five or ten times bigger. Meanwhile he'd make a portfolio to house the drawings. There would be subtle changes in the larger drawings but very few. He'd get to the painting and do the green or blue cubes. Eventually he had all the portfolios piled up, all dated and never shown to anyone. When he did show he rarely sold. He showed in the Project

and in the Independent Artists. He had a partner, Donal O'Connell, who wrote under the name of Dan Treston. He wrote a weekly column for RTÉ called 'Scrapbook for Women'. Donal was English and he was very friendly with Micheál McLiammóir and Hilton Edwards. He got himself a flat on the Liffey, on Usher's Island near where Joyce set *The Dead*. Himself and Michael lived in the flat. Michael had lived with his mother in Cabra and didn't have a day job. When she died she left the house to both of them, he built a studio out the back. His work didn't progress. I think Gerald Davis tried to sell his work after Michael died.

VR: *Your own first exhibition was held ten years before the Project opened?*

JK: I had my first exhibition in the Hendriks Gallery in 1957, in the original Ritchie Hendriks. It was only open a couple of months. David became a great friend. I strolled in with a portfolio and asked him to look at the work. David said 'Leave the portfolio with me and I'll have a look'. He said to me 'I love it, would you like to have a show?' Everyone in Dublin would have told you the galleries wouldn't open the portfolio unless you were recommended by someone. David himself didn't have any backers. His great friend was Gordon Lambert but Gordon wouldn't have been an influence on what he would and wouldn't show. David had a wide open field.

Left to right: John and Mairead Kelly, Eileen Delany, Niamh Smyth, and Seán Rothery at the Ritchie Hendriks Gallery, 1963.

Gordon

was very faithful. He would loan his collection and he would always send me a card saying 'John, I'm showing your work in such and such a place'. Waddington was taking on hardly anyone else. He had Yeats, Campbell, Dillon, the pick of the best.

VR: *Do you remember Leo Smith well?*

JK: Leo was very strange. He would discuss customers and their affairs in the Gallery and he'd do this at the top of his voice. His sister was his housekeeper. She always called him Mr Smith. I remember one day his sister said to him 'Mr Smith, will you be home for lunch?'. He said to her 'What did I say to you this morning?' and after giving her a lecture he said, 'No I won't'. This was typical of Leo, he could be very bitchy. The Dawson Gallery was upstairs over the hall. I was standing at the window with Gerard Dillon one day and there was this young priest walking down the steps, leaving. 'Ah look at him,' said Leo. 'God help him, his trousers are too tight.' We looked at each other and thought 'Jaysus.'

Leo was very good to his artists and he was a very good dealer. Brian Bourke had his first one-man exhibition with him. Brian gave us all invites for the opening, which didn't please Leo. He gave Brian a colossal sum of money, something like £50, at the opening and said – this again in front of everyone – 'Would you take your scruffy friends out for a drink?'. We were getting in the way of him selling and we were drinking his drink. There was Leo and John Taylor. John was sort of the apprentice. 'This is all John's when I go', he'd say. He let everyone know that. John did turn out to be an excellent dealer. He had a long hard apprenticeship, with possibly the toughest dealer. But Leo died intestate [in 1977] and his brother came from Canada. Leo had a terrific collection – he bought in his own gallery. The rumour was that the brother was flooding the market with Leo's collection. Without Leo and John the Dawson Gallery was just two rooms upstairs on [4] Dawson Street.

Quite a senior guy from income tax picked galleries for a year or so and went to all the shows, kept the catalogues, added up the prices and came out with a grand total. He didn't seem

to understand that even if everything sold, the gallery only got one-third. The work of art remained the property of the artist until sold. There was a court case, a test case. He took Hendriks. That was a mistake. I think Leo maybe wasn't as careful as David. Leo was buying his own artists, he'd buy from the auctions and keep the prices up. I was to go as a witness, along with Colm as director of the Arts Council, and a woman maybe from Boylan's Shoes, who bought from David and knew the scene. The case started. The income tax guy drew a line under the prices for the year and added them all up. 'I have submitted my books,' said David, 'and showed you all the sales lists. You can contact the artists who will tell you they get two-thirds of every sale.' Colm confirmed this. The woman from Boylan's did too. I wasn't called. The judge asked Colm a few questions and kicked the whole case out. From then the galleries changed from being art dealers to being art agents.

VR: *Back to your own first one-man show with David.*

JK: The exhibition was, if I may say so, an incredible success. It was opened by Fr O'Sullivan. I don't know whether David asked him. I used to have cuttings from the paper, he said amazing things – that Church art had stood still, a young Dublin painter has come along and invigorated the scene single-handedly. It was in all the papers. I never got one commission. Mairead found a lot of old catalogues and papers recently. I found I did a stained-glass window in Cavan and some in the North.

I was honestly a rather devout naïve follower of Jesus Christ. The themes I painted were rather hackneyed religious images. At that stage I hadn't left Ireland, I hadn't gone away to Europe. 1960-61 I spent in Spain. That opened my eyes. I was with Ronnie Drew, Pat Hall, and Michael Kane. We all met up in Seville. Ronnie was teaching English. Everyone in the area we were in could say 'fuck off'.

VR: *Would it be fair to say that by the mid '60s you were influenced by Abstract Expressionists like Kline or Motherwell?*

JK: For a while, without doubt. I couldn't believe the freedom.

When I saw the Abstract Expressionists – I think it was in the Municipal in the Johnson and Johnson exhibition [in 1964] – the group seemed to have blown away the taboos. They showed incredibly fresh paintings with wonderful brushmarks.

The 'shit and muck school' was what the RHA called members of the Independents. The battle was unbelievable. Gradually we were called the younger artists. I was called a younger artist until I was about 45. The so-called supporters of modern art, the IELA, were seen as the younger artists for a very long time. But they were accepted by the arbiters of art at the time, the Arts Council. They tended to be very respectable. They had Colonel Knox as secretary. Michael Kane had a huge row with him by asking him which army he was in. Michael Kane's annoyance, like James', was all about standards.

VR: *The Gate was strongly associated with the emergence of the Project but had you worked there long before the 1967 event?*

JK: I think in 1961 I had a few plays in the Gate. Ronnie came along at the interval with his guitar and played. It was a strange play, set in Dublin, in a tenement, about two guys. One orders his own coffin and gets into it. *The Third Day*, it was called.

VR: *Had it religious resonances?*

JK: I was accused of being influenced by people I'd never seen: Genet and Beckett. I had to go and look them up and see who I was being influenced by. John Molloy acted the old guy at his own wake. I was aware of Sean O'Casey. Funnily enough I ended up designing for the Abbey, but my first designs were for my own play. The play got great reviews. Seamus Kelly reviewed it. I was in my twenties. It was very young to have a very successful show and a very successful play.

I didn't believe any of my critics. I didn't think any of them were accurate. So I never wrote again. I never kept the script of the play but Mairead found the programme the other day.

I got really involved in the theatre, designing. I designed sets for the Gate and the Gaiety and the Abbey. The theatre, strange to say, seemed a more secure income. Most people

wouldn't believe that freelancing in the theatre was less precarious than being a painter. There were terrific people like Jim Fitzgerald, a founder of the Project. At his very best he was one of the greatest directors of all time. He was a genius. Like so many theatre and art people he took to the drink and became a full-time drinker and a part-time director. He did *Borstal Boy*. *The Hostage* had its first performance in the Damer on Stephen's Green. Jim did the Irish version. It was a successful little Irish play, beautifully rehearsed, acted and directed. Then it went to London. Joan Littlewood got her hands on it. It took over London. The sign said 'If this is not a masterpiece London has not seen a masterpiece'. Jim had directed it, but the play that became a success was very camped up. It had gays of every kind mincing up and down the stairs. It was no longer the intimate play set in an ordinary house. It ended up with them all singing 'oh Death where is thy victory?'. Brendan made a fortune out of it. The Germans loved it

I worked with Dominic the younger brother. We ended up working for a company painting silos on the docks. I was writing huge lettering, twelve or thirteen feet high about 100 feet up for Esso. Dominic wrote a play, *Posterity Be Damned*. Dominic was very witty. I got to know Brendan. He was very difficult. He was bursting with money. It was coming in by the sackful and he was drinking it as fast as it came in. Stephen was the father, he was a house painter as were Dominic and Brendan. When Brendan came home and said he was writing a play the father said 'be Jaysus, the cat will be writing a play next'.

Gradually all sorts of people came in [to the Project], people who were interested in smaller plays; people like Lee Gallagher. Very much later the Sheridans, Jim and Peter, became involved. Jim Fitzgerald and Colm Ó Briain took over the Gate at a time when no plays were being rehearsed – there were fallow periods in the Gate, maybe Micheál and Hilton were on holidays – and decided it would be used day and night for debate. Jim organised it so that you could come in and out at

any stage, ask any question you liked. Sometimes he'd stand up and take it, sometimes someone else would. It was to open up debate on all the arts. He said 'In case this looks like a theatre event could you organise an exhibition?' Myself, Charlie Cullen, Michael Kane and John Behan contributed work. That was our first coming together with writers.

Most of the two weeks was tearing the Arts Council, the government and the censorship body apart. We had people on stage who were banned. The place was always full. Lady Christine Longford was a great supporter. What a wonderful woman! She was so knowledgeable. Her husband ran the Longford theatre company. He was thoroughly soaked in theatre. He held a collection box, with 'Keep The Gate Open' written on it, outside the Gate. I can't think of anyone else in his position who'd be standing outside a theatre with a cardboard box, trying to keep it open. The price of the cheapest seat was a shilling. That was on purpose. The Longfords wanted to guarantee that anyone could go. She was in charge of the Gate, we couldn't have got it without her. She was very small with grey hair pulled back, rather sharp features and a beautiful voice. I used to work through the night, painting the late-night set on stage. The Gate was used during the day for rehearsals. When she was leaving, she'd shout back at me, I'd hear her voice in the darkness, 'Now John, you know the rules of the house, no French letters on stage, no four letter words'. And laugh.

How would we have seen Ibsen without Mac Liammóir? At that stage the Abbey were putting on plays you wouldn't put on even if you got a big grant. Plays like *Robbing the Bank* by Donal McCann's father, I think. Ernie (Blythe) would keep bringing them back, because the lads were great gas. I think it was Brendan (Behan) who said the difference between the Gate and the Abbey was the difference between 'Sod him' and 'Begorrah'.

VR: *Did you exhibit much throughout the '60s?*

JK: I had two more shows with David, in 1959 and 1960. I went off to Spain and shared the house with Ronnie Drew. I did a lot of

painting. I went up the mountains to a place called Ronda. I came back and had an exhibition of Spanish work with David. It got good reviews, and the work sold.

You couldn't give away art in the '50s. I found old catalogues of James McKenna's with little reproductions of drawings that were being sold for £4, framed, in the late '60s. If he sold four or five he'd be knocked out. I showed with the IELA, occasionally. We used to hire hand carts to deliver our work to IELA, from Granby Row in Parnell Square. Myself, Brian Bourke, Michael Kane and John Behan would push it up to Kildare Street and then back to Granby Row, to redeliver it. In the IELA if they sold something they would open a bottle of wine, even if it was just a drawing. You might get in by luck. They generally had a fixed amount of their own favourites who always showed with them. They held their exhibitions in the big gallery in the College in Kildare Street, that's where the RHA showed. They were both equally difficult to get into. People in the Academy would very rarely send in to IELA. Brian King took over from Norah McGuinness as president of IELA. IELA were all of the same age up to then and they couldn't persuade any of them to take on the responsibility of the presidency. Brian stepped in [c. 1971], simply because he had the energy. It was quite a surprise.

The people who became the Independents and then founded the Project were out there blazing a trail. He wasn't one of that group, but we were of the same generation. Brian has just retired from the College. There was no arts centre in Ireland. The Project was the first arts centre in Ireland. Very ambitious. It was a great group. Brian Bourke, Michael Kane, John Behan and myself were always together. It opened up possibilities for other groups in the country.

VR: *Can you tell me about your Internment images (1971)?*

JK: At that time if I had been born in the North I do genuinely believe I would have been in the IRA. I was totally in agreement with the civil rights group in the North. Yet it seemed so little to do. The Republicans were not what became the Provos later.

They were genuine people who were living in appalling conditions. I heard someone on the radio recently saying that when they were registering their children's names, ordinary Irish names, the Registrar wouldn't accept them. I was driving up to the North with someone from Queen's. He asked me would I go up and suggest alternative murals. I wasn't of any political leaning. I rambled up and down the streets. I saw a terrific mural at the end of a little road with little red brick houses. As I went up to it, a woman came out. More doors opened and a crowd came out and shouted at me and told me to go back to where I came from. I backed out. I ended up in a big housing estate, a Catholic one. A car with four guys started following me. It passed me by and stopped. Two guys got out and asked me what I was doing. 'I don't think it is any of your business,' I said. 'It's obvious I am from Dublin. I am looking around the city. I have been asked to suggest murals which might not be sectarian. I will suggest in my report that they block them all out.'

I found a rather grey looking old people's home. I suggested they get art students to paint a garden on the gable wall. I said I'd leave it at that. There is such an aggressive feeling in these big murals, whether it's UVF or IRA. Or blue, red and white or green, white and yellow stripes on a pavement. I said I'd blot them all out. On the way up North we were stopped by soldiers with blackened faces and brought into a hut. On the map on the wall in graffiti it said, 'We walk through the valley and we fear no evil because we are the biggest bastards in the valley.'

VR: *You first got a bursary from the Arts Council in 1977, even won a Carroll's award at IELA in 1980, and in the '80s the Arts Council arranged a touring exhibition.[7] Was it all improving?*

JK: It was getting better then. The '50s were terrible. John Hunt[8] told me the touring show was the most popular touring exhibition they ever ran. It went and went and went. Eventually I had to call a halt to it. I only went to about two openings. It was being opened by an official in one of the towns. He said, 'First of all I have to say this is not my idea of art at all.' Having insulted

me about five times, he said he and his lady wife – his lady wife – were bringing me to lunch. I declined. I said I had made arrangements.

VR: *How did you get involved in the Graphic Studio?*

JK: I had attended the Graphic Studio to learn about the process of etching. I spent a couple of years at that. Lithography was fading away. There had been a great lithography tradition in Dublin in the nineteenth century. Pat Hickey, who had been the founder of the Graphic Studio and the only teacher, decided to give up, so I became the director and teacher. Pat Hickey had gone to Italy and in Urbino he had learnt lithography and etching. He had started it with Anne Yeats and Leslie McWeeney.[9]

There were people coming and doing printmaking with me in Mount Street who were students at the College. Printmaking was very dated at the College, techniques were badly understood. I was asked by the College (in 1977) if I would go in for one morning a week and talk about different processes of printmaking. Gradually students from painting and sculpture began to come. College asked me to do it one day a week. I wouldn't see students for a week. I suggested to College that I would do two half days, in order to see the students two days a week. The place was bouncing. There was some very good work being done. They asked me if I would become half time, half time whole time, non-pensionable. I quite happily did that for a while. Some of the teachers said to me that if I did one more morning a week I'd be pensionable. Gradually the teaching was biting into my time. There were times I was there five days a week, but I was on half time. They sent me out a note saying that in order to get full-time status, people on half time would have to be interviewed. I refused to go for interview. I'd like to know who in the College would interview me. As far as I know there was no one else there who knew more about printmaking. We were at this stage giving degrees in printmaking. The guy who was full time over me was an ex-student. I thought it would be dreadful to go before a panel of administrators and

people who were students a few years before. So I remained on half time, without pension [until the mid '80s].

There was a visiting fellow from England, lovely guy, Steve Barraclough, full of life. He was ideal. I shared the job with Steve. Steve had plans to set up a huge print workshop in Kilkenny; Robert Rauschenberg was coming over with his team of printers and he'd be parking his big truck and there would be an amazing studio. In the meantime College wanted a head of department. Steve was interested, I wasn't. I encouraged him. His salary would be more than double. Steve made arrangements with Noel Sheridan to do something important and didn't turn up. His absences became longer and more noticeable. I was really running the department. He had a falling out with Noel. Noel as director gave him an ultimatum to get in and attend College. After all, he was head of department. His reply was to resign as head. Noel came to me and said, 'Whether you like it or not you are going to have to run this department'. I said to Noel that my place was in teaching, I had no intentions of sitting in an office filling forms.

Noel would say, 'I know what you mean, man, I wish I could help.' He was very funny with all his '60s Americanisms. He would say 'You are pushing an open door but when push comes to shove and you are against the wall, there is ice in the heart'. Noel was terrific. I was staff representative on the board.

Steve made an appearance, not in College, but in the pub and said 'I've done a stupid thing, I resigned.' I said 'What do you want to do?' He said 'I'd like to take it back.' I went to Noel and said 'His letter of resignation has only been seen by you. There won't be a board meeting for ages and he wants to withdraw the resignation.' That was all agreed, Steve came and talked to Noel. Everything was fine. Next morning he didn't come in. His wife rang in. Where was he? Then we were contacted by the police in Northern Ireland. Steve had killed himself by adding a tube to the exhaust pipe of his car.

College had to advertise the job and they gave it to Brett

McEntaggert. I think he was quite happy to sit in the office and fill the forms. When Steve died I agreed to take over as acting head, but I would have to be made whole time.

Before that, there was a split in the Graphic Studio. It had two basement rooms in Upper Mount Street. Printmaking had really taken off in Dublin. I got tired of turning people away. There'd be people knocking on the door saying, 'I did a bit of etching in Dún Laoghaire or Cork or wherever'. I'd have to say no. It was terrible. We had three little etching presses and the lithography stones. In lithography, the stones remain on the bed of the press until you are absolutely finished with them. I got tired of saying, 'I love your work, I'm sorry you can't join. We haven't even room for the people who are members'.

VR: *Who were the members who used the place most?*

JK: There was Anne Yeats, a founder member, and Leslie, Leslie McWeeney, who went off and got married in America or went off to America to get married. Anne suffered as an artist from the Yeats fame, she was W.B.'s daughter. She was a lovely woman, very gentle, very kind. She liked ordinary things. She had a retrospective in the National Gallery when she died. There was a woman called Chris Reid. Some of her prints were very interesting. Sara Horgan became the secretary and was very much involved in the running of the place and moved to the Coombe. She bought her own etching press but she had a terrible accident and stopped making prints. Ruth Brandt, while and after she was married to Michael (Kane), worked there and was technically very good and very meticulous. We didn't do silk-screen in the Graphic Studio then. Constance Shortt, who had been married to John Behan, also worked there, doing woodcuts and linocuts, I think.

Phoebe Donovan[10] was an extraordinary old woman. I think she had run a pottery. When she was younger she had done portraits. She was well into her eighties when she was hand-printing lithographs of landscapes and flowers. It was just remarkable to see her. She was a non-stop smoker. The wheel was about five feet in diameter. She'd be bent over the press

with the big handle, cigarette in hand. It was a big heavy flat-bed lithography press. We saw an advertisement for a motorised press in Edinburgh or Glasgow and we bought it. That sort of relieved poor Phoebe's efforts. I think her niece writes in *The Irish Times*. Phoebe's house was something like the tallest house on the top of Killiney Hill. Her studio was right on the top. It had four windows in a square room. You could look out one window and see nothing but the sea, look out another and see the whole of Killiney laid out underneath.

Marie Louise Martin made some very interesting prints, etchings.

Mary Farl Powers[11] never took an ordinary image. She always had a fantastic reason for making an image and the image gained from her intelligent approach. It set her aside. You'd see a real character behind the image. She had very high technique, very high finish.

Patrick Pye was there from very early on. He's a sweet man. He absolutely genuinely believes that art has to take a long time and you should see the suffering in it. He had that English thing of the quality of the craft.

Liam Ó Broin was working for a printer and came along one day and asked could he try doing lithography. He was very good at picking up technique. An awful lot of people would make the same mistakes again and again but not Liam. Liam was told once. He was very good. He had a young family and he enrolled at the College and did the teaching degree and became an art teacher, in Drogheda, I think.

Charlie Cullen made etchings. He had a recent exhibition of etchings in the Davis Gallery. He has just retired from the College. He ended up as head of painting. He was a great man on the floor of the studio, teaching painting or drawing.

VR: *Did you edition for people?*

JK: I tried to avoid editioning, but I did do some. I did some for Patrick Pye.

VR: *Did you do* Apples and Angels?[12]

JK: No. I might have helped him when he was etching it. If it's over
 etched it becomes a very crude line. You have to do it with care
 and patience. I think Louis le Brocquy's *Tain* prints were to be
 printed in the Graphic Studio. I was approached to do them for
 him but I was not interested in offset lithography. I don't like the
 photographic process in lithography; giving the image to a litho-
 graphic photographer, having it put on a plate, pressing a button
 and printing it on handmade paper. It takes a couple of hours. If
 you were drawing on a stone it would take days and days.

VR: *Is the issue whether it's an original print or a reproduction?*

JK: There are people selling prints which are photographic reproduc-
 tions, signed by artists. If the prints are signed in pencil, the pencil
 is the artist's approval of the quality of the print. If you sign it in
 pencil you guarantee it is yours. Not if you sign it in biro. The edi-
 tion is numbered, that's the other criterion. A lot of studios frown
 on offset printing being considered as legitimate printmaking.

VR: *Where did you drink when the Graphic Studio was in Mount
 Street?*

JK: In the early days of the Graphic Studio we drank in Waterloo
 House, Andy Ryan's place, mainly because Michael Kane lived
 around the corner. Michael is better known for the linocuts and
 woodcuts, which he did at home. John Behan lived in a laneway
 around the corner.

 We started to look for a larger premises. I had been told
 that the Black Church building was the property of Dublin Cor-
 poration and that the Protestant church had a stipulation that it
 could be used only for civic or cultural purposes. I approached
 an architect about the possibilities of the print studio taking
 over. The Corporation were trying to get rid of it for 99 years
 for six pence a year, a peppercorn rent. Myself and Sara Horgan
 immediately went off to Dublin Corporation. We thought a
 building with no rent was a godsend. The guy in the Corpora-
 tion demanded that we would never discuss the inside of the
 building with anyone. We said what should we do? 'You could
 apply to the Arts Council for a grant.' It was a 1798 parabolic

building, the walls become the roof. It had plain glass in very long windows. It was perfect. It had a huge basement. We asked Richard Hurley to do drawings and he came up with a design for a mezzanine. We submitted plans to the Arts Council. Within six months we got a reply that they had agreed to give us £100,000, an enormous sum at the time. We went galloping back to our man in the Corporation and gave him the fantastic news. 'I'm afraid that won't be enough,' he said. 'We could go in tomorrow and sell the seats,' we said. 'What you don't know is that the whole building is covered in asbestos. Did you not wonder what all the white powder on the balcony was? That was asbestos'. We said 'Why did nobody tell us?' He said, 'It's not in anyone's interest to tell you the building you are getting for nothing is covered in asbestos.' He gave us the name of a firm in England who could remove the asbestos.

It's called the Black Church because the stone is Dublin kelp. It absorbs moisture and holds it in the air like a sponge, and it glistens. Some time in the '50s the Church body had the building sprayed. Asbestos was the wonderful new material. I saw it everywhere, sprayed on pipes, lagging pipes, in hotels, a wonderful insulator. It hadn't been used long enough for anyone to find out that in its old age it flakes and comes down like snow and is deadly. We got a guy from *The Irish Times* to look at it, the heading was something like 'Church of Death.' The Dublin Musical Society and us were in the running for the building. Can you imagine? You couldn't think of anything worse than guys sucking in large gulps of asbestos-filled air to sing Handel's *Messiah* or something. It would become their Requiem.

£100,000 sounded like winning the Sweep twice over. The guys from the firm in England would build a tent in the building, get on their gear, wear oxygen on their backs, and proceed with huge scrapers and gradually scrape off the layers and suck them into red bags with sealed openings. These would be put into a big tanker lorry and burnt at sea. We contacted them. It was going to cost several hundred thousands.

It might have gone ahead but members of the Studio said it was too far from the centre of the city. We had gone ahead and patented the name. I timed it; it was a little more than twelve minutes walk from the GPO. They wouldn't venture to the North side. Eventually that came out; they thought the North side was dangerous. I've lived all my life on the North side. I was born on Mountjoy Square. We lived at the end of Blessington Place and we've lived here [near the Mater Hospital] for nearly twenty years.

George Dawson was always an adviser. He was not a legal man, but we could ring him up at any time. He was incredibly generous with his time. I said, 'We'll call a meeting and we will each nominate a spokesman. I'll nominate George to chair it. He is our independent adviser with a lot of goodwill.' Each group nominated a spokesperson. The dos and the don'ts were fairly level. George said, 'Having listened to everyone, you all have terrific cases for staying and terrific cases for moving. If you break up you should decide you are doing so because the

John and Mairead Kelly and Niamh, Fiona, Roisín, Sorcha,
Catriona and Lara, c. 1979, in Blessington Place.

present premises, the two rooms in Mount Street, are too small.' We couldn't raise the money for the twelve people who did want to go ahead. The rest went back to the Arts Council and said they wanted to stay in Mount Street. They then moved to a warehouse on the docks, where U2 have their recording studio. Down the docks was a no-go area. There was no bus; you had to walk to Butt Bridge for the bus. When Temple Bar started up the Arts Council provided them with an outlet, the Graphic Studio Gallery. We meanwhile [1980, 1981] found a large disused building in Ardee Street in the Coombe, called it the Black Church Print Studio and got a grant from the Arts Council. We built a terrific studio. Some years later [1990] there was a break in and it was set on fire. Some artists lost all their prints. The presses were all burnt. It was a part of an old mill, I think. It was a large building with huge thick walls and large windows. A solicitor had an office in the same building. We think it was a criminal act – burning his evidence.

VR: *If you were to have a retrospective could you locate the work? That fire in 1985 which destroyed records in the The Project was terrible.*

JK: We weren't the generation who took slides. I was well into my fifties before I took slides of my work. A student told me one day that he was coming down Stephen's Green and he saw hundreds of David Hendriks' photos and catalogues being thrown in a skip. He collected some of them. That would have represented a large part of the history of art in Ireland from the '50s. David kept all the photos. There were thousands. They were all put in the skip. I left the College and shot up to Stephen's Green but the skip had been removed.

VR: *Your significant routes around older, less fashionable Dublin are very interesting: you're in Joyce country in a sense here. You've painted Joycean themes; I'm thinking of the* Ulysses *triptych.*

JK: I knew the old Bloom house very well. I remember when the hall door was removed and John Ryan put it in the Bailey.

I don't know how many houses the Joyces lived in. But when they left their house in Rathgar they were quite prosperous.

The father had property in Cork and elsewhere. It took two delivery vans to deliver their furniture on the first move. On the last one it was one suitcase. I think the father liked only James. As long as he could be in a comfortable lounge drinking whiskey he didn't give a damn if they were at home without a crust. James was sent away to school with the Jesuits. Some kid asked him what age he was. 'Six o clock' he said. He was tiny. The others avoided that through poverty. Stanny, the youngest brother, who adored James, wrote a terrific book, *My Brother's Keeper*. He never developed James' love for Dublin. Stanny never returned to Ireland. James came back to set up a picture house. He made a proposal to some guys in Trieste. He could name an English-speaking capital in Europe that didn't have a cinema. They were intrigued. In Europe? 'If I tell you will you let me run it?' It turned out to be the Volta Cinema in Mary Street.

VR: *I think it said at the Joyce in Art exhibition in the RHA[13] – it is just over a few weeks, did you see it? – that he designed the poster.*

JK: No, I didn't see it. I think the films were rather uplifting. Good educational Victorian films. He applied to the Woollen Mills on Halfpenny Bridge to represent them in Italy selling tweeds. When he worked in the bank in Rome he wore his overcoat at all times. He couldn't tell them that the whole arse was out of his trousers. Even in the most steaming clammy Roman heat James stayed in his overcoat. When you think of the terrible poverty – they owed money everywhere – and the terrible jobs he endured, and the total, total commitment to his art, he was the greatest artist I've ever come across. He makes you realise what you take on if you say you are an artist.

'If Dublin was destroyed you could rebuild it from my work,' he'd say. He'd say to people from Ireland, 'Correct me if I am wrong' and he'd name all the shops on a street and the owners. He had an extensive love for a place that he had every reason to hate.

For some people being an artist, it's six or seven water-colours of Howth a year. He lived and slept and dreamt of art. You could say 'incredibly f–ing selfish' but even when his

eyesight had vanished he was writing in pencil with huge lettering. Such commitment. Someone said disapprovingly of him 'He only wrote masterpieces'.

In Gardiner Street Church there is a long corridor with a door leading to the pulpit. The Lenten regulations were being read out by a Jesuit: if it wasn't a day of total fasting, you could have fish for your breakfast or an egg, another indeed for your lunch and again for your tea. I couldn't resist asking him 'Are you responsible for the sermon you read this morning? The vast majority of people here live around the corner, in Mountjoy Square. They live on tea, sugar, bread and butter. Their last sixpence of the week goes to the Church. You're telling them that at a time of fasting they can have 21 eggs or 21 fish a week. When it's not Lent, what do you have? What do they have? They are sitting there, marvelling at your boiled fish for breakfast, another for lunch and another for tea. They gather leaves of cabbage in Moore Street on Saturday evening for lunch on Sunday, before the men come along to clean up.' 'The words are not mine,' said the priest. 'They are the archbishop's.' 'Would you contact him and tell him that he has lost touch with people,' I said.

The Jesuits moved into Gardiner Street, thinking Mountjoy Square was the next Merrion Square. Within a very short space of time Mountjoy Square was full of very poor people. The Jesuit order loved to be at the seat of power. When I was a child there was a large section of Mountjoy Square

John Kelly in Mountjoy Square. Photo by Fergus Bourke.

wired off and Judge Little and his daughters had the exclusive right to play tennis there. They were the only ones left who actually owned the whole house. If the ball came over the wire, we'd run off with it. We'd get stockings and tights and make a ball but it was great to get a real ball. We'd leg it.

VR: *Where were you the night Nelson's Pillar was blown up?*

JK: I was in Groom's Hotel. It's opposite the Gate. It was used by politicians. Joe and Patty Groom ran it. They didn't give a damn what party you were. It was very late, two or three in the morning. We heard this incredible puff. Very loud. There was nobody around. From Groom's we couldn't see that half the Pillar was gone. John Molloy walked down O'Connell Street and picked up Nelson's sword. It was a huge thing. It was massive because of the scale of the Pillar. John had it for ages and he showed it to a guy dealing in metals, who said it was a very rare combination of bronze and silver. It was to commemorate Nelson's victory, after all. John went to America and I don't know what happened the sword.

The head was blown off and landed at the foot of the Pillar. It was later stolen from the Corporation yard, where it was stored. It was about three feet high and full of bullet holes. When the Dubliners were doing a show in the Gate, they borrowed it. They heard a rumour that the Special Branch were going to prosecute so they asked me to do a copy, so that if the Guards went in, they would pull the head off the stage and put up my mock-up instead. Mine was made in foam.

If they'd left the stump there it would have been wonderful. The building of the Pillar was paid for by the traders in O'Connell Street; they were mostly Protestant traders. What a statement it would have made, 30 or 40 feet of stump sticking up in the air and Nelson gone.

Mairead was brought up in Grafton Street, where her mother, Daisy McMackin, had a flat for about 50 years. It was over Dr Scholl's shop. I think her mother was the last resident in Grafton Street, where she died in 1983. She was a great

linguist. She got a scholarship to the Sorbonne from Queen's, later studied Russian and went to Moscow where she worked as a translator. She met Mairead's father, Patrick Breslin, there. He had been recruited by Jim Larkin to go to the Lenin Academy in Russia. After kicking him out for asking too many awkward questions, they re-employed him as a teacher. He became a well-known journalist and an expert on Georgian poetry, which he translated into English. But he wrote articles criticising the corruption of the party, was arrested and given the sentence of eight years in the Gulag. He had sent Daisy back to Ireland as she was pregnant. Mairead was born in Belfast. Daisy then came to Dublin. She supported herself by giving grinds and doing translations. She later taught in TCD. Mairead had been an only child all her life, but Patrick Breslin had two children from his first marriage. Mairead found them, thanks to the research done by Barry McLoughlin. She went to Russia in 1993 and they came here several times. My niece, Yvonne McDonald, made a documentary about Patrick Breslin: *Amongst Wolves*. It was shown on RTÉ [February 2001]. They went to Kazan where he died. An old German who had been in the Gulag at the same time pointed out the little room where people were put to die. Mairead stood in that room. They found the cemetery. His name had been added to the list of people who died in the Gulag. His death certificate says he died of TB but an old friend said in the documentary 'they always said that when they shot people.'

Mairead, John and the twins at Blessington Place, c. 1968.

VR: *You've been a stone's throw from the Municipal all your life.*

JK: James McKenna arrived at

the Municipal with his big wooden horse; he'd delivered it on the back of a horse and cart. This was for the Independent Artists. The attendants said he couldn't bring it upstairs. The floor boards were rotten, as was later proved. They wanted James to leave it in the hall. James got into a rage; he insisted that he would take it home. We all struggled out the door with the horse. But we persuaded James that it would look fantastic downstairs. We brought it back off the horse and cart and inside. It was called *The Red Horse for the People*. The twins were about five. James insisted that they sit up on the horse. Looking warily at the attendants, one of them said to James, 'What will the people say?' 'We are the people,' thundered James.

I think the Municipal slipped up. I always thought they should be making a collection that could be capable of putting on a major exhibition of any period of the development of modern art in Ireland. If you were showing work produced, not necessarily the best, without prejudice, you'd be showing early Gerard Dillon and the mature Maurice MacGonigal and so on. They went through a brief period of buying two or three Micheal Farrells, Brian Bourke, a few Ballaghs. It's very jumpy, very hit and miss. They seemed to get what was made popular by the Arts Council.

In a second-hand bookshop I came across a little catalogue with my painting on the cover, but I have never seen the painting on show in the Municipal. I had a terrific battle with the Municipal to buy the Michael Ayrton. It's there now. I went down to the Solomon Gallery and collected it. I brought it up to the committee – I was on the committee.

I really did drive Ethna Waldron mad. She was an archaeologist. I would try to talk her into something before the committee meetings. Otherwise she might say, 'the Corporation would not approve'. When her car was parked outside the Gallery, she was in. I got to know that she went out for lunch. I'd get the porter to let her know I was waiting for her. He'd come down and say, 'I'm sorry you've just missed her'. I'd say, 'I'll just stay around'. In about six or seven minutes I'd hear the

phone ringing and he'd say, 'Yeah, Yeah.' She would often stay up there the whole lunch time.

When James [White] went over to the National Gallery [in 1964] it was wonderful. He was a great storyteller. He made up wonderful narratives. The Sunday audiences loved him. There was always a front row of nuns crying. He genuinely moved them about the painting. James was like a ballet dancer, describing the divine face of the Virgin. 'You see the way the nail has been forced into the hand, it has broken through the flesh ...' The nuns would have their hankies out, he'd be on his tippy toes. He filled the (National) Gallery every Sunday. People would go there early to get their seat.

VR: *Black Church (Print Studio) having moved from Mount Street, is now in Temple Bar, over the Original Print Gallery, isn't it?*

JK: Yes.

VR: *Good name, Original Print Gallery, with its emphasis on the originality of the composition. Do you see the two print studios as having different traditions?*

JK: Graphic Studio had a little shop. They would print your edition and they would give you a selling outlet. I don't think Mary [Farl Powers] was big into teaching people from the beginning. She would print an edition, it was under Mary's conditions. Mary was a terrific etcher; she didn't go in much for lithography. I think that James O'Nolan who was working in the [Graphic] Studio set up a place on the northside, printing editions. Margaret Peart has a place in Kildare; it's great it's spreading out. Some girls in Cork were setting up a studio. I found a press, a lovely little press and got it in working order and sold it to them.[14]

VR: *After the split over location, was Black Church more about individual artists doing their own work, while Graphic served painters and sculptors who wanted to have some prints?*

JK: They came and they learnt techniques in Black Church. The whole point of the exercise was that they printed editions of their own work. I met Hayter once; he had an exhibition here in Dublin. We invited him to Black Church. He was extraordinary. He literally

didn't want to tell us anything about printing. He assumed we knew nothing. I got annoyed with his attitude so I started asking questions. I said some of his techniques could be guessed at. He didn't want to reveal how he got certain effects. His idea was that if you paid the large fee in his studio you left with a couple of stunning etchings. You became a salesman for his courses.

Pat Hickey was very good. He had a natural feeling for lithography. He was big. He'd be above the stone as he rolled it. John Behan did some etchings and lithographs. Eamonn O'Doherty did some good work.

Micheal Farrell had a big zinc plate which I helped him to etch. I recommended he contact the Ordnance Survey; they have an enormous press used for printing maps. Poor old Micheal. They had a condition that only printers in the Ordnance Survey were allowed to use it. He had to leave his beautiful zinc plate with a guy who had never printed on zinc in his life; the maps which were photo engravings, were printed on copper. When they told him to come back, the plate was ruined. They had printed from it with such force that the lines had been flattened out. The zinc was too soft.

They never wiped the plate properly. The ink was wiped off and there was too much in the darker areas. The ink became black runs. I have a feeling that was one of the *Madonna Irlanda* series.[15] He had to take it off to France to have it printed.

I rescued all the lithographic stones from the Ordnance Office. I was in Spain and I met this American guy. He had a very nice studio. We went out drinking one night and he said 'I have a great thing going, I get all my lithography stones in Ireland'. In 1961 I read a book about lithography stones. You couldn't get them anywhere. It told you what you could expect to pay per pound weight. He said, 'I go up to a place in Phoenix Park, I have a van hired and I take away a load.' 'What do you do then?' I asked. 'I just pay the £3 each for them and sell them.' He was selling them in America, making thousands.

When the British Army were in control, they controlled the

map-making. If you occupy a country you don't want the people you occupy making maps. The army was still running the Ordnance Survey for the same reason as the British Government, keeping control. They had stopped printing lithographic maps.

The guy in the army told me that somehow the news had got around that they had lithographic stones. A woman had come from France and measured and crated them and took them away in a lorry. They never heard from her again. I said to the Captain, 'Could I ask you to do something, could I ask you not to sell anymore?' I went to the Arts Council and told them the story. Fortunately it was Colm (Ó Briain) who was director. 'Now you are commissioned, go up to the Ordnance Survey, count them, get a price, and come back to us,' he said.

In Phoenix Park up against the wall there were all these stacks of lithographic stones, some cracked and broken. They had taken down a wall and found rows and rows of stones. They got a guy with a JCB to take them out of their way. I went through them all, down to the smallest piece, and measured them. Fortunately all the big ones were intact. They were wonderful. The big ones were up to twelve stones each in weight. I said to the captain, 'The guy from America has been robbing you blind. I assure you that any stones we get from you will be used to make prints here.' 'Give me a reasonable amount, and take them all,' he said. First of all I went back to the Arts Council and said, 'We should pay a couple of hundred pounds to them.' I then got permission to have a lorry deliver them to the Arts Council. We had them transferred to the Coombe. I rang the Graphic Studio and they got their share.

Lithographic stones have a limited life span. You have to grind off the stone, you must clean off the image completely. The guy who discovered lithography (in Munich in 1798) Senefelder, had been using lithographic stone to mix inks. He was printing an etching in his studio and he picked up some of his ink which was like soap, and wrote a message on the stone, something like, 'don't forget to put the cat out', some message

for himself. He went off and when he came back next morning, there was a slight image of 'don't forget to put the cat out' on a stray piece of paper. The stone had the ability to transfer the image to the paper. He set about finding a surer way of doing it. He hit on the idea of gum Arabic and nitric acid.

If you look at a print the marks are totally unlike any other mark on paper. It's not a pencil drawing, it's not a photograph. It often has the quality of both but it's an image of its own. Take engraving; it's simply taking a copper plate and cutting into it with a little burin. You cut the lines. You see a coil of copper rolling up before you. If you left a fine line it will print lightly. You keep rubbing ink into the line, wipe and take a print. Engraving will always have a very sharp crisp line, both edges will be equally sharp.

In etching the plate has been covered in wax and you make the drawing on the wax with a sharp instrument and put the plate into the acid. The acid bites. If you magnify it you won't see a sharp precise line. You'll see a ragged line.

There's no acid with dry-point. You are not removing any of the copper, you are displacing it, scratching directly onto the copper with a sharp instrument.

VR: *Lithography is so soft by comparison. Manet's are beautiful.*

JK: When Lautrec decided to do lithographs the lithographic printers, who were terrific printers, said 'You can't do that, lithography is a black and white technique'. He had used his toothbrush to dip it in the ink and spray on a very fine mist. He was spraying on yellow, cleaning the stone, spraying the same area with another colour, blue and making a third, green. The chance of drawing the dancers and singers with the lithographic crayon was amazing.

What appeals to painters about lithography is the great broad marks you can make. He produced tonal prints. His colour lithographs are super.

VR: *Bonnard introduced him to lithography and Bonnard[16] learned much about painting proper from making lithographs in colour. Were the great prints of the school of Paris printed for them?*

JK: Two brothers called Mourlout Press printed all Picasso and Braque.

They were two experts. Picasso couldn't have made all those lithographs without their incredible skills. I have a very large book on lithography. It's down in the studio. It shows a lot of studios in Europe, particularly in France. And it shows American studios. It's extraordinary how different the American and European ones are. The American studio is gorgeous, the prints are often awful, corny. You'd see the technicians gluing together lithographs by Rauschenberg, they would all be pre-sold, huge pieces.

Then it shows a French studio, two guys with small lithographic stones the size of an A4 page, you see the prints and they are fabulous. You say, 'There's one studio with all the money and there are these guys in a back street in Paris, re-inventing printmaking.' The fanciest printmaking doesn't make for good printmaking always.

VR: *Print students have been responding very excitedly to the potential of digital imaging, and have been using lens and time-based media for some time now. Did you find that students were less interested in learning etching, lithography, wood-cutting?*

JK: It's true that lithography and etching and wood-cutting are not exactly techniques that lend themselves to some modern approaches to art.

Some of the students who used photographic images in their work never found a way to use the photo as another tool in mark-making. Some slavishly transferred their photo to a copper plate, it added nothing to the image. Others used the photograph as a drawing process – to get information. The best of them who used photographs had very little qualms about eating out bits of the photograph with acid and adding their own lines. I don't think I ever made a photo etching in my own work. I did draw from a photo for some etchings.

Photocopying has become terrific in the last 30 years and I found a way in photocopying to develop a technique in lithography. About 30 years ago it was very crude, you'd hardly ever get a clean photocopy. Now it can be as good as the original, whether in colour or not. I found I could take a photocopy and

coat the back of it with silk-screen thinners, they smell like nail varnish. After drawing the image I'd wind it through the press. When I peeled off the photocopy, the image was on the stone. The gum Arabic was to protect the non image, so when I rolled on the ink the only place that would take it was the image. I could make a montage of photocopied images, type something onto it, put my thinners on the back and wind it through the press. It suited some students very well, especially if they wanted to include written material. For me the very nature of etching is narrative, but while I say that there are some terrific large abstracts. I remember bringing the students down to Kilkenny, to the Butler Gallery, to see the Tàpies exhibition [in 1992]. He did enormous etchings in black and white with a tiny bit of colour. They were maybe five feet square.

There was this video there while the exhibition was on and you could see his assistants pouring buckets of acid over the steel plates. Sometimes you couldn't see them for the fumes. It was outdoors. Acid is dangerous stuff and you'd be irresponsible if you allowed that in an art college. I think the students were all ready to go back and fill the buckets with acid.

Generally speaking I think etching works better on a modest scale with a narrative.

VR: *It really can be hard to identify technique, so much is mixed or multi-media now.*

JK: I had a show in Kerlin about the French Revolution (in 1989).[17] There were two women there, they were from France. They insisted that my paintings were lithographs. One of them told me I didn't know what I was saying, she was a lithography teacher and she knew. I said, 'I know what you are saying, but I painted them and I am a lithographer and so they probably look like lithographs all right.'

I was in Henry Street and I was going to buy shoes for about £22. While I was in the shop I saw a chart of the jars for shoe polish. They were in all colours; pink, red, sepia, black. Instead of buying the shoes I bought the jars of waxy polish. The

man said, 'You don't have all these shoes, do you?' I said, 'I am going to use them to paint.' I worked from Rembrandt's painting of the cloth makers' guild sampling officials. What I did was I put all the figures in a band and I extended the tablecloth, and filled the whole tablecloth with writing that didn't say anything. You could wrap a cloth around your finger and dip into the polish and put it on. I used scarlets and reds. One was bought for Michael D. Higgins' office. I'd polish the surface at the end. I used to joke about going home to polish off a few paintings.

In conversation, Dublin 5, 9 and 30 July, 4 and 17 August, 1 October and 26 November, 2004

1. Artist Gerald Davis, (1938-2005), opened his art gallery in 1970.
2. Turpin, J., *A School of Art in Dublin Since the Eighteenth Century,* Dublin, 1995.
3. Stephan E., *Spies in Ireland,* London, 1963.
4. The RIAI Church Art Exhibitions committee was established in 1956.
5. When Louis le Brocquy's painting *The Spanish Shawl* was refused by the RHA, Sybil le Brocquy, (1892-1973), suggested that an alternative exhibition be set up and on 16 September 1943 the Irish Exhibition of Living Art opened. See Hartigan, M, 'The Irish Exhibtion of Living Art', *Irish Arts Review,* Vol. 4, no. 4, Winter 1987, pp. 58-9. JK exhibited with IELA in 1956, 1959, 1965, 1968, 1969, 1974 and 1980, with Gerald Davis in 1972, 1974, 1975, 1976, 1977, and 1978, with the Hallward Gallery in 1994, 1996 and 1999.
6. Oh, Bowsies all as bad as Bulgar/s, don't forget that Pawky pack/ was born on the wrong side of the track./ McKenna, Kelly, Behan and Bourke/ have less of Greek in them than Turk,/ They're hardly civilised, barbarous,/ And not like us purely agrarious./ 'The smelly Armpit of Irish Art/' Is what a critic who was smart/ called the crowds. Oh the left Alignment/ Bears no resemblance to refinement! Quoted, p.57 Sharpe, H., *Michael Kane, His life & Art,* Dublin, 1983 and *Structure,* a magazine by Michael Kane, published between 1972-8.
7. John Kelly's touring exhibition, An Artist's Notebook, went to sixteen venues. See Dodd, L., *Circa,* No. 21, March/April 1985, pp. 26-7. See Brenda O'Reilly's BA thesis 'John Kelly: An Artist's Contribution to the Development of the Arts in Ireland', NCAD, 2001. A synopsis is published in *Thoughtlines 6,* NCAD, 2002, (ed.) Hayes, M.L See also Walker. G., *John Kelly RHA,* Hallward Gallery, Dublin, 1996.
8. Art historian, critic, journalist, and administrator John Hunt (1957-2004)

established the first company in Ireland to provide the professional installation of visual art exhibitions. He worked for a time with the Arts Council, as Visual Arts and Film officer. He was chairman of the Tyrone Guthrie Centre in County Monaghan. He was a founding director of the Hunt Museum in Limerick, which opened in the old Customs House in 1997. From the late 1970s until then, the collection, valued at €70 million at John Hunt's death, was housed in the University of Limerick. It comprises around 2,000 artefacts, from the Neolithic period to the twentieth century.

9. 'In 1962 Liam Miller, Anne Yeats, Leslie McWeeney and Elizabeth Rivers and I decided to start a print studio, for teaching graphics, and searching flooded basements in Cork, buying the, by now, late Sean O'Sullivan's press, garnering every sort of tool, device, accoutrement, object and instrument, we rented a basement flat at 18 Upper Mount Street and opened our school. The ups and downs, the spreading and contracting, the triumphs and disappointments of the Graphic Studio as we called it, is another story.' Gandon Editions, *Works 3, Patrick Hickey*, 1991, p. 14.

10. See B.A. thesis, Stedman, A., 'Phoebe Donovan 1902-1998', NCAD, 2000.

11. IMMA, 9 March to 7 May 1995, Mary Farl Powers (1948-1992)

12. *Apples & Angels*, a selection of Patrick Pye's etchings and his reflections on art, Dublin, 1988.

13. Joyce in Art, RHA 10 June to 28 August 2004.

14. Cork Printmakers was founded in 1992 by Pat Mortell and Sinead Ni Chionaola. It opened in 48 MacCurtain Street, Cork, in 1994 and is now based in Wandesford Quay, Cork.

15. Purchased by the Municipal Gallery, Farrell's painting *Madonna Irlanda: the very first real Irish Political picture*, (1977) was based on Francois Boucher's *Nude on a sofa* (1752) in the Alte Pinakothek, Munich, and presents Ireland as a woman, ready if not watching out for ravishment. Farrell did a print edition based on the painting. See Gandon Editions, *Profile 9 – Micheal Farrell*, 1998 p. 11 and p. 15.

16. *From Manet to Toulouse Lautrec, French Lithographs 1860-1900*, Carey, F. and Griffiths, A.,BM, 1978, p. 91.

17. Fallon, B., 'John Kelly at the Kerlin', *The Irish Times*, 7 October 1989.

The Scott brothers and sisters in Barleycove, County Cork, August 1964.

Patrick Scott

Patrick Scott was born in Kilbrittain, County Cork, in 1921. He was educated in Dublin, in Monkstown Park School from 1933 to 1935 and St Columba's College until 1939. He studied architecture in University College Dublin from 1939 to 1945. He began painting while studying architecture and has exhibited nationally and internationally since 1940. He practised as an architect in the office of Michael Scott from 1945 to 1960. He exhibited regularly with the Dawson Gallery between 1961 and 1977 and with the Taylor Galleries since then. He has had two major retrospective exhibitions, one in the Douglas Hyde Gallery in Trinity College, Dublin, which travelled to the Ulster Museum, Belfast and the Crawford Gallery, Cork, in 1981, and the other in Dublin City Gallery, the Hugh Lane in 2002. It travelled to the Crawford also. He has worked on many design projects and served on several national boards. He is a member of Aosdána.

VR: *Pat, since the death of Pope John Paul II last week[1] people are reminiscing about his visit to Ireland in September 1979. You were involved in the Phoenix Park installation, designing banners.*

PS: Ronnie Tallon was asked to do the installation in the Phoenix Park six weeks before the Pope was due to arrive. I was down in Kerry and I got a phone call from him, could I come and help. I said, of course I would. The banners were made of ordinary cotton bed sheeting. I flew over to Manchester as soon as I'd done the designs. I got someone to take me around the weaving areas and found a factory who could do the width. Then I found a silk-screen company to print them.

I was worried a couple of days before the Mass. We had assumed the wind would be west. The fact that the wind changed to the east was a bit of a nuisance. A banner started to tear. That batch with faulty thread had to be taken back to the convent who had sewn them which happened to be in Dublin. I had to have a police escort to get me through rush hour, in order to have them ready.

VR: *Did you go to see the Pope in the Park?*

PS: I did, oh yes. I was there in one of the front corrals.

VR: *What happened to the banners afterwards?*

PS: They were sold off at an auction. I asked a friend of mine to buy me one. There were about 25 or 30, they were 60 feet high. I made a duvet cover out of mine.

Some months after the Mass in the Park we who had worked on it, Ronnie and his wife Nora and Robin and Dorothy Walker and myself, were invited to Rome for an audience with the Pope. He had to go into hospital, but we were received by Monsignor Magee, his secretary and given the freedom of the Vatican for the day. We saw all the treasures and had an opportunity to see the new gallery of modern art, which was being put together at that time.

I was particularly interested to see the collection, because Charles Merrill had offered a painting of mine to the Vatican. I'd done this twelve foot high painting of a cross; what you might

call a Protestant cross. He wanted it presented by the State, so he approached Erskine Childers, who was president at that time.[2] But he refused to be involved and suggested that he had a moulded glass Madonna which would be more suitable. However, my painting turned out to be too big for the available rooms. St Patrick's Cathedral in New York said they would take it. But Charles refused and finally sold it in Whyte's[3] in Dublin.

When the Pope died, I was getting out a canvas to start working on when I thought I might do a memoriam for J.P. It's black and gold and silver.

VR: *Was that Charles Merrill, editor of* The Arts in Ireland*?*[4]

PS: Yes. Henry McIlhenny telephoned me one day to say that an old friend of his from Philadelphia was coming to Ireland, with a young man called Charles Merrill. 'Her name is Princess Evangeline Zalstem-Zallesky. She is a member of the Johnson and Johnson family from Philadelphia and was married to Leopold Stokowski. They are interested in coming to live here, and publishing a magazine on the arts. Charles will be the editor,' he said. In due course Charles called on me and outlined their plans, which resulted in the publication of *The Arts in Ireland*. Dorothy wrote an article on me in the first edition [Autumn 1972].

Evangeline had two children with Stokowski, who married Greta Garbo afterwards. She finally married Charles just after they left Ireland. He was still known as her nephew when they left. She was years older. She had all sorts of drugs to keep her young and she kept them in the fridge. She looked very splendid. She wrote me a letter that I was to have after she went to the grave. She had written on the envelope 'Not to be delivered until after my death'. Charles gave it to me. It was thanking me for being such a good friend to her when she was in Ireland and saying how much she enjoyed our conversations.

VR: *Was the Johnson and Johnson Collection, shown in the Municipal exhibition,* Art USA Now, *in 1964, her family collection?*

PS: Yes, her family business collection.

VR: *Used you go up to Glenveagh Castle in Donegal when Henry*

*McIlhenny had all his pictures and
parties there?*

PS: Yes, Pat McLarnon and I were often
asked up for weekend parties,
which he held during the summer.
He always had guests flying in
from America.

VR: *Did he and Derek Hill inspire one
another to give their lovely places
to Ireland? What were they like?*[5]

PS: They were great friends but they
fought like mad. Henry always
wanted important people to be visi-
tors. I wouldn't know the half of
them. There was a vast collection of
celebrities there every year. I got to
know the composer Samuel Barber
by meeting him there.

*Patrick Scott in a school
blazer with an umbrella and
bucket.*

It was very funny. They were so bitchy. Henry called on
Derek once when Derek had just been sent a present of a Tiffany
lampshade. They were just being revived. Derek asked Henry
what he thought of it and Henry said, 'I think it's hideous but it
suits the house perfectly'.

VR: *Your own family's fortunes didn't prosper due to the economic
war in the '30s, when Britain declined to buy Irish cattle follow-
ing the withholding of annuities payable. All that agricultural dis-
appointment made people see the merit in education, didn't it?*

PS: To be quite honest it was an absolute disgrace. It destroyed my
family financially. Did you read *Woodbrook*, about the decline
of the Kirkwoods, by David Thompson, the tutor for Phoebe
Kirkwood? She happened to be a friend of mine when she was
in Trinity.

We were short of cash but we did manage to have a car,
paid for by some arrangement my mother made. My education
was all paid for by my aunt's friend.

VR: *Aunt Linda whose photo is shown in the film* Golden Boy?[6]

PS Yes. My real aunt, Aunt Linda's friend, was never called Aunt Janey. Both my mother's sisters refused to be called aunts. The other was Violet. She was called Vi.

VR: *What was your mother's maiden name?*

PS: Tucker. She was Eileen Tucker. Her father was bank manager of the Bank of Ireland in Bandon. My father was the second son so he didn't inherit the family house. But he inherited the farm excluding about 25 acres, which went to his brother in Argentina. His widow lived in the old family house. There were a couple of seaside cottages on the farm. When my parents got married they lived in the larger of the seaside cottages for a few years before they bought and moved into the big Victorian house, called 'The Glen'. They died in 1950 and 1951. The farm and house and everything had been left to my brother. He also inherited the overdraft of £2,000. The whole farm was valued at that. My nephew, Guy Scott and Diana, his wife, live there now and run it as a guest house.

VR: *Tell me about the* crios *you are wearing in this photo with your parents.*

PS: I made that crios in St. Columba's. I made the loom[7] first. I looked up looms in the Encyclopaedia Brittanica and made little drawings from the illustrations. I made lots for my friends. I made a whole line of Christmas scarves.

I would have been fourteen or fifteen then.

VR: *The spaces you have to do with, whether it's your presence or your paintings, seem to become very calm,*

Patrick Scott and his parents.

very meditative.[8] *Has this anything to do with your background?*

PS: The Victorian house was monastic for a while. Monks lived there. My brother used to dream he saw monks. I did think vaguely for a while of becoming a Protestant monk. There was a Protestant monk who came regularly to St Columba's, to visit the warden. He'd tell us about the leather breeches he wore under his habit. They were passed down from a previous monk.

The German writer Gesa Thiessen used one of my paintings on the cover of her book [*Theology and Modern Irish Art*]. They have this little meditation room in DCU. I gave them one of my gold paintings for it. I suppose it's still there. It was when I said I thought my paintings were helpful for meditation [*c.* 1991]. I was talking to John Hurley, one of the professors out there and he hinted they would like it.

VR: *In an article, Medb Ruane emphasised the Zen interests of the White Stag Group, who came to Ireland during the War.*[9]

PS: Basil Rákóczi was always flirting with Zen. He gave a lecture called the Japanese Zendo. I went to it, I was about nineteen. Purely as a sort of skirting around the Zen thing, I went. We would get a quan, a phrase, every two or three months. We'd have that to meditate on for the next few months. I remember one. We had such a laugh. It was 'There is an old sage about'. Everyone was pointing at anyone vaguely old. I was a bit light hearted about the whole Zen thing. My sense of humour got in the way.

If someone had a copy of his lecture that would be interesting. There is a copy of Kenneth Hall's *Excerpts from an Autobiography* which he was writing when he was still here. It was inspired by the *Autobiography of Alice B. Toklas*, it was very Gertrude Stein. Hall was Gertrude Stein and Basil Rákóczi was Alice Toklas. It was mostly about themselves and when they met. Kenneth Hall tried to persuade me to write my autobiography at this time.

VR: *Why didn't you?*

PS: I was only 23. I didn't have an Alice B. Toklas then.

VR: *You hadn't met Pat McLarnon?*
PS: No.
VR: *How did you meet? Was he as beautiful as he is in photos?*
PS: He just came up the stairs. I lived in a slum house, 15 South Leinster Street. It was an open stairs. He'd obviously been a bit curious about me. He was only eighteen. I was 23.
VR: *Was it a case of immediate rapport?*
PS: Absolutely. I'd seen him around. He was the talk of the town. Micheál MacLiammóir said he was the best-looking man he'd ever seen.
VR: *Did he get his looks from his mother or his father?*
PS: Not from his mother. His father was a street bum. He'd been in the British Army. He was known as 'the Captain'. Pat didn't tell his mother whenever he met his father on the streets. His father was a brother of old Elizabeth Brittain, the grandmother of the Brittains who owned the Swastika Laundry. She'd drive around town in an open carriage during the war. When she'd return after shopping she'd often find 'the Captain' holding the horse and he'd have his hand out for a few bob.
VR: *Tell me about art activities in Dublin during the War?*
PS: There was a psychologist called Billy Williams [Dr Ingoueville Williams]. He was financing the White Stag. There were three galleries in the White Stag years. They were drawing-room floors in Georgian houses. The first one was in 34 Lower Baggot Street, near town: that was Basil Rákóczi's apartment. Then there was one on [30 Upper] Mount Street; that was the same situation. It was Kenneth Hall's apartment.

I had my first show in 1944 in two rooms over Keating's Bicycle shop in Baggot Street, the narrow bit near Merrion Row. Deirdre McDonagh, Leo Smith always referred to her as Dirty Mac, she was my first dealer. When I was a very young student I happened to be walking along South Leinster Street and saw a big framed Picasso print in the window. I'd never seen a Picasso reproduction in a shop window before. I had a book on Picasso from my schooldays.[10] David D'Oyley Cooper, a science teacher

who played the flute, used to bring us on watercolour outings around Ticnock – he gave me a book on Picasso.

She was the first person to show a painting of mine. It was a painting of a view just off the corner of Baggot Street, near Waterloo Road. There was a Georgian house, the last house near Waterloo Road in Baggot Street, that had a garden. I lived in that house and painted the garden when the laburnum was in bloom. I think I gave it to someone.

In 1938 she opened that tiny gallery in [5]South Leinster Street, in the house next to the Kildare Street Club. It was a tiny shop, about 8' square. She started it with her boyfriend, Jack Longford. When she met him he was probably a student at Trinity.

They moved up into Baggot Street directly opposite the Tesco supermarket. [In 1939] she had the first Yeats exhibition I ever saw, long before Waddington would allow Yeats into his gallery. The official story is that Waddington pretty well created Yeats. When Leo Smith worked with him Leo tried to get him to take on Yeats but Waddington wouldn't. Leo left Waddington. He was a junior partner. He opened his own gallery. Leo asked Yeats to show with him and Yeats said 'yes, of course'. Waddington jumped in and tried to get all the big pictures. Yeats was absolutely faithful to Leo and gave him paintings right up till he died.

VR: *Smith's offering of the three major Yeats'* – Bachelor's Walk – In Memory, The Funeral of Harry Boland *and* Communicating with Prisoners *to the National Gallery as a special deal shows his concern for Yeats while the artist was alive.*[11]

PS: Yes, it does.

VR: *Do you remember Yeats at all?*

PS: I remember him. He wasn't very forthcoming, he was an old man. I remember meeting him at the Dublin Painters' Gallery. They were still having exhibitions there then. It was one of the few places you could show. Norah [McGuinness] and Mainie [Jellett] and Evie [Hone] showed there. Fr Hanlon would have shown

there. Norah and Evie were staunch supporters of White Stag exhibitions. I remember Mainie lecturing there. I think Yeats did have a painting in that exhibition at the Dublin Painters' Gallery.

VR: *Did you know that he had Rákóczi, who was his neighbour, to tea in his studio in [18] Fitzwilliam Square in 1942, and visited at least one White Stag exhibition?*[12]

PS: No. Deirdre showed all the Northern people first – O'Neill and Campbell and so on – before Waddington took them on. She had been an actress with the Dublin Drama League.

VR: *Her real name seems to have been Moira Pilkington?*[13] *Was she English?*

PS: I never thought of her in terms of where she came from. She certainly didn't have a Dublin accent.

Her boyfriend committed suicide, jumped out of the window on Baggot Street [in 1944]. She was never very ambitious. I think she just retired. She lived in a house on Rathmines Road. I saw her several times when she was a really old lady. She used to sit in the window.

VR: *Was Mainie Jellett an influence on you?*

PS: I don't think so. I admired her work. In the early '40s she used to hang her paintings in The Country Shop. Her Achill horses used to hang there. She was a friend of Muriel Gahan.[14]

I was just a young primitive. Norah McGuinness came back from New York just after the war started in 1939. She had her show in Deirdre McDonagh's tiny gallery. It was the first exhibition opening I was ever at. It was opened by MacLiammóir – I was very friendly with MacLiammóir and Hilton. Micheál said the houses in Norah's paintings looked as if they had been dropped by Giotto!

VR: *He had been a painter himself; would he and Hilton buy?*

PS: No, they didn't buy many. They had a Mainie Jellett, a little small painting of hands by White Stag artist Phyllis Teale and a painting by Yvonne Jammet, who was a close friend of Micheál's. She was very chic. She was chic in her clothes and the work had a French chic to it.

Hilton and Micheál were broke all their lives, until Micheál wrote and acted *The Importance of Being Oscar* [in 1960, 1961].

VR: *Were you aware of how much Rákóczi and Hall admired you as an artist? In Rákóczi's journal he wrote that you were the most original, delightful and best artist in Ireland and Hall, in a letter, wrote that you were by far the most gifted painter he had ever known.*[15]

PS: Yes, I knew they both admired me. Kenneth was very shy and reserved. Rákóczi was very gregarious and knew everyone. Kenneth only knew a much smaller circle. He was the one I knew most and talked to about painting. He was a real friend. So was Rákóczi – Basil kept on writing to me until he died, and wanted me to go to his house in Majorca. Kenneth had been hospitalised several times before he went back to England. I went to see him in the Adelaide. He seemed to have digestive problems.

My first exhibition opened shortly after I met Pat McLarnon. Immediately after it [in 1945] I went straight to Michael Scott.[16] I wasn't doing a lot of painting – I was painting five or six a year. The paintings were done when I was an architectural student.

VR: *Your painting of the white gate, Renvyle (1943), in the IMMA exhibition made me wonder did you go and visit the White Stag painters when they were in the west?*[17]

PS: No. I stayed in Renvyle House hotel in 1941. It was still being run by old Mrs Gogarty. She ran it with the help of just one girl. There was no one staying there except an Englishman who lived there. I went with Carl Bonn. We went on bicycles. Old Mrs Gogarty came out in a long black velvet skirt to meet us. She looked a bit surprised when Carl and I walked in. 'Oh, Mr Bonn,' she said. 'I thought you were on your honeymoon and I booked the honeymoon suite'. We said, 'That's all right'.

They had a wonderful collection of Penguin books. They must have had an order for every Penguin that came out since 1935. There were walls of them. It was a wonderful library. The old Englishman used to sit beside the fire and every time his pipe went out, he tore the page he had read to make a spill for

the pipe. All the books were being quietly destroyed.

There was no food except conger eel and magnificent globe artichokes. We had eel and artichokes every day. The house had been burnt down in the Troubles but was rebuilt according to plan. They hadn't built on the extensions. The original eight foot high wall was still there. It went right around the property. You went out one opening in the wall through that gate onto the beach, and there was the Atlantic.

I was brought up by the sea but I'd never been in a house that had a wall around it. It made it very snug.

VR: *So many of the White Stag artists – like you – were self taught. Did the belief in subjective art mean accessing the child within, free of academic art tuition and talking a lot about artists like Paul Klee?*

PS: We all talked about Paul Klee, I'm sure. Nick Nicholls was the one who was most influenced by Paul Klee. I think you could say my work was free of academic tuition. My paintings were very naïve in those days. The naivety was what made so many people abuse me.

VR: *You showed in London in 1945 – indeed you showed outside Ireland a lot, right from the start. Did you like the Ben Nicholson shown early on in the Irish Exhibition of Living Art?*

PS: I was mad about Ben Nicholson as a painter. He could easily have had an influence on me, definitely. I was very taken by his work from an early age – I'd seen reproductions maybe in 1940.

VR: *How do you feel when you read the history of this period?*

PS: Virtually the whole White Stag section in S.B. Kennedy's book [*Irish Art and Modernism*] is based on an interview with me. I don't mind: it should be public knowledge.

VR: *And he does acknowledge you. May I tap into your memories of Living Art and start by asking you about Norah McGuinness, its longest serving president, please?*

PS: She could be very strong. Norah took over the Living Art when Mainie died [in 1944]. She ran it with a pretty iron fist. Norah was very enthusiastic. She was tough if she wanted her way. We

had endless meetings. We often had the meetings in Michael Scott's offices on [19] Merrion Square, he was on the committee [from 1947]. Anne Yeats was treasurer and kept press cuttings and organised who would look after the exhibitions. When we decided that we'd hand it over to Brian King and co. Anne was devastated. She had been on Living Art since 1947. At Anne's funeral [in 2001], I said to Michael that the scrapbook of Living Art should go to NIVAL.

The Living Art did a tremendous amount of good I think. We got groups from various countries to exhibit here in later years. Some members would go to another country and choose artists from Germany or America or wherever.

VR: *Tell me about Colonel Kyle Knox, secretary from 1948 until his death in 1963, please.*

PS: He was an old friend of Norah's, from the North, like Norah. I think he'd been to art school. He was retired from the army as a colonel. He had a nice house near Highfield Road and we used to have many meetings there. It was the time we had film shows on artists and got the films from embassies and the British Council and so on.

Louis' mother [Sybil le Brocquy] was secretary in the early years. We had other ladies. We had Seán McBride's great friend Louie O'Brien as secretary. Gerry Dillon, Paddy Collins and Fr Hanlon were on the committee.

Norah was Fr Jack Hanlon's closest friend. Fr Hanlon's mother was very French, very stylish. She always wore nice little hats and lovely clothes. Another of Norah's friends was Bobs Figgis, a major collector.

VR: *In the late '40s and early '50s, IELA showed some great names; Modigliani, Klee, Picasso, Rouault, Matisse – lent by the Bomfords. Who were the Bomfords?*

PS: The Bomfords were big collectors in London. Louis was friendly with them when he was living in London; they bought some of his early works. Bomford came over. Ralph Cusack was around then and he was giving a party. The party was the day before the

opening, in Ralph's house in Annamoe. Ralph had a habit of getting violent when he was drunk. Some row broke out and he hit Bomford over the head. So the opening was without Bomford. He wasn't exactly hospitalised, but he was well bandaged.

VR: *Ralph Cusack in White Stag, who was on the IELA committee and advertised bulbs and plants for sale in the catalogue?*

PS: Yes. He also wrote a book,[18] it has a wonderful opening scene, of a man with his mouth propped up having his teeth done.

The Cusacks were quite a distinguished family. They lived in 'Abbeville'. The last one in 'Abbeville', the one who sold it to Percy Reynolds, the first chairman of CIÉ when it was formed [in 1945] was an uncle of Ralph's. Ralph was a painter. He lived in Menton in the south of France before the war.

Reynolds had been head of Dublin United Tramway Company and all the railways, the trams and most of the buses, which were all independent until then, were taken in under CIÉ. Before that, the buses used to race each other to see who'd get to the bus stop first. They were all painted different colours.

VR: *You had a big design involvement with Irish public transport[19] at a lot of different levels – you designed the colours for the trains, for example. Did you love working with mosaic?*

PS: That's from the bus station days [1944-51]. Really it was practical. We thought it was a good way of protecting places that would get roughed up. The wear and tear in a bus station is terrible. We found this firm in Venice. I went to Venice and saw them. You just sent your designs to them and they mounted the mosaics on paper and sent them to you on a foot square of paper. Two nice old men came from Venice to mount them in Busárus.

VR: *Back to IELA, do you remember a Gladys McCabe, with a Belfast address, showing at IELA? Was she the collector?*

PS: There were two Gladys McCabes. The one who lived in the North was a painter.[20] The other, Gwladys Mc Cabe, had a collection. She was a fine looking woman, very tall and blonde. She gave parties for artists. I was often in her house [18 Clyde Road]. She was at all the openings. She had an affair with a chap called Nicky Bloom.

He was very good looking and was said to be a German spy.

VR: *What was the story about deporting René Buhler, White Stag artist Georgette Rondel's husband?*

PS: Nick Nicholls was their friend. He was English and he came to Ireland with them. Zette decided she was having an affair with Nick. She was a really lovely looking girl and lots of people had the hots for her. I knew her and Nick well. I didn't get to know Buhler as he was deported. She then had another affair and went back to England to her husband. She died [in 1942] of something like kidney failure. I remember saying to Nick how sorry I was and he said she had died for him years ago.

VR: *Such a sad, mysterious story. I love the drawing Nicholls did of her painting outdoors.*[21]

PS: I haven't seen the White Stag exhibition yet, but I remember the line in those drawings was a very solid line, not a fluctuating one. They went off somewhere to do those drawings, maybe the West. Perhaps Nick used an architect's pen. When he lived in the top flat in Leinster Street and I lived in the floor underneath, we organised life classes. We had friends and out of work actors and actresses to pose for us. We had a pot bellied stove lighting and we started with five-minute poses, a couple of ten and twenty minute ones, and had one longish pose of 30 minutes. We used a kind of free-flowing pen. It was two shillings an evening.

VR: *After the war, Basil Rákóczi used to send work back to IELA from Paris, and Louis le Brocquy from London.*

PS: Basil practised as a psychoanalyst in Dublin and he used to come back to see patients. I think he was very helpful to some of them.

VR: *Rákóczi, Phyllis Teale and Doreen Vanston had young sons around that time, as White Stag and Living Art overlapped. What happened Martin Teale and Tony Rákóczi and Doreen Vanston's boy?*

PS: I remember going to Paris just after the war. Tony and I used to swim together in a swimming pool made out of a great big

barge, the Bain de Lignys. He was about seventeen then. He got married and went off to the Caribbean, teaching swimming and sailing, and committed suicide. He had a son, Christopher, who is still around. Basil Rákóczi inherited Kenneth Hall's paintings, so Christopher has them.

VR: *So much death.*
May we talk about invited selectors at IELA – like Eric Newton in 1951?

PS: I was all for Eric Newton. He gave me a good notice in *The Listener* in 1960. He was the art critic. In 1945 they reproduced one of my paintings [*The Zoo*].

VR: *Essentially though, was it the Living Art committee who selected?*

PS: It was the committee. We wouldn't necessarily all turn up. The conscientious ones like Norah and myself would put all the paintings we didn't think were eligible in a row down the middle of the big gallery. Everyone who agreed to come in to Kildare Street to select would look at everything. It was very hard work. I hated it, I must say. I had to do an awful lot of things. I designed the catalogues, the posters, the bus stickers. They used to have these long advertisements they would stick on buses.

VR: *May I ask you more about IELA organisers? For example, Elizabeth Curran, secretary to the first IELA and later committee member?*

PS: She got married in those early years and went to live in America. Her father, Constantine Curran, was a very distinguished person, he wrote a book on plasterwork in Ireland in the eighteenth century.[22] They lived in Garville Avenue and had soireés. She[23] was serious, tending towards the blue stocking.

VR: *What were the IELA openings like?*

PS: For the first couple of openings it started off like the Academy. The Academicians used to stand in line and greet people. So we were asked to stand in line and shake hands. We were got up in black tie. One of the things that stopped the standing in line was Phyllis Teale rooting in her handbag for her ticket – she knocked a powder compact. We were all covered in pink dust. We stopped after that.

VR: *Was booze served at the openings in the early IELA years?*

PS: No, I don't think so. I went to an opening very early in my life in Dublin, maybe 1941, where they served sherry. That was, I think, the Dublin Painters' Gallery. We always had a bottle of gin in the room behind the stairs in Kildare Street during Living Art openings. Anne Yeats organised that. We'd nip in and have a drink.

[For years] all my shows were opened in the afternoon. Three to six, no drink. I tried to have my exhibitions in May. I used to have drinks parties here in Baggot Lane after the openings. I used to serve dry martinis in the garden, with someone serving from a table at the end of the garden. Oisín Kelly said he was going to sue me for alcoholic poisoning. Irene Broe fell into the bath, somebody fell into the flower bed. Maybe Philip Pearce.

VR: *The first year your name was listed as being on the IELA committee, 1950, you showed* Bird Nesting, *lent by Philip Pearce.*

PS: I sent my little White Stag invitation to the Pearces. I think I got the invitation list from Living Art. The Pearces were on it. The card I designed for my opening over Keating's Bicycle shop was very unlike the usual type of card that was sent out. Philip, whose father had a printing works outside London, liked the card so much he came to the exhibition. Philip was trained as a typographer. They asked me to stay in Shanagarry. He came to every exhibition and bought a painting at every exhibition. Stephen started to buy later.

Stephen and Simon were christened when they were eight and ten. When they were going to boarding school, Lucy suddenly thought 'when it comes to Confirmation will they feel left out, will they feel neglected?' So she thought 'we better christen them'. They hadn't really become Quakers then.

Bird Nesting came later than my first exhibition. It was a new painting [when it was shown in 1950]. It was the first of those like *Wet Day* – they were painted in transparent pigment on paper and then mounted on board.

VR: *Despite or perhaps because of being part of a very supportive group, you got a bit of negative criticism from time to time.*[24]

PS: I had a one line review from Stephen Rynne when I was in the White Stag group. 'Poor jokes in good frames' was the complete review. I used to buy the antique frames, we all did in White Stag, and paint pictures to fit them. There were some very good frames. 'Jet black is all right but Pat Scott will have to add to it' was another. There wasn't a pick of black, I was using indigo.

VR: *Then there was Myles na gCopaléen being a bit satirical about* The Deserted Racecourse *(1954). Did negative criticism affect you?*

PS: It didn't affect me. If I thought it was in a paper my mother would read I would be upset. She would have been upset by any derogatory remarks about me. Aunt Janey kept a great file of press cuttings.

Brian Fallon had some savage things to say.

VR: *Some of the IELA exhibitors, like Nevill Johnson who taught Cecil King for a while, seem to have gone off the map. Eoin O'Brien is working on him, I know.*[25] *When you lived at 24 Lower Leeson Street, didn't Johnson live nearby?*

PS: He lived down a lane on Hatch Street. I could see his lane from my bathroom window. He went back and lived in London. Thurloe Conolly fell for his wife, Noelle. She was French. Thurloe was at the White Stag opening in IMMA [5 July 2005]. Unfortunately, I didn't see him, I was away in Thailand. Steven Gilbert came over too. He's 92. Thurloe had an exhibition at the Hillsboro Gallery [in Dublin] when he was over.

Nevill [Johnson] became a great friend of Anne Yeats. They collaborated when he did that series of photographs of Dublin. He took them and she looked after them. He concentrated around the Liberties and Moore Street. When I worked for Signa, if we were looking for photos of Dublin, we'd ask Anne. They are wonderful and are now published.[26] Nevill had to try and support himself. I remember him telling me he took a job as a milkman, thinking he'd get up at four and deliver the milk and have the day to himself. It didn't work, he was exhausted.

VR: *Was it exciting when the Arts Council was set up in 1951?*[27]

PS: There was a feeling of expectation. The first director was P.J.

Little,[28] he was a retired politician. He didn't make much impression. The real lift seemed to come when Sean O Faolain took over [from1956-1959]. Norah was very friendly with him. I only met him a few times.

VR: *Michael Scott's friendship with Fr Donal, director from 1960 to 1973, must have boosted the artists Scott admired.*

PS: Exactly. James White was on and off on the Arts Council, he would have backed them up. The Arts Council were allowed into exhibitions before the public. The Arts Council then did a lot of good by buying. They got a lot of abuse for it.

VR: *Fr Donal started the collection, and 800 pieces were acquired during his time.[29] Galleries like Dawson and Hendriks mightn't have survived without these purchases, not to talk of artists.*

PS: No. We lived on the smell of an oily rag.

VR: *At that stage, they didn't fund individual artists directly. Do you remember who bought* Still Life, *illustrated in the 1955 IELA catalogue?*

PS: That might have been bought by Gerald Pringle. Gerald was a very good and close friend of mine and he bought a few things of mine over the years. I had these frames made for those paintings. Most people, I think, took them off. The big painting that Dorothy [Walker] had, the very early landscape one that was in this retrospective in the Hugh Lane,[30] had a very smart gold frame, which I bought in a junk shop. It was in my first exhibition in 1944. It was an 1830s frame. Dorothy decided she didn't like it.

I introduced Gerald to the Pearces. He was from Dublin. He lived in his mother's family home. It's where Alexandra College is now. It was a farm. He lived with his mother and a maiden aunt, who was a Henshaw. They were builders' providers. He was exceptionally good at everything he did. His writing was good. Every letter I've had from him I've kept. He was a theatre designer. He was a very good actor. He came back at the beginning of the war from London, where he was working as a theatre designer. He was a friend of Carl Bonn's and they both went

to work with Lord Longford [in the Gate]. They revolutionised the company. The productions and the designs were top. It's amazing how little has survived. I think Lana [Pringle] has Carl's designs for *The Tempest*.

 Gerald went to Belfast and was acting in the Belfast rep. company. I suggested he should go down and see the Pearces. He got friendly, particularly with Lucy. He'd done pottery at school. He worked as a potter in his cousin's pottery near Bath. He wanted to try it again and he went down [to Shanagarry] to play at it. They realised how good he was.

VR: *Did he make his own pieces?*

PS: No, it was all Shanagarry. They had a fellow before that, Max Halliday, he was very good too. He made some cups and saucers and I decided they were so good I bought them.

 I worked on the house with Philip. I designed all the details like the way of treating the old front door and later did a little bit for them when they lived in Ballymaloe. Philip was a partner in the Ballymaloe farm, for a while.

VR: *Did Francis Bacon come to Dublin when his work was shown in Living Art or in Dublin generally?*

PS: No, I don't remember him coming over. He never seemed to have any interest in being in Dublin. When James White was planning a book on Irish painters, he sent a note to Bacon asking him would he like to be included. Bacon sent back a note saying certainly not.

VR: *If you look at the big Evie Hone exhibition at UCD in summer 1958, which followed the smaller IELA showing of her work the year she died, and Sweeney's role in IELA 1963, four years before the first Rosc, could you regard Living Art as a kindergarten for bigger exhibitions?*

PS: I hadn't thought of it that way. The Evie Hone retrospective in Earlsfort Terrace was the first big exhibition here in Dublin, in my memory. I had to take de Valera around it and go through all the glass with him. He was practically blind. James White organised a book for members of the committee; for Fr Donal,

Michael Scott, Stella Frost, a good friend of Evie's, and Judy Boland. Cearbhall Ó Dálaigh was chair. We had a dark pavilion for the stained glass. I designed it. I had a spotlight coming down from the middle, on Oisín Kelly's sculpture of Evie's head.

It was quite an expensive thing to do the pavilion; it had a lot of construction. Judy Boland organised the finances. She was in a good position; she had been in London[31] as the wife of Freddie Boland, the ambassador. Fr O'Sullivan was a great supporter of Evie's. Michael Scott was on the Cultural Relations Committee.

VR: *There is the story that one of his employees said to Michael Scott, 'I can't even afford an overcoat I'm paid so little' and Michael said, 'There's one over there, someone left it behind'.*

PS: That was William O'Dwyer. He was married and had children and was really finding it very hard. I didn't get a living wage but I had two rooms at seven and six a week in Leinster Street.

VR: *R.R. Figgis, the collector whom we've spoken about already, moved from one official IELA position to another – from being a guarantor to committee member.*

PS: Bobs was also on the Friends of the National Collections. He went to Paris and bought the Bonnards, one for himself and one for the Friends. He had a house in Shankill. He was a great friend of Norah's. She was a very good friend of mine. I went on several holidays with her.

In 1960 Norah asked me and Shelagh Richards to join her, sharing a small house in Leirici. It was a wonderful arrangement, two houses joined by a long terrace. We were in one and in the other was the family who looked after us and brought us delicious food. It was a woodland setting, with a path down to a lovely sandy cove, for our use only. That was the year I represented Ireland at the *Venice Biennale*. Norah and I went on to the opening in Venice and had great fun partying for four days. That was when I met Annely Juda, who became my London dealer.

Later I went to France with Norah, Lucy Pearce and Shelagh. Kay Gimpel of Gimpel Fils gave us a loan of their magnificent

house in Menerbes, a wonderful hill village in Provence. It had been a presbytery. We had the use of their car, which enabled us to explore other villages and make a trip to Camargue.

VR: *What about Norah's husband?*

PS: Geoffrey Phibbs, he was a poet but he wrote under another name, Geoffrey Taylor. The marriage didn't last very long. He had disappeared with another woman before I met Norah.

VR: *Success came before you were 40; in 1958 you represented Ireland at the Guggenheim[32] exhibition in New York and MoMA bought* Woman Carrying Grasses, *their only purchase from the 115 paintings shown.[33] In 1960 you were there again and won the National Award,[34] as well as representing Ireland in Venice, which Norah had done in 1950.*

PS: The little painting *Woman Carrying Grasses*, which MoMA bought in 1958, was hanging in the Dawson Gallery for a long time. Theodora FitzGibbon [the cookery writer] was saving up to buy it. It was only about £30. She was outraged when she heard Alfred Barr had found it in the store room at the Guggenheim, when I got it for the *Biennale*. When I tried to borrow *Woman Carrying Grasses* for this Retrospective [2002], they said it had been damaged. Years ago I went in and got a transparency of it. I tried to get one again.

VR: *Did it help or hinder that you were part of the chosen few?*

PS: That would have helped to heap the criticism. It would have turned me into a sort of teacher's pet.

I was surprised to be chosen for the *Venice Biennale*. Michael Scott was one of the ones who was pushing for me. I was also working for him, so I said, 'I can't get any work done for the *Biennale* while I'm working for you'. He very kindly said, 'You can just use the front room'. I was keeping my eye on some of the jobs. I'd been there so long I knew the ins and outs. I was the longest person who worked for him. He didn't want me to leave. He was paying me so little I hardly knew I was being paid. I never asked for a raise, I was very vague about money. In 1959 he decided he was going to put the office into a partnership –

Ronnie Tallon, Michael Scott, Robin Walker and me. We had to go through the accounts. We found that year that Michael Scott's bill for Jammet's was £9,000. I was being paid £1,000 a year. He went to the Russell [Hotel on St Stephen's Green] as well. We had an actual occasion when we had no actual money in the bank so we had to wait to be paid double the next time. The lady who used to do the accounts said, 'I've learnt to walk past the manager with my knees bent'. Michael was very generous to his friends and was always going to lunch. Some would-be art critic was regularly spying when Michael and Fr Donal went into the Russell.

The prize money [for the Guggenheim National Award] was $1,000; that was £365. That's how I bought this place. It just happened to be £365. I bought the studio next door a few years later.

James White was the commissioner in Venice. When we arrived the exhibition had been hung. I had a whole room to myself. The hanging was terrible. I took the whole lot down and re-did it myself. I was dragging ladders around, stripped to my t-shirt, sweating in the heat. Brancusi was in the next room.

VR: *Did you like your exhibition in the end?*

PS: I think I was too pressurised. The [eighteen] paintings were all right. I was building a water tank for my house in the mountains and I used one for the top of the water tank. I've recently destroyed about twenty things, old things I wasn't satisfied with. I got someone to help me and we had a 'yes,' 'no' and 'maybe' pile.

I suppose Venice meant a lot. The flag was flying for me. The Irish Ambassador didn't turn up to introduce me to the president of Italy, who went around every single exhibition and was introduced to every artist. James White introduced me.

VR: *Like Norah McGuinness and Anne Yeats, you did quite a bit of theatre work. How come you did the sets for Synge's* Playboy of The Western World *in Teatro La Fenice in Venice in 1960?*

PS: It was just chance *The Playboy* happened to be there the same year as I was in the *Biennale*. I was back in Venice in October.

I had to adapt the set, which was made for the Gaiety for the Dublin Theatre Festival. I had to go to Berlin before that and adapt the set for a smaller stage.

Siobhán McKenna and Pat Scott on Sutton Strand.

I gave the *Playboy* designs to Siobhán McKenna. I didn't make a proper model for it. That was the last time she played Peigín.

I would only do one set design every ten years. I always got a prize for the best set from the *Evening Herald*! I have a battered model for the set I did for *The Plough and the Stars* in the Abbey.

VR: *After Venice you started having one-man shows with Leo Smith in the Dawson Gallery and showed with Taylor Galleries after he died.*

PS: I'd known Leo Smith for years. I never got on with Waddington. I brought in paintings to be framed. They were oils and they weren't dry. His framers put them together, so you had the imprint of one on the other. Waddington always had a step in the front of his gallery, so that he could step up and look down on you. 'I'd be glad if you never came back here,' he said to me, 'you simply don't know how to paint.' He approached me later on to show paintings and I did show with him [in 1953]. I used to call to see him in London.

Leo Smith was so decent to his artists. He was wonderful. He always paid them immediately he was paid. I know some paintings he sold were never paid for. He gave people twenty

years to pay. He lived in a flat in Camden Street. No one was ever in it, or in his house. He wouldn't let you even stop outside the door – you had to go to the end of the road. He had his sister in floods of tears quite often. He had Norah in floods too. But he really had a heart of gold. He was such fun. He loved watching people go by and telling stories about them. One year I was there one January day – I used to pop in and see him quite often. As I was leaving I said 'it's my birthday today Leo' [24 January] He came over and stuffed something into my top pocket. When I got home and counted it, it was £1,000. He'd like to take you out to a good meal. The day he died [in April 1977] we had lunch in the Hibernian. I had oysters. We went up to Hilary Heron's funeral in my car. She'd got some awful disease and had been in Patrick Dunn's hospital.

VR: *John Huston opened your first exhibition with Leo Smith.*

PS: Leo had to get someone out on the street to stop people coming in. You know the story that Leo suddenly got into a panic and made everyone stand with their back to the wall; at an auction in Ennis earlier in the week a floor had collapsed. I had been doing up John Huston's house ['St Cleran's', near Loughrea] in the West in 1958 or 1959. We were spending millions. When the bill came to a million we were told to stop. Then the guys from Hollywood came and said 'go ahead' with the control room for heating, every room wired for sound, screens carved to cover the technology, and the Japanese bath – big enough to hold four people. Each seat was tiled. The hot water was running over rocks. We got all our tatami mats and screens from Japan. We got acres of tiles from Mexico and all over. I was very friendly with Ricky, his ex-wife. She had plenty of ideas, so it was a pleasure to work with her. She was extremely beautiful, like a very beautiful version of Angelica. Angelica and Tony were kids. Tony wrote the script for the film of *The Dead*. As a kid he was interested in falconry.

VR: *It's interesting that James Johnson Sweeney, who used to holiday in the west of Ireland too, selected so many top names in*

contemporary American painting for the 1963 IELA *exhibition.*[35]

PS: I'm sure Morris Graves would have come into that. [Mark] Tobey was a great friend of Morris Graves'. I saw Tobey's work in his house. I remember Morris going to New York the year Jasper Johns and Rauschenberg appeared and coming back and saying he was no longer in vogue. Tobey and himself are, of course, regarded as top American artists.

Abstract Expressionism overwhelmed everyone. Morris stopped painting for a while, he did those strange sculptures. They were like astronomical machines, shiny glass and steel. I think he did ultimately have a show of them. He used to show in New York. He had a retrospective that toured around when he was nearly 90.

He came here in the fifties. He lived in Skibbereen for a couple of years before he came to Dublin. He'd been quite successful in America and was fairly well off. He built a magnificent house in the forests near Seattle. Boeing were producing supersonic aircraft for armies around the world. They were testing them there. So he heard these terrible noises as aeroplanes were breaking the speed barrier. There's one of his works in the Municipal Gallery – *Spring and Machine Age Noise*. He painted lovely spring flowers and then he took a yard brush, dipped it in paint and dragged it along the surface. From Skibbereen he went off to Japan for a year and came straight back to Dublin. That's how I met him; he came into Michael Scott's to ask about rebuilding Castlefreke.

He found a house in the mountains, a small Georgian house. It was derelict. It had been used as a brick factory. With my help he restored it and it turned out very well. I can't remember how long Morris stayed in Woodtown Manor, but he made it into a splendid house. He bought some really beautiful eighteenth-century Irish furniture. Some of it had come from Russborough. He really had a talent for making his surroundings special. He also made a wonderful garden. He sold it to Gareth Browne, who I think sold it on.

Nick Nicholls bought a house near Sallygap and then he went back to England. I was caretaking it. When he was selling it, I couldn't raise the £250. That price included 40 acres, and turbary and grazing rights. That was 1947. Caroline Scally bought it.

VR: *Tell me about your own involvement in* Rosc '67.

PS: As everyone knows, Michael Scott was chairman of *Rosc* and he and James Johnson Sweeney planned the format for the exhibition. I had been Michael's chief assistant, so he asked me to be involved. I had retired from architecture at that time. When searching for a location, the RDS seemed the best option, because the big halls were then only used twice a year, for the Spring Show in May and the Horse Show in August.

Some of the trade stands in the main hall were permanent, but had to be removed. The existing lights had to be taken down and a new fluorescent lighting system had to be installed. White muslin was stitched between the trusses, and the surrounding white walls were cotton, hung proud of the balconies. Sweeney had experimented in Houston, Texas with what he called piggy back hanging, i.e. hanging the paintings free of the walls, a large painting with a smaller one on its back. We developed that idea, hanging screens on nylon, and fixing a painting on either side of it. It worked very well. It got great press. I remember *The Observer* said 'this would make London gasp'. The *New Yorker* art critic gives me a great boost in that film RTÉ made about *Rosc '67*. The thing about the RDS was the time limit. We only had a fortnight to transform the place. I got all that side done by a firm called Modern Display Artists. I'd worked with them before in the RDS. I knew they'd be the only ones who could do it. They had no union problems; anyone could pick up a hammer and use it.

Rosc '67 was where I cut my teeth. I designed the cover for the catalogue [and for the next three *Rosc* covers].

VR: *Did people admire your versatility?*

PS: 'You're just a commercial artist,' they used to say if I did any design work.

Carroll's commissioned me to do big versions of the *Rosc* covers, some in oil, some in tempera. Ronnie Tallon was doing Carroll's. That was after I left. I was commissioned to do various things. I did a tapestry for the part of the buildings where they made the cigarettes. It had to be designed so that it wouldn't be destroyed by dust. It was kind of beige. I had it woven by Lenora Fowler. I don't know what happened to the Carroll collection, about to be handed to IMMA, I hear? The old Carroll's building in Dundalk was supposed to be turned into a museum.

Don Carroll was chair of Bank of Ireland when Ronnie was making the collection.[36] I had the commission to do the tapestries. They put a mezzanine floor in the Bank of Ireland and left *Blaze* [1972], my tapestry, on a stone floor. It got soaked in water and it rotted. They got a price for having it remade. I burnt the cartoons years ago but they could have made it from what was left of the original. I was in negotiation with a weaver in Wexford to do it, but it all dried up. Dorothy was always at me to keep at them. They were going to present it to IMMA. The tax saving would pay for making the new one. But I don't think there is anywhere high enough in IMMA to hang it. When I was having my exhibition in the Douglas Hyde [in 1981] it was too tall but we managed to fit it in, it's about 21 feet. Hugh Lane, the Municipal, were thinking of trying to get it but they wouldn't have anywhere high enough to hang it. The Bank refused to apply for insurance. It was just negligent. They damaged one of my big gold paintings. I managed to clean it up, and they gave it to IMMA under the tax concessions. They had Robert Ballagh's on the wall and filing cabinets were pushed against them.

VR: *Like sculptor Oisín Kelly who, incidentally was also involved with the preparations for the Pope's Mass in Phoenix Park, you had a long involvement with Kilkenny Design Workshops.*

PS: A few years after Kilkenny Design started I went on the board [in 1969].

Bill Walsh was an extraordinary man. Kilkenny Design was a semi-state body but it was the only one I've come across

where the board were not political appointees. They were appointed by Bill Walsh, at least in the early years. I was on the board for eighteen years and I think the government changed three times. I had to practically shoot myself to get off it.

It was done in some style. We were wined and dined. We stayed in the New Park Hotel and then later in Butler House.

I was the one on the board who had a special liaison with the designers. We had a standards advisory board. We met not more than three times a year. They had famous designers from around the world on it. Of the original Scandinavian design group[37] [in 1961] Ake Huldt was the one who remained on the board.

VR: *Wasn't it Bill Walsh who selected Irish products for the Irish Design Exhibition in 1956, before* Córas Trachtála Teoranta *[The Irish Export Board] had taken over official responsibility for design from the Arts Council?*

PS: Bill Walsh resigned as chairman of CTT and devoted all his time to Kilkenny.

VR: *He was the one who invited the panel of five Scandinavian designers[38] to Ireland in 1961, when he was still in CTT?*

PS: Yes. At one of the public meetings in the RDS they were asking people to produce things that were designed and they would comment on them. There was a young Dane, Erik Sorensen, on the panel. There were Germans in Waterford glass, Hans Wincklemann was one of them. He gave Sorensen a glass of cut Waterford crystal. Someone in the audience shouted up, 'What would you do with that?' He said, 'This is what I would do', and he just dropped it. The Scandinavian report [*Design in Ireland* (1962)] sparked off Kilkenny Design.[39]

I remember the exhibition in the Hugh Lane, Tradition and Modern Japanese Production [in 1963]. It was chosen by one of the panel, Gunnar Petersen. He was sent by CTT to Japan to select objects that were individual and traditional. There were beautiful objects in it.

Kilkenny Design achieved an awful lot, I think. It was obvious that what we needed more than anything was some

place where you could train designers. That was the big thing. There were no designers in Ireland.

VR: *Were the government good about money for Kilkenny Design?*

PS: They were very mean. That's one of the reasons why the shops were started. They decided that Kilkenny Design had to pay for itself. That was not part of the original idea. In the early years things that were made were put on show. People could buy them. They were done as prototypes. Quite a lot were one offs.

When the shops started I was the one who was given the job of checking all the goods in the Dublin shop [which opened in Nassau Street in 1976]. I threw out an awful lot of things – things that weren't of a high enough standard of design or craft. The manufacturers could ask Kilkenny to design a new range for them. But they didn't usually do that, they usually went off in a huff.

VR: *What about Signa, the design consultancy company in Dublin and London? You'd been designing with them since 1953.*

PS: Signa was founded by Louis [le Brocquy] and Michael Scott. Louis designed the logo for KDW. Signa was based on Magnum Photo Agency [founded in 1947]. They had a stable of photographers. They were an agency. They recommended photographers. We didn't employ designers. We had a stable of designers and we recommended them. Dorothy was the manager. It was based on the need for designers. They were rarer than hen's teeth.

The way it was supposed to work in Ireland was that Kilkenny Design would supply international designers to industry and provide them free of charge, with the proviso that they would have to pay royalties on designs that made money. Various industries that took up on that were always trying to get out of paying royalties.

VR: *What products do you remember?*

PS: Oisín Kelly designed lots of printed linen. Kilkenny Design had their own silk-screen printing table at first. All the printing was finally done by some firm in Belfast. We tried to use native materials. There was a place in Youghal we did cotton printing for.

Various people designed furniture. There was a series done

by a German architect, Gustav Sauter, who lived in Killarney. It was good and it was all manufactured here.

There was a silversmith who did good work, called Byrne. Rudolph Heltzel came to Kilkenny from Germany.

There was a pottery firm in Kilrush called Celtic Ceramics, who had designs done [by Jim Kirkwood] in KDW.

VR: *Let's talk about your own designs for them.*

PS: Kilkenny got a franchise in one of the big shops on Fifth Avenue, Altman's. Kilkenny had almost a full floor there. The shop had an Irish connection, I think the president or his wife were Irish. They were very keen on buying Irish things. They were trying to get a few special things for Fifth Avenue. They asked me to do a few scarves, which I did [in 1969] but the American woman who commissioned them through Kilkenny did not want them. She said they were the wrong size or something. In fact, I made them the exact same size as Hermès scarves. I made them in Kilkenny. They were quite simple to do. It was one scarf in three or four colours. There was one screen and I chose different coloured silks to print them on. There was a very good silk-screen studio in Kilkenny, with a great long table that was later sold. They did all Oisín Kelly's tea towels with the Irish proverbs there.

Altman's was across the road from Lord and Taylor. The vice president of Lord and Taylor was a friend of mine, Sarah Lee. She was a fine lady. I probably met her through CTT. I was designing things for them when they were doing the Shannon shop. Kay Petersen was in charge of that.

VR: *Tell me about your* Rainbow *rugs, an edition of twenty.*

PS: They weren't very expensive [in 1979]. They weren't for sale off the wall. The arrangement was that I designed them for Kilkenny. They had the expense of getting them made up. They kept a sample, one of each, in the shops. They would order them to be made up for customers by V'soske Joyce. Quite a lot were made.

The reason V'soske were in Galway was that they were going around the world looking for cheap labour. They got an old building in Moycullen and set up there. The Joyces were in

at the start [in 1957]. He was the famous rugby star. His widow went on working there for a while. The husband moved the main production to Puerto Rico – the Puerto Rican girlfriend was around at the time. Vesta, his wife, was a great old warrior. They always had

Patrick Scott and Tim O'Driscoll in front of Patrick's tapestry for Bord Fáilte in Paris, c. 1965.

an enormous range of colours. I used to go up and down the wool stalls. The wool was in great skeins and you could pull it out, and pick. It's easier to do it with the actual wool than on paper.

Kilkenny [Design] didn't last much longer after that. The thing that finished Kilkenny [in 1988] was the London shop, which we were forced into [in 1986] by the government, because they were embarrassed by the fact that they had got this place in Bond Street. Donald Davies leased it for a while and he wanted to sell the lease. Roderick Murphy did a survey of what you could sell in Bond Street. You could sell shoes. It was the wrong place. We didn't have anyone designing shoes. We had maybe one pair in the shop.

VR: *When did Margaret Downes have come onto the board?*

PS: She came on just before Bill Walsh retired [in 1976]. We were under the Minister for Industry and Commerce [from 1974]. Justin Keating was minister when Bill decided to resign as CEO and remain as chairman. Jim King was appointed as new CEO and Justin Keating decided that Jim King, who had been next in line to Bill for four or five years, would find it difficult to have

Bill as chairman. So he decided to make Basil Goulding chairman [in 1977]. Bill came to the first meeting, he was especially asked to stay on as board member. He never came again.

I had been trying to get an archive going. When it was finally agreed that we were going to do an archive, the plan was that we would be given a room in the Castle. The idea was that Bill would look after it when he retired. He had his pad in Kilkenny, but the fact that he was in such a huff after Justin Keating asking him to step down as chair meant that the archive never really got going. We were wrapping items and putting them in a store room, which was acting as the archive room and then everything got robbed out of that.

Kilkenny Design would never have happened without Bill. He was tough, you know. The fact that he insisted he was the one to appoint to the board was extraordinary. Towards the end it was political.

VR: *Who was on it with you?*

PS: Stanley Mosse, Louis, John K. Keane, Pat Hickey and others. [In 1981] Margaret Downes ended up as chair. She actually managed the end of it very well. It could have been awful aggravation with the government.

Basil Goulding had a great sense of humour. He had a business alphabet. He called it alpha basil. When I did my second V'soske rug, for Paris, he wrote me a long letter about how to say it in wool.

Basil hung his paintings in the workshops and in Butler House. Some were stolen almost immediately. When he died [in 1982] Valerie said, 'You can have them' to Kilkenny, but they said 'We must pay something'. So Leo Smith's insurance valuation, which was then about half or quarter of what they were worth, was agreed. Valerie did not have much money, so she sold the Yeats', *My Beautiful, My Beautiful* – the one of the man saying goodbye to his steed. Tim did a copy of it for her. His copy is fantastic. I think he did it upside down.

When Tim O'Driscoll was head of CTT, I did the logo. Bill

Walsh was one of the juniors then. Tim went off to Holland or somewhere as an ambassador. It was great when Tim was head of the Tourist Board. We did lots of promotional things – promotional literature done with a bit of style.

The one printer I always tried to use was Hely's in East Wall Road. The managing director was George Hetherington. He did more for the improvement of printing standards than anyone else in Ireland.

When J.F. Kennedy came here [in 1963] and did his speech to the joint houses of the Oireachtas, there was a presentation copy of his speech. George Hetherington was doing it and he asked me to do the binding. We did a pre-run and George gave it to me before he died. He was a great man, completely ignored.

VR: *Had Pat Hickey, printmaker, on the Kilkenny Design board with you, worked in Michael Scott's?*

PS: He was a friend of mine since his teens. He was in the British Army after the war. He studied architecture and ended up in Michael Scott's office. He started the Graphic Studio; he did it on his own. I remember working in it [in Mount Street] in the first few weeks. We had only a few stones, they took hours to clean. They'd been thrown out as paving stones. I did one little lithograph, I did three prints. I never got involved in print making until a couple of years ago.

VR: *Rákóczi, Doreen Vanston, Patrick Pye, Nano Reid, Camille Souter and Frank Morris, Yeats, Leo Whelan, Paul Henry, Louis le Brocquy – so many artists had bases around Mount Street, Fitzwilliam Street, Leeson Street and Baggot Street. As an architect, how do you see that?*

PS: Baggot Street was known as the arts quartier. We all had flats there. Basil Rákóczi had a flat, a top flat in number 60, Fitzwilliam Square, I think. I was in Upper Baggot Street for a while. The Gilberts [Stephen and Jocelyn] were in number 25, the same house as Zette Rondel and Nick Nicholls and they were able to go and pick up orange peels from Norah's bins during the war. She was around the corner in [13] Fitzwilliam Square.

I don't know how Norah managed to have oranges during the war. The Gilberts told me they made marmalade from them. Everyone was moving to Foxrock then.

VR: *You were on the board of the National Gallery for some time.*

PS: James White brought me onto the board [in 1973]. They hadn't had an independent artist since Evie Hone, apart form the RHA artists. I was pushed off after ten years, quite rightly, by Garret FitzGerald. I think Jack Lynch might have been Taoiseach when I went on. The Gallery was directly under the Department of Education. Salaries were paid by them. No one was paid properly. Rooms were always being closed.

In Kilkenny it was simple. We did our sums and asked the government for the money and spent what we got. It was ludicrous in the Gallery. The Museum was in the same situation. They were always doing reports saying they needed to arrange their own affairs. We bought the frescoes of the apse of the little chapel [of St Pierre de Campublic]. That was a bit dubious. I don't know where it is now. The Board of Works were doing a terrible job of installing it. I suggested we make those alcoves and then put the apse at the end [in 1978].[40] Ned McGuire was chair when I went in first.

VR: *Father of Edward McGuire the artist, and employer of Norah McGuinness as window dresser for Brown Thomas?*

PS: Yes. Ned was a painter himself. It was a sort of flash in the pan. When he was middle aged he decided he could paint. He was influenced by Jack Yeats, and that's not easy.

I remember we got Margaret Clarke's painting of the woman at the beach in Laytown, with a black baby in her arms.

VR: *She was another IELA committee member from the very early days.*

PS: That's where I met her. I became very friendly with her. I think she was Crilly before she married [Harry Clarke in 1914]. Michael [Clarke, her son] might have presented it to the Gallery. It was out in his house in Killiney. I was at college with Michael. I knew Anne and David, of course. They said, 'as kids we called

it *Jesus, Mary, the child is black*. So when James brought it out to the board I remember saying, 'Jesus, Mary, the child is black.'

In conversation, Dublin 8, 21, 29 April and 1 August, 2005

1. Pope John Paul II died on 2 April 2005. He was elected in 1978 and was 84 when he died. He was associated with the solidarity movement and the fall of communism in Poland. At the time of his visit, Ireland was at a zenith of Catholicism.
2. Erskine Childers was elected president of Ireland in 1973 and died in 1974.
3. Sarah McCloskey at Whyte's confirmed that *Cross (Polyptch) 1973* was sold there on 18 February 2003.
4. Charles Merrill, photographer and artist, edited and wrote for *The Arts In Ireland*, which was published from 1972-1975. In vol. 3 no. 2 1975 he wrote on Andy Warhol and Edna O'Brien. He took the photograph of Pat Scott which was on the invitation to the artist's exhibition at the Dawson Gallery, 28 November-7 December 1974.
5. Henry McIlhenny, who had been curator of decorative arts at Philadelphia Museum of Art, bequeathed his collection, which included an Ingres portrait of Comtesse de Tournan and a Renoir portrait of Melle Legrand, to the Philadelphia Museum in 1986. In 1975 the lands of Glenveagh were purchased from him by the State. He gave his castle and estate, 'Glenveagh', to Ireland in 1983. From 1937 until 1983 he stayed for several months there each year. The English painter Derek Hill gave his house and contents to Ireland in 1981.
6. *Golden Boy*, Mermaid Films 2003, director Sé Merry Doyle.
7. In the Hugh Lane, Dublin City Gallery catalogue *Patrick Scott a retrospective*, Dublin 2002, see Kennedy, C., 'An Intellectual nature: Patrick Scott's tapestries, screens and tables for meditation', pp 89-95.
8. Ibid. See Scott, Y., 'From the Ridiculous to the Sublime' pp. 33-55.
9. Ruane. M., *Ireland Today*, Bulletin of the Department of Foreign Affairs no. 980, September 1981, pp 1-6.
10. The 1993 St Columba's College 150th Anniversary Exhibition of Paintings, Sculpture and Works of Art by former pupils and teachers included work by pupils W.J. Leech, David Hone, Pat Scott, Robin Walker, Patrick Pye, Michael Warren and Brett McEntaggert and teachers Oisín Kelly and Brian Boydell.
11. Schreibman, S., 'MacGreevy and Yeats', *Irish Arts Review*, Spring 2005, pp. 96-99.
12. IMMA *The White Stag Group*, Dublin, 2005, p. 27.
13. Ibid. p. 46. See also Arnold, B., *Jack Yeats*, New Haven and London, 1998,

pp. 291 and 397, where Arnold points out that she was born in Tyrells pass, County Westmeath in 1897, educated in France, married in 1920 (T.H. Hinkson) and died in 1970.

14. Muriel Gahan (1897-1995) was an advocate of rural Irish craft. She founded The Country Shop (1930-1978) on 23 St Stephen's Green, Dublin. Here craft workers could sell their products in a café/restaurant setting. Artists like Gerald Dillon and Mainie Jellett showed there. She was the only woman member of the first Arts Council. In 1960 an Taoiseach Seán Lemass transferred responsibility for design from the Arts Council's remit to *Córas Tráchtála Teo.* See Mitchell, G., *The Life and Work of Muriel Gahan*, Dublin, 1997.

15. IMMA *The White Stag Group*, p. 36.

16. Walker, D. *Michael Scott architect in (casual) conversation with Dorothy Walker*, Kinsale, 1995.

17. IMMA *The White Stag Group*, Dublin, 2005, cat. no. 78.

18. Cusack, R., *Cadenza*, London, 1958.

19. In *Patrick Scott a retrospective*, Dublin, 2002, see Ryan, R., 'Design as Communication, Pleasure, Knowledge', pp. 103-109.

20. See 'Gladys Maccabe, A Lifetime of Art The Retrospective', pp. 92-99. *The Irish Figurists and Figurative painting in Irish Art* The George Gallery, 128 Lower Baggot St. Dublin, 1989.

21. IMMA *The White Stag Group*, cat. no. 55.

22. Curran, C., *Dublin Decorative Plasterwork in the Seventeenth and Eighteenth Centuries*, London, 1967.

23. Curran, E., 'Jack B. Yeats: Painter', *Cosmopolitan*, Edinburgh, November 1936 pp. 13-15 and 'The Art of Nano Reid', *The Bell*, November 1941, are two examples of her publications.

24. In *The Irish Times*, 14 August 1963, D.F. wrote 'Patrick Scott is another question mark ... he is still in quest of a style. This year he pays homage to Mark Rothko, to the Americans. These stylistic changes are a sacrifice to the all devouring god of fashion'.

25. O'Brien E., and Dickon, H., 'Nevill Johnson's Dublin', *Irish Arts Review*, Winter, 2002, pp. 68-75.

26. Johnson, N., *The People's City, The Photographs of Nevill Johnson 1952-53*, Dublin, 1981.

27. See Kennedy, B.P., *Dreams and Responsibilities: The State and the Arts in Independent Ireland*, Dublin, 1990.

28. Patrick J. Little (1884-1963) director of the Arts Council from 1951 to 1956, had been a Fianna Fáil minister for Posts and Telegraphs, 1939-48. He had

been to university and had published some poetry. In 1994 Iona and Catríona McLeod gave Yeat's *June Night* (1929) on permanent loan to the National Gallery in memory of their stepfather, Patrick J. Little.

29. Bailey, C. 'The Arts Councils', *Circa* no. 59, Sept/Oct 1991, pp. 40-41.
30. Cat. no 1, *Patrick Scott a retrospective,* 2002.
31. The Hone exhibition was shown in London at the Arts Council Gallery and Tate, from 2 January-3 February 1959.
32. At the Guggenheim International Award in 1958, the other Irish artists were Patrick Collins, who won the National Prize for Ireland, and Louis le Brocquy, Gerard Dillon and Norah McGuinness.
33. Walker, D., *Patrick Scott,* Dublin, 1981 p. 37.
34. In 1960 the other artists from Ireland at the Guggenheim International Award were Nano Reid, Dan O'Neill, Richard Kingston and Louis le Brocquy.
35. Artists who showed at IELA in 1963 included Gottlieb, de Kooning, Rothko, Motherwell, Tobey, Rauschenberg, and O'Keefe.
36. *On Reflection Modern Irish Art 1960s-1990s: A Selection from the Bank of Ireland Art Collection* accompanied the exhibition at the Crawford Municipal Gallery, 6 August-1 October 2005.
37. Caffrey, P., 'The Scandinavian Ideal, A Model for Design in Ireland', *Scandinavian Journal of Design History 8,* 1998, pp. 32-43.
38. 'No professional fees were accepted by members of the group on the grounds that they wished the assessment to be regarded as a contribution to the furtherance of design and as a gesture towards the undertaking.' Quoted from *Design in Ireland* (1962) in Hickey, T., 'The Kilkenny Design Workshops', *The Arts in Ireland* vol. 1 no. 3, 1973, p. 35.
39. Quinn, J., *Designing Ireland: A retrospective exhibition of Kilkenny Design Workshops 1963-1988,* catalogue for the Crafts Council of Ireland exhibition, 21 Lavitt's Quay, Cork, 8 November-14 December 2005 and the National Craft Centre, Kilkenny, 4 February-2 April 2006.
40. Somerville-Large, P., *1854-2004, The Story of the National Gallery of Ireland,* p. 393. What were thought to be twelfth- or thirteenth-century frescoes turned out to be forgeries. Other museums, including the Kimball Art Museum in Texas, had purchased similar works from the same Swiss dealer who sold them to the National Gallery of Ireland.

James O'Connor (left) and John Taylor (right) in Taylor Galleries,
34 Kildare Street, Dublin.

John Taylor

*John Taylor was born in Dublin in 1948. He was educated in de la Salle
College in Churchtown, Dublin. He started working in the Dawson Gallery
in 1964. In 1978 he opened Taylor Galleries. He is married to Mary Preece
and they have three children.*

VR: *When did your interest in art begin?*

JT: It began when I went for an interview at the Dawson Gallery in
1964. There was a Richard O'Neill exhibition on. It was the lay-
out of the Gallery that attracted me first.

VR: *What did it look like?*

JT: After climbing a fairly standard Georgian staircase to the first
floor and entering the most tasteful two rooms I had seen; it was
just like a little oasis. The walls were painted white, with beige

carpet, and natural linen screens. In both rooms the electric lighting came from five cream pleated round lamp shades hanging from two pieces of plain wood, cross shaped, and a series of spot lights (the spots were not part of the original design, they were added because some artists wanted them). The furniture was very sparse. The back room had a large linen screen, 10 x 6 feet, with a pale mahogany chest of drawers, 2 x 6 feet, against it and a square stool. The front room had two petite metal chairs with blue leather seats and backs. It was a perfect setting to show contemporary art.

VR: *When was The Dawson Gallery fitted out like that?*

JT: It was designed by Patrick Scott, I think, around 1961, just after he stopped practising as an architect in Michael Scott's (no relation) office.

VR: *You later set up on your own beside Leo Smith's famous Dawson Gallery.*

JT: Yes, the landlords of 4 Dawson Street were an insurance company who occupied the basement and ground floor. They had been trying for years to buy Leo out. He did consider it and very nearly bought a building in Hume Street, but decided against it because of the huge amount of stock that had to be handled and the risk of damage or loss. And as Leo's relations had no involvement in the day-to-day running of the Gallery, they accepted the landlord's offer after he died. I think it was the right thing to do; it was the end of an era. It had been Leo's world since 1944, after he split with Victor Waddington.

At the same time as it was closing, similar rooms over three floors in 6 Dawson Street, just two doors away, were on the market to let. We engaged the architects de Blacam & Meagher to design the interior. My only request was that they have a door / screen dividing the two main rooms, similar to the Dawson. It was closer to what preceded it than what came next. 34 Kildare Street is a small building and not very suitable for a gallery. The architect Ross Cahill-O'Brien did a great job in transforming it, visitors loved it. Then up the road in 16 Kildare

Street we wanted to keep it simple, using its own wood floors and painting the walls white. We asked Ross to design a modern chandelier to give even light. Artists can spend all day trying to get spots right.

VR: *You've always been in galleries which had lovely natural light from the big windows.*

JT: Yes; Georgian buildings, like this one [16 Kildare Street].

VR: *And the Oliver Dowling Gallery just down the street in number 19 Kildare Street but it closed before you came here. Did the Dawson Gallery occupy three floors?*

JT: Only for a short while before it closed. There was an electrolysis clinic on the second floor run by a Miss Read. She worked alone and didn't have use for the back room. She allowed us to use it for storage and when she retired we got the front room as well.

VR: *When did you open?*

JT: We opened in 1978. The Dawson closed near the end of 1977. Leo died in April that year. He was on his way back from Hilary Heron's funeral. Patrick Scott was driving when he slumped forward. Pat pulled off the busy road and hailed a passing car for help. One of the two passengers, a young woman, was trained in resuscitation. They lifted Leo from the car and she tried for about fifteen minutes to revive him. Pat had called for an ambulance. When it arrived he told the driver that Leo had only just been discharged from the Mater Hospital; however, St Vincent's was the hospital on call. He was pronounced dead on arrival there.

VR: *What age was he?*

JT: He was 67.

VR: *Tell me about establishing your own business.*

JT: Taylor Galleries was in number 6 Dawson Street for twelve years. We moved then.

VR: *Why?*

JT: Our first rent was £7,000 per annum. After our first term the suggested increase was to £18,000. James Adam & Sons

negotiated on our behalf, and it was brought back then to
£15,500. With rates and insurance to take in, you'd add on
another £10,000. Not over-priced for a basement and six rooms
over the ground floor in that location, but we thought if the
next increase was similar we would be swimming against the
tide. It turned out to be a blessing in disguise. We started to look
for suitable premises. We were always losing buildings. I very
nearly got one I had viewed on Baggot Street, one I liked, and
on a Friday afternoon I plucked up the courage and rang to say,
'I'll take that'. But the auctioneer said 'that's not how you do
business'. The following Sunday I was going down to see Tony
O'Malley in Kilkenny and I was telling him about it. He told me
how much he liked Baggot Street and had fond memories of it.
But the only thing he would be concerned about was that when
foreigners were coming to Dublin, they would look at the map
and think a gallery being that far out from the centre must be a
secondary one. I didn't ring the auctioneers back, and they did-
n't ring me.

A short while after that a house in Duke Street came up for
sale as an investment property and we bought it – a nice build-
ing with a beautiful shop window and on a very good street for
a gallery. But when the guy on the ground floor gave on his
lease to someone else, we had to
start looking around again. One
day, on my way to Adam's on
[26] St Stephen's Green I took a
different route. 34 Kildare Street,
a small Georgian building with a
shop window that had been
added later, was for sale. We sold
10 Duke Street and bought it. Six
years later, 16 Kildare Street, a
building I had admired for years,
came on the market. We had very
little work to do on this place. The

Leo Smith in the Dawson Gallery,
4 Dawson Street, Dublin, 1975.
Photo by Derek Hill.

previous owner, the antique dealer, Ronnie McDonnell, had painstakingly restored it, including the rebuilding of the façade in 1968. There was a magnificent pink and blue marble fireplace just inside the front door. It must have been 5 x 7 feet wide, too big for the room. It would have been awfully difficult to mount exhibitions around it. As it turned out it was part of Ronnie McDonnell's stock and not included in the price.

VR: *Shop windows seem to be important to you.*

JT: People were forever telling stories of the pictures they had seen in Victor Waddington's and it was nearly always the one they saw in the shop window in [8] South Anne Street. I thought it would be an ideal way of promoting art.

VR: *Tell me more about those first impressions in 1964.*

JT: I was in the Dawson for just a few weeks when an exhibition of Anne Madden's arrived from France. The colours were pale greys, purpley pinks and she used a fine sand. Anne and Louis le Brocquy were beautifully dressed. It was exciting. Things were starting to change in the '60s. Patrick Scott was always very smart,[1] whether in a suit or casuals. Micheal Farrell wore lovely blue denim suits. Nano Reid was a very frail woman with bandages on her wrists. She wore country tweed skirts, cardigans, a nice blouse, a dark brown sheepskin coat and a scarf. You could imagine her buying her scarf in the drapery shop in Drogheda. You would know she was an artist, but could never have imagined this frail lady painting with such vigour.

Exhibition openings were very special events: people dressed up. Champagne, brandy, was served. After a glass or two of that stuff, you were inclined to forget why you were saving your money. Leo's sister, May Murnane, was a great sales lady.

It was customary to introduce a buyer to the artist. I remember saying to Nano Reid, 'this collector has just bought your painting'. Nano said in a voice that sounded like a female version of Cyril Cusack: 'Did you buy that ... that's funny ... I couldn't imagine anyone buying that.' She could not have been less commercial.[2]

VR: *Surely if a person momentarily forgot about money pressures, you'd hear from them soon after?*

JT: Yes, but money held its value back then and most people paid 'on the drip', over years, and when it suited them, with no interest. The idea was to have a big number paying small amounts, rather than the opposite. But inevitably there were some cancellations.

VR: *Used you go across to the National Gallery?*

JT: After I started in the Dawson I was very much into modern art, everything else just seemed like brown-tinted paintings. Modern art was exciting, it was alive. I attended some of James White's lectures in UCD; his passion was infectious. I started visiting the National Gallery and was immediately taken by *About to Write a Letter* (1935) by Jack B. Yeats and *The Convent Garden* (c. 1912) by William J. Leech, although in a letter to Leo Smith Leech described it as a blown up watercolour, and wanted it replaced by a brooding nude painting of a negress! In correspondence, they addressed one another as 'My Dear Smith' and 'My Dear Leech'.

I got to know Tom MacGreevy from coming in and out. He was a regular visitor. He'd come in for a chat and stay ages. I think he may have been lonely. He was very encouraging.

VR: *He'd retired as director of the National Gallery, having written on and supported Yeats and given his own* Singing the Minstrel Boy *(1923) to Sligo County Library, not the Gallery, on retirement.*

JT: Yes. I enjoyed his visits, and listening to his stories about the Gallery, which would go on and on. I mean he was like a visiting lecturer.

VR: *What had you done before that?*

JT: I was working in Brown and Nolan's. Leo Smith was a regular visitor, especially to the art department. He was friendly with the two ladies who worked there – Miss Leahy and Miss Moon. On one such visit he told Miss Moon he was looking for someone to replace the young man who had been working as his assistant. She told him of this 'nice young man', and after the second interview I got the job, and was told to wear 'suit, shirt

and tie'. Leo was very complimentary on my choice of suit.

VR: *Was it a better job?*

JT: I would have been paid a little more than at Brown and Nolan's but the prospects were better. I was going to get a ten shilling rise every three months for two years, that sort of thing.

VR: *Where did you get your sense of style?*

JT: I think the best lesson I got was in 1962 when Bernard, my uncle, brought me to Canada for three months. The day after I arrived he bought me a complete new wardrobe. He helped me to pick two suits, that could, by mixing and matching, be made into four different outfits. It wasn't only the colours, the fabrics were very important as well. That was a great lesson. Toronto was amazing, beautiful houses, bright sunshine, stylish people everywhere; they even walked stylishly.

VR: *What was your first art purchase?*

JT: It was Nano Reid's *Foundry Workers*. She was my favourite. Other people found her work too muddy. The second I bought from Tom Caldwell's gallery; it was a Charles Brady[3] *Haystack*; it came in for framing and I fell for it. He was one of the two artists I wanted when I started out on my own, the other was Charles Tyrrell. I admired Charlie Brady's work for a long time.

VR: *Do you see Pat Harris as continuing that subtle still-life approach?*

JT: Campbell Bruce once said that Pat Harris' mentor was Rembrandt. He would go to the National Gallery and study the self-portrait and he was fascinated with the way the paint disintegrated coming towards the edge of Rembrandt's portrait of his mother. Pat is a talented landscape, still life and portrait artist who happens to be enjoying a very good spell of still-life painting. He studied under Charlie at the College of Art and naturally learned something from him. There may be a superficial likeness but no more than that.

VR: *Did the Dawson Gallery artists go with you from the outset?*

JT: I was very lucky; all the Dawson artists backed me from the start. I wanted to name it the Dawson Gallery. But Leo's relations were

advised the name would have the value of £15,000. I didn't have that sort of money. People were very supportive, especially Pat Scott. The quiet man of Irish art. A national treasure.

VR: *Did you see the film?*

JT: *Golden Boy?* I thought it was very good, very honest. It is great to have a film like that.

VR: *Absolutely. Who were the Dawson artists?*

JT: Louis le Brocquy, Anne Madden, Patrick Scott, Nano Reid, Norah McGuinness, Mary Swanzy, Micheal Farrell, Brian Bourke, Colin Harrison, Pauline Bewick, Seán McSweeney, Edward McGuire, Maurice Mac Gonigal, Oisín Kelly, Brian King, Patrick Hickey, Kitty Wilmer O'Brien, Camille Souter, Brian Henderson, Anne Yeats, Barbara Warren, William J. Leech, Evie Hone, Gerard Dillon, Derek Hill and Gerda Frömel. We also carried a good stock of Jack B. Yeats.[4]

VR: *Are you always collecting?*

JT: It's a bit like a drug. The third painting I bought was again a Nano Reid. After that it was Patrick Scott, then Micheal Farrell, and Brian Bourke. Quite a few of the Dawson artists were of a different generation than myself. Micheal Farrell and Brian Bourke, although ten years older than me, I found exciting. We got on well. This would have been the late '60s. I bought quite a lot at auction. I bought a Barrie Cooke painting of a Rubens-like model holding a pheasant cockerel for £35. It was at Adam's. Old James Adam stood up and said 'will anyone give me £30 for this nude study of a fat woman holding a cock?' We all laughed. It was a good painting. I bid £35 and got it. Most of the people who attended auctions back then had no interest at all in contemporary art. It was not taken seriously, but there were great bargains to be had. Now it's the opposite. Prices are good, and vendors insist on high reserves.

VR: *Used you go to the Project Arts Centre exhibitions?*

JT: Very seldom. I did go to Michael Mulcahy's show [in 1983] that had the *Navigator* painting. This is an exhibition that stands out in my memory.

VR: *Mine too. Robbie McDonald brought that show to Triskel in [5] Bridge Street in Cork. At what stage in an exhibition would you usually select a work for your own collection?*

JT: I try to be as fair as possible. I'd take something at the end of the exhibition. I did, for a short while, try to purchase from every show but it wasn't possible; I couldn't afford it, and you don't necessarily want everything, even when you think the work is good.

VR: *How do you decide what to keep in stock?*

JT: We are agents. Our storage is good, and the stock is the artist's. There's an artist's agent's association. There are six or seven of us. We used to meet regularly – Rubicon, Kerlin, Green on Red, Solomon, Kevin Kavanagh, Hallward, and ourselves. Since things have taken off over the last eight or nine years we rarely meet.

VR: *Do artists find it difficult seeing their work for sale on the secondary market?[5] They make nothing on the sale, and lose a potential purchaser of work they could have made money on.*

JT: They don't like it, but when a very high price is achieved there is greater demand for their work. Over the years, we sold paintings to collectors from around the world. I think that was very important. But with the high prices paid for Irish art at auction and with the onset of the internet age, Irish works are being bought abroad and resold here.

VR: *Although people are usually nicely supported by gallerists in making purchases, do you think there are some people who respond better to auction?*

JT: There are people who buy at auction and would never go into a gallery. If you go into a gallery and see a work for €6,000 you might think 'where did they get that price?'. But if you are at an auction and someone bidding in front of you is prepared to spend €5,500, your bid of €500 extra does not seem such a big deal. In that way, it can seem less risky to buy at auction. But at auctions you pay a premium of about fifteen per cent, making the price €6,900.

I set up an auctioneering partnership, Taylor de Veres, with

John de Vere White. That was over fifteen years ago, while still in Dawson Street. We thought by getting involved, we could bring attention to contemporary art at auction. If collectors wanted to sell a number of works by any one artist, we could advise them on when and how to sell. We could do a little work behind the scenes that might help to place the works. At that time art was selling at auction for about 66 per cent of the gallery price on average; that was bad. We wanted to close that gap. It was good for a while. In some cases that gap more than closed and I made enough money through the auctions to put a deposit on this [16 Kildare Street].

VR: *You sell paintings, drawings, sculptures – work in traditional media. How do you respond if people say painting is dead?*

JT: Some years back people were asking was the cinema dead. Look at it now. Painting is alive and will remain that way as long as we have true artists, a few museum directors who are open to it and will move with it and have the courage to defy current trends. That is not to say conceptual artists don't deserve to have a place, the better ones certainly do. I mean many directors are ignoring painting and showing more conceptual art. There was great excitement with the opening of the IMMA [in 1991]. But back then, they seemed to have very little interest in showing Irish painters. We all know how hard it is to put together a representative collection when you are depending on the secondary market or donations. But there were a few of the more established artists that earned the right to be included in that first show.

After some reception, Bill Crozier, Jim O'Driscoll, Ciarán MacGonigal and I were lamenting the fact that so many museums don't seem to have any real interest in showing what has been happening in painting. And what could be done to rectify this? We started by listing the artists from Nathanial Hone, John B. Yeats, Walter Osborne, John Lavery, Sarah Purser and William Orpen, with maybe just a token example of their work, artists whom we thought had made a significant contribution to

modern art in Ireland, and the range broadening from the '20s right up to date. The list wasn't very long: there are only a small number of true artists at any one time. We thought between us we knew enough people that might be prepared to loan works or get involved in doing something like this. And with some of the artists we represent, it would be easy to put together a museum quality exhibition.

VR: *You're doing a little independent museum?*

JT: We are hoping to get planning permission for a large room at ground and first floor levels, a sculpture garden at the second level and quite a big room in the basement. We just took down the notice yesterday. The response was very positive. I suppose it would be something between a gallery like this one, and a little independent museum or interdependent foundation. But there are a few serious hurdles like finance and planning to be sorted out first. I think there are a lot of people feeling the same about doing something.

VR: *It doesn't sound very commercial.*

JT: It's very uncommercial, certainly. We were in that mellow mood induced by good art and wine when we discussed it first. We thought the EU would back it. After all, we'd be filling a gaping void. Then a few years later my accountant rang and said 'there's ten million coming from Europe, for cultural and tourist related projects, by way of a 50 per cent grant scheme'. In a mad rush we had the architects draw up plans. The quantity surveyors priced the extension at about £500,000 and we made a submission, but didn't get anything. Without a grant, that seemed to be the end of it, but with visitors asking where they might see a representative collection of Irish art, I wasn't allowed forget this void.

VR: *Were you surprised not to get the grant?*

JT: I feel happier about it now. There's no such thing as a free lunch; I bought this building with the Foundation in mind at exactly the right time, just before the property soared. I tried to hold on to 34 [Kildare Street] as Taylor Galleries. We held on for

a while. The first morning I came in here, there was a brown envelope on the floor. It was a sizeable bill for rates. I went down to 34 and there was an identical brown envelope. I just had to sell.

VR: *Did many people ask where they could see Irish art?*

JT: It really hit home in the late '80s. I was working in an advisory capacity with GPA at the time. They were a very positive team; it was a real buzz working with them. When Maurice Foley or Tony Ryan asked you to do something, you said 'yes' and worked out the logistics later. Like one Wednesday, Tony phoned and said 'That Charlie Brady painting I admired in the Gallery, can you get it to Kennedy Airport (New York) by 4pm on Friday, and give it to a man who will be going through the airport?' We had the painting handed to that man at 4pm on Friday. Another day Tony Ryan phoned to say he had a Japanese client coming to Dublin who had an interest in the cultural history of Ireland. Where should he go to see a representative collection? This time I knew what to say, because I had been asked that very question too many times before. I don't know of any public venues that housed such a collection. Maybe this is the moment that subconsciously led me to think that I should try and help to rectify this. Like others, I was in the comfortable position of thinking it was up to someone else. We were coming towards the end of a millennium. This last century produced many fine home-grown artists. And I am the one now running a gallery whose legacy goes back through Leo Smith and Victor Waddington, and between us we have shown the development of some of the best Irish artists from Jack B. Yeats onwards. What better time to start to put this part of local history together? If we start by displaying works by the artists we represent, it would give some idea of how art developed over the years. And hopefully put a few pieces of the puzzle together. I get some hope from the encouragement I receive and knowing that every journey begins with the first step.

VR: *Do you think that people will work together in an altruistic way?*

JT: Some artists and collectors have offered to donate or loan works for thematic exhibitions; that's an encouraging start. In about 1962 there was a large Patrick Scott painting [*Large Solar Device*] that Leo

John Taylor and his daughter Jessica in Dún Laoghaire, March 1987.

was showing to Sir Basil Goulding. Basil said it should be in the Municipal Gallery. They asked nine or ten people to produce £10 or guineas – it was guineas then – to purchase it. That was the start of the CIAS. I think it's a great idea when people work together to do something to support the arts. Sir Basil Goulding was a great supporter of the arts. A lovely man, couldn't be much nicer. When he died his collection was returned for exhibition to the David Hendriks Gallery and to Dawson/Taylor Galleries, depending on where he purchased the work. We shared a catalogue, as far as I remember. There was the David Hendriks with artists on one side and ourselves on the other.

VR: *Can you tell me about opening shows in each of the three Taylor Gallery premises?*

JT: I tend to prefer to open with a group show of Gallery artists. As it happened we opened here with an exhibition of paintings by Louis le Brocquy because it had been scheduled a long time in advance. It was a great privilege to open with it.

VR: *To what do you attribute your success?*

JT: To Leo Smith, for thirteen years of advice and training and introducing me to the wonderful world of art, but mainly for the postcards he would send asking me to come back after I'd walked out

following the latest almighty row. I also have to thank my mother for talking me into going back on each occasion.

James White was enormously helpful to me, as were all the artists I showed, and of course the people who worked with me. For nearly three months before he died, Leo was in hospital. Also he hadn't worked on Saturdays for years and managing in his absence was a good grounding for me.

VR: *Is temperament, as well as a good eye and good business sense, relevant?*

JT: I don't boil over too easily. By nature I'm easy going. I learned from seeing what returns you get from losing your cool, and the benefits of staying calm. Leo had both sides, in the morning a lion; he'd give me a telling off fairly often. He'd give an artist a telling off too. Some left crying. That was the way it was then. I was lifted out of it once by this lady for saying her picture was a hand coloured Cuala Press print. She thought it was a Jack Yeats watercolour. I was only thinking of how much more she would have to pay for the frame, and not thinking how much that bit of knowledge changed the value she had on her picture. Framing was an important part of the Dawson and Leo was a perfectionist and had the temperment to go with it.

To give you an idea of the sort of thing that would blow his fuse: the workshop was in Anne's Lane, just up from where the Kerlin is now. Leo would phone each morning with his list of instructions. Once, when halfway down the list, Desmond (a first-class framer and a few years older than Leo) said 'hold on till I get a pencil'. The next day Leo said, speaking very slowly and deliberately so as not to lose his temper, 'Mr Hanna, do you have a pencil?' Desmond said 'yes'. Halfway down the list he said, 'Hold on till I get a piece of paper'. I think, in a strange way, setting Leo up like that was their way of getting even. Another time he was choosing a frame with this lady, and he asked one of the lads (sounding like a Dublin version of Sir Noel Coward) to fetch him the green French material. The young fella said, in his inner city Dublin accent, 'Do ye mean the stuff ye got in Clery's?' And

then most evenings he was a decent, generous man, giving the lads money for the pictures; he could be so charming.

VR: *After 40 years in the art trade how would you estimate the power of the critic?*

JT: When you have people of the calibre of Brian Fallon, Caomhín Mac Giolla Léith, Aidan Dunne, Dorothy Walker and Medb Ruane, the public are well served. We hold them in high regard.

VR: *Do you have a typical buyer?*[6]

JT: No, it's a catholic mix. Couples mainly. About one per cent of our sales are now to foreign buyers. A few public places buy, like the OPW. The public galleries have all bought, but very little. The Arts Council were our best supporters, especially in the early days. Representatives came in before the exhibition and carefully chose a work. That was Fr Donal O'Sullivan, Sir Basil Goulding, Michael Scott and R.R. Figgis. The Gallery had a little label we put on the wall beside the picture saying 'Purchased by the Arts Council'. Hotels and schools would reserve something. They'd have to apply to the Arts Council for half the price. The Great Southern did avail of the Hotel Purchase Scheme. I'm pretty sure it was the Great Southern who sold a le Brocquy for a good price. The Arts Council wanted half, but it was decided they would only get what they paid.

VR: *Do the banks buy much?*

JT: Yes, the banks have been very good buyers. Neil Monahan was a very good buyer for the Bank of Ireland, and now Derville Murphy is. By appointing advisers with knowledge and a good eye like Frances Ruane, AIB have put together one of the most impressive collections in the country. They were very wise.

VR: *Do the modern millionaires buy? Which ones would you regard as having the best eye?*

JT: A fair few of them do buy. We're very pleased that they come in. They are very good judges usually.

VR: *Do people buy for their mistresses?*

JT: No. If they do I am not aware of it. There's no buying-for-the-mistress as far as I know.

VR: *You have a very small staff - yourself and Pat, your brother. How do you manage holidays, for example?*

JT: And Tom, he helps with maintenance and a little framing. And we usually have a female staff member. After the last one (Tia) left we thought it better to wait and see if we get the permission to expand, because the position might be different. It's very expensive to expand your staff; you could be caught in a recession. As for the holidays, the year before last we met at the airport; Pat returning from the States, and I was going to Portugal.

VR: *It's a family business really?*

JT: My brother Bernard worked for me for a while. He worked in the framers. He is very good at mounting exhibitions. Pat was in the Dawson for a little while before Leo died.

VR: *Were your family interested in the arts?*

JT: Not really. My father was a very fine gardener. The garden was always beautifully laid out. He had a good feeling for space and colour.

VR: *Who selects the exhibitions? Do you?*

JT: It's shared. Pat does some studio visits, although there are very few studio visits now. The artists select the exhibition and it is delivered to the Gallery. Then the hanging is shared. I usually do a layout.

VR: *Would you initially have taken artists on by viewing their work on slide or by going to their studio?*

JT: Mostly from seeing the work in group shows like the College of Art graduation exhibition. We have no fixed rules. We are inundated with requests, but we have a fairly full stable at this stage.

VR: *Who do you most admire that you don't show?*

JT: These would include artists like Sean Scully, Hughie O'Donoghue, Basil Blackshaw, Barrie Cooke, Dorothy Cross and Alice Maher. There are so many, it is like an Irish renaissance.

VR: *How do you feel when artists sell from the studio and bypass the gallery system?*

JT: Artists are a fairly honest lot. We've no problem in that respect.

VR: *Still, for the gallery system to work, wasn't it important, for*

example, that people like Basil Goulding or the banks collect
through the galleries?

JT: Without a doubt in the world. Basil was the king. There were few
people like Basil. Gordon Lambert was another good client at Dawson. He was more Hendriks but he wasn't exclusive. There was
Donal Carroll, from Carroll's cigarettes. They had a collection in
their factory in Dundalk, le Brocquy tapestries and a Gerda Frömel
sculpture. They gave monetary prizes at the IELA, £1,000 or £500.[7]

VR: *Do your artists have an age profile? Are many under 50?*

JT: A few. We can only take on a certain number. After they die we
often work with the artist's estate.

VR: *Do you?*

JT: Yes, we deal with Charlie Brady's and Micheal Farrell's and
Tony O'Malley's. There's such a demand for exhibition space
from living artists. Ideally we should show them every two
years. With the amount of artists we have, that isn't possible. As
it is we have back to back exhibitions every three weeks. So we
don't get fazed if the artist is not ready with an exhibition.

VR: *Do you like to do catalogues?*

JT: A good catalogue is a tangible record and can be distributed to
a greater audience than most shows could attract. Catalogue
entries, I mean biographical notes are a good reflection on how
the artist wants to be seen and remembered. As an example,
Charlie Brady wanted his CV made shorter as he got older.

VR: *The catalogues help sales I suppose?*

JT: People do buy without seeing. They ring and give a price and
ask you to select one. We don't like it, we prefer it if they choose
for themselves. 'Is this the one that didn't sell?' they might
think. It could be the best one in the exhibition. We once sold a
painting from the catalogue reproduction to a man in London.
After the show, while arranging the transport, he said the reason he bought the painting was because the turquoise colour in
the painting was exactly the same as in the one he already had,
and it was to make a pair. The turquoise was in the bad reproduction but not in the painting.

VR: *Is it fun to go to dinner parties and see work from your Gallery on people's walls?*

JT: I look at paintings more than at the people. I like looking.

In conversation, Dublin, 10 December 2004

1. Wilson, M., 'The Quality of Attention: the work of Patrick Scott', pp. 111-16 in *Patrick Scott: A Retrospective*, Dublin, 2002.

2. Mallon, D., *Nano Reid*, Drogheda, 1994. Taylor Galleries held a special exhibition of Nano Reid's work in 1984. In 1974 *Nano Reid a Retrospective* Exhibition was shown in The Municipal and in the Ulster Museum, cat. Jeanne Sheehy.

3. Between 1975 and 1995 Charlie Brady had eleven exhibitions at Dawson/Taylor Galleries. In 1995 RTÉ showed *An American in Ireland*, produced by Sean Ó Mórdha.

4. Snoddy, T., *Dictionary of Irish Artists Twentieth Century*, Dublin, 1996, has entries on deceased artists.

5. Eckett, J., 'Under the Hammer – Collecting at Auction in Ireland', *Circa 108, Special Theme: Collectors and Collecting*, pp. 48-51, (ed.) Ader, L., Summer 2004.

6. O Kane, M., 'An Insight into Private Patronage in Ireland', pp. 36-9, *Circa 91*, Spring 2000 and O Kane, M., 'Coporate Insight', pp. 39-42, *Circa 92*, Summer 2000.

7. In 'Irish Company Collections' in *The Arts in Ireland*, vol. 1, no. 2, Winter 1973, pp. 14-27, Dorothy Walker wrote 'The living museum of twentieth-century Irish art is not in the museums but in the often-maligned new office blocks. P.J. Carroll and Co., the cigarette manufacturers, were the first big firm to patronize the visual arts. Since 1964 they have donated the major prizes awarded at the annual Exhibition of Living Art. Two new buildings, an office block in Dublin and a new cigarette factory and offices in Dundalk, provided the opportunity of acquiring new paintings and sculptures. The firm started by buying the pictures which won the major Carroll's prize – selected by well-known critics and curators from abroad. Special works were also commissioned ...'

Frances Ruane in front of Manes [1996] *by John Boyd. (Collection AIB)*

Frances Ruane

Frances Ruane was born in New York in 1946. She obtained a BA in Art from Queen's College, City University of New York in 1967 and an MFA in Painting from Penn State in 1969. In 1973 she completed her PhD there. She is married to Jim Ruane. They have two sons. From 1974 to 1977 she was education officer in the National Gallery of Ireland. From 1977 to 2005 she lectured in History of Art and Design at the National College of Art and Design. She has been art adviser to Allied Irish Bank since 1980. She has written widely on Irish art, curated major exhibitions and presented several television programmes. She was on the boards of the Douglas Hyde Gallery (from 1983-93) and Business 2 Arts and was chairperson of the Crafts Council from 1999-2003.

VR: *Frances, you are perhaps best known as art adviser to AIB. But were you the first education officer at the National Gallery?*

FR: Yes – I was able to settle into the Irish scene thanks to James White giving me that job. I had just finished my PhD at Penn State University. My research involved looking at the way people respond to art works depending on their personalities, their social backgrounds, etc. I had always wanted to work in a gallery and remember one day opening *The Irish Times* and seeing the job advertised. I had arrived in Ireland the year before, in 1973, and was teaching in St Ann's in Milltown. I wanted that Gallery job more than any other job I've ever wanted. Around that time there was very little happening in that line in Ireland but James had been putting a lot of pressure on the Department of Education to create the post. It was completely new territory. I started off with high falutin' ideas of what you could do, based on what was done in Chicago, Boston, New York.

But I had one big advantage. James White was director at the time and if anyone in the world was in tune with the way the Gallery could bridge the gap with the outside world, it was him. I learned a lot from him. He was a great communicator. We started doing lectures for young children; maybe that's too formal a word. They were morning sessions. The lecture theatre held about 200 kids and it was always crammed. For the first series I went to him and showed him the themes. He said, 'I'll give you a little bit of advice; take the word "art" out. You're competing with *Sesame Street.*' So *Portraits* changed to *Through the Looking Glass* and so on. It was more than a shift of title; it changed the way I looked at things. He made me get out of the art history mode with neat survey courses. We wanted to bring more fun and enjoyment into the place. For example, we got David McKenna to come in with a theatre group and did sessions where the paintings came alive through theatrical tableaux. We researched the periods and had actors perform parts.

It certainly went over very well, with a lot of good press about all the new things that were happening – we really

brought crowds into
the Gallery. Whenev-
er we did things for
young people it was
standing room only! I
was fortunate in
being the first educa-
tion officer. It's great
to be the first person
doing a job because
no matter what you
do, it's bound to be
seen as a big
improvement.

At the National Gallery. Left to right:
Frances Ruane, President Cearbhall
Ó Dálaigh and a colleague, admire children
making art, c. 1976.

VR: *Who were your colleagues there?*

FR: There was Andrew O'Connor and Mairéad McParland in Restoration. Michael Wynne was a wonderful benign presence, very supportive. John Hutchinson was hired around that time and we did some lectures together, a kind of double act for Leaving Cert students on Wednesdays and Thursdays. After a few weeks the female contingent swelled. I was convinced they were all in love with him.

VR: *Do you remember Jim Guerin, a wonderful head attendant, who lived with his family on the premises?*

FR: You can't underestimate the role that the attendants played at that time. They knew a lot about the pictures. We didn't have docents or headphones or ways of giving information about the art. The attendants had a vast pool of knowledge, from years of hearing people come and lecture. They were vital to the educational function of the Gallery, even though they never got credit. Then there were part-time people like Ruth Dromgoole and Mairín Ní Murchú who, for very little pay but with great dedication, came in and lectured. The full-time staff was minute. There were research studentships; Julian Campbell had one. Another person who was part of the fabric of the Gallery at the

time was Ciarán MacGonigal. He did research, gave lectures and generally entertained us. He always knew things that no one else knew, two or three weeks before anyone else.

The Gallery was a magnet for people doing research on Irish art. That was the heyday of Anne Crookshank's tenure in Trinity. There seemed to be a lot of people doing MAs and PhDs on Irish art – John was working on James Arthur O'Connor. Nicola Gordon Bowe was in and out doing her work on Harry Clarke and Jeanne Sheehy was working on Osborne.

VR: *How long did you stay?*

FR: A little over three years, from 1974-1977. I loved the Gallery but when I found I was expecting my first child, his birth coincided with a job opening up in the NCAD.

I remember going to James White and saying I was thinking of applying. He gave very strong reasons why I shouldn't leave the Gallery. Then he said, 'That's the advice I'm giving you as director. But if you were my daughter, I'd say "go to the College; you'll have more flexibility".' It was very kind advice. He was incredibly kind. Nowadays you wouldn't admit to making a professional decision on a personal basis. But it was a consideration. The job I had in the Gallery wasn't a five-day week job. I did the children's sessions on Saturday mornings and there were Sunday and evening lectures and you'd pop in to see was everything all right. There were teacher seminars on weekends and the Children's Art Holiday, a week-long event between Christmas and New Year. You could never have called it a pressure cooker situation, but you did put in an awful lot of hours.

VR: *Did you use the Gallery in your teaching at the College?*

FR: I used it a lot in the early period, before the College moved from Kildare Street to Thomas Street. I personally preferred the ease with which you could bring students to an exhibition without taking up a whole morning. You could say at the end of a lecture, 'We'll head off to a gallery for half an hour'. Now, if you are going to the Cross Gallery in nearby Francis Street, you

might lose, say, five per cent of the group. But if you go to Taylor Galleries you might lose up to 30 per cent. You have to factor in the weather, too. Our facilities are a lot better here, but in Kildare Street it was easier to have discourse in galleries on an ongoing casual basis.

VR: *Used you ever nip down to the Hibernian Hotel for afternoon tea when you were teaching night classes in Kildare Street?*

FR: No, nothing as posh as that.

VR: *Had you no Irish connections before you came here?*

FR: No, not a drop of Irish blood. Although I grew up in New York, the neighbourhood was primarily Italian and Jewish. When you'd meet people you'd say, 'What are you?' meaning Italian or Jewish. I don't think I met a Protestant until I was ten or eleven. Ireland was connected with St Patrick's Day and corny movies about leprechauns. I shouldn't tarnish all Americans but certainly geography isn't a strength of American education. So when I met my husband and it looked like it was more than a casual date, I took out a map and bought some books. Jim was doing a PhD at Penn State when I was there. He was dating my best friend, but she was totally unsuited to him so I don't feel any guilt.

VR: *When you came here in 1973, the year we joined the EEC, you married into quite an academic family, the Ruanes.*

FR: It was a family of multiple academics. Jim's father was professor of Agriculture at UCD and was a great innovator in that field. His legacy, among other things, was the UCD purchase of Lyons Estate. But he influenced, for the better, the practice of farming throughout the country. For years I went with my box of slides giving lectures on art in parish halls in little towns and villages all over the place, and wherever I went people always asked me if I was related to the famous J.B. Ruane.

Of his seven children, two are in UCD, one in UCC and one in TCD. It was a little intimidating, I have to say. They are far more serious academics than I am. Stemming from those days in the Gallery my interest has been more in popular communication.

I don't apologise. That's what I like to do – television programmes included.

People tend to fuse my sister-in-law, also Frances Ruane, and me together, so I get credit for being a scholarly economist as well as churning out my art stuff. However, although I don't know much about economics, she's really up to speed on contemporary art. I was on the board of the Douglas Hyde Gallery for a good many years and when I retired, they appointed her. Very handy – they didn't have to change the name on the

Jim and Frances Ruane.

headed paper. She's now chairperson. She used to be on the board of the Abbey, and I heard that her letter of appointment nearly went to me. There was a mad dash to the post room to retrieve the letter when someone realised there were two of us.

VR: *Were there things you found hard to get used to when you moved here first?*

FR: The thing I missed most was the range of vegetables. You couldn't buy aubergines or courgettes in Ireland in the early '70s. Even broccoli was considered a little suspect. You could get cauliflower, cabbage, carrots, turnips, parsnips and onions – that was about it. But I still miss sweet American corn on the cob. The corn here is a pale facsimile of the real thing. It's such an ordinary common food, nothing exotic about it. My mother laughs at me. It was also hard to get used to the cold – the houses were freezing. When I moved here in 1973 there was an oil crisis. But there was also an idea lingering from previous generations that heating was somehow bad for you. Then I discovered Michelina Stacpoole. She did layers and layers of wool. You

could buy knitted tops, knitted throws, knitted dresses, and put them all together in layers. It was absolutely thanks to her that I was able to get through the first winters.

Another thing I found difficult was people's reticence in talking about their personal lives. There's a myth that the Irish are very friendly. They are sociable and very charming but they don't reveal a lot about themselves for a long time. Coming from New York where you got on the subway and by the time you got to where you were going, you knew the life story of the person beside you, I thought Irish people were very secretive. Now when I go home I am aghast at what people will ask me. In Ireland, you find out by asking other people; you find out by an indirect route. This quality was so much to the forefront of my thinking at the time that it made its way into my writing. For example, in *The Delighted Eye* in 1980[1] I was describing Irish art as suggestive rather than delineating. Irish art was grey and misty, not in sharp focus; Paddy Collins' work is an example. Just when you are about to see the figure, the artist lets it go. On the other hand American art (I think I called it city slicker art) was much more blatant and direct.

VR: *Was your catalogue for the Patrick Collins[2] show in 1982 the first major publication on this great artist, then over 70 years of age?*

FR: Yes, it was. The Arts Council were doing the show.[3] The previous exhibition I'd curated, The Delighted Eye, included Paddy. I had a natural affinity with his work. I thought then and still think that Collins, Tony O'Malley and Louis le Brocquy are the three kingpins of their generation.

VR: *How did you get to know him?*

FR: I got to know Paddy through Tom Caldwell. He had been exhibiting for several years in the Caldwell Gallery in Fitzwilliam Street. Before that he had been with David Hendriks. David and Tom were very helpful in locating all the old gallery catalogues. I went through all of them with Paddy and he remembered every picture he'd painted; he knew the good ones and who had them. He was very definite about the work and

was very good at describing a picture before I saw it. But he wasn't going through an easy phase. He had been in France and was trying to settle here. I think it was Tony Ryan who lent him a flat in Stephen's Green, at the top of one of the houses near Ely Place. But there was the inevitable falling out. Paddy never had it easy in terms of his personal life or his finances. Given that he was getting on in years, you'd expect that an artist of his stature could live in comfortable surroundings. Yet it was only later, when his wife Patricia came back from France that he finally got a house and began to achieve better prices for the paintings. She was the one who made sure his later years were more comfortable.

I tracked down as many paintings as I could, visited the owners and photographed all the work. I put all the slides into chronological order with Paddy and we spent weeks talking about the work. The wonderful thing about working with living artists is that you can talk about what triggered certain works. He was very good about that.

Paddy often measured himself against someone like Louis [le Brocquy], whose career was so much more commercially solid. Paddy had difficulty separating aesthetic worth and market value. The truth is that Louis, in addition to being an amazing artist, was always much better at managing the business element of his career.

VR: *Collins was placed in an orphanage early on, wasn't he?*

FR: I remember once being at dinner hosted by Tom Caldwell and people started talking about their families. Paddy got extremely annoyed, saying he didn't know why people always dragged up the past, which he felt was irrelevant. I think his response showed that there was some resentment about his childhood; his widowed mother was forced to leave him in an institution. It's interesting that Paddy made a point of telling me that his mother paid to keep him in St Patrick's, that he wasn't abandoned as a charity case. But as an adult, he certainly could be difficult. For example, David Hendriks was an amazingly gentle man. If you wanted to find a dealer who went out of his way for artists it was serene, calm, intelligent David. Yet Paddy treated him badly.

VR: *In leaving the Hendriks Gallery around the early '70s?*

FR: Paddy would get illogical resentments. This usually came from periods when he was drinking. David Hendriks told me that Louis and Anne generously invited Paddy to their house in France, when he was living in poverty in a dilapidated farm house on the other side of the valley. Louis was having a party and among the guests were some art critics and dealers from Paris – a fantastic chance for Paddy to make contacts. But Paddy got drunk and poured a bottle of wine over an art critic. He was a bitter man, but luckily none of that bitterness ever came out in the painting. Because of Paddy's unstable domestic situation during the time I was working on the exhibition, I used to meet him in our house, in College or in Caldwell's.

VR: *He had no studio?*

FR: There is an artist, Carmel Mooney,[4] who was very good to him. She fed him if he hadn't had dinner and helped him to get places to stay. I don't think he could have made it through that period without Carmel. Carmel is generous when she says she got a lot out of it. He talked to her about her work, but she was critical to his survival before Patricia came back to Ireland.

There's a painting [*Travelling Tinkers*] from the late 1960s which I bought for AIB, which was one of the last paintings Paddy did before he left for France in 1969. It sums up all the romance of Collins' growing up in Ireland, that life of ballads and folklore, of poetic attachment to Ireland that perhaps only exists nowadays in the romantic memories of Irish-Americans who left. The painting was in the Gorry Gallery [on Molesworth Street] and we queued for two days to get it. Jimmy and Therèse are very structured about the way their sales operate. If you are a national institution you might get in beforehand; otherwise they sell on a first-come basis – you queue.

When Paddy went to France the work became crisper, the colours lightened and all that moisture evaporated. I'll never forget the 1979 show in Caldwell's, right after he returned to Ireland. There were some French pictures and some Irish ones.

These were phenomenal paintings. Everything came together. And the work continued to be strong right up until those oddly shaped pictures at the end. I'm not a big fan of those, but I absolutely admire the fact that at a period when he could have been complacent, he tried to push the boundaries of his art. I don't think that series ever came to resolution.

VR: *Shall we go back to The Delighted Eye exhibition?*

FR: Dorothy Walker used to go to west Cork for the summer and she asked me to do the reviews in *Hibernia* when she was away. I had been writing for the *Evening Press* from 1977 to 1980. Paula McCarthy and Colm Ó Briain at the Arts Council would have noticed things I'd written, first of all in the *Evening Press* and then in *Hibernia* and they asked me to curate The Delighted Eye and write the catalogue. Although the exhibition eventually came to Ireland, it originated as part of A Sense of Ireland.[5] There was another exhibition in that festival which dealt with artists who were part of a more international mainstream, while The Delighted Eye tried to identify a more intimate, romantic genre. More indigenous? Maybe, though I made a strong case for that at the time.

VR: *Whether buying for yourself or for clients whom you advise on purchases, do you ever buy directly from artists?*

FR: I rarely buy from an artist directly, because it benefits everyone if you have a really healthy gallery system. The commercial gallery allows the public to come into the gallery and see the work – all sorts of people – people who might become buyers in ten or twenty years time, critics, students. They show work properly, produce proper catalogues, promote the work abroad – and you can go back and look at it again if you want to. And for me as a prospective purchaser, a gallery is a more neutral place for looking at an artist's work. Believe me, it's a lot easier not to buy when you're not face-to-face with the artist in their studio. It's easier for me to be objective when I'm at a remove.

VR: *Do you watch out for students here at NCAD who might be the good artists of the future?*

FR: Paul Doran is an artist whose work I bought for AIB from his degree show.

VR: *I see that he is one of the artists short-listed for the 2005 AIB Prize, with Orla Barry, Julie Merriman and Tom Molloy. It is one of the best prizes around, at €20,000.*

FR: He showed with Breda Smyth in Kilcock and then I've watched Green On Red take him on. He did his MA here as well and I remember being very excited by the work. I'd go to all the degree and MA shows but, no, I wouldn't buy often.

There are really good professional gallery people going to art fairs, showing their artists' work abroad as well as here, promoting the artists beyond the boundaries of the gallery. Some of the eager beaver women who run galleries are power houses. They have tremendous initiative in terms of ringing up and promoting their artists. There's Suzanne MacDougald and Tara Murphy at the Solomon, Josephine and Kate Kelliher at the Rubicon, there's Mary Tuohy at the Hallward, Breda Smyth in Kilcock and Noelle Campbell Sharpe at the Origin. They really are dynamos.

What surprises me is that there are some galleries that never ring me up. Others are more proactive, produce good catalogues, send me digital images, like the Kerlin and also, the new guy on the block [on Anne's Lane], John Daly across the street from them at Hillsboro [Fine Art]. And take the Rubicon: if you're a regular client, you get a password so that before the show opens you can see works on their website before others do. They update regularly. There are some very young gallery people like Nicholas Gore Grimes in the Cross Gallery doing a great job identifying new artists, like Gillian Lawlor and Cara Thorpe. That kind of gallery owner is what's needed now. The only way to compete with the likes of the Taylor Galleries with its bevy of blue chip artists is to find the best young artists around and to work your backside off promoting them.

I used to be able to say I saw every exhibition, everything that moved on the Irish art scene. I certainly can't do that now.

At least three or four invitations come through the post every day, so I'm much more selective now about what I go to see. Also, things are so much more vibrant outside Dublin. Now you have Fenton Gallery in Cork, a major force on the Irish art scene. And there's a gallery called the Mill Cove Gallery in Castletownbere, amazingly go ahead with a terrific web site. They send you CD-ROMs in the post and emails letting you know about new work that's come in. They're very remote geographically but people are making an effort to go and visit them. It is jointly owned by an artist called John Brennan; he and John Goode run the Gallery. About a year ago a new gallery opened up in Glengarriff, of all places. I have to say it probably shows a Dublin bias on my part, but when I saw the space I was bowled over. It is so sophisticated.

VR: *The Catherine Hammond Gallery?*

FR: Yes, it certainly isn't aimed at a tourist market. I think it shows that the indigenous market has become more interested in contemporary art and is much more discerning. If people in Dublin think they have the market cornered they are mistaken. West Cork is very well served, and you can't forget Kenmare. Between art and craft galleries you get a wonderful selection of work. But the benefit of Kenmare over Glengariff is that you can always get such a good meal there.

VR: *Which is your favourite restaurant there?*

FR: Packie's, without a doubt.

VR: *You've recently built a house in Kenmare.*

FR: Like most people, our Dublin house evolved over time. There never was a sense of creating an environment from scratch. It just gradually becomes your home. We had been looking for a summer house for ages and I was beginning to be embarrassed because it had been the subject of conversation for so long. As our needs and interests changed, things kept being added and subtracted. For a while we thought about a place in Italy. I spent a year or more going back and forth. My husband was in the thick of work, so I would fly to Bologna and drive down to

Umbria a couple of times a year. Unfortunately I started to get carried away. A bolt-hole became a bigger place where people could come to stay. Then wouldn't it be nice to have a pool, it was so hot. A few fig trees were mandatory, but why not some olives? Yes, your own olive oil would be nice. Might as well have grapes too. It got completely out of hand. Even so, I managed to find an ideal house, near a good town, even though it was more or less a pile of rocks. We were just on the brink of doing the deal when the brown paper envelope reared its ugly head. The vendor didn't want the real value to be shown as it would prove he hadn't been paying enough tax. I, being Sicilian, was completely sympathetic. But my husband, being a banker, wanted nothing to do with brown paper envelopes. The deal really started to flounder when our plans to expand the house depended on using the triple bluff, which included some creative use of the measuring tape, a few phantom out-buildings and employing the architect who was sleeping with the planning officer. In the end of the day, the banker won out. I think Jim felt a little badly about dampening my enthusiasm about Italy and rang around a few friends. Within two months he produced this magical site in Kerry. We built from scratch – a great project.

VR: *How have AIB through their art collection[6] responded to the increasing nationwide interest in art?*

FR: Over the last few years, we did a big tour with eleven venues [in 1996, '97] called AIB Art on Tour[7], we did a big show at the Ulster Museum, and just recently sent one to Cork, after the thaw[9]. We also take six AIB branches every year, usually ones that have just been refurbished, and buy art for them, a lot of it locally. That would often include art by people who are not in the gallery system. We'd contact the local arts officer and talk to the branch manager, or someone in the branch who was interested in art, to get their guidance as to where to see things in the area.

VR: *Would the emphasis in these cases not be on an investment value in the art?*

FR: I don't think art should be caught up with the monetary issue. Investment was never part of my brief with AIB. If you're interested in investment you're into buying cheap and selling dear; you're dealing in art as a commodity. AIB's motivation has nothing to do with that. It has to do with having a workplace that is stimulating to be in; it has to do with supporting living artists. We're talking about conserving our cultural heritage, about supporting artists through purchasing and showing their work.

VR: *It's now a very good, very prestigious collection of over 2000 works, possibly the most important corporate collection in Ireland?*

FR: I'm convinced that the environment of the bank is better to work in because the art is there. It does cause debate. I remember when I bought the painting *Manes* (1996) by John Boyd. There was tremendous discussion, some good and some bad, on what people perceived to be its strengths and weaknesses. Some people were unsettled by it and said, 'What is it that's making me uneasy?'. When I walk into the bank in Ballsbridge I love it; I love being there. I'm sure a lot of this has to do with the art. It isn't just 'wallpaper', the visual equivalent of muzak. You can't avoid contact with some seriously fantastic pieces. AIB have the most important corporate collection in Ireland, yes. And a lot of people who are not as biased as I am say that too.

VR: *Did AIB or Bank of Ireland start collecting first?*

FR: The Bank of Ireland did, definitely [in 1970]. They were part of an early group of corporate collectors. The first was P.J. Carroll, who started to collect in the late '60s and early '70s when their headquarters and [cigarette] factory were being designed by Scott Tallon Walker. Don Carroll was connected with Bank of Ireland and Carrolls, and the main mover in the early days of corporate collecting.

VR: *It's extraordinary to look back to the importance of cigarette manufacturing then, and to see what a success the prohibition of smoking in public places has been.*

FR: Yes. In terms of corporate collecting Carrolls was unique, not only because it was buying art before anyone else, but also

Frances Ruane 157

because the commissioned work for its Dundalk cigarette factory resulted in pieces of unprecedented scale. AIB started collecting about a decade after that. Unfortunately the impetus to collect isn't always sustained. AIB has been remarkable in its continued enthusiasm for their art.

VR: *Was this because you were brought in to advise and presumably that involved curating, conserving, etc, as well as purchasing?*

FR: They had a few things in the bank before I came. AIB Bankcentre in Ballsbridge opened in 1979 or '80 and it was then, when Niall Crowley was chairman, that the board decided they wanted to go about collecting in a more structured way.

VR: *Who was the architect for Bankcentre?*

FR: It was Andy Devane.

VR: *Did he commission the big Alexandra Wejchert sculpture,* Freedom *(1985)?*

FR: Yes; Oisín Kelly was originally commissioned to do something for the forecourt but he died [in 1981]. I was then brought in to discuss the options but the architect was central to that decision. There's also a John Behan in the garden. That was commissioned by the architect.

VR: *Can you remember your earliest purchases for AIB?*

FR: One of the first things I bought was Louis le Brocquy's *Presence* (1960). I saw it in Taylor Galleries. One might think you have a master plan but, in reality, you have to respond to the circumstances, be open to a great artwork whenever it happens to present itself to you. It's always unexpected. The great thing about advising AIB was that from the start there was no pressure to fill the walls or deal with investment issues. The strategy was to collect over the long term and to be prepared to wait for quality items. A lot of companies make the mistake of trying to fill their walls as soon as they move into new offices; I've seen that pattern again and again.

The emphasis of the AIB collection has changed. In the early stages it was historical. I was able to buy Jack Yeats, Roderic O'Conor, Mary Swanzy before Irish art became hot on

the London market. It allowed us to buy well on a very modest budget. A lot of those older things were acquired alongside contemporary works, holding out for quality on both fronts. Anyone seriously interested in Irish art knows that not many significant pieces come up in any one year. The hardest thing is to learn to walk away. I never buy my second favourite thing at an exhibition. Not for myself, not for a corporate client. It's just like looking for a husband – you don't want the second best one! That's the way you get a collection you end up loving. The odd time you realise it was a case of infatuation ... I'm very happy with most of the AIB collection. After 25 years I'm still mad about most things.

VR: *How did you get the job of advising AIB?*

FR: My understanding is that they got three or four names of possible advisers. They had each of us come in and talk to a subcommittee of the board about what approaches we would take. The idea of doing a historical collection, Irish art from around 1880 to the present, was the one I proposed and they went along with it. If you just relied on contemporary works you'd spend an awfully long time getting a really excellent collection together on the scale that AIB required. Also, the historical dimension gave their collection an identity that was different from other corporate art.

VR: *Presumably you buy at auction as well as from the galleries?*

FR: Initially there was only Adam's.⁹ There were auctions in London with Irish art, but it didn't feature very strongly. In the beginning there were more people willing to sell privately, people who wanted to convert art works into cash. Nowadays that's drying up. People are affluent and there aren't too many who have to sell art because they need cash – unless they have to help their kids buy a house. But in the early 1980s there were a lot of people selling privately. We have a magnificent Sean Keating that came through a telephone call to the Bank, from the vendor. In the case of Yeats' *A Race in Hy Brazil* (1937), we went to James White, who would have known where every

important Yeats was, and he put us in touch with the vendor. We decided with the seller that in order to establish a fair price we'd get three independent valuations, one from Waddington's in London. There wasn't a decent photo and we were in the process of getting one for him. Waddington wasn't too fussed about it and just wanted to know what size, what year, what condition, what subject, and how many horses in it! 'For a picture that size, generally we're talking about £20,000,' he said, 'and you can add £1,000 for every horse.' I'm sure it was said in jest but anyone who witnessed the frenzy for Frank McKelvey several years back saw that the more chickens in a picture, the more it was likely to cost.

VR: *Your father-in-law would have had something interesting to say about that.*

FR: When you think of the role of the horse in Irish culture you can see that people would be attracted to it as a subject. Add to that the particular significance of the horse in Yeats' work; they're iconic images.

The picture we were unbelievably lucky to get was the Mary Swanzy *Samoan Scene* (1923). Again, someone in the owner's family approached the Bank. There were a limited number of paintings the family wanted to sell. We weren't interested in the others but the Swanzy, yes, without a doubt. It was spectacular, and the size was unusually large. It was exceptional from the start but we discovered it was exhibited in Honolulu in 1929, and that there were four that size [152 x 92 cms]. Somewhere there are three others that are similar and some dealers in London have told me that they've been working very hard to find them.

VR: *What's the secret of success in building a corporate collection?*[10]

FR: I attribute a lot of the success of the AIB collection to the fact that they never delegated responsibility for collecting very far down the line, and that there were people right at the top who were both interested in and knowledgeable about art. Initially Niall Crowley, when he was chairman, headed up the Art Committee. There were

enthusiastic people on the board, like Denis Murphy and Richard Wood from Cork, and Maurice Abramson, a collector. They were very supportive of the art collection. On the ground I reported directly to Michael Carroll who was in a very senior position. He is a collector himself and was a friend of Cecil King and many artists, including Tony O'Malley and Mary Fitzgerald. Michael has an insatiable appetite for talking to artists. I was dealing with someone who had clout in the Bank and who loved art. When Michael retired, art came under Dermot Egan's wings. He was also a friend of Tony and Jane [O'Malley] – we had a memorable visit to their studio in St Ives.

Dermot Egan went on to become deputy chief executive of AIB, so responsibility for collecting ended up at a very senior level. On a broader level, Dermot was committed to the role the wider business community could play in support of the arts. He was the force behind the formation of *Cothú*, the organisation which develops relationships between business and arts organisations, and became its first chairman. It's called Business 2 Arts now. When Dermot Egan retired, AIB gave responsibility for their art collection to Michael Buckley, who was head of Capital Markets.

There's a certain amount of luck in this. There happened to be three fabulous people in positions of authority who coincidentally were not only passionate about the arts but also knowledgeable. Michael Buckley is particularly sympathetic to contemporary art. He was the prime mover in shifting

Left to right: A friend, Tony O'Malley, Frances Ruane and Dermot Egan in St Ives, c. 1985.

Michael Buckley and Frances with Robert Ballagh's painting behind.

the emphasis to living artists. That was around 1994. He's inter-
ested in young art and likes us to hang all the newest acquisi-
tions in his office. I don't think he's ever had a Jack Yeats in his
office. He's not into trophy art. When he moved from Capital
Markets to head AIB's operation in Poland he still kept art under
his umbrella, even though he was travelling all the time.
Michael became very interested in Polish art, encouraging us to
bring some contemporary examples over here and send some
Irish art to the Bank in Poland. When he became chief execu-
tive of AIB, the top job, he still kept the art.

It was the idea of Michael and of Lochlann Quinn, who was
chairman of the Bank, to start an AIB Prize. It's a significant
cash award for artists early in their careers. It's open to artists
in any medium but a lot of the people nominated for it over the
past four years have been involved in performance, installation
work, video or photography. The 1994 winner was Amanda
Coogan.[11] We've just bought a photo based on her Beethoven

piece. She tries to capture the essence of that performance in a controlled photographic situation. Caroline McCarthy, Dara McGrath and Katie Holten were winners other years.

VR: *Now that Michael is retiring soon, I hope the new man, Eugene Sheehy, will keep up the tradition.*

FR: I'm optimistic, because the art has become so embedded in the culture of the Bank. I hope we don't lose impetus.

VR: *Do you try to collect a few works by each major artist – say works from the early, middle and late periods or whatever?*

FR: Yes. A good example would be Colin Middleton, or Paddy Collins; we have works from different decades by each of them.

VR: *What about Barrie Cooke? Have you anything earlier than the magnificent* Long Rakaia Cliff *(1989) recently shown in* after the thaw?

FR: We have an early bone box by Barrie and a nude study but, come to think about it, we could do with another painting. We have nothing later than that painting.

VR: *Is the world of big art collecting a male-dominated preserve?*

FR: I've never felt I was in the middle of a male preserve.

VR: *Are there gender issues that you note, enjoy, reject or whatever?*

FR: No, not at all. The gender issue is completely irrelevant to me. However, it's fascinating to look at the kind of person, male or female, who is collecting and the reasons they are collecting. If a person is motivated by a real love and understanding of the work and of artists, that's different to someone who wants a trophy collection. I once described these people as big game hunters. They want to collect big names and there's rivalry going on when they want to 'bag' works.

VR: *Indeed. Tell me about the experience of being in the auction room, and maybe bidding for a client and maybe for yourself.*

FR: The auction room is the most exciting place to be. I get exactly the same buzz bidding for someone else as I do when bidding for myself. The only time I've really ever over paid is when I've bought personally, when I'm not spending someone else's money. When I bid for a client I tend to be very conservative.

When I'm bidding for AIB, it's shareholders' money and, at the end of the day, I think that even though AIB don't buy to sell, I would be conservative in my bids. It's my job as an adviser to be realistic about intrinsic market worth. For myself, I can be self-indulgent.

There was a recent Adam's auction where there was a mediocre work on paper by an artist which went for three or four times its estimated value. At the end, there was a moment of silence when I looked in disbelief at other people in the room, many of whom were dealers, standing there with absolute incredulity. I can accept that there might be one crazy person in a room of 200 people, but what are the odds of having two people who are completely bonkers? You get people who hear so-and-so is a hot young artist, people who may have an awful lot of money and maybe don't go to too many auctions. They want their gratification now. It's a recent phenomenon. One auctioneer I was talking to said there's a tendency for it to happen before Christmas, when couples decide to get an art work as a present to themselves and they just keep going for it.

VR: *Would you always make the bid yourself?*

FR: No. Sometimes I deliberately don't want to be seen bidding.

VR: *Do you have many corporate clients?*

FR: No. Not many. You have to be conservative about the number of clients you take on. The number of desirable art works that come on the market are too limited.

VR: *Would you know who the new collectors are from going to the auctions?*

FR: No; there seem to be an endless pool of property developers out there – the new Medicis. There are loads of people who have impressive collections and they're very discreet about it. There are also younger people who have grown up with art who are becoming buyers as well.

VR: *Do you think tax concessions play a role in motivating people to collect? At least now that art has got so expensive do you think the tax allowances for giving works to institutions influence*

companies in their attitudes to art?

FR: No, absolutely not. The legislation doesn't subsidise companies or give them any advantages, and it's wrong to view them as concessions. What the law does do is to help national institutions acquire major works of national cultural heritage that would normally fall beyond their limited budgets. It doesn't encourage people to collect; however, it provides a vehicle for people who face a big enough tax bill to give work to the State, setting off the value against their tax, instead of selling it on the open market. The donor still is liable for capital gains tax, so there's no net financial advantage, and the work has to be of real significance.

There are two different categories of donors. There's the donor who is solicited. That's where a big company is used as a vehicle for a national institution to acquire a work which is on the open market. Let's say the National Gallery wants to buy a painting offered to them – they believe it's of national importance. They apply to a company with a tax bill that is big enough to cover the cost. They ask the company to buy the work and to give it to them. The company is using its own money to buy the work. They give it to the institution – the National Gallery – and the value is set off against their net tax bill. The company is in a completely neutral situation financially. The money they put up to pay for it is the money refunded to them as a tax credit. In fact, what the company is doing is putting money up front and putting in man hours to facilitate a national institution's acquisition of an important work. There's no benefit to the company. The company is just being used as a middle man to allow an object of national cultural heritage to stay in a designated national institution, by spending on the work what they would be paying in tax.

VR: *Goodwill comes into play there, doesn't it?*

FR: Yes. Galleries that are not one of the designated national institutions can apply on a case by case basis. It becomes very problematic if the item is coming up at auction. A company

would be very wary of committing itself to purchasing an object of potentially very high auction-driven value which the Revenue Commission might not agree on.

The second category of donor is where the individual has something that is of itself of cultural value to the nation. In order for them to benefit they would need a tax bill in excess of the value of the object. They are still liable for capital gains tax. So if I have a work worth €100,000 and I donate it to the National Gallery who want it, the €100,000 minus the capital gains tax is set off against my tax bill.

To go back to your original question, I can't imagine how this legislation [The Consolidated Taxes Act 1997] influences anything in relation to a company's own art collection. It is, however, a good way of ensuring valuable historical objects go to Ireland's public collections.

VR: *The money in contemporary craft is so much less than in fine art and the challenges different. How did you get involved with the Crafts Council of Ireland?*

FR: It just started one day when I was at AIB and a message came to me that somebody in the Tánaiste's office was looking for me. When I phoned they said Mary Harney wanted to talk to me. She was Minister for Enterprise, Trade and Employment. She asked me if I would take over the chair of the Crafts Council. It was intense involvement for four years. I loved it. It was completely different to anything I had done up until then. It was so different from academic life and consulting, where doing a good job or not falls on your own shoulders. In the Crafts Council it wasn't a question of working on your own. It was working in an organisation where the relationships with crafts people, government funders, with buyers, with craft fair personnel all determine the outcome. It involved having a long-term strategy, deciding where we wanted the Irish craft sector to be in twenty years.

When I started, I just thought that the difference between craft and art was simply a question of medium. And yes, there are a small number of craft professionals who are art led. They

basically are artists who make one-off pieces in craft materials, sometimes exhibiting in galleries. But this is only a tiny bit of the craft story. Most people in craft produce objects in small batches and run a business. They could be making textiles – throws, cushions, hand knit garments for fashion, or maybe batch-produced furniture. They may have a small factory. They're employing people. They have to look not only at aesthetics; they have to be in tune with fashion; they have to look at routes to markets, the pluses and minuses of selling on the internet. They have to label, display and promote in a way that has little in common with the rarefied world of fine art.

VR: *There are issues of audience too.*

FR: There are; there isn't much of an audience for fine craft in Ireland. It was intimidating being chairman because there is a lot of work to be done. I learned a lot about the contribution this sector makes to the Irish economy and the support it needs from government. We were lucky Mary Harney was the minister responsible. She is actually very interested in craft, goes to craft fairs, collects craft pieces. We didn't need to convince her about craft, or of the essential importance of craft traditions in Irish culture. We did need to convince her of the merit of our strategic plan.

VR: *How would you compare the Crafts Council to the Arts Council?*

FR: The Crafts Council works very differently to the Arts Council, who get money and, for the most part, divide it out to constituent organisations. Also, some money goes directly to artists, through *Aosdána* and through grants, capital grants for projects.

 The Crafts Council, on the other hand, runs projects that promote the sector. It doesn't see itself as a funding channel from government to individual companies or people. For example, when it identified a need for small craft companies to develop websites, it initiated the *Hands On* project. The Crafts Council is project centred. We noticed that when it came to producing brochures or putting up photos on the website that a lot of crafts people didn't have good visual images of their work. We

developed a subsidised photo scheme where on a periodic basis we would hire photographers and stylists to do photo shoots. We'd have craftspeople set up objects and they would be beautifully photographed. The Crafts Council retained copyright of some of the images which they could then use to promote Irish craft. As a result you rarely see an Irish magazine like *Image* or any of the glossy weekend supplements that don't have beautiful craft images in it. Rather than giving money the Crafts Council gives support.

VR: *As you teach design students did you find you could use your experience with the Council in College?*

FR: Although a lot of craft people came out of the design side of art college, others are self taught. But Ireland is a tough environment for indigenous crafts. It's a high wage economy. If you have someone producing wooden turned bowls where the insurance and other costs of doing business are enormous, where the rents are high, you find there is no way you can produce an object that can compete with a similar one in Habitat made in China. So how do you make an object so desirable that people are willing to pay for it? The design has to be extraordinary.

All over the world there's a romance and appeal attached to Ireland and things Irish. We got feedback from people who stocked Irish craft abroad and they said people were not making enough objects that visibly relate to Ireland. Take Cormac Boydell. There are subtle elements in his pieces that connect to landscape and his surroundings. When promoting his ceramics there should be a photo of him there on the Beara Penninsula where he lives, right on the edge of the ocean. You need to reinforce the image of the person, where they live and what inspires them, to promote them.

VR: *He is one of the art-led crafts or craft-led arts people who show their magnificent work in galleries. Claire Curneen would be another.*

FR: If you look at Nicholas Mosse, a lot of his pottery has taken motifs from older Irish sponge ceramic ware and objects in

museums. The market responds to Irish makers who are able to draw on their surroundings and reinvent old forms and make them modern without completely throwing out elements that are indigenous. That's my bandwagon.

A Bebhinn Marten sweater can remind you of a field, stone walls, etc. It doesn't have an urban feel. How do you keep something with a flavour that is indigenous without being kitschy and relying on shamrocks, shillelaghs and green? The market is sophisticated and can see through clichés a mile away.

VR: *It's interesting that her father Seamus Murphy and indeed her grandfather Joseph Higgins were notable sculptors.*

FR: The whole textile area is very interesting. Foxford Woollen Mills were loping along quite happily doing very standard throws, what used to be called rugs. People used them when their cars were inadequately heated and used to wrap them around their knees. Recently they started working with fashion designer Helen McAlinden and designed ranges of woollen throws and other pieces that were co-ordinated. They drew on the designs of the old blankets that wove plain wool with turquoise bands and updated them with fashionable colour ways, giving the patterns a modern edge and co-ordinating them with sheets, pillows, etc. That company is growing from strength to strength. They always had technical skill, but craft for interiors is now a fashion industry. You have to reinvent yourself season after season.

There is a small weaving operation in Donegal called Studio Donegal. They do wonderful tweed fabrics, and a huge range of traditional throws. They used to be appealing but lacked a certain edge or excitement. I remember about three or four years ago the Crafts Council started product awards where prior to its trade fair, Showcase, we would encourage new products. We brought in adjudicators from abroad. Studio Donegal brought out this unbelievable colour range that drew on traditional weaving designs but had an intensity of colour that was a little more quirky and modern.

VR: *Did they win the award?*

FR: I don't think they did, but I ended up buying a few myself. The Crafts Council experience has shown me how all artists, whether craft- or fine-art based, could benefit from thinking a little bit more about promoting themselves. If the only thing that drives you is making the object and you have a gallery that can sell enough to keep you going, that's all right. However, if you want a reputation that goes beyond this country and you want an affluent return on your efforts as an artist, I don't think you can do that without having a gallery that promotes you.

I was fortunate enough to visit Sean Scully in his London studio before we bought *Wall of Light, Summer* (2001) for AIB. While I was waiting to talk to Sean he was on the phone for quite a while, and what came across was a man who was completely in control dealing with galleries in Paris and New York – he was clued in to the art scene as a market place. Although I have no hesitation in saying that Sean Scully wouldn't have been successful unless his art was magnificent, the thing that raises him to superstar status is the way the career is handled. He knows how to do it. Artists like Hughie O'Donoghue and Sean Scully can get the support of their galleries in dealing with the business end of their practice. A few decades ago this was not available in Ireland and the artist had to rely on their instincts and the force of their personalities. A prime example is Louis, who always understood how systems work.

VR: *Where an artist has a supportive wife it is a great help, I'm sure.*

FR: I don't think it necessarily has to do with there being a woman there supporting a man. In any job if you can do it with the support of another person, it's going to be easier, particularly if that person has skills that are relevant. Nicholas Mosse's wife, I believe, takes care of the business end. They complement each other. But if you are a woman in business and you have a husband or partner in the background helping, it frees you more. The whole male/female thing doesn't come into it. If you have a companion, friend, relation or business partner who gives you support, it's got to be an advantage.

Take Cecil King and Oliver Dowling or Gordon Lambert and David Hendriks; the business skills of one partner must have helped the other. In the same way, if an artist has a gallery that gives emotional and practical support, they're in a better position.

VR: *Absolutely.*

FR: A lot of people go into the art or craft area because they like to make objects or have ideas or emotions they want to translate into some material form. This is the driving force that makes them artists or designers. Unfortunately nowadays you need a range of other skills and expertise that needs to be provided either by a gallery or another person. Craftspeople who don't have galleries find that they need to become business people. In some ways it's easier for artists as there are savvy people out there; galleries, agents and dealers, to work for them. But the galleries are doggedly resistant to showing craft and this leaves the art-based craft person out on a limb.

VR: *I know you translate your professional belief in Irish art and craft into purchasing for yourself.*

FR: When I left the Crafts Council there was a big void. It coincided with both my sons leaving home for London. To paraphrase Oscar Wilde, to lose one son is unfortunate but to lose two is careless. Luckily it coincided with building the house in Kerry, where I was able to draw on traditional crafts like stonemasonry, blacksmithing and basketry, as well as looking for things with a more contemporary feel in ceramics, wood and textiles. All my curtains are Irish tweed and all the furniture is upholstered in it – the texture and colour fits in so well with the Irish countryside. The local woman who made my curtains said that in the twenty years she'd been in business, this was the first time anyone had asked her to use tweed.

When I'm in Kerry I'm forced into wellies, one element of Irish life that I'll never get used to. There was a feature in one of the Sunday papers recently about whether you are a 'flats' or a 'high heels' person. I'm afraid I'm the latter and won't walk outside the front door without full make-up and earrings. If I

didn't have earrings on I'd think I was naked. It used to be eye make-up, earrings and shoulder pads. In the last couple of years I've reluctantly let go of the shoulder pads.

VR: *I'm sure contemporary jewellers on the Irish scene are really glad you didn't let go of the earrings.*

In conversation, Dublin, 10 March and 7 April, 2005

1. Ruane, F., *The Delighted Eye: Irish Painting and Sculpture of the Seventies*, Dublin, 1980.
2. Ruane, F., *Patrick Collins*, Dublin, 1982.
3. Muinzer, L., 'Patrick Collins Retrospective at the Ulster Museum 17 June-25 July 1982', *Circa*, no. 5, July/August 1982, pp. 25-7.
4. Gandon Editions, *Carmel Mooney*, Kinsale, 1999.
5. The Delighted Eye as part of *A Sense of Ireland London Festival of the Irish Arts* was shown from 5 February-5 March 1980 at 52 Earlham Street Gallery, London. It was subsequently shown in Dublin, in the Bank of Ireland head-quarters in Baggot Street.
6. Ruane, F., *The Allied Irish Bank Collection: Twentieth-Century Irish Art*, Dublin 1986.
7. Ruane, F., *AIB Art*, Dublin, 1995.
8. Dunne, A., *after the thaw: recent Irish art from the AIB Art Collection* Kinsale, 2005.
9. Adam's at 26 St Stephen's Green, Dublin was founded in 1887 and is Ireland's longest established firm of fine art auctioneers and valuers.
10. Ruane, F. (ed.), *AIB Art 2*, Dublin, 2002.
11. Dunne, A., 'Body of Evidence', *The Irish Times*, 29 January 2005, p. 6. *The Irish Times* carried a colour photo of Amanda Coogan 11 March 2004 when she won the AIB prize.

James White, the outgoing director of the National Gallery and Homan Potterton, the new director, June 1980. Courtesy of The Irish Times.

Homan Potterton

Homan Potterton was born in County Meath in 1946. He was educated at Trim National School and Kilkenny College. He graduated from Trinity College in 1968 and completed post-graduate studies in art history at Edinburgh University in 1971. He was cataloguer at the National Gallery of Ireland from 1971-1973, assistant keeper at the National Gallery, London, from 1974-80 and director of the National Gallery of Ireland from 1980-1988. He was editor of the Irish Arts Review *from 1993-2002.*

VR: *This is a very nice part of France, Homan.*

HP: I've only been here about a year. Before that, I lived about ten miles away, in a small hamlet. The house was attached to a

castle on a promontory. It was a small house but it had a wonderful view. But I always wanted to move right out to the country.

VR: *You were brought up in the country. Had you always known you'd be a creative writer?*

HP: I was always interested in writing. In writing art history, I always tried to put as much into the writing as into the research. But I didn't think that I had, and I don't know that I have, the talent to be a creative writer. I am very pleased that people seem to have liked *Rathcormick*.[1]

VR: *Are you writing a novel now?*

HP: I'm writing, but I don't know what it's heading towards. It's very slow.

VR: *Was writing* Rathcormick *a very slow process?*

HP: It took eleven years, on and off.

VR: *Did you write it without knowing it would ever be published and when you were living outside Ireland?*

HP: Yes. I was writing it when I was living in New York. I rarely went back to Ireland and I think that made a huge difference insofar as it distanced my recollection.

VR: *How did your family like it – it's a family memoir in many ways, is it?*

HP: They all loved it. I was stunned. I thought they'd never speak to me again. I thought they'd say, 'It wasn't like that'. I thought they'd be embarrassed, and hate it. As a family, we don't like publicity, we are low key. Publicity is anathema to our ethos. In the memoir, the stories are all true but, of course, the conversations are all made up. However, it is the way we spoke and the things that my parents, for example, said express their attitudes.

Homan Potterton and his mother, graduation day TCD, December 1980.

VR: *Your mother had died before*

Rathcormick *was published – do you think she would have enjoyed your presentation of her, which I think is very moving?*

HP: She had died. As I wrote it and questioned myself as to how and why she did things, a picture of her was built up and she became much more than she had seemed.

Quite a lot of people write childhood memoirs because they are angry. I always think that expressing the anger ruins such books. I thought, 'I have anger about certain things but I'm not going to ruin the book with it'.

VR: *The story of the Scottish girl who came to visit your brother and had to be whooshed away when it transpired her father was a butcher was cruel, ridiculous and funny at the same time.*

HP: People commented on the cruelty of it, the cruelty to the girl, who was so nice. But she wasn't 'suitable' and being suitable mattered at that time. Ireland has changed. I think such snobberies have largely disappeared. When I talk to my brothers about things like that now, they say to me 'Homan, not only do we not speak that way, we don't think that way. We think "is she a nice girl, is he a nice young man"'.

Mixed marriages were quite an issue then, on account of all the children having to be brought up as Catholics. That was very divisive. Catholics disapproved of such marriages as much as Protestants. Mary Robinson's father wouldn't go to her wedding because she was marrying a Protestant.

VR: *Attitudes and habits that now seem archaic and inhuman, like borrowing orphans for the summer holidays, were real features of Irish life in the 1950s.*

HP: My father wanted to lend our seaside house to an orphanage so that the orphans could have a holiday. 'You can't get the orphans now', is what the warden of the orphanage told him, as if they were some rare commodity. When I looked into it I found that legal adoption had just been introduced into Ireland at that time, and that was why orphans were in short supply. I recalled things which happened and then I found that there were historical reasons for such things. For example, my brother wanted to go to Denmark

to learn about farming which might seem odd today, but the other day I was talking to Ib Jorgensen and I asked him why his family had come to Ireland. They came in the '50s. He said his father was brought over to Ireland to advise the government about farming. Denmark was at that stage very advanced in dairying and pig farming. 'So that's why my brother Edward wanted to go there,' I thought.

Our summer house was in Kilkee [County Clare]. There was a low wall opposite the house and beyond that the cliffs. As children, we weren't ever allowed to go near the cliff edge. Someone got in touch with me from Kilkee a few months ago and told me that the man who lived in what had been our house in Kilkee was sitting on the wall reading *Rathcormick*. A man and a woman were swimming below, and the husband got into difficulties. The wife shouted for help. The man who was reading my book and owned what had been our house was by coincidence a trained lifeguard. He jumped into the sea to help the man in difficulty. He drowned. The man who was in difficulties was saved. They found my book on the wall and put it in the man's coffin.

I wasn't the better for hearing about the incident for days.

VR: *Uncanny.*
 Is that the cuckoo I hear?
HP: Yes, there are loads of them around here. They start at 4.30 in the morning. They are a one-note – well, two-note bird. I don't know why people make such a fuss about them.
VR: *Rarity, in Ireland now. Do you write art history now?*
HP: Hardly at all. I haven't lost interest. It's just that I don't want to do that any more. It's more difficult living here where there is no possibility of doing research. I suppose moving down here [to south-west France] shows I wanted to move away from it. In attempting creative writing I do lose confidence. 'This is only rubbish', I say to myself and then put it aside and mess about. When I take it up again I often think, 'it's not as bad as I thought'. I wouldn't write any more memoir though.

I got burnt out as an art historian. And I was certainly burnt out as a museum administrator. The scholarly side I had always liked. I loved aspects of running the [National] Gallery but there was a lot that was emotionally very draining. I did try to work very hard. Apart from the administration, I was very determined to do the catalogue[2] of the Dutch collection of over 200 pictures. And I did that because I worked most weekends, and in the evenings to an extent. But the director has a very hectic social life so there weren't very many evenings available. I'd put aside a week for it now and then. I was able to work in the library in the National Gallery in London. In the last run the board gave me three months off to complete it. To publicise that part of the collection we sent a travelling exhibition of Dutch paintings to the States under the auspices of the Smithsonian Institution.[3]

VR: *In doing the Dutch Catalogue, did you have much contact with the Rembrandt Research project?*

HP: The small painting *La Main Chaude* had been lost sight of art historically, although it was on exhibition. When I went into the history of it, I saw it had a chequered history of attribution. I had it x-rayed and there was a portrait like an early self portrait by Rembrandt underneath. I published this in *Apollo*[4] and included the picture in the big exhibition we sent to the London National Gallery.[5] I'm no Rembrandt expert so I brought it to the attention of the Rembrandt Research Project and asked them to look at it very carefully. They don't give instant answers. I was delighted to hear many years later that they had decided it was a Rembrandt. It's hard to reconcile the title with the activity in the painting.

On the other hand, I notice the Rembrandt Research Project has dismissed the Lane *Portrait of a Young Woman with a Glove* [c. 1633]. I pressed very strongly for it to be a Rembrandt, in the catalogue. I gather the *Old Man with a Beard* is now a genuine Rembrandt. I didn't see anything in that. People outside art history don't understand the vagaries of attribution, but they are very pre-occupying.

VR: *Of all the ten directors who preceded you, would Walter Armstrong,*

*a great scholar of Dutch art, be the one you would most identi-
fy with?*

HP: He was the one I felt most empathy towards. He was serious about
his profession and he had integrity. He had a sense of right and
wrong. That comes across in his dealings with Lady Milltown. In
Somerville-Large's book[6] that comes across very strongly.

VR: *Did Peter Somerville-Large interview you when he was research-
ing his book on the history of the National Gallery?*

HP: No, he didn't. But I think he dealt very fairly with me.

VR: *You mean in acknowledging how helpful your introductory his-
tory of the Gallery in* The Illustrated Summary Catalogue[7] *was
to him?*

HP: He was generally very fair.

Dutch art wasn't my first love. Italian is. I was curator of
seventeenth- and eighteenth-century Italian paintings in the
National Gallery in London and that suited me. I like almost
everything eighteenth century in art. Furniture. Silver. Porcelain.

I admired Armstrong because he published so much. He
was friendly with Walter Osborne and travelled with Osborne to
Spain. Osborne's sketchbooks show Armstrong asleep on a train.
Armstrong was right in identifying what the Gallery needed
when Lady Milltown was making her gift [c. 1902]. She wanted
to dump trinkets in the Gallery as well as give the big things.
From her point of view, that of the widow, it was understand-
able. She and Armstrong both wanted different things, and in
retrospect, few of Lady Milltown's conditions have been com-
plied with. There are other examples of that, where a donor's
wishes have been sidestepped: the Nathaniel Hones for example.
There was to be a Nathaniel Hone Room but that wasn't hon-
oured. Reading Somerville-Large's book, I see Armstrong was-
n't happy at the end of his directorship and I wasn't either.

VR: *At least the Milltown[8] wing did get built.*

HP: Yes, but the less conditional a gift the happier the donor is going
to be.

VR: *Where someone is giving a great deal of stuff would it be better*

to give it to the nation than to an institution like the National Gallery, which cannot show everything?

HP: Chester Beatty[9] gave to the nation and the Chester Beatty pictures were all over the place. We did find them all when I took up the directorship and got them back. It was a good idea to send them out all over the country, but it hadn't worked.

VR: *They weren't safe?*

HP: They weren't safe, no.

VR: *Still linking you with Armstrong, there is the amazing parallel of the two major gifts coming from Russborough House during your respective times as directors.*

HP: If you mention the Milltowns and the Beits in the same sentence, from the point of view of directors, you couldn't get two more opposite situations. The Beits were extremely easy to deal with. When I went to the Gallery, the Beit pictures were lent every year for the winter when the Beits went to South Africa. The main pictures were still the Beits' property. They had not been assigned to the Beit Foundation [set up in 1976] and certainly not to the National Gallery. At that stage the Beits weren't young. It seemed remarkable to me that the fate of the pictures hadn't been decided. Then discussion took place and the Beits decided they wanted the Gallery to own the pictures. I was very, very excited by this, needless to say. It took a couple of years for the legal arrangements to be made, in the context of the Beits' own personal situation.

VR: *Like Lord and Lady Milltown of Russborough, they had no children.*

HP: They had no heirs, which is why they were so generous to Ireland, both in giving Russborough and in giving their collection. For a time their intentions with regard to the main paintings were known only to me and to the chairman of the board, Bill Finlay. It was a huge responsibility and a terrific secret. I think I can say I was terrified in those years in case something, like the death of Sir Alfred, would come between the Gallery and the promised gift. Then when I knew all was about to be finalised,

the bloody things were stolen. The Beits went through with the gift, even though four of the seventeen paintings donated were missing; the Vermeer [*Lady Writing a Letter, with her Maid* (c. 1670)], the Goya portrait [*Doña Antonia Zárate*] and the two Metsus. 'The General', Martin Cahill, and his gang had taken them although, of course, that wasn't known until later. Everyone knew what the General looked like, as he had appeared on television disguised in a hooded anorak. Tom Ryan did a very funny cartoon for me of 'The General' visiting the Gallery.

VR: *Lady Clementine Beit is still alive.*[10]

HP: I believe she will be 90 this year [2005]. She was quite beautiful. He was very handsome. They were a striking couple. Lady Beit was born a Mitford and she would boast that if she was a man, she would be Lord Redesdale.

VR: *Isn't one of her cousins the Duchess of Devonshire? They are doing lovely things with contemporary art in Lismore. What were the Beits like to chat to?*

HP: The Beits made a point of being agreeable but, understandably, they had an hauteur. There was nothing un-nice about them, though. They were very, very devoted to each other. Were they out of touch like many such people? It's too simple to say they weren't in touch. They'd lived in Ireland for at least 30 years when I met them. I remember talking to Lady Beit and she asked me, 'Are you a Roman Catholic?'. I thought, 'You've been in Ireland twenty or 30 years and you don't know by looking at my face that I'm Protestant'. They were very grand. Then when they first opened Russborough [in 1978], they discovered 'the public' and were fascinated. They would go to the cafeteria on Sunday afternoons and queue with their trays just so they could look at the public. They talked about this. Lady Beit loved telling, in the minutest detail, about the first Russborough robbery [in 1974][11] when she and Sir Alfred were bound and gagged by Rose Dugdale in the library. She was hilarious sometimes, quite unintentionally I fear.

VR: *I think Nancy Mitford's book* Love in a Cold Climate *(1949) is still hilarious.*

*Inviting Sir Alfred Beit onto the board of the Gallery in
1967 was a good thing to do, it seems to me.*

HP: It was a good thing to do. But there are board members who
wouldn't give the Gallery tuppence. They don't think of the
Gallery in that way at all.

VR: *Is the Irish identity thing strange?*

HP: Being Irish, one feels it very strongly in one's bones. It's a draw.
Other people don't have that draw – I suppose they do, all
nationalities do, but I think being Irish is different. We have a
very definite identity. Especially the way we like fun. If you
have an evening with Irish people and an evening with English
people there is no comparison.

When I was director of the Gallery, and that was now
twenty years ago, there were people who to a certain degree
would not think of me as properly Irish. I came up against that
all the time, particularly with civil servants and politicians. They
exuded suspicion of me. At a formal dinner I'd be sitting
between the wives of top civil servants. They'd say, 'Do you like
living in Ireland?' and I'd say 'Yes'. 'How long have you been
here?' they'd say. '35 years,' I'd say. 'We farm in County Meath.
We run cattle markets.' But that was not Irish enough for them.
'You must have gone to school in England,' they'd say. Then I
would reply 'No, I went to school in Kilkenny College.' Finally,
with an air of triumph they'd announce, 'You have to have gone
to Trinity then.' That provincial chauvinism has gone now, I
think.

VR: *Was it painful?*

HP: Yes. Being told you didn't belong to your heritage when you
were working your guts out for Ireland was painful.

VR: *Your father had died before you went to Trinity.*

HP: My brother paid for me in Trinity out of the family firm. But
when I was going to Edinburgh to do post-graduate work, I won
the Purser-Griffith. The Arts Council used to give a grant in those
days. I got that. Because my mother's grandmother was Scots, it
was possible for me to get a grant from some Carnegie fund in

Scotland. So in that way I put myself through Edinburgh.

Trinity was a very intimidating place in those days. Most people are very unsure of themselves at university and I certainly was. I was also shy and I didn't take advantage of the university as much as I could have done. But I did study. I did French and English and then Law for a while. My final degree was in Art History, English and Economics.

VR: *Did you have rooms in Trinity?*

HP: Yes I did. I shared with an Englishman with whom I'm still in touch. I'm godfather to his daughter, who is now a 23-year-old doctor, and she and I have formed a great friendship. When I was in Trinity it was the time of the first *Rosc* [1967]. The effect was electric – as much for the installation in the RDS as for the art. Anne Crookshank and Pat Scott were very involved. The installation was brilliant. Before that I'd only known the RDS as a farmer's son going to the Spring Show and standing under the clock for hours on end after I'd got lost.

I was in Trinity in Anne Crookshank's second year of teaching. You could only do art history as part of a general studies degree. Anne did the works, from the early Greeks to the present day. When I went to do post-graduate work other people on the course were often at sea but I had that survey. Anne taught us so brilliantly. I sat in awe of Anne. I was withdrawn because I was timid and unconfident. I hardly ever spoke to her.

There were only three places you could do post-graduate art history then – the Courtauld Institute, East Anglia and Edinburgh. I applied to the Courtauld. I was interviewed by Anthony Blunt. He was a horrid man, cruel in the interview. It was one of the most unpleasant experiences of my life. Subsequently I met him when I worked in the National Gallery [in London], but I never had the nerve to tell him that he once interviewed me very harshly. I knew I wasn't his physical type. He had his pets – young men. But I had no magic for him.

David Talbot Rice was professor in Edinburgh. He was charm itself. I was turned down by the Courtauld and got a place

in Edinburgh. By coincidence Alistair Rowan was teaching there and I did his course. At that time he was doing research,[12] with research assistants, for his Buildings of Ireland project. I did my research on eighteenth- and nineteenth-century Irish church monuments. I travelled all over Ireland with a camera and note-book. I later published all my findings in my first book, *Irish Church Monuments*.[13] Charlie Brett published it under the aus-pices of the Ulster Architectural Heritage Society. Driving around Ireland at that time opened my eyes and, inadvertently, I became aware of how much was beautiful. Planned villages, for exam-ple. Places like Tyrellspass and the sensitive siting of early nine-teenth century churches in the countryside. Contrived landscapes surrounding country houses. I'd never been aware of that aspect of Ireland before but by then I knew enough to look. I didn't have an entrée into great houses and I didn't have the confidence to seek it. But getting into churches was only a matter of getting the key from the clergyman or the woman in the local shop. On one occasion I found two women scrambling over tombstones in a churchyard. We started to chat. One was Helen Roe, doing her research.[14] She was very dismissive of the fact that I was doing

Homan Potterton and Anne Crookshank in Ramelton 1990.

nineteenth-century funeral monuments.

Later, I knew Ada Leask Longfield who was also dismissive about the nineteenth century. 'Too many documents,' she would sniff. She was notably an acid and difficult person, but for some reason she loved me. She was a tiny little person and she loved putting people down. She did wonderful research[15] in the '40s and '50s on Irish wallpapers and lace. She also discovered the bird paintings of Samuel Dixon. She put those on the map. Her husband was Harold Leask in the OPW, who wrote on Irish castles.[16] He was dead by the time I knew her. She held him in great esteem.

My final thesis for Edinburgh was confined to one sculptor, William Kidwell, but my research covered 1580-1880. I looked at the few seventeenth-century monuments, like the one in Youghal. There weren't many Catholic monuments. There's a beautiful one in Emo. Emo was where the Portarlingtons lived, and a nineteenth-century countess had converted to Catholicism and there's a very affecting recumbent effigy of her in Emo church by Behnes, I think. When I finished in Edinburgh, I was faced with having to have a job. By that stage Anne [Crookshank] was a friend and she told Desmond Guinness about my thesis. He very kindly gave me a job at Leixlip, doing research for him for a couple of months. He also published my Kidwell article in the *Irish Georgian Society Bulletin* and an abbreviated version was accepted by *The Burlington*, which gave me a great thrill.[17]

In my student days in the '60s lots of people went to Castletown House to help with the restoration. Desmond Guinness had saved the house from probable demolition and it became the headquarters for the Georgian Society, which he also founded. I was never a Castletown groupie, I was too reticent. It was a sort of cliquey thing.

VR: *After working for two years in the National Gallery here did you get a job in the National Gallery in London?*

HP: Yes. James White was a great example to me in those two years. He got things done and was always cheerful and friendly. He started the Association of Irish Art Historians at that time and I

was secretary for a while. There was a project to supply biographies of Irish artists to the Thieme-Becker dictionary but nothing ever came of that. Another project at the time, with people like Maurice Craig, Eddie McParland, the Knight of Glin and Jeanne Sheehy was a dictionary of Irish architects. Rolf Loeber, who specialised in the seventeenth century, was the only one who did any work. He found the names of hosts of architects that nobody had ever heard of and became impatient when the rest of us were so Irish and dilatory. The project petered out.

I loved my job in the National Gallery in London – I was there seven years. There were only six curators, including the director. It was very prestigious, though I say so myself. It was a lovely place to work. I loved every minute of it. Getting to know colleagues in other museums and galleries, making friends, and 'living the life' in London was all wonderful. The best years of my life.

VR: *Your guide to the National Gallery[18] in London was very well received.*

HP: Yes. I also wrote the Thames and Hudson book on the National Gallery.[19] Michael Levey [the director] just asked me would I like to do it. The thing is that it was a private contract, and the money I made on it paid my mortgage for years, as the book sold perhaps as many as a quarter of a million copies. It only went off the shelves about five years ago.

VR: *Presumably you didn't buy a home in London?*

HP: I did buy a home in London. I assumed I would work there all my life. I got a flat in Pimlico which was near enough to walk across St James' Park to the National Gallery in Trafalgar Square.

VR: *Tell me about the subsequent careers of the other curators in the London National Gallery.*

HP: Christopher Brown is now director of the Ashmolean in Oxford. Alistair Smith is director of the Whitworth in Manchester. They were the only others who went on to become directors.

VR: *Did you take over from James White as director of the National Gallery exactly 25 years ago, when you were 34?*

HP: Yes, and, amazing though it seems, it's now seventeen years since I left.

VR: *The collection expanded so much under your directorship of eight years. Were you expecting the Máire MacNeill Sweeney gift[20] to be so good?*

HP: No. It was astonishing. The solicitors wrote informing me of the bequest and sent me the list. The Picasso was on it. I wrote back and said thanks very much. We often got letters like that. I'd never heard of Máire MacNeill Sweeney, I'm ashamed to say. The carriers went to collect the pictures and they were in the Gallery for a few days before I bothered to go and look at them. I thought the likelihood of the Picasso being real was very remote. I thought then 'Good Lord, how amazing'. Personally, I prefer the Gris [*Pierrot*] to the Picasso [*Still Life with a Mandolin 1924*].

It's very American that she would think of giving them. It's not the ethos in Europe to give the way it is in America. In America people, especially Jews, are very generous in what they give to museums.

VR: *Tell me about some of the smaller gifts and bequests.*

HP: I do remember getting the huge seventeenth-century landscape from Mrs Murnaghan, Judge Murnaghan's widow. It was in the mews in the back of her house in Fitzwilliam Street. It is vast. She wanted to give it as a gift to the Gallery because the painting was so colossal. The men wheeled it across on a trolley one Sunday morning. Michael Wynne researched the picture and found out that it was a Murillo [*The Meeting of Jacob and Rachel at the Well*]. It had to be cleaned. It was several years before it was shown.

I'd bought the Moynan *Military Manoeuvres*. Moynan was hardly known then, and Gordon Lambert, who was on the board, said to me, 'That's funny, I have Moynan sketchbooks. I knew his daughter'. He gave the sketchbooks to the Gallery. Gordon was very discreet. He and David [Hendriks] were partners, although Gordon was not someone who would ever want to parade that. But the link with David was extremely important

to Gordon's development as a collector. His bereavement following David's death he kept very private. I knew Gordon well personally but he still maintained his privacy. I'd known him since I was a student, through a mutual friend. Then he wanted to give the Hennessy painting [*The Oracle, c.* 1967] to the Gallery in memory of David. I was very pleased because I had known David as well.

VR: *Can we talk about purchases?*

HP: In the old master European context the Gallery didn't have much that was twentieth century. My predecessors like Doyle and Armstrong had bought lesser names, but better pictures. 'Let's go for lesser names,' I said. So we bought the Soutine *Landscape with a Flight of Stairs* and Nolde's *Women in a Garden*. Also, a Signac [*Lady on a Terrace*] and a Kees van Dongen [*Stella in a Flowered Hat* (c. 1907)]. People said the woman in that looked like Rosaleen Linehan.

VR: *The board allowed you to buy at auction, spending up to a quarter of a million pounds without needing prior ratification by them.*

HP: I liked the business of buying at auction. I bought the Pissarro *Chrysanthemums in a Chinese Vase* in New York at auction. That was great fun.

VR: *Your family's involvement with auctioneering didn't go astray.*

HP: No. I wasn't frightened of bidding.

VR: *Did you find the modest purchasing budget a serious problem?*

HP: It wasn't the main problem. I did manage to buy quite a lot. There was the Lane Fund and the Shaw Fund. The collection was already fabulous. The '80s were a very depressing time in Ireland. The public finances were in a parlous state. There were enormous cutbacks in terms of staffing throughout the public sector and that affected the Gallery. Not only was there no chance of getting extra staff but existing posts were cancelled out when someone left.

VR: *When in 1982 responsibility for the Gallery went from the Department of Education to the Office of an Taoiseach, where*

Hanging Wheatley's The Marquis and Marchioness of Antrim,
c. 1780, in the National Gallery, 20 December, 1980. Left to right:
Homan Potterton, Peter Noctor, Matthew Crowe and Matthew Russell.
Photo by Jack McManus, courtesy of The Irish Times.

Ted Nealon was the first Minister of State with responsibility for the arts, did it get easier?

HP: Ted Nealon was someone I did find open, very open. But he wasn't able to do anything for me. There was no money for refurbishment. The Gallery was in a hideous state, which made me very ashamed. The storage facilities were horrific and dangerous, dangerous in terms of fire risk and security. Lack of funds to purchase was not the main problem.

It was important to buy Irish pictures abreast with what scholarship was turning up. When I went to the Gallery in 1971 the best-known Irish painters then were James Arthur O'Connor and Sadler. Also Jack Yeats, of course.

VR: *In the portrait of you as director by Andrew Festing, you are surrounded by your favourite Gallery paintings, including the*

James Barry self portrait and the double portrait of the Earl Bishop of Derry and his granddaughter.

HP: I commissioned that portrait of me as director privately, it's mine. The room, which was my office, is shown exactly as it was. I had it painted that green colour and the paintings were hung floor-to-ceiling like that. Instead of the pictures which actually hung there, however, I had Andrew 'insert' into the frames paintings that meant something to me. Every picture within the picture is there for a reason. The Nolde, the acquisition that I was proudest of, is deliberately shown nonchalantly thrown on the floor, for fun.

The Gallery has no policy in regard to having portraits of its directors. Edward McGuire painted James White and I bought that and I persuaded George Furlong, who, as an old man was a friend of mine to present his portrait by Frances Kelly. There's no portrait of Doyle or of Langton Douglas [in the collection].[21]

I was thrilled to be able to buy the portrait of the Earl Bishop by Hugh Douglas Hamilton. Neo-classicism in art is close to my heart: there was a fabulous exhibition at the RA when I was a student and that set me off. I love Hugh Douglas Hamilton's pictures. I love Rome, I know the Borghese gardens [where the painting is set] very well. I just think it's an absolutely beautiful picture.

Homan Potterton and Dr Michael Wynne discussing The Earl Bishop of Derry *with his granddaughter Lady Caroline Crichton, c. 1790. Photo by Paddy Whelan, courtesy of* The Irish Times.

VR: *Two of the great scholars on nineteenth-century Irish art,*

Jeanne Sheehy and Julian Campbell, were of your generation.

HP: Jeanne was a great friend of mine. We were friends when we were both starting out. She had done her thesis in Trinity on Walter Osborne. She went back to study after being in Paris for several years. Julian and John Hutchinson were the next generation; they were a bit after me. Eddie McParland had just gone in to teach in Trinity. Roger Stalley was already there by then. We looked up to people like Anne Crookshank and Maurice Craig and Cyril Barrett. But, as we were all regarded as 'Trinity', we were anathema to Françoise Henry in UCD. Françoise, who was *très formidable*, put up this great barrier between herself and Anne Crookshank. Ironically, years later, Françoise was on the board of the National Gallery when I applied for the directorship. I heard afterwards that some board members favoured an American applicant but Françoise, who was by then quite ill and had to be brought to the board meeting in a wheelchair, became her most magisterial – she was colossal physically – and told the board firmly that they had got to appoint me. 'I wasn't going to be dictated to by businessmen', she told her friends afterwards.

Maurice Craig, who had lived all his life in England and always wanted to return to Ireland, was back in Dublin by the early '70s and he was both an inspiration and very helpful to people like Jeanne and Eddie and me. Jeanne taking up Osborne, a painter that few people gave much thought to, and Julian following into the Irish artists in France opened up vistas of research that no one had ever dreamed of. Their work was seminal. Jeanne and I wrote a book on Irish art with Peter Harbison.[22] We had written it as a schoolbook. I had the contact with Thames and Hudson as I was doing the National Gallery book for them and I asked them if they would do the Irish book. They were delighted. They later realised what a market there is for Irish art books. When Jeanne was writing her Celtic Revival book[23] she was aware there were acres of research to be done. She knew it wasn't in-depth research. The book's great forte is that it brought the material to people's attention. She knew

what she had to say was important, but she also knew she was only touching the surface of the subject. Then she got a permanent job in Oxford Poly. That's where she made her life – she was happy. She was another, like me, who love Ireland but was aware of its pitfalls and had a dual attitude to it. I think she was happier out of it.

VR: *Her dad, Edward Sheehy, had been an art critic, hadn't he?*

HP: He had. Jeanne was very Irish. She put herself through Trinity by designing fabrics for Donald Davies. She had a gift for designing colour. They gave her a little hand loom and she put the colours together. By happy accident they were always the best sellers. It wasn't scientific, it was a gift she had. I remember being in a café with her and her saying, 'That woman over there is wearing my design'. She lived in Enniskerry. Gifford Lewis, who wrote about Somerville and Ross and the Yeats sisters, set up the little printing press that published Jeanne's book on Osborne.[24]

VR: *Was that before Jeanne published on the Gothic Revival?*[25]

HP: Yes, I think so. Jeanne died four or five years ago [in 1999]. We hadn't been so close in later years. In the '70s when I was working in London and she was in Oxford we were very close friends. She could also have a sharp side, she could put you down.

VR: *The Irish exhibitions in the Gallery were wonderful.*

HP: James White was a great person for organising temporary exhibitions. When I came, I wanted to do the catalogues of the permanent collection as an absolute priority. So I asked the board to put a moratorium on temporary exhibitions for two years. I knew there were good theses coming through in both the universities. Alistair Rowan was professor in UCD and he and Eileen Kane would say who was working on what. The same from Trinity. I thought it would serve everyone to get the people who had written the good theses – Jeanne, John Hutchinson,[26] Julian – to curate temporary exhibitions within their fields of research and write the catalogues. That was the start of so much.

The Irish Impressionists[27] was a silly title I put on Julian's exhibition for marketing purposes. Julian, understandably, did

not care for the title, as he knew it was nonsense. Tom Ryan [PRHA], the artist, was on the board and he did a cartoon and gave it to me. It was of an exhibition of pictures all hung on the ceiling, and the spectators all lying on the floor. The caption read: 'Now after the Irish Impressionist painters, let me present the Irish Sistine painters.'

It was good that Julian's work, which was so valuable and so scholarly, was made available in such a popular exhibition. The public responded very well. Julian is an example of someone who likes to share his learning. Those exhibitions, in retrospect, are ones I'm very proud of. Their success was due to Jeanne and Julian.

I'm also very proud of the series of catalogues of the permanent collection. Museums always make excuses for not doing catalogues. We had no resources but we got these catalogues done: I was absolutely determined to prove it was possible. AIB gave the cataloguing programme a lift by sponsoring *The Illustrated Summary Catalogue* very handsomely.

VR: *Did you have a favourite painting in The Irish Impressionists?*

HP: Everyone loved and I loved the little Aloysius O'Kelly *Girl in a Meadow*.

VR: *You yourself later published something on Aloysius O'Kelly.*[28]

HP: Only an article about his time in New York. I was living in New York and it was easy for me to find out about him. I also studied the John Quinn papers in the New York Public Library and wrote a couple of articles about his patronage of Irish artists, notably Jack Yeats.[29] Years earlier, I'd done work on the American-Irish sculptor Andrew O'Connor at the time of his centenary in 1974.[30] Patrick O'Connor, his son, had been curator of the Municipal Gallery. I knew Patrick. He was a rather larger than life, colourful character but very helpful to me when I was doing research on his father.

VR: *Is Andrew O Connor, one of the first staff members of the Restoration Department which James White set up, the sculptor's grandson and son of Patrick O'Connor?*

HP: Yes.

James White was a terrific presence and a very nice man. He and I always got on very well. We became friends and confidants.

VR: *Was Michael Wynne assistant director under James and you?*

HP: Michael Wynne was a friend of mine from the time I'd worked in the Gallery in the early '70s, when I was very junior and he was already eminent. We remained friends in the years I worked in London and we would always see each other whenever he came over. He used to stay in the Travellers Club on Pall Mall. He had always 'enjoyed' poor health. It was an ulcer problem in the early days. In later years his health really did decline. He had several breakdowns and his eccentricities became much more marked – this is noticeable in his writings from the time – so that he was not an easy colleague and it was difficult to be indulgent towards him. However, as director, I did manage to pressurise him into completing the *Later Italian Paintings*[31] and that was something. Good for his self-esteem too. But it was not always easy to find him whenever he was needed. The University Club was a favourite haunt and I think quite a lot of time was spent in Clarendon Street church. You see, his faith was very important to him. So was his snuff. There was a lot of dribbling. I suppose he was a good old-fashioned eccentric. But he died in a very sad way.

VR: *Yes, he was so gentle. Tell me about the younger staff, people like Barbara Dawson and Kim Mai Mooney.*

HP: They were the bright side of working in the Gallery. The Gallery was understaffed and there were huge restrictions on taking on staff. Through Manpower, I got a scheme going and I got young graduates from both universities to come in. They were only paid £50 a week. It gave them work experience. A lot of very good people like Barbara Dawson, Kim Mai Mooney, Wanda Ryan Smolin, Frances Gillespie, Nuala Fenton, Anne Millar and Joanna Mitchel worked under the scheme. They were terrific. Then I raised some money and when the six months were up, I was able to offer some of them scholarships, little scholarships, so that

they could continue in the Gallery. Barbara Dawson asked to come and see me. I was going to offer her a scholarship. 'My mother tells me I'm wasting my time here and should get a proper job,' she said. 'I can tell you my mother once said exactly the same thing to me and look where I am now', I said to her. Within ten years [by 1991] Barbara was director of the Hugh Lane. Barbara came from a somewhat similar business/ farming background to me. Although she pretended to be ditzy, she was anything but. She was very serious in her approach to her work.

My PA, Honor Quinlan, was also an honours graduate in Art History from Trinity and a super-efficient PA. Janet Drew, also a Trinity graduate, came after her and likewise was a treat to work with. The point was, although I don't know if I'm allowed to say this without seeming sexist, that a lot of those young women were very alluring. They were smart, they were savvy, they were lovely people, and they were very professional in their work. I got them to write and publish. Most of the older staff had been there since the expansion of the Gallery, about 1968. They came to resent these younger people. I seem to remember the Union coming at the behest of the older staff to try and stop me taking them on.

Adrian le Harivel, whom I took on, was a dynamo. I had been temporary cataloguer and when I left John Hutchinson got my job. Adrian graduated from Edinburgh. He was a brilliant worker with an open, enquiring mind. Terrific at doing work on those illustrated summary catalogues.[32]

VR: *Did Kim Mai always dress in an extraordinarily beautiful way?*

HP: She was either wind in the willows or else a lotus flower about to open. She is half Vietnamese. She had a lot of antique clothes: beautiful lace and muslins.

VR: *Were you at her wedding to Raymond Keaveney?*

HP: It was in University Church on St Stephen's Green and the reception was in the Shelbourne. It was a full Nuptial Mass and I remember a solo *Panis Angelicus* that was haunting. It must have been the first time ever anything like romance blossomed

in the National Gallery. Maybe that's why the marriage didn't last, which was a great shame.

When I went to the National Gallery the assistant directorship was vacant. Michael Wynne had been assistant director. Before I came in, he was given the opportunity of becoming keeper on an equivalent grade. I said to the board that I would like to keep the position of assistant director vacant for a year, to see were there suitable candidates within the Gallery. The job was duly publicly advertised. By then, I had formed a very high opinion of Raymond, who was very willing and efficient and practical. I thought he would be excellent. The board interviewed and made the appointment. I was delighted it was Raymond. I liked working with him very much and he proved to be excellent. I'd say to him, 'Will you get the Board of Works in and get that room decorated', and he'd go and do it. In his personal character he was much more acceptable than I was to the civil servants in the Department of Education and the Board of Works, who had responsibility for the Gallery. That was a big point in his favour when it came to being assistant director.

Raymond was well trained. He was knowledgeable about art and he had scholarly ability. He had lived in Paris and he'd lived in Rome. I did commission him to do a catalogue of the earlier Italian paintings, about which he knew a lot, but his administrative duties came in the way of his getting that done. He comes from a very successful business family.

VR: *Peter Mark, the hairdressing magnates, are his brothers, aren't they?*

HP: Yes.

VR: *It was great the way you got as many staff as possible involved in publishing – with the* Fifty Pictures *series, for example.*

HP: That series gave the public an informed commentary on parts of the collection. There were different titles: *Fifty Irish Paintings*, *Fifty Watercolours*, *Fifty Views of Ireland*, *Fifty French Paintings*, etc. I paid all the authors a fee out of the bookshop funds.

VR: *Ann Stewart did* Fifty Irish Portraits.

HP: Yes, at my request. Ann had started making a compilation of RHA exhibitors at the time I was working in the Gallery in the early '70s. It was a terrific idea. But it was her private work and not a Gallery project. She started long before computers made such compilations easier. Her published volumes are an incredibly valuable contribution to the study of Irish art, as they document a phenomenal number of artists and their pictures.[33] It's almost on a par with Strickland and, of course, Strickland also worked in the Gallery when he was compiling his *Dictionary [of Irish Artists (1913)]*. Ann's achievement will remain undimmed for generations to come. What generations to come won't know – any more than we know anything personal about Strickland – is that Ann Stewart is a complex and difficult personality, a thorn in the side of the Gallery's administration for more than 30 years.

VR: *Are you thinking of the closure of the Library to the public?*

HP: Yes, and other aspects of her record too, all well-documented in the minutes of the board. She developed novel ideas about the duties of a librarian, which precluded her from performing many of the tasks that such a post normally demands. The library suffered as a result, and the Gallery as a whole suffered too.

Ann and I had been friends in the past. When I worked in the Gallery in 1971-1973, she lived next door to me. I had a house on the Rathgar Road. Ann shared a flat with Fiona Duignan, who was the daughter of M.V. Duignan, professor of archaeology in Galway. They gave parties and that was where I first met Mairéad Dunlevy, a bright new light in the dim corridors of the National Museum. Michael Ryan was also new then at the Museum and I met him for the first time there too. Also Mary Kelleher who later became librarian at the RDS. Colm Gallagher, who knew about Irish coinage, but worked in the Department of Finance, was also a friend of Ann's.

In order to pay my mortgage I rented out rooms. Upstairs there was the actor, Alan Stanford, then newly-arrived from England; and also another actor, Gerard McSorley. The photographer

Mike Bunn, who had also just arrived from England, shared the basement with Jim Bartley, who was then the heart-throb in *The Riordans* on RTÉ. It was quite extraordinary and quite a coincidence having all these people who turned out to be celebrities. They were all unknowns then. I lived in one room myself. When Gerard McSorley, as the priest in *Dancing at Lughnasa*, was on Broadway in the 1990s, I went backstage and was thrilled to find he remembered well his days in Rathgar Road.

VR: *Institutional unhappiness is a very interesting topic.*

HP: The background for me was that the '80s were a very depressing time in Ireland. The Gallery then, and I think now, was not necessarily the happiest of institutions, in the way that many of the staff had fairly negative attitudes.

I found that also depressing. One of my most abiding memories is the amount of time I spent in the Labour Court and in union confrontations, all of which I should say were only peripherally of my own making. I was still young. I thought I had a lot of my life in front of me and if I stayed in the Gallery I too could become very negative. So without consulting anybody, I put a date into my mind and decided that if the Board of Works did not put the promised refurbishment in hand by that time, I should cop myself on and go. Maybe it was a foolish decision but I have no regrets now. The day I left Ireland, in June 1988, the Irish recession ended. The good times rolled. It's a different world now.

I'm realistic about happiness. At the time I was in the Gallery I was happy and content in my private life – I still am – and that has always made a great difference to me. I think a person's attitude is different if they do not have the responsibility – and the expense – of bringing up a family. I didn't, so I was free to do as I wished. All I needed was a suitcase.

A lot of people won't move on. I have a lot of friends in Dublin and had a lot of fun there but I was unhappy because of the frustrations of the job. In a way, the Beit robbery was the last straw. There I was, going to get the Beit pictures for the Gallery,

and they were gone. Following the robbery I had some uneasy brushes with the Dublin criminal underworld and I didn't really care for that. I thought, 'this job, the directorship, is now becoming ridiculous'. I'd thoroughly enjoyed the life of being director of the Gallery. Equally I'd had enough and wanted a normal life.

VR: *Do you advise collectors now?*

HP: No. I've never had any success advising anyone, because I get irritated when they don't take my advice. I don't have the manner. I don't like having to butter up rich people. I couldn't be bothered. It's not one of my fortes.

VR: *Tell me about your time in New York, where you went after resigning as director.*

HP: I lived in the Upper West Side, very centrally – on West 71st street. I had a beautiful flat. I wrote for the *Financial Times* on a freelance basis. It was quite well paid. I was able to select what I wrote about. I was in a world I liked. I also wrote for *Apollo.*[34] I was writing *Rathcormick* at the same time. Journalism was quite good for that. I liked music and I went to a lot of concerts, also theatre, and I travelled all over the States.

VR: *Did you have many Irish people coming to stay?*

HP: Too many.

VR: *You became editor of the* Irish Arts Review, *then a yearbook.*

HP: What did I do? I did eight issues. I think I only did eight. My life goes in tranches of seven or eight. Ann Reihill rang me and asked me to do it. When Brian de Breffny died in 1989, Ann asked Alistair Smith, an Englishman, to be editor. Then he became director of the Whitworth and he didn't have the time. So he gave it up. She then asked me.

VR: *He had been a candidate for the directorship of the Gallery after you, hadn't he? There was quite a fuss*[35] *about it, Raymond eventually becoming your successor.*

HP: Yes; but I had moved on and I didn't concern myself with all that. I loved the *Irish Arts Review*, as I had I loved the publishing side in the Gallery. I would find out who was researching what and commission people to write articles on their subject. I

also loved putting the book review section together. But I wasn't in Ireland enough to make the *Review* topical. It occupied about four months of the year full time, and there was always something to be done at other times as well.

There's nothing equivalent for English art. Brian de Breffny and Ann Reihill created it. Ann put her money behind it.

VR: *You yourself bought it from Ann Reihill?*

HP: At the very end – during the last two years – Ann wanted to dispose of it. She had put fifteen years into it. I wanted to keep it going, so I decided to risk owning it. It did become too onerous to do it from abroad – advertising was very important and if I wasn't there to keep an eye on it, it wouldn't work. John Mulcahy, who bought it, does a very good job.

VR: *You annoyed the dealers a bit when you started to publish the auction prices – something that will be very helpful to future scholars.*

HP: The dealers were understandably annoyed. When I worked out that it was feasible to do an art price index, I decided it would be interesting. The prices were published in *Art Index* anyway. Dealers have a shop to run and a stock to maintain, anyone would know they'd have to have a mark up, but they didn't like the extent of their mark up being made so readily available. Several of them withdrew their advertising and were quite bad-tempered about it.

VR: *Why did you leave New York?*

HP: After about five or six years I found the cultural differences between Europe and America too much. I began to find the Americans very tiresome. Their level of education is very odd. Then there is their naivety ... if that is the word. I just felt that I'd be more at home in Europe. I love Ireland but I have always wanted to live abroad. I like being an outsider. I like France and the French. In retrospect, all my moving on has always ultimately opened up other excitements. If I'd stayed in the Gallery, I'd never have written *Rathcormick*. That's the thing I've done I'm most proud of, that's a vindication for myself.

In conversation, Gaillac, 23 June 2005, Toulouse, 26 June 2005.

1. Potterton, H., *Rathcormick: a Childhood Recalled*, Dublin, 2001.
2. Potterton, H., *Dutch Seventeenth- and Eighteenth-Century Paintings in the National Gallery of Ireland: A Complete Catalogue*, Dublin, 1986.
3. Potterton, H., *Dutch Paintings of the Golden Age from the Collection of the National Gallery of Ireland*, Washington, 1987.
4. 'Recently cleaned Dutch Pictures in the National Gallery of Ireland', *Apollo*, February 1982.
5. *Masterpieces from the National Gallery of Ireland*, Exhibition at the National Gallery, London, March-May 1985. Catalogue by Keaveney, R., Le Harivel, A., Potterton, H. and Wynne, M.
6. Somerville-Large, P., *The Story of the National Gallery of Ireland, 1854-2004*, Dublin, 2004, pp. 191-9.
7. *National Gallery of Ireland: Illustrated Summary Catalogue of Paintings*. Introduction by Potterton, H., Dublin, 1981.
8. Benedetti, S., *The Milltowns: A family reunion*, Dublin, 1997 and Kelly, A. 'The Milltown Collection', *Irish Arts Review*, Autumn 2005, pp. 114-7.
9. Kennedy, B.P., *Alfred Chester Beatty and Ireland 1950-1968: A Study in Cultural Politics*, Dublin, 1988.
10. Lady Clementine Beit died on 17 August 2005. *The Irish Arts Review* Winter 2005 reprinted Sir Alfred Beit's (1903-1994) essay on Russborough pp. 120-124.
11. Hart, M., *The Irish Game: A True Story of Crime and Art*, New York, 2004.
12. Rowan, A., *The Buildings of Ireland, North-West Ulster*, London 1979.
13. Potterton, H., *Irish Church Monuments 1570-1880*, Ulster Architectural Heritage Society, 1975.
14. Roe, H., *The High Crosses of Western Ossory*, Kilkenny, 1958.
15. Ada Leask Longfield 'An Index of paper stainers in Dublin, Cork, Limerick and Waterford', IRSAI LXXVII (1947) Part 11, pp. 117-120 and *National Museum of Ireland Guide to the Collection of Lace*, Dublin, 1982.
16. Leask, H., *Irish Castles,* Dundalk, 1949.
17. Potterton, H., 'William Kidwell Sculptor and some contemporary mason-sculptors in Ireland', *IGS* Quarterly Bulletin, July-December, 1972; 'A new pupil of Edward Pierce', *Burlington Magazine*, December 1972.
18. Potterton, H., *A Guide to the National Gallery*, London, 1976.
19. Potterton, H., *The National Gallery*, London, 1977.
20. Máire Mac Neill Sweeney (1904-1987) began working in The Folklore

Commission, with Séamus Ó Duilearga, in 1935. She married John Sweeney in 1949 and worked in Harvard, in the Celtic Department, publishing regularly. They came to live in Ireland, in Corofin County Clare, in 1967. He died in 1986 and the paintings they left to the National Gallery were valued at her death at £10 million. See Ní Mhurchú, M. agus Breathnach, D. *Beathaisnéis 1983-2002.* Baile Atha Cliath, 2003.

21. Tuohy painted a portrait of Captain Langton Douglas. See Murphy, P.J. *Patrick Tuohy from conversations with his friends,* Dublin 2004, pp.89-91.
22. Harbison, P., Potterton, H. and Sheehy, J,. *Irish Art and Architecture; From Pre-history to the Present,* London, 1978.
23. Sheehy, J., *The Rediscovery of Ireland's Past: The Celtic Revival 1830-1930,* London, 1980.
24. Sheehy, J., *Walter Osborne,* Ballycotton, 1974.
25. Sheehy, J., *J.J. McCarthy and the Gothic Revival in Ireland,* Belfast, 1977.
26. Hutchinson, J., *James Arthur O'Connor,* Dublin, 1985.
27. Campbell, J., *The Irish Impressionists/Irish Artists in France and Belgium 1850-1914,* Dublin, 1984.
28. Potterton, H., 'Aloysius O'Kelly in America,' *Irish Arts Review Yearbook,* vol. 12, 1996, pp. 91-4.
29. Potterton, H., 'Jack B. Yeats and John Quinn', *Irish Arts Review Yearbook,* vol. 9, 1993, pp. 102-114; 'Letters from St Louis: Ireland's Exhibit at the St Louis World's Fair 1904', *Irish Arts Review Yearbook,* vol. 10, 1994, pp. 245-51.
30. Potterton, H., Exhibition catalogue, *Andrew O'Connor, Sculptor,* Dublin, 1974.
31. Wynne, M., *Later Italian Paintings in the National Gallery of Ireland – the Seventeenth, Eighteenth and Nineteenth Centuries,* Dublin, 1986.
32. Le Harivel, A., (compiler) *National Gallery of Ireland: Illustrated Summary Catalogue of Drawings, Watercolours, and Miniatures,* Dublin, 1983; Le Harivel, A. (ed), *National Gallery of Ireland: Illustrated Summary Catalogue of Prints and Sculpture* Dublin, 1988.
33. Stewart, A., *Royal Hibernian Academy of Arts: Index of Exhibitors and their Works, 1826-1979,* 2 vols. Dublin, 1986/87.
34. *Apollo,* April, May, June, July and December 1989; April, June, July, September and November 1991; April 1992.
35. Arnold, B., 'A Gallery in Crisis', *Magill,* April 1999 pp. 30-36.

Left to right: Patrick Pye, Hilary Pyle and David Hendriks at Patrick Pye's
exhibition in the Cork Arts Society, 16 Lavitt's Quay, Cork, 1973.
Courtesy of the Irish Examiner.

Hilary Pyle

*Hilary Pyle was born in Dublin in 1936 and educated at Knockrabo and
Alexandra College. She took degrees at Trinity College, Dublin and Cam-
bridge University, England, and worked at Ockenden in Surrey, before work-
ing in the Ulster Museum from 1961 to 1963. She has been writing on con-
temporary art since 1963. Her publications include books on artistic, liter-
ary and cultural figures. She worked in the National Gallery of Ireland from
1965 to 1970. In 1969, she married Maurice Carey, who became Dean of
Cork two years later. They have four children. She was Yeats curator at the
National Gallery from 1994 to 2004.*

VR: *Hilary, the Brian O'Doherty drawing of Jack Yeats is on the left
as you enter the Yeats Room in the National Gallery; he gave it*

in honour of you, and your pivotal role in Yeats studies.

HP: I was very grateful – stunned at his gesture. It was quite unexpected.

VR: *Had you known him?*

HP: Yes, mostly recently, but in fact I'd been corresponding with him for years. He wrote the first penetrating article on Yeats.[1] He had a feel for Yeats' work. He visited Yeats a lot in Portobello before he died there in 1957, and he made that most moving drawing about two weeks before he died.

VR: *You started working on Yeats a few years later?*

HP: Yes, I did. I had written a book on the poet James Stephens and the publisher with whom I'd got on very well said 'What's next?'. I said I'd like to write on Irish women artists. No one had written about Irish women artists then, or on Jack Yeats – W.B. had his centenary that year (that is,1965). There was an interest in Jack just on the edge of all the celebration. I grew up on *The Turfcutter's Donkey* by Patricia Lynch, which was illustrated by Yeats. The book really belonged to my brother Fergus but I think I read it more than he did. There's a rawness to the drawings. They're so vivacious, not bland or juvenile in style. That was illustrated by him in the '30s. I also grew up on the Cuala cards, which are earlier than that. Having grown up on *The Turfcutter's* drawings I had no trouble with the fact that Yeats' style changed. An awful lot of people find that a hurdle. But artists grow. As they get older and more relaxed the line loosens. Yeats said the artist starts by expressing himself in line and then breaks from its confines.

VR: *Where did you grow up?*

HP: I grew up in Mount Merrion in south Dublin. I was born in Carrickmines. The house was too small. When my sister was born, my parents put their name on a house that was being built in Mount Merrion. To go to school in Goatstown we had to walk about two miles through the Deer Park woods. At the top of Mount Merrion Avenue was Mount Merrion House, I think it was the Herbert family house. At the time we lived there, part

Patrick Ireland, Hilary Pyle and Andy McGowan.

of it had become the local church. The building was a long, low house with the stables opposite it, and I remember going up to get gas masks there during the war. The new building was a conglomeration of church and priest's house. It has since been superseded by a bigger church. The national school was the other part of that complex. The little Catholic boys used to throw stones at us when we were passing to go up to the wood. We hated it. Then one day we lost a purse and the priest announced this at Mass. The ring leader, a little red-haired boy, found it and got a reward of sixpence, and after that there was no more throwing of stones – in fact, we used to smile at each other.

VR: *Tell me about your family.*

HP: We were a Protestant family and there were other Protestants in Mount Merrion. We lived next door to someone who worked in the Ulster Bank and owned a car. My father didn't get a car till I was sixteen. He was a TCD lecturer; they were paid absolutely nothing. But at least you got reduced fees when

your children went to college. It was the same in the Church – you got by on benefits. When I went to Trinity in 1954 the fees were about £10 a year: and we all went to college. My father lectured in medieval and modern English and was an authority on Shakespeare and Milton. He acted with the Dublin Shakespeare Society and would get us to put on little plays at Christmas, just in the family. He took part in a mummer's play we did, he could play any part. His family came from Birr; his name Fitzroy was a Mitchell name. His mother was Kathleen Mitchell. Both my parents were very musical – in different ways – Mother was a fine pianist. She was very gifted. She would sing Irish ballads and Tom Moore songs to us, and she could repeat all the poetry she had learned by rote at school – you know *L'Allegro* and *Il Penseroso*! She was an omnivorous reader.

My sister Fionnuala had a very academic brain and she was very artistic too. She went digging in Tara when she was fifteen, with Professor Macalister. She dug up the first skeleton to be found there. She knew all the archaeologists like Etienne Rynne and Brendán Ó Ríordáin, who were students then. When Macalister died, something switched off for her. Tara, of course, is under threat now – I think O'Ríordáin's reconstruction of the entrance was the only interference for centuries – but now this new motorway will split up the hinterland and cause immeasurable cultural destruction. She did natural science in Trinity. Fionnuala – she was called Bibi – then went into Guinness' to become records officer. She could write really imaginatively and should have done brilliant things but she never seemed to have the urge. There seems to be some barrier between having the burning desire to achieve and having the ability, but not necessarily having a goal. Fergus was the one who had no fear of doing anything. He wasn't shy. He was, as my mother said, an absolute extrovert.

As children, my mother encouraged us to go to the National Gallery. She had a little book with black and white portraits of Irish men and women – I remember in particular Lady Pamela

Fitzgerald with her daughter. I suppose Mother talked to us about art a lot but there was no art history training then. The fact is that if you were an educated person you looked at pictures. I used to go to Françoise Henry's lectures at UCD. She was very decent, she'd let Trinity students go to the lectures.

My mother was called Patricia Conerney. I think it's an anglicisation of McInerney. She came from Clare. Her grandfather and uncle converted from Catholicism in the nineteenth century and both became Church of Ireland pastors and clergymen – they were Irish speakers. I don't know how fluent Daddó, my mother's father, was. He was brought up in Belfast with a Scottish mother and he went to Queen's [University]. My parents were students in the 1920s and both learned Irish.

I'm a member of Cumann Gaelach na hEaglaise. It was founded in 1914. There were people agitating from about 1907, Seán O'Casey among them, for Church of Ireland services in the Irish language. From 1914 they held regular services in St Patrick's Cathedral and in Christ Church. It's not a large group but it still has a faithful following.

VR: *I think Bishop Gregg who was so supportive of Burges doing St FinBarre's Cathedral in Cork had fluent Irish – in the mid 1860s.*

HP: Yes indeed. Many members of the Church of Ireland had and have a great love of the Irish language and feel that the Church of Ireland is a continuation of the original Irish church founded by St Patrick, which did not concede to Rome. While I was at school the Catholics seemed far more fluent. When I did a degree in Irish at Trinity, the Catholics were also far more fluent. I was very impressed by their Irish.

VR: *There would have been very few Catholics in Trinity then surely? Wasn't their attendance prohibited by the bishops?*

HP: Kerry Catholics, for instance Brendan Kennelly, had no problem about going to Trinity, and there were some Dublin Catholics who ignored the archbishop – also lecturers.

VR: *Your parents gave Irish names to two of their four children.*

HP: I was meant to be called Gráinne. But some people living near us had a daughter of about nine called Gráinne and my parents liked the name, but thought it might seem they were copying them. My grandmother Conerney had just come back from visiting a church of St Hilary's in Wales and thought Hilary was a suitable name. Daddó, my grandfather, was delighted when told about my birth, because the first two children were boys. He lived in Rathgar and would walk in and out of the city. On Rathmines Road he met someone who asked had the baby arrived. It was 14 July – Liberty, Fraternity, Equality, you know – and when asked what I was to be called he said 'Bastille!'. My brother Fergus was born on 17 March. The fact that we were born on momentous days affected us – at least we were quite proud of it.

VR: *He went on to be the editor of* The Irish Times *and you became a writer. The Yeats painting on the Gráinne and Diarmuid theme,* The Death of Diarmuid – the Last Handful of Water, *on loan from the Tate, in the National Gallery here, is very dramatic, isn't it?*

HP: Yes, it is. He actually did another painting on the same theme – *And Gráinne Saw this Sun Sink.* The picture from the Tate refers directly to the legend. The second picture links the epic to landscape – to a particular place. It transfers an agonising moment to a place we now know in modern times. Gráinne had married Finn but then eloped with Diarmuid, a much younger man, who had been very loyal to Finn. They remained in exile in Scotland for years but were persuaded to come back. Diarmuid was lured into a wood where he was wounded and the only person who could cure him was Finn. It was the administration of water that was the cure and Finn could offer the water three times. He loved Diarmuid, but each time he let it slip through his fingers. When it came to the third time he faltered as he remembered how Gráinne had eloped and the water slipped through his fingers. Diarmuid died. It is the moment before the last handful of water slipped away that is painted by Yeats in the Tate picture. There are other great water

pictures by Yeats. For him water had a sacramental quality.

VR: *Yeats had earlier done a tiny drawing of some of the Irish Renaissance figures attending W.B.'s play,* Diarmuid and Gráinne.

HP: I think when someone makes a drawing it leaves an indelible impression on their mind. That drawing was made during the heyday of Irish theatre, when W.B. was using Irish themes for his dramas. In that drawing Jack is just recording a particular night at the theatre. He may not have looked back particularly to that drawing when making his great painting 40 years later, but it would have remained in his mind, like a seed stretching itself.

VR: *Did you know Thomas MacGreevy, director of the National Gallery until 1963, and a great supporter of Yeats?*

HP: I must have met MacGreevy at openings in the Dawson Gallery. I knew him. I went to see MacGreevy about James Stephens and about Jack Yeats, because he knew them both. He wrote a little book on Yeats which came out after the war. He would be sitting at this lovely desk in his office in the Gallery. It had belonged to Hugh Lane. Ethna Waldron was at his shoulder, he depended greatly on her. She had a very clear and sympathetic mind. She was there right through the interview. I found him a bit pompous. We weren't on the same wavelength and I was not a very commanding person. I was too shy.

Ethna Waldron has been absolutely low profile since she retired from the Municipal Gallery [in the mid '80s]. She had the wisdom to bring in Cecil King to help her with the hanging. She was a very determined person and did a lot, in very difficult circumstances, for the Hugh Lane.

MacGreevy was really a writer, with a classical literary education and no formal training in art history, but he knew how to look at paintings. And when you come to think of it, there was a close relation between writers and painters during the Irish Renaissance.

I found doing my research that there were three kinds of people; those who loved the artist or writer and their work and wanted to share their stories, those who thought me too young

to have the experience and intellect to give the proper picture, and then the third kind who deliberately held back information for some reason or another. But you do what you can do and at the end of the day whatever you write, your opinion, is only one aspect of the story.

VR: *Would you say that Jack Yeats had considerable literary achievement?*

HP: Yes. In 1930 Jack Yeats published *Sligo*, and in 1944 his last book, *And To You Also*. *In Sand* was published posthumously. He was writing for about ten to fifteen years. *Sligo* was composed really of jottings he made during the '20s. He wrote some novels. The last two prose works, *Ah Well* and *And To You Also*, are in the form of musings by various characters from his novels – very much streams of thought, streams of consciousness.

VR: *Isn't his friendship with Beckett interesting?*

HP: Beckett was looking at his paintings during the '30s and bought some of them. Beckett's books were in his library, Beckett sent them to him. They went for walks along the canal. There was interaction between the two of them.

VR: *Were you working in the National Gallery when you started on Yeats.*

HP: I went to the National Gallery when James White was director. James just rang me one day and said would I come on the staff. My book on Stephens had been published in 1965.[2] His widow had asked an American to write his biography so she wouldn't let me look at his papers. But there were some publications in the Irish language and she let me look at these – in fact she gave me a little book of Irish songs that belonged to him which she didn't want. It has his annotations. In the end the American never published his biography but I was delighted to make a study of Stephens' interest in Irish – as well as of what was a very interesting life in every way. I wrote the *Stephens* book in my spare time. My first two books were written in bed; it was a way of being undisturbed. I wasn't ill but used to go to bed for the weekend and write.

My first job was in the Ulster Museum as assistant to Anne Crookshank; I started there in 1961. Anne is another person – like James – to whom I owe a lot. Some time after I left the Museum she asked me would I go to Italy with herself and Deborah Brown. You could hire a car and get a bed on the first and last night of the holiday as a package deal. We got the smallest baby Fiat. I was told I must bring the smallest suitcase I could. My brother David was in Eason's at the time and I got one for £2 – a nice red colour! They were impressed by the minute size of the case I brought! We went away for several years running, driving around Italy, Holland and Germany. I got a great grounding in art history, a terrific grounding. Anne would look at everything from the point of view of an art historian and Deborah from the point of view of an artist. We usually got a room for three, it was cheaper, and we'd talk at night about what we had seen. One night Anne said to me, 'Hilary, you should be an art critic'. That was how I started.

In 1963 in Turin we saw the exhibition Turinesque Baroque. It was mainly photographs and drawings. Then you went around all the buildings in the city with a map. When I got home I wrote an article about it for *The Irish Times*. I used to go and visit Anne and Deborah a lot in Belfast. Anne did a big exhibition of William Scott in September 1963 and he said my review of it was the best review he'd ever got.[3] Even at that time Deborah was a leading artist, making three-dimensional paintings in wire and papier maché, mounted on canvas. Those led to her fibre glass paintings and sculptures. More recently she has been making bronze sculpture, and she has abandoned abstraction for figurations – animals, even a fish and an insect! They're marvellous! I was asked to edit a book about her which comes out this year.[4] We were invited to have a conversation about her career at IMMA fairly recently, in the Artists' Talks series.

VR: *What kind of National Gallery would we have had if Anne Crookshank had got the job instead of James White? Peter Somerville-Large wrote that she had missed the job by one vote.*[5]

HP: Anne would have been a splendid director – and the fact that she was a woman would have been important. She might have done more about scholarly publications, something that Homan Potterton later did. But both she and James had been seeking out forgotten Irish artists in country houses, she in the North, and James in the South. James opened up the Gallery to a much wider public than MacGreevy had done – he was totally dedicated and enlightened. Anne's importance as a scholar made her invaluable to Ireland and to Trinity, where she started the Art History course. It is impossible to estimate how great her influence has been, and still is.

VR: *She has done so much. Back to reviewing; you have written a very great number of reviews since the 1960s.*

HP: When I started, art criticism was very often clichéd, and it was not easy to write, as editors were conscious of their readers, and more than one critic had been asked to go because they had been over critical. I try and get inside what I am looking at, to understand what I am looking at and interpret rather than just criticise. Mary Swanzy once said to me that she didn't think an artist should have to explain their work. I think she said 'How does the artist know?' The fact is the artist does their work and yours are the eyes that look at it. My interest in writing is in making people understand the artist and the art better, and not so much in dissecting as an intellectual exercise. Of course, I am critical too.

VR: *You're in a sense mediating?*

HP: Exactly. When I did those two first articles for *The Irish Times*, Brian Fallon was already beginning to write – he was already a journalist in *The Irish Times*. There was no regular art critic and they gave him the post. But they made me art critic for Northern Ireland. I used to go up for the openings and write the review on the train on the way down. Then I'd hand it in when I arrived in Dublin. My handwriting was dreadful! Later they asked me not to give it in until I typed it.

Art was flourishing in Belfast at the time. There were

regular exhibitions – like the Royal Ulster Academy and the Ulster Women Artists: Cherith McKinstrey, Deborah Brown and people like that. I knew Basil Blackshaw, William Conor and Terry Flanagan. Sheelagh Flanagan I knew – she was acting at the time and later opened an art gallery. John Hewitt the poet was there.[6] Much of the creativity revolved around Mary O'Malley's theatre, The Lyric, an amazing drama group performing in her house in Derryvolgie Avenue in south Belfast, with splendid amateur acting.

The artist Alice Berger Hammerschlag started a little art gallery while I was reviewing in Belfast, called The New Gallery [on 23 Grosvenor Road]. Heinz Hammerschlag and Alice Berger were Jewish. She married Heinz who was very involved in music in Belfast. He lost his wife and a child I think in a concentration camp. He had left Germany at the beginning of the war and met Alice in Belfast.

She brought shows of contemporary art from London and in 1965 she did a small Yeats exhibition. The Bell Gallery showed contemporary artists and also more traditional ones like William Conor. Nelson Bell and his father were lovely, eager people, interested in everything. Nelson still runs the Gallery. Then there was the Arts Council Gallery in Bedford Street, which was later bombed a few times during the Troubles.

There were regular exhibitions at the Ulster Museum. Anne was still there as keeper of art. It was an exciting time for art in Belfast as well as Dublin.

Maurice [Carey] also had worked in Belfast, but I didn't know him then. He lived next door to Anne [Crookshank].

When I came back to Dublin after the Ulster Museum I was asked by Timothy O'Driscoll in Bord Fáilte to take over The Little Theatre Gallery in Brown Thomas. To be honest I couldn't take it on, I'm not a business woman. Somebody awfully good did take it on.

My first reviews for The Irish Times were in 1963. Later in the '60s I did reviews for the Irish Independent and the Sunday Independent. I reviewed for Andy O'Mahony on the radio, the

Arts Programme. When I started, I used to write a script and read it. Then they changed over to a question and answer format. Sometimes when we were at work Andy would say, 'Do you mind if I leave the room for a minute?' Then he'd go out, read the news and come back in another door and say, 'Where were we?' He could switch very easily from discussion to performance. I did the *Rosc* exhibition television commentary with Bob Quinn, who was still in RTÉ. I had to write a script and record it and they flashed on the slides at appropriate intervals. It was awfully awkward. For the same programme they had Seán Keating going around the exhibition and they followed him with the cameras. He demolished everything. He was very amusing. I would have been much happier talking in front of the pictures, but was told there was very little interest in the visual arts as such and it wasn't worth RTÉ's while putting its resources into a live commentary.

VR: *I presume you didn't ever meet Yeats.*

HP: I never met him. Deborah [Brown] used to meet him coming in and out of Kennedy's. I think Kennedy's was off Grafton Street then.

VR: *They'd both be buying art materials there I suppose. Didn't Yeats get his own paper made in Saggart in Dublin?*

HP: Elizabeth Yeats, his sister, went to the Saggart Mill for paper for her hand press. When Dún Emer Guild and Cuala Press were founded, Evelyn Gleeson and the Yeats sisters wanted all Irish materials. That was part of their manifesto. Jack was living in Devon when he was doing first the Dún Emer and then the Cuala Press prints; and he bought his watercolour paper in London.

Leo Smith had been showing exhibitions of his work. The pictures were sent over from London by Waddington and Leo was Waddington's agent in Dublin. I could see that Waddington had misdated some of the paintings. They were not as early as Waddington said. He had only started handling Yeats' work in the late '40s and early pictures were unknown territory for him. So I felt I'd like to investigate them. Waddington was the great guru. I think he was perturbed when I began.

Leo was enormously helpful to me. He was a great enthusiast and could give me the names of a lot of collectors. Since they knew him, they didn't mind me coming to see the pictures. I never found anyone in Ireland objecting to me seeing their Yeatses. Waddington did give me names of collectors in England and America.

One person who really objected to me writing the book about Yeats was Cormac O'Malley's mother, Helen Hooker O'Malley,[7] the sculptor. She invited me to lunch in the Hibernian; smoked salmon and Chablis. It was most enjoyable but she really objected to what I was doing, maybe she thought I was too young. She and Waddington and Terence de Vere White tried to dissuade me at first. They seemed to feel that Yeats belonged to them, or that the Yeats they knew might be misunderstood.

Terence was actually a great help to me and we became good friends. He read my book on James Stephens and put me in contact with Colin Franklin of Routledge. On Terence's recommendation Colin read it. He accepted it. Terence would have been Arts Editor of *The Irish Times* then and he encouraged me to write feature articles. My brother, who was working on *The Irish Times* then also, encouraged me.

It came to a point that Fergus suggested I write under a pseudonym because somebody thought two Pyles in *The Irish Times* were a bit too much! I adopted two pseudonyms: One was Adam Mitchell. He was a direct ancestor of ours, a complete Unionist and a Mason and all of those things, totally bigoted maybe but a charismatic character exuding bonhomie and really a man of his time without malice or pettiness. He lived in Birr. Birr was very strongly Protestant. I think he was a generous man. I wrote a book about Susan Mitchell,[8] the poet, another member of the same Birr family. She was of a later generation that got beyond religious bigotry.

The second pseudonym was Peta Cullen. Cullen is another family name – well, laterally – and PC were my mother's initials – Patricia Conerney. Apart from family connections I was interested in the period of the Irish Renaissance, which was an

exhilarating time. They were all faithful to whatever faith they were in, but it didn't matter which faith. They were Republicans. All that mattered was the movement for freedom. Susan Mitchell and the people in the Irish Renaissance that I've written about have all, strangely enough – because it wasn't planned – been Protestants.

VR: *That's a very interesting consistency.*

HP: Well, I suppose it just happened – I didn't set out with any such intention – I was just interested in creative people. What I really did was I resolved to write about people who had not been written about already; they'd been forgotten. W.B. Yeats tended to dominate. Even in more modern times I was interested in Mary Swanzy, who had hidden herself away in Blackheath in London and wasn't seeing anyone. I can't think how in the world I had the courage to knock on the door, but she did see me. That was in the '60s. It was the first article that was written about her. She was very pleased. We just clicked. She asked me to supper and gave me a picture later.

VR: *Who are you currently writing about?*

HP: The artist Sadhbh Trínseach.[9] Her real name was Francesca (really Frances) Trench. She was very dynamic and very much into things Celtic. She was a member of Cumann na mBan, but an artist also. The possibility of Irish independence was so inspiring to the youth of that generation. She was the victim of the great 'flu in 1918; she was only 27 when she died. The book is finished; it should be coming out soon.

VR: *Did you stay reviewing right through the '60s?*

HP: When I got married in 1969 I went on reviewing. I remember Hector Legge of the *Sunday Independent* rang me and said, 'Come to me, please', and he was going to pay me far more than *The Irish Times*. I said, 'I can't, I'm getting married.' He said, 'What difference will that make?'. I suppose I sort of felt I needed to think out my new role.

VR: *As a clergyman's wife?*

HP: Yes. Maurice liked the fact that I wasn't a really churchy person.

VR: *What kind of dress style did you have then in the '60s?*

HP: It was the late '60s when the skirts came up above the knee. The cape came later – I remember crawling round the floor on my knees cutting it out – it was circular. The late '60s was all skirts. There were people who wore slacks – if you were sailing or something. I later found it quite difficult to transfer into trousers. I wore a lot of tweed. I used to make a lot of my own clothes. You could buy beautifully coloured hand-woven tweeds in people's cottages then. Patrick Pye's wife's family, the Kennedys, ran The Weaver's Shed, just off Grafton Street. I always used *Vogue* couture patterns. For my twenty-first birthday I made a brocade dress. It had two petticoats. It was dark blue – I used to wear blue a lot. On my first visit to America in 1968 I wore a green tweed dress when I was giving lectures. I hadn't thought about it but the Americans loved it. They thought I was very Irish and said I looked like Greta Garbo!

When I got married I still worked in the Gallery. I should have left, that was the rule in the public service in 1969; a woman had to resign when she married. James White said to me 'What are your plans, are you going to have a family?' I said I had no idea. 'Anyway', he said, 'How do I know you are married?'– even though he had been at our wedding! So I continued to work in the Gallery. I did resign four months before Colm was born; I left the Gallery in 1970.

We had a wonderful lecturer in Trinity called Mrs Risk, who had a large family, but she planned well and had each child during the summer vacation.

Maurice went to Cork in 1971, as Dean of Cork.

VR: *So you'd left Dublin just before the Yeats Centenary exhibition?*

HP: Not really – we didn't move until December. I did the catalogue for the 1971 exhibition.[10] It wasn't easy because Waddington wanted it to be his baby. There was a bit of a clash. He wanted the exhibition to be a showcase for his collectors and he had a network of George, his brother, in Montreal and someone else in New York and Leo in Dublin. He made most of the selection. They gave in to me sometimes. He was the centre of the Yeats

empire. I had published my book on Jack Yeats in 1970.[11] I had made a catalogue of the pictures to go with it but Colin Franklin at Routledge didn't want it, he just wanted the biography. So I continued working at the catalogue notes, and adding to them over the years, making it much richer. I went to owners who had bought directly from Yeats. Even after Waddington had become his agent, people bought directly from Yeats. And those owners had stories to tell, straight from the artist himself.

VR: *Who would Dr Best, whose bequest of Yeats to the Gallery includes wonderful works from the '20s, have bought from?*

HP: The Bests bought directly from Yeats. I think Dr Best had all his collection bought when Waddington started dealing in Yeats, which would have been in the mid '40s. The work in the Best Bequest is from a period of his life when Yeats was painting contemporary life, so there's a tram painting, and the paintings of the Islandbridge Regatta [c. 1925] which Yeats, and more than probably, Best attended. Jack was determined to be a modernist. He showed in the Armory Show in New York in 1913. He showed *The Circus Dwarf* [1912]. Some of the others he showed wouldn't be included in an international show nowadays. The Irish paintings for the Armory Show were selected by John Quinn. Jack and John Quinn travelled around the west of Ireland together. Jack didn't go to the Armory Show. Quinn had arranged an exhibition for him in 1904 and Jack went to New York for six weeks. That was Jack's only visit to America. He had a very successful exhibition in America in 1951; that was organised by Waddington.

VR: *Is it true that Yeats was reluctant to have his date of birth, reproductions of the work, and interpretations of it, in the catalogue for that American show in 1951/2?[12]*

HP: Jack's deciding against reproductions in the 1951 catalogue wasn't exactly new – he'd always felt that a reproduction was a poor substitute for the real thing, and that it could be misleading. You know that when he sold his painting to the Tate Gallery in 1925 he made it very clear that he'd not sold the right to

Hilary Pyle 217

reproduce it. But I think also he was fed up with the fuss over the American show. It was a kind of limelight he wasn't used to – he'd handled his own exhibitions up until the age of 70 – all the details, and though Waddington was useful as an agent he had a completely different style. I can understand Yeats being worried about what his pictures would look like reproduced in a catalogue. I often wonder what he would think of the platoons of them being regurgitated in facsimile today – something he fought specifically against.

VR: *Do you think his move from [61] Marlborough Road to [18] Fitzwilliam Square was partly to be able to receive buyers in a top location?*

HP: I always thought it was because it was more central, he was on the verge of 60 when they moved. But also there was a sense of snobbishness, I suppose it was the place to live. His brother W.B. lived in [82] Merrion Square in the '20s. It was said there wasn't much communication between them then. Anne Yeats [W.B.'s daughter] had a story of a letter which she had to bring over to Jack. He made cartoons in *Punch*, using the name W. Bird so that no one knew he was still doing cartoon work. The letter from *Punch* for some reason was delivered to Merrion Square instead of Fitzwilliam Square by mistake. Anne's story is that Jack was absolutely furious that they knew he was W. Bird. Jack and W.B. did work together amicably enough on occasion and Jack illustrated W.B.'s last publication, an essay on public speaking, *On the Boiler*. They both knew an old man in Sligo who used to stand up on an old boiler on Sligo quay and give out to everyone, as if he was at Hyde Park corner.

VR: *They had very different childhoods, Jack spending these very formative years from seven to sixteen in Sligo with their grandparents, and maybe being a little less in awe of his father than the other children?*

HP: W.B. also stayed for long periods in Sligo. In his autobiography he talks about being introduced to the local folklore and stories by the maids in their grandfather's house. But in Dublin, the father having a powerful personality and him being eldest, W.B.

got the brunt of things.[13] John, the father, realised W.B. was unusual and wanted to have an influence on him. W.B. had the father lecturing him without stopping. He was at school in Dublin, the family lived in Howth. Then they moved to London; that was when Jack rejoined them.

VR: *What a time Mrs Yeats senior had.*

HP: Don't forget she was a depressive and it wasn't easy for her husband either. John remained faithful to her all through. In the 1880s she had that awful stroke. Jack lived with his grandparents in Sligo – it was very natural in the nineteenth century for people to send their children home to their extended family. I sometimes think Jack married so young because he wasn't mothered.

W.B.'s experience of Sligo was the mythic, the otherworldly. Jack's was very much the masculine world of business and action, as well as visual poetry.

VR: *We were beginning to talk there about the catalogue raisonné of Jack Yeats' work, published in 1992.*[14]

HP: Leslie Waddington rang me one day to ask me would I publish the catalogue with him. It had originally gone to the Irish Academic Press, but Captain McGlinchy died suddenly so it came back. I sent it to OUP, who wanted to publish it but then decided against it. It was too expensive. I tried Blackstaff, without much hope. I was really in despair. Then I was in the National Gallery one day, I wasn't working there at the time or anything, I was just looking something up and someone said there was a phone call for me. It was Leslie Waddington saying, 'I want to publish the catalogue *raisonné*'. I've always had a great respect for Leslie. He went into French contemporary painting and it wasn't until the father died that he took up Yeats. I think the idea of the catalogue dedicated to his father [Victor] may have been on his mind for some time. Something went a bit wrong then and it seemed as though he might have changed his mind. Next I had a call from Tom Rosenthal of André Deutsch who said he wanted to do a reprint of the biography and after that agreed to do the catalogue *raisonné* for Leslie. Rosenthal had

done the Yeats number in the *Masters* series in the '60s. He liked to feel he was cock of the walk. He's an affable character though. We sort of fell out about the time of the Yeats centenary, so it was quite surprising and very nice when he came back to me and said he wanted to reprint the biography. It's good to be able to forget the past.

I had worked the original catalogue on a typewriter, but of course had to re-use it and update it thoroughly; and my brother said, 'You can do it with a computer, where you can store detail (think of all the exhibition references!) and reproduce it as you need it'. I was at a conference in the Gallery where Jennifer Johnston was talking. I had been having awful problems with my typewriter. I was writing letters to Haughey and everyone trying to persuade them to found a Yeats museum. The ribbon on the typewriter was awful and the letters looked miserable. I went up to Jennifer Johnston after her talk and asked her opinion, and what were the snags with the computer. She said she wouldn't be without a computer, but that there was one essential thing she did, she always printed everything out at the end of the day.

Then back home a friend in Cork said, 'Here is the key of my office, you can use my office between 6 and 10pm for a few weeks and see if a computer is any use to you'. It was so decent of him. Computers were a foreign voyage then, hardly anyone had them, though they were beginning to be used in businesses, and it was quite an outlay if you weren't absolutely sure how to use them. They also made writing different. I had learnt to compose my reviews straight onto the typewriter. That makes you quick to decide how you express yourself – if you want to change it you have to start again. On the computer you can move things around, or wipe out or polish up your text; you are doing much more considered edited writing. You can lose the spontaneity. Computers are responsible I think for a lot of those turgid, wordy, over-factual articles nowadays.

VR: *Tell me more about the move to Cork.*

HP: It was a complete break with everything I'd been doing. I remained on the panel of the lecturers in the National Gallery, though. I sent articles and reviews of Cork exhibitions to *The Irish Times*. They already had a critic in Cork, Geraldine Neeson,[15] who wrote for the *Cork Examiner* as well. Around 1975 she retired and I took over from her. But I did feel out of things. The children were all coming then. It was a very difficult time for me personally but I could write reviews and wrote quite a lot of poetry, some of which was later published, some in *Poetry Ireland, The Irish Salmon* and *The Irish Press*.

In Cork they look in a different direction, they look to London. They don't know an awful lot about Dublin. When we went to Cork the old deanery had been sold to the VEC, it was used by the School of Art and I taught History of Art there for a time. When we first arrived, we lived out in Bishopstown in a modern house. It really was too far from the Cathedral. Maurice had to have the car, and I'd be pushing the pram up and down those narrow paths on the way to services. We had looked at several temporary houses. In the Bishopstown house when we were looking at it, there was purple striped wallpaper, kinetic style furry paper that you could stroke, a brilliantly coloured settee and a purple carpet with enormous acanthus patterns on it in the sitting room. The effect of all this vigorous décor hit me, literally, and I leant against the wall and cried and said I supposed we would have to take the house but would they paint everything white please.

The Church had been given land to build a house on, Brookfield House land, but Maurice had his eye on the eighteenth-century house in Dean Street, just near the old deanery. We'd been in Cork five years when we got that house. Having been in flats previously there were bathrooms on every floor, which was great because there were so many people visiting or staying. Someone coming to preach would stay the night, or nights, for example. Life was very lively. Clergy need to be inviting people in – though nowadays there is a tendency for

the clergy to have offices. The children loved the house, the shallow Georgian stairs. We were in the centre of things, and very happy living just beside the Cathedral.

I was invited onto the Cork Arts Society and the Sculpture Park Committee. People from other places can get very lonely in Cork. They can be regarded as blow ins. But in the arts people don't care where you come from. Der Donovan [curator of The Crawford Municipal Gallery][16] was a very fine person, very friendly. I was very fond of him.

I also liked Mary Dwyer and everyone on the Cork Arts Society Committee – Mimi Crowley, Charlo Quain, Daithí Ó Coileáin, Máiréad Murphy, wife of Seamus Murphy – very much. The CAS rooms on Lavitt's Quay were made available by the newspaper family, the Crosbies. David Hendriks brought exhibitions there for three or four years in the '70s. He would come down, set up, and go back to Dublin and then come back later to collect the paintings. He did it about four times a year. They were very good exhibitions but unfortunately they didn't sell well. Any Cork collectors were already going to Dublin and buying from him there.

VR: *Which collectors in Cork had the best Yeatses then?*

HP: J.B. Kearney and Gerald Goldberg had the best Yeatses. I think J.B. had *A Banquet Hall Deserted* (1943) at the time.

VR: *The three Cork* Rosc*'s were really important, weren't they?*[17]

HP: Yes, both for the main *Rosc* in Dublin as a counteraction to the avant garde art, and for the Cork people themselves. In Dublin the original committee originally decided not to include Irish artists, since we were only, as an artistic nation, coming out of being in a backwater; it was ten years before Irish artists were included, but they advocated exhibitions of historic art, glass and silver in Cork, Waterford, Limerick and Galway. Cyril Barrett did the first Irish art exhibition in Cork, nineteenth-century art, but he didn't want to do the second. What interested him most was avant-garde art.[18] He was writing a book on Op Art. It was quite a stretch for him to do the nineteenth century. But I think

he didn't want to do the first half of the twentieth. I was asked to do the Cork *Rosc, Irish Art 1900-1950* in 1975.

I was amazed I was able to research and select the exhibition with the children so small. Manus was born just after it opened. Der was wonderfully co-operative, and Maurice was very helpful. I had to travel around the country and select suitable works and afterwards write the catalogue.

Mr Parfrey, CEO of the VEC, was the chairman of the committee, he was the power machine. We were having a meeting in his office, to celebrate, just before the exhibition opened. He was distributing drinks to his buddies and he ignored me. I didn't say anything. Then J.B. Kearney came in. He was my gynaecologist; he had confirmed that I was pregnant. He saw what was happening and he poured me a drink, a full whiskey, a treble whiskey not just a double. I needed a drink badly so I drank it! He also brought my daughters into the world. All we ever talked about was pictures. Michael Solomons, who brought Colm into the world, was like that also. He had a Yeats in his consulting rooms. He was a nephew of Estella Solomons.

VR: *A fine portraitist, and politically so interesting, but not adequately represented in public collections, is she?*

HP: She's coming into her own. David Britton did an exhibition of her work not so long ago. I published a small booklet about her in 1966, *Portraits of Patriots.*

The person who opened *Rosc 75* was Cearbhaill Ó Dálaigh. At the committee I raised the matter of how to deal with his entertainment and the committee passed it over. So I wrote to Áras an Uachtaráin and said that if he had nothing arranged he would be welcome to have supper with us. We heard nothing and then a week beforehand, we had a phone call from Áras an Uachtaráin who said the President was at the King of Spain's funeral but would be delighted to have supper with us; he was going straight back to Cork. We were living in the little house in Bishopstown. Maurice said, 'I must paint the kitchen'. I got out a recipe book by Theodora FitzGibbon and found a recipe

for Elizabethan ragout of pork. The opening was at eight and at about six a cavalcade of motorcycles appeared; all eyes on Bishopstown Avenue were out on stalks. The President arrived and had his aide de camp with him. He asked could he talk to me and I took him into the sitting room. The aide de camp sat in the dining room/kitchen with Maurice and enjoyed the ragout, while the President ate just a slice of meat and had a glass of wine with me. The doorbell rang and it was the babysitter; and Ó Dálaigh said, 'may I say hello to the babysitter?' and to her astonishment he came in and shook her hand.

Four or five months later there was a call from Áras an Uachtaráin saying the President would like us to go to the ballet in Cork. His wife was with him and they took us in the presidential car. We had dinner in Arbutus. Afterwards there was a reception at which I fainted ignominiously. Manus was due. When I opened my eyes there was Cearbhaill Ó Dálaigh enquiring how I was. He was such a nice man.

VR: *It can't have been too long after that when he resigned.*[19]

HP: No, wasn't it the following year? But he was a man of principle,

Reverend Maurice Carey, Dean of Cork, Hilary Pyle and President Ó Dálaigh, 1 December 1975. Photo by Pat Langan. Courtesy of The Irish Times.

and felt he had to challenge the Government. In a way he opened up the office for the future presidents, because he made it clear he was not a puppet.

VR: *Maurice as Dean of St Fin Barre's became very involved in the architectural treasures. He would have been so pleased that the Burges models and drawings will be shown as part of the 2005 European Capital of Culture programme.*[20]

HP: All the drawings by Burges were preserved there in volumes. Maurice was very enthusiastic about them. The Nicholl models for the sculptures had been forgotten about, put away. Some were in the towers, some in the library. They were just *trí na chéile.* He rescued them and got an expert to assess them. I know some were conserved. His idea was to make a museum eventually with the designs.

On the west side the stone in the carvings was crumbling and they found someone who could restore them. Maurice also raised funds for the restoration of the Cathedral and wrote a booklet about it.[21] He lectured about St Fin Barre's and courted the businessmen of the city. He wanted a quarter of a million, but a generation later now I see they're looking for twelve or fourteen million to restore the roof and other deterioration. It's a magnificent building.

The carvings had been done locally, by McLeod. I think that's how we got friendly with Seamus Murphy. He was very interested in the Cork stonies.

VR: Stone Mad *must have been republished at around that time.*[22]

HP: Yes. Maurice commissioned the processional cross from Patrick Pye; that was in 1974. He commissioned Oisín Kelly to do the church warden's wands, inspired by the angel crowning the east end. Maurice also opened up the Cathedral to other denominations, starting an ecumenical study group and inviting the Lord Mayor and Corporation to a service on St Patrick's Day, at which they were encouraged to communicate. Cork people, of whatever persuasion, regard the Cathedral as their own.

VR: *Indeed. Its proximity to the Crawford College and to UCC is a great asset. Was it difficult for you to keep up your research?*

HP: Usually clergy wives are expected to be what they used to call unpaid curates. At the same time, Maurice was always in favour of my research. He was a great support. I did do a great deal, but I felt people would have liked me to be more involved. I was asked to be Chairperson of the Mothers' Union but I had never been a member and I declined. But I think there were some eyebrows raised.

I did get closely involved in the Ecumenical Study group. I was instrumental in bringing Hans Kung to Cork in 1985 – you remember Pope Benedict and he were colleagues at Tübingen for a while, though Hans Kung was anything but conservative. I was fascinated by his book *Art and the Question of Meaning* (1981). It seemed a crazy idea to hope to get such a controversial figure to Cork; but then Dublin became interested and he spoke in Trinity College, and then in St Finbarre's, which was packed to the door – complete silence for two hours!

I was invited to, and did, a little book on the liturgy for the Mothers' Union in Wicklow. Alicia Boyle did the illustrations.

I didn't play a really major role. Maurice was keen for me to continue with my writing.

The books in the library – it was the diocesan library – went to UCC, and Maurice was looking for an alternative use for the library building. The approach to use it for artists' studios may have come from artists. I was very keen that there would be artists in it. We went with them to oversee it. It was wonderful seeing how they responded to the rooms.

VR: *So that's how the Cork Artists' Collective was set up; artists like Billy Foley, Mick O'Shea, Collette Nolan, Mags Fitzgibbon and Irene Murphy have wonderful studios there. Can you remember which artists were there from the beginning, from the mid '80s?*[23]

HP: Mags Fitzgibbon I think and Seán Taylor and Annette Hennessy and June Fizgerald and others.

VR: *Maurice gave the address for Cecil King's memorial service [10 May 1986] in Christ Church Cathedral. Did you both know Cecil King well?*

HP: Yes. In fact, I met Oliver Dowling when he was about eighteen,

at one of Cecil King's parties. Cecil lived near me in Blackrock.

VR: *Although the food culture was less developed then, apart from the great Arbutus Lodge, the '70s were an exciting time in Cork, with Triskel opening, for example.*

HP: I wasn't very much aware of the Triskel when they were in Paul Street. When they opened in [5] Bridge Street I was there all the time. That was 1980 and art centres were a new thing, a reaction against group exhibitions like Living Art and the Munster Fine Art. The great thing for me about Robbie McDonald who was founder and administrator, and that group of young artists, was having taught them [in the School of Art]. I remember Éilis [O'Connell], Maud [Cotter] and Vivienne [Roche]. James Scanlon never turned up for class! They were such a good year. They were very lucky to have John Burke as tutor. SADE, the Sculpture and Drawing Exhibition, was great in 1982. It was a pity it could not continue. But there are problems in moving sculpture, I know. John Burke organised it. SADE started Mick Mulcahy's career really, when he won the main prize for drawing. Drawing is never usually given the credit for what it is. Cork art was on a high. John was a great influence. Also Gerald Barry – music was an important element of performance art, particularly for Danny McCarthy[24] and Tony Sheehan. Performance in Triskel was very advanced then. Alastair MacLennan was often there.

And people generally were getting more interested in the visual arts. I was asked by Professor Teehan to teach a course on art history in UCC, which eventually led to the College having a permanent visual arts officer, and now there is an art history degree there.

Peter Murray changed attitudes in the Crawford Gallery a good deal, deciding that exhibitions which might travel elsewhere should always originate – open first – in Cork, which gives Cork a status it did not have before, and room for developing scholarship. The extension on Half Moon Street has also opened up the exhibition space, and with the Ballymaloe café brought in many more people. Peter has been an inspiration. He

taught at the School of Art for a time, commuting from Dublin. After he started in the Crawford Gallery, he spent some months at the RHA, before returning to the Crawford.

VR: *Was Maurice transferred back to Dublin around the time of the publication of the catalogue* raisonné? *You became first curator of the Yeats Collection in the National Gallery around then.*

HP: We came back to Dublin in 1993. Maurice was in charge of St John's, Sandymount, and I was appointed Yeats Curator Emeritus of the Yeats Collection in the National Gallery by Raymond Keaveney and the board the following year. I set up a Yeats Museum and Archive Room in the Gallery. The initial idea had been that the Yeats Museum was to go to the new Millenium Wing, and plans were made for this, but had to be changed – only the Archive Room is in the new wing. The collection, which includes all the Yeats artists, is in the Yeats Room in the Shaw Wing, where it looks very good. It is very popular with the public.

VR: *Wasn't Marsh's Library going to be taken from beside St Patrick's Cathedral and put where the Yeats Room now is, as part of the original plans for the Gallery?*

HP: Yes. When they were re-doing the room for the Yeats Room, stripping everything down, you could see the door for the separate entrance for Marsh's. In the times that were in it, the mid nineteenth century, the idea justified the National Gallery. It was to be an educational institution, very much the Victorian concept of a gallery. Marsh's Library, however, is perfect where it is, in the old building beside St Patrick's Cathedral.

My longest period of working full time in a job was during the last ten years or so in the Gallery, from 1994 to 2004. Otherwise I've worked on my own. But I've also been more and more involved in contemporary art over the years, and working on arts committees. I was president of the Friends of the National Collections of Ireland until recently. The Friends were founded [by Sarah Purser] in 1924 to bring the Lane pictures back to Ireland and to assist the Municipal Gallery in Dublin in particular. But since the larger galleries have formed their own Friends, we

have been assisting smaller galleries more, purchasing pictures or assisting in the purchase of works, including glass or furniture. In 2001 we arranged the anonymous donation of Imogen Stuart's *St Kevin*, and its siting in Glendalough. We also assisted the Crawford Gallery in buying an important interior, perhaps *Words of Counsel*, first exhibited at the RHA in 1877, by James Brenan, and just the other day bought a nineteenth-century portrait for Waterford Treasures. It was of Sir Benjamin Wall Morris K.T.J.P (1795-1875), Captain of the 25th Regiment of Foot and Deputy Lieutenant of the city of Waterford. He was thrice Mayor of Waterford and a supporter of O'Connell's Repeal movement.

VR: *There is a lot of anticipation around the forthcoming (24 May) auction*[25] *in Cork, where the John Butts* View of Cork *(c. 1760) might be too expensive for the Crawford to buy back from the owners who lent it to them. By the time the Yeats Room opened in 1999, had prices gone sky high?*

HP: *Harvest Moon* [1946] went for a quarter of a million in Adam's in September 1989. Smurfit bought it. His interest was in acquisitions for his art collection. It was good for his profile but I wonder did he care much about the actual art. He had his office stuffed with Yeatses. He had them on display too in Kildare, in the K Club where the public could see them. The Club has now been sold. There was always a bit of a mystery – at least for me – as to whether or which pictures were owned by Smurfit or by Jefferson Smurfit and Co. Once they sold out to the Canadian Company the Smurfits disposed of the Yeatses, gradually; I suppose not to put them on the market all together and flood it.

I did an exhibition for Michael Smurfit in Monaco in 1990. The Princess Grace Irish Library have lectures and seminars on Irish literature there. He wanted a Yeats exhibition there to accompany the seminar on James Joyce. The paintings were all put on screens in the Centre de Congrès where the conference was held. About half of the pictures came from the Smurfit Collection, the rest from private collectors and a few

from the National Gallery. At the opening of the exhibition everyone gathered in the lecture theatre. Princess Caroline was sitting on the platform as honoured guest and she was to declare it open. She had an appalling cold; I was full of sympathy for her. I brought her around the exhibition, and not surprisingly she wasn't that interested. Prince Albert was though. Out of the blue during the opening proceedings, Michael Smurfit took *The Bar* [1925] off the screen and presented it to the Princess Grace Library. It's a beautiful small painting; in essence like Manet's *Bar at The Folies Bergère* [1881/82]. It's from the period when Yeats was painting contemporary life. I think Smurfit liked to make dramatic gestures. The picture was then put back on the screen. He hadn't reckoned that as it had gone out as a loan, it had to go back to Ireland after the exhibition. But being honorary Irish Consul in Monaco he had no problem getting it back there, I'm sure.

In Monaco Virginia Gallico, a very British lady, widow of Paul the writer, was in charge of etiquette. I had to have an interview with her before I started. We had lots of discussion about the form and etiquette of the catalogue. Princess Caroline's photo is at the front but so is Michael Smurfit's. Virginia had to know what size the photo of Michael Smurfit was to be. If it was full page, it would not be permitted to include a photograph of the Princess. Caroline's had to be bigger and determining the actual size was a very delicate question. Virginia is the daughter of a military person who had a role in advising about similar matters in London. It was in her bones. She was very polite but this rigid etiquette had to be adhered to.

There is another story about the opening ceremony. Smurfit gave one of the speeches. Sitting in front of me was David Norris who was over for the Joyce Conference. David and I had a bit of a chat and then things started. Smurfit said Mr Pyle did this and Mr Pyle did that. David Norris turned to me and said, 'Oh, a sex change?'.

Smurfit invited me to do the exhibition but I worked

through his assistant David Austin, a very pleasant man to deal with. Smurfit did give me a *póg* at the reception, but I don't think he even knew who I was.

In conversation, Dublin, 18 February and 8 April 2005

1. O'Doherty, B., 'Irish Painter, Jack Yeats', *Irish Monthly 80*, May 1952.
2. Pyle, H., *James Stephens: His Work and an Account of His Life*, London, 1965.
3. *The Irish Times*, September 25,1963.
4. Pyle, H. (ed.), *Deborah Brown: From Painting to Sculpture* Dublin, 2005.
5. *1854-2004: The Story of The National Gallery of Ireland*, Dublin, 2004, p. 375.
6. The poet, who was keeper in the Ulster Museum until 1956, wrote *Art in Ulster 1557-1957*, published in Belfast in 1977.
7. Helen Hooker O'Malley Roelofs, (1903-1995) widow of Ernie O'Malley, donated her art collection to the Irish American Cultural Institute in 1981. Her son Cormac O'Malley has been instrumental in keeping the collection together, while ensuring the Irish people can see it. It is now on permanent loan to the University of Limerick. See O'Malley, C., 'Gifting the Nation', *Irish Arts Review*, Winter 2003, pp. 104-9.
8. *Red-Headed Rebel: Susan Mitchell, Poet and Mystic of the Irish Cultural Renaissance*, Dublin, 1998.
9. *Cesca's Diary, 1913-1916: Where Art and Nationalism Meet*, Dublin, 2005.
10. National Gallery of Ireland, *Jack B. Yeats: A Centenary Exhibition*, Dublin, 1971.
11. *Jack B. Yeats: A Biography*, London, 1970.
12. *Jack B. Yeats: A First Retrospective American Exhibition*. Shown in Boston, Washington, San Francisco, Colorado Springs, Toronto, Detroit, and New York.
13. Foster, R., *The Apprentice Mage, 1865-1914 (W.B. Yeats; A Life)* London, 1997 and Pyle H., *Yeats Portrait of an Artistic Family*, London 1997.
14. Pyle, H., *Jack B. Yeats A Catalogue* Raisonné *of the Oil Paintings*, London 1992.
15. Geraldine Neeson (1895-1980) wrote a memoir, *In My Mind's Eye, the Cork I knew and Loved*, published in Dublin in 2001.
16. Diarmuid Ó Donobháin or Der Donovan as he was equally known (1917-1992) was curator of the Crawford Gallery effectively from 1971-1983. He started working in the Crawford as an art assistant under Soirle MacCana in 1948. That year he took a diploma in Social and Economic Science in UCC. In the

'40s and '50s during annual leave he did art study courses in major European cities, funded mainly by himself. In 1962 he received a Gulbenkian award to pursue further study. In 1970 he founded the Cork Art Teachers Association. The author is indebted to John O'Regan of City of Cork VEC.

17. 1971, 1975, and 1980.

18. Barrett, C., *Irish Art 1943-1973*, Cork Rosc, 1980. This exhibition travelled to Belfast.

19. Former lawyer and Attorney General Cearbhall Ó Dálaigh (1911-1978) fifth president of Ireland 1974-1976, clashed with the Minister for Defence over a constitutional issue.

20. Wood R. (ed.), *Conserving The Dream, Treasures of St Fin Barre's Cathedral*, Cork Public Museum, from 6 October 2005.

21. Carey, M., *St Fin Barre's Cathedral Cork*, Dublin, Eason Heritage Series no. 48, 1984.

22. *Stone Mad*, Dublin, 1950; Republished 1975, Cork.

23. Gallagher, W., 'Cork Works', *Circa '64*, Summer 1993, pp. 43-5.

24. Pyle, H., 'After a Conversation with Danny McCarthy', *Circa*, no. 7 November/December 1982, pp. 18-19.

25. Thanks to an anonymous benefactor, the painting was purchased at a cost of €700,000 and donated to the Crawford Gallery.

Bruce Arnold, having received the OBE.

Bruce Arnold

Bruce Arnold was born in London in 1936 and educated at Kingham Hill School in Oxfordshire and in Trinity College, Dublin where he read Modern Languages. In 1959, he married Mavis Cleave, and they have three children. He has published fifteen books. He has worked for Independent Newspapers since 1968 and is Chief Critic of the Irish Independent. He was Literary Editor from 1986 to 1999. In 2003 he was made OBE for services to journalism and to British–Irish relations.

VR: *When you came over from England in the mid '50s, how did you like Dublin?*

BA: It was 1957. It was exactly what I expected it to be. It was a city I had envisaged from literary sources, from *Portrait of an Artist as a Young Man* more than any. The year immediately before,

1956, 1957, when I was teaching in Kent, the BBC had a very dedicated Irish subsection, presided over by men like MacNeice, W.R. Rodgers and a few other people in the literary field. They put on dramatic readings. I remember buying the Tauchnitz edition of *Portrait*. I have it still and it had a huge influence on me, as a source of inspiration to be a writer, coupled with the idea that being a writer in Dublin was an escape. The idea of writing in Ireland is life, not luxury or indulgence. If, living in Ireland at that time, you wrote at all, then you were seriously expected to become a writer. If, living in England, you wrote at all, you were also expected to get a job. Writing was a small subsidiary of English life. Dublin was the opposite. I favoured what I found coming to Ireland. Writing was at its centre and the more I got to know the city over those four glorious years at Trinity, the more I was thrown into a writing environment almost without having to do anything about it. The world of creative literature was linked to the world of creative debate. Our lecturers only had to say, 'if you want to meet the people we're talking about, they are in the Bailey or Davy Byrnes', and literally they were there.

VR: *Who are you thinking of, Bruce?*

BA: If you went to the Bailey you'd find John Ryan, editor of *Envoy*. If you went to McDaid's, you'd find John Jordan. John Jordan was a drinking companion of other writers. Harden Rodgers, W.R. Rodgers's daughter, was in my year. She married John Jay, a solicitor, who was also a writer. I suppose what I'm trying to say is that the intellectual size of Dublin was terribly closely knit. It wasn't in any way formalised, it wasn't self-conscious. The likelihood was that you'd have a conversation with a painter or a writer. In those four years I just moved in that circle. There was a coffee bar called the The Old Clog, just off Chatham Street. Pauline Bewick was someone I met in those days. She had illustrated *Icarus*, the termly magazine in Trinity. I was editor for the tenth anniversary issue. The playwright Conor Farrington was there. He married Meryl Gourlay – who became an actress. At an early stage I met Flann O'Brien; he was

a civil servant, a writer, and a conversationalist. He saw the city from the rather dismal viewpoint of a civil servant. I wanted to be a writer. That was central. Dublin appealed to me as a city in which to do that. There was no idea of what profession to follow. It seemed incidental. Everything was structured around that idea of being a writer. People think of me as being a polymath and say his net is too widely spread. It wasn't that. It was my view then, and it's my view now, that writers turn their attention to whatever will make them write. If you live in a society where in principle, everyone knows everyone else, then they all coalesce. If you live in a small community, by bringing to it a truthfulness of perception, you can make your life work there, as a writer.

I saw myself as someone who could represent that. Quite unusual; an English settler in Ireland in the mid-twentieth century can be an unpopular observer of Irish life. There's a sense in which the principle of observation is all right for those who live in the society all their lives but not for those who don't.

VR: *Is Dublin Ireland?*

BA: I started as a denizen of Trinity, there's no escaping that. The centre of my life in 1957 was Trinity and the map of my existence was Trinity, Baggot Street, Donnybrook. I had digs in Donnybrook. It expanded geographically from that in odd directions. I acted in Trinity, I was very keen on theatre and I was quite a good actor. I played two parts in my first play, *Jim Dandy* by William Saroyan. It was in that production that I met Mavis, she was acting in it. By the beginning of the '60s I was writing plays myself. We put on my first play, *The Life and Death of Sir Walter Ralegh*. Ralegh had an Irish dimension to his life. He was part of that group of Elizabethan, and then Jacobean, courtiers who were suspected of treason. He was a great traveller.

I admired him. He was a Renaissance man. The whole structure of one's life was embraced by the teaching that was going on. Shakespeare and the metaphysical poets were central. Ralegh

seemed to me to have a poignant end with his political trial.

In the spring of 1958 I directed *Exiles,* Joyce's only play, with Terence Brady playing the lead. It had never been put on in Dublin, except as a reading. It was the first proper production as a play.

VR: *When did your interest in Irish art begin?*

BA: I was already keen on art. I had been introduced to it as a child in London. When I came to Dublin I explored it through the Irish Georgian Society and became involved with a particular group of people. I knew Desmond Guinness in those days. I collected prints of eighteenth-century Dublin and hung them in my rooms in front square in Trinity.

In those days, Trinity was a university for those who either couldn't get into Oxford or didn't want to go to a red brick university, or were waiting to get into Oxford. I had a place to go to in Oxford a year later but I was 21. There were a lot of people who came from abroad in Trinity at that time. Properly abroad: Rhodesia, South Africa, that kind of thing. It was full of English and full of colonials.

I was quite a dandy. I dressed well. It wasn't arrogance. It was self-definition. I wasn't prepared to relinquish what had defined me, the English style. I never have been. It's a characteristic that irritates people. They feel I should have more symbiosis with Ireland. The typical Englishman irritates the typical Irishman. I rather liked irritating people.

When I came to read Laurence Durrell I thought his portrait of Alexandria could have been a portrait of Dublin. That particular time, the '50s, was the precursor to Ireland's recovery. There was the ethos of getting ready, of getting organised, though it wasn't until the '60s that there was any prosperity, or any chance of having much of a life.

Halfway through Trinity I got married. I married Mavis, an Irish girl whose home was in the west. My knowledge of Ireland expanded to Sligo and the west. This was a permanent aspect of my life for the next twenty years. By marrying Mavis and by

having children I established a completely different relationship with Ireland.

VR: *Had Mavis been born in Ireland?*

BA: She was born in India, but came back to Ireland as a two-year old. All her growing up was here. Her father was Indian army, her mother was west of Ireland stock, the daughter of a Protestant clergyman whose roots were in Mayo. Sligo became, quite literally, a second home, to which we went in the summer, at Christmas and at Easter. It was a Protestant household. My mother-in-law was a devout member of the Sligo Protestant community. It was a confident society and had echoes of Yeats.

Strangely enough I never really liked W.B. Yeats.

The final piece in the jigsaw was the decision to stay, after I finished college in 1961. We had a child in 1961, who died in the same year. A little girl. It created a huge trauma. There was the grief side of it. It stopped me in my tracks, in the trajectory of my life. After a smooth passage into Irish life it made me feel vulnerable, it made me re-think everything. There was an extensive reaction to what happened. We suddenly found that the wider

Mavis and Bruce Arnold.

community, the Protestant community, the Trinity community, all responded to what had happened to us in a way that told us we were a bigger piece of what we thought we were. I thought we were a temporary part of the life we inhabited. Suddenly we had letters from the archbishop of Dublin, Dr Simms, we felt embraced. It had a huge effect. That year I decided to stay. I was terribly lucky to get a job in *The Irish Times* as a leader writer and a sub-editor. That made me a professional writer. I worked with Fergus Pyle, Alex Newman was the editor. Bruce Williamson was in the paper. Cathal O'Shannon, Seamus Kelly, was *Quid Nunc*. Terence de Vere White joined the paper at roughly the same time, as literary editor. Shortly afterwards maybe.

Sub-editing is a terribly neglected skill. I rewrote articles by people like Garret FitzGerald, whose style I didn't think was up to scratch. A lot of the sub-editor's job is making more forceful what people produce. I also became the *Guardian* correspondent.

I became the editor of a little magazine called *The Dubliner*. That put me professionally into the field of literature and that's when I began to meet writers like Edna O'Brien and John McGahern. I reviewed John McGahern's first novel, *The Barracks* (1963). I founded the Censorship Reform Society and took up the issue with Brian Lenihan. We were supported by Frank O'Connor. John Jay was another initiator in that. Not long afterwards the whole censorship thing crumbled. Television came in '62. That spelt the end of censorship.

VR: *Were you aware of Jack Yeats' Sligo?*

BA: I was aware of Jack Yeats. In those days he wasn't a high focus in public collections. He wasn't even hung in the National Gallery. If the Municipal had works by him they weren't given a lot of attention. The person who revered him most was Norah Niland[1] in Sligo. She bought spectacularly well. The Sligo Library collection is a really integrated presentation of Jack Yeats. She begged and borrowed works. It was done on a shoestring. There was a climate of donation which has changed since. I knew her. I formed a strange friendship with Norah

Niland. She, I think, saw my involvement with *The Irish Times* as a way of getting help.

The Yeats Summer School was founded the year I got married. I went to the lectures. I wasn't that involved. I always had the Orpen view on [W.B.] Yeats, which is that he is slightly phoney. As editor of *The Dubliner* I published an article on Yeats by Yvor Wynter, an American, which I still think is one of the most profound articles on Yeats ever published. It examines the ideas of a flawed intelligence. I was seriously criticised. The very fact of my publishing it caused a row. I remember being accosted at a theatre by someone who was livid at what I had done. I said I believed it was important not to put people on pedestals. The anger became rage. That I, an Englishman who didn't belong to Ireland, was attacking Ireland's most famous national poet! It's consistent with what I was later to do with Irish politicians and artists.

I think I formed the view at that time that Jack Yeats, for all his qualities and appeal, is a flawed painter, which is why I wrote the biography.[2] In my judgement of Yeats then, there was a distinction between Yeats as a painter and Yeats as an artist. He was inspired to represent the people he came from and he did it miraculously, from the 1890s until he died. As an artist he was supremely dedicated and focused. If you take a work like *The Metal Man* [c. 1912] from early Yeats, and you take *The Circus Dwarf*, that magnificent early work [shown] in the Armory Show, and then you take *Queen Maeve Walked Upon the Strand* [1950] you see a coherent vision, linking a view of Ireland. It has the threads from which the tapestry of Irish life runs – the life of the horse, the freedom of spirit; you can almost smell horses when you look at a good Yeats. Yeats recognised the perversity of Irish life, the poverty; that's another thread that runs through the work, along with Ireland's struggle.

But if you forget the artist and think of him as a painter, he was handicapped by poor training, he never worked in a studio with an older wiser man, he never learned good rules about colour or mixing colour, he struggled to make paint come up to

his creative demands. As many works fail as succeed. He doesn't know the difference between the ones that work and the ones that are unresolved. Composition in Yeats is accidental. Another interesting thing about him – I'm more critical than the individual works justify – if you look at the watershed of the late '20s when he went for strong colours, which became rainbow-like in later works, you realise that earlier works have a limited palette. It's the palette of ignorance. It's not deliberate. The paintings are monochrome. They are blurry; mauve, pink. If you take certain colours and mix them you get mauve. Red and yellow make orange, there's a manipulation of colour which a well-trained painter like Orpen,[3] who went to the Slade, can manage. He manipulates flawlessly, so that he can create paintings which are logical in a visually correct way. You never have doubt with Orpen. You know what he wanted to say and you see it. You may say 'was it worth saying?' I'm thinking of pictures like *The Holy Well* (1916), a great feat.

Just to get back to the narrative, in 1962 I founded a little gallery called The Neptune with a friend. It sold prints and watercolours. It was quite modest but I look back on it with such pleasure and it was a moderate success. By 1965 I realised there wasn't a handbook of Irish art. I asked why was this. I thought it was because no one believed in Irish art. Irish art was verbal. Professionally owning a gallery, I saw that there was a visual performance that went back to pre-Christian times. If no one else was going to write the handbook, then I would. The book, *A Concise History of Irish Art,*[4] is readily accessible to everyone and it has sold tens of thousands of copies. Its most recent publication was in Japanese. It is a basic tool.

I had supreme confidence in my judgement of what is a good picture or a bad picture. I still stand over every word I wrote. I think it's a great book. It's in the public domain as a key book. Other books have been written which have made great contributions, but one of the greatest collectors in Ireland used it as a bible to inform an outstanding collection

made over twenty years. The book grew out of my having started the Gallery, having invested in and collected Irish art; prints, watercolours, drawings, and becoming, willy-nilly, a collector. I collected on the basis that I was a good judge of pictures, not really of artists. Some of the works I collected were not identified by artists. This was the case with Orpen, who is now regarded as one of the greatest Irish artists of the twentieth century.

VR: *Did you show Orpen in the Neptune?*

BA: I showed him twice – in 1971 and in 1982. I had to be satisfied with unfamiliar names because I didn't have the money to deal with familiar names. Leo Smith had twentieth-century art more or less tied up. Antique dealers had the nineteenth century sown up. A new gallery had to find new avenues. Writing the book and collecting pictures by artists who were not rated was how I went about it. Mainie Jellett was not rated, it was easy to buy her, but hard to sell her. As a writer I was able to do biographies of major figures like Orpen and Jellet.[5]

So there were various dimensions to my involvement with The Neptune. Firstly, it allowed me to collect. Secondly, it encouraged me to write about Irish art generally.

As well as *A Concise History* I wrote a column in *The Irish Times* on the fine arts. It was the first column of its kind in the country. I signed with a pseudonym, Jonathan Fisher.

Prices were always low then. If you got £45 for a James Arthur O'Connor, a thirteen inches by nine inches, in the '60s you were doing well. You'd celebrate. Because of that, when a really nice one came along, I took it home. I bought one of Edward McGuire's finest portraits in Adam's, because no one could read the signature.

VR: *Who was the sitter?*

BA: A Palestinian artist, Matti Klarwein.

VR: *Who bought from you in the Neptune?*

BA: The customers in the Gallery who came to our shows and bought pictures were ordinary people who wanted to collect.

They couldn't afford the highfliers. They were cautious, limited in their spending power, conservative in their taste. They sought advice; all of that was part of the pleasure of the purchase. They were doctors, lawyers and accountants. I formed my own apprenticeship based on Victor Waddington. I saw him dealing, I loved his approach. The idea that you could find a marriage between a person who was buying a work of art, the work of art and the dealer was an important part of his thinking.

Great dealers are magical matchmakers who make marriages between paintings and collectors. They created collectors. Victor did that for me.

VR: *Did you buy from him?*

BA: No, I didn't buy much from him. I steered clear of Jack Yeats, he was in a price range I couldn't afford.

VR: *Anyway, Waddington left Dublin around 1957.*

BA: Yes, I knew him in London. I was a journalist on *The Irish Times* and then in the *Irish Independent*, but my work and life were flexible, so I did cover the auctions. In the '60s and '70s it was a buyer's market. The '80s changed, not because the dealing side got better, but the collecting fraternity grew in size, so that by the end of the '80s you had a boom in Irish art. There was a bit of a collapse in the '90s, then it recovered, thanks to the persistence of Christie's, Sotheby's, Adam's, Bonhams and Whyte's. An entirely false market has been created which is inappropriate to the quality of the work. Irish art is a bit overrated now.

VR: *Do you think it's well represented in the public collections – for example, in the National Gallery, now celebrating its 150th year?*

BA: I've known the National Gallery, used it and liked it for virtually all the time I've lived in Ireland.

VR: *You're on the board now?*

BA: I've been on it for about two and a half years. I think the National Gallery in the last twenty years has failed the Irish people in that it has not collected intelligently works that reflect the artistic life of the country in the last 300 years. It hasn't created proper

sources, by gift or bequest. What we have is a growing number of intelligent well-motivated private collectors who have scooped the pool to the disadvantage of the National Gallery.

It's easy to blame the State for not funding the National Gallery, but it's wrong. The State had limited resources. There wasn't a climate or a cult for substantial expenditure. The relationship of politicians, civil servants and institutions was a cobbled together thing that didn't work properly. At a time when Haughey was Minister for Finance, between 1966 and 1968, given his pretensions about helping the arts, the National Gallery was an institution which needed help. I'm a believer in the French system: you bring all the institutions together. We have such a mixture of local government and national government. There's hopeless confusion between the Hugh Lane and the National Gallery. They're owning parallel collections. Apart from an attempt by Brian Lenihan to do something about it, when he was Minister for Education, nothing has been done. In those days the national institutions were under Education.

We have a fine collection of Impressionist paintings in the Hugh Lane, which should have been hanging in the same gallery as the other Impressionist paintings. Under Cosgrave the national institutions were transferred from Education to the Department of the Taoiseach. Arts came under the Taoiseach. That process should have been continued by Haughey. He had an alleged interest. In fact he started another museum [The Irish Museum of Modern Art] which was under funded and had no collection and was too far from the city. I'm particularly interested in two painters, Orpen and Jellett.[6] Early on, during the past twenty years, small sums would have bought good examples. Today you would spend between one and two million. The National Gallery never addressed the problem of the greatest abstract Cubist painter of the day being properly represented. We persistently buy paintings by bad artists like Roderic O'Conor.

Going through the Irish rooms in the National Gallery, I don't feel inspired. It's quite a mediocre collection. There has to

be a criterion. If you go back 50 years, people left us pictures and we couldn't say no. If you went to the collection of five great business men you would see a finer collection of Irish art. I don't think we've made any provision for what happens when these people pass on.

VR: *Is it hard to give to the Irish nation?*

BA: It's very hard. There is a central reason – doubt and distrust on the part of the giver as to how the gift will be handled by the recipient. In America – if you look at the Phillips Collection in Washington or the Metropolitan in New York – there is a glorification of the act of giving, which inspires people of immense wealth to give phenomenally generous collections of art to the American people. They feel the bond is an honourable and wonderful one.

VR: *Tax laws here now make gifts to institutions easier.*

BA: Some gifts are not gifts. The taxpayers pay for the art that is given.

Why should you and I be forced to buy works of art?

VR: *Do you like the Caravaggio the Jesuits have lent to the Gallery?[7]*

BA: I'm in doubt about its authenticity. It would seem clear that the newly discovered one in Rome has greater claim to being the original version by the artist. It's not my period, it isn't the period I revere in Italian painting. There are far better Caravaggios to be seen in the churches of Rome, and I admire them. When you get into that period, it's all drama and theatre. I'm not sure painting should be all drama and theatre.

VR: *Can we talk about Derek Hill and his gift of the Glebe House, which he bought in 1953, to the nation in 1981?*

BA: Derek Hill was an immensely generous person all his life. He was, in his private capacity, phenomenally generous. It's an unwritten, unspoken part of him. He genuinely wanted to make available his collection and his house and in a sense, his life, to Ireland, which was his home for the last 40 years. He remained quintessentially English. He's part of that strange capacity in the Irish psychology to love people who love them. Derek Hill never

tried to be Irish. He was relentlessly English in every way. His contacts in England were upper class and royalty. But his friends in Ireland were of every kind and he always treated them equally. He was astonishingly kind to the people of Tory Island and he was the same to artists in Dublin, and to the Wexford Festival Opera.

VR: *Do you have favourite paintings or objects in his collection?*

BA: He was a strange and not entirely satisfactory collector. He had sufficient income to live the life of a gentleman, never to work, and to paint without reliance on commissions, but it did not give him enough money to be a grand collector. He bought essentially small pictures, the right collection for a glebe house in Donegal. And also for the modern gallery that was made [by the OPW] from the outhouses. It's an intensely personal collection and that's its great appeal.

VR: *His generosity to other institutions, giving his Degas, for example, to some British institution, meant that his collecting range isn't necessarily visible in the Glebe.*

BA: It's a collection that is emblematic of the man who made it. The appeal of the Glebe House and Gallery is that Derek still lives at the centre of it. He's the presiding spirit in a way that's unique.

VR: *His things being there, the William Morris wallpaper, his lovely textiles and so on, create a charming, intimate atmosphere.*

BA: His talent was far greater than was recognised by critics. He was an underrated painter. His own status led to unevenness between pictures. He didn't have to satisfy his market. He controlled his market. It was dependant on him. He was a great judge of art, had a wonderful eye.

I was enormously gratified on one occasion, when I wrote a libretto for an opera, *A Passionate Man*. James Wilson wrote the music. It was put on for the two-hundredth anniversary of Swift's[8] birth.

Derek came to it with the American Ambassador, Jean Kennedy Smith. She left at the interval and Derek stayed on. At the end, his face glowing, he said, 'I had such trepidation coming

to this, but you and Wilson have made a real opera'. That was high praise from someone who knows opera as well as anyone in the British Isles. It stuck in my mind as being so true to Derek. He always spoke the truth, and kept silent if the truth was painful.

VR: *What do you think of* Aosdána?

BA: I have a distinctly dismal view of *Aosdána*. I'm not a member of it and have had a couple of skirmishes with it, which were handled abysmally. From a personal point of view, since I'm an established writer,[9] I presume there must be some sort of prejudice. I believe the provision in the Finance Act is unconscionable, since the Constitution does not allow for the creation of an elite. *Aosdána* is an elitist organisation.

In my view entry is clearly not on merit but on the basis of who is appropriate for the agenda of those who control it, combined with the belief that artists need help to make a living. But I don't think it should be done in a public way. These are aspects that I find not just obnoxious but truly appalling; it's an organisation that one should look up to and revere. It certainly doesn't inspire that sort of feeling. There are even people in it who are half ashamed of being on it. It's part and parcel of Haughey-ism in the arts. He sought to create an inner circle of art experts focused on himself. He had no idea how to do this and he had limited judgement about what was good in the arts. He rarely attended artistic events, except to give speeches. I never saw him at the theatre, where I went regularly. Music, theatre, seemed to pass him by – I think he liked the company of painters, like for instance Anne Madden and Louis le Brocquy. I think they behaved like good courtiers. They recognised the hierarchy and responded well to it.

There was a time when I wrote his speeches on the arts.

It embraced the period of his dismissal over the arms crisis – '67, '68, '69. I think the view that Haughey[10] did something great for the arts is a mistaken one. He wielded the power. He could have reformed the Abbey Theatre. He could have done something dramatic, like reclaim the Customs House, turf out

the Department of Health and Social Welfare, and turn it into a gallery or museum. It is near the Abbey Theatre. Using the river-side between O'Connell Street and Butt Bridge, he could have created a really outstanding equivalent to the Berlin Island on which stand the great museums of that city. Instead of that he gutted a seventeenth-century building [The RHK] too far from the city to make it a valid centre for the arts. In all of what I'm saying, which is judgemental, I'm trying to convey what I feel profoundly about him, which is that he was a visionless facilita-tor, who fumbled with the arts. It was parallel to how he treated businessmen; if someone came to him with a good idea he facil-itated it. He did that with Dermot Desmond and the Irish Finan-cial Centre. It wasn't his idea; it was Dermot Desmond's.

My personal involvement in Haughey's affairs is odd. The house he lives in, 'Abbeville', was owned by Mavis' family, the Cusacks, a long established Norman family. I had some knowledge of the house before Haughey owned it.

VR: *Is that a portrait of him by Edward McGuire in your hall?*

BA: Yes. I knew Edward McGuire very well. Haughey and I have portraits which came from the same commission. Haughey wanted only one; he didn't want McGuire to paint any others of him. He commissioned a seated equestrian portrait. McGuire painted a really good portrait; I acquired it from his widow. To give Edward credit, he tried to destroy it. He tore it in four pieces. His wife rescued it, and I had it properly reconstructed after Edward died.

VR: *I'm amazed you choose to own a reconstituted C.J. Haughey por-trait.*

BA: Why not, if it's a good portrait? I have to tell you that I owe Haughey a lot. Had he been a better politician I would have been a less famous journalist. There are two McGuire portraits, Ulick O'Connor's and Charlie Haughey's, out there. Ulick O'Connor and I usually row when we meet. He disputes my right to live in Ireland. I do like the portrait. It captures him at a time when he was a *bête noir* in Ireland, the time he was very

outspoken about things artistic and intellectual. If a portrait is good, it gives you a living representation of the person in an objective way, neither favouring nor denigrating them. When I look at the portrait of Haughey I see his weakness and fallibility, a weakness in the mouth. It confirms me in my judgement. What Edward McGuire saw in the face is what I saw in his actions, which reassures me in my criticism of someone I think has done lasting damage to this country.

VR: *Do you see Arts legislation, specifically the legislation that brought in the Arts Council in 1951, as important in the Irish State taking responsibility for the arts?*

BA: I think the misconception is that State involvement in the arts was somehow newly invented after the Second World War. This is to ignore the vitality and complexity of the artistic structure that had been given to Ireland as part of the UK by the Westminster government. It is astounding that Ireland, Scotland and to lesser extent Wales have national collections that are greater than the collections in some nations. This was part of a process in the age of enlightenment that began with the formation of societies and the concept that there should be places that showed works of art. Ireland inherited an enormously rich tradition; it inherited good art galleries in Dublin, Cork and elsewhere. The new State allowed these institutions to get on with it. It funded them on a low budget. The three greatest artists in twentieth-century Ireland came out of that system – Orpen, Yeats and Jellett.

All that happened from the 1950s on was that the State began to bring in some regulatory control or direction. My experience over half a century is that it hasn't appreciably changed the quality of the best art or made for greater painters than we had for the first half of the twentieth century. When we look with complacency on all that the organisations have achieved, we have to remember there were many things wrong with the institutions. The Arts Council was outstandingly elitist under Fr Donal O'Sullivan.

VR: *Do you link that to the power of the Church?*

BA: No. I feel that the Arts Council, the Department of the Arts, the boards of institutions, and I'm thinking particularly of the Abbey Theatre, all feel that it's more important to show that they are on top of issues and participating in them rather than thinking in terms of whether it's right for them to be there at all. For example, should the Minister need to have a hands-on approach to the arts when he is responsible for an Arts Council, which is there to do that job for him? It is idiotic for a man like John O'Donoghue to pretend that he has an interest in and knowledge of the detailed workings of theatre in general and of individual theatres in particular. He would be a better minister if he kept silent but made sure that the administration went smoothly. The same thing applies to the Arts Council. It should not be trying to present itself as intelligently involved in the arts, saying how much it wants to help and how much it wants to know about what people need. Greater silence on all of this would be better. Greater answerability on all of this is what the Oireachtas is about. We are not dealing with an intimate relationship between the sources of money and the artists. We are dealing with the fair, intelligent deployment of funds. Furthermore there is a strong argument that a clear division should be made between funding the facilities for the arts, rather than actually funding individual artists, which should be a minor part of State involvement. History has shown that this latter task is almost always badly done but that great good can be done in proper arms length support for good buildings for the arts, good art education and good people to help in the essential back up that so many artists need. In a nutshell, that's how I feel.

One of the worst influences on the corrupting of that was Haughey. He turned it into a fiefdom. Patronage is inherently unfair and where the Arts Council goes wrong is in seeing itself in the role of a hopefully neutral patron. There is no such thing. The same applies to politicians. I find it embarrassing to watch politicians pretending to have an understanding of the arts

when they don't. I felt this about Charles Haughey. He knew virtually nothing about the arts but he intruded himself upon the artistic community, causing the weak-minded artists to gravitate towards him, idolising him as though he were a Medici prince. He, of course, saw himself precisely in that light.

Politicians when they look at any area of human action want a hand in it. I think it was the inter-party government who introduced the Arts Act. I think it was Liam Cosgrave who introduced the 1973 Arts Act. It was not a deep-seated concern for the Arts. It was a way of channelling funding for the arts. The criterion now is that the budget should be increased. As long as the share out of money, now running at €61 million, satisfies the recipients, no one rocks the boat. It may have made more art, but I don't think it's made better art. Improvements can now only be measured by saying that more money went into theatres or more theatres are open, not what's on in the theatre.

It so happens that theatre is very vibrant in the country at the moment. More and more galleries are open. In terms of scale, it's bigger than it was in the '40s or '50s, but in terms of quality of art, it's about the same.

VR: *You were a very engaged critic of contemporary art and art issues in the 1960s and early '70s.*

BA: Yes, that's correct. I was art critic for a number of publications beginning in the early '60s. My first foray into that area was with *Hibernia*. For *Hibernia* I wrote criticism for a brief period, not very long. I became art critic for the *Irish Press* for a time. It was an exciting time in the arts. I wrote about current artistic controversies as well as reviewing art. I wrote about contemporary art when it was not a sale-room issue. I wrote about Fr Donal O'Sullivan and the perception that Tony , and to a lesser extent Brian Fallon, and I, had that the Arts Council was an elitist organisation, supporting established artists. These artists were given a greater share of the resources. We were concerned with the younger painters. That created tensions which we all enjoyed very much. Those tensions created what we are now.

VR: *What was Tony Butler like?*

BA: He was a very *Irish Press* journalist – he had a lofty old-fashioned, cultured way of speaking. He was very witty, full of newsy stories. He was a close friend. We'd meet at openings and he'd say, 'have you heard this?'. He would egg me on. We were in conflict and in combat, like two brigadiers fighting a common and much stronger foe by skill and strategy. He was balding. He had funny protruding teeth that gave him a certain appeal. I really liked being in his company. He was impish, droll.

VR: *You have all your articles?*

BA: Every one. I am thinking of giving them to Trinity. I am torn over it. If I were ever to write memoirs I would need them, but otherwise I have no further use for them.

Criticism has become very bland. As criticism became an accepted part of the artistic world, it became less about the phenomenon of people painting at all, and more about describing work by established artists. When we started in the early '60s, the struggle, even for artists like Gerard Dillon or Norah McGuinness, was phenomenal. There were galleries like Leo Smith's Dawson Gallery and the Ritchie Hendriks Gallery. Now there are twenty or 30 galleries and young people are having sell-out shows. The whole ethos has changed. Criticism doesn't have the edge it had when what you said mattered.

VR: *Could we talk about something specific like the Critics Choice exhibition in 1971, which you and Tony Butler and Brian Fallon selected, presenting artists who were not represented in* The Irish Imagination 1959-1971, *selected by Brian O'Doherty?*

BA: The real row was in '67. Tony Butler and I took grave exception to the exclusion of Irish artists from the main *Rosc* and attacked it. It was authoritarian and elitist to bring in these artists and not have some parallel showing of Irish artists. We took on Michael Scott and, in effect, Charlie Haughey. We hammered them in the press. That was the bigger controversy.

VR: *Yes. '67 was an amazing year in Irish art,* Rosc *on the one hand, the Project opening on the other.*

BA: Brian O'Doherty had a reputation in New York but was out of touch with what was really happening in Ireland. He came in to do that show in '71. I think we made a serious change. Brian Kennedy in his book[11] discovered how much of an impact we made. Journalists always get sneered at as neither scholars nor artists. The reality is that behind closed doors people quake. But it is such a frail hold on power. People don't understand what journalism is about. You do your article, you get it in, it might be cut. You have to put criticism in writing for the public the day after an opening.

VR: *Did you know Michael Scott and Fr O'Sullivan and the people whose policies you criticised?*

BA: I knew them all. The flow of people at exhibitions was such that it was open house. Today it's not. Even at openings like the RHA where all the artists and policy makers might be, the policy makers are surrounded by heavy-handed *amadáns* who protect them and know very little about art. You go to exhibitions and it's full of lawyers making investments. I was launching a book on art prices at the RHA recently. There were three or four hundred people there. I said we mustn't let Irish art run away with itself, it isn't that great. The book which published the prices was before their eyes. Many of those in the audience were disturbed by this. I think Irish art is quite limited. There are less than six or seven great Irish artists in the twentieth century.

Leech[12] isn't one. He is a journeyman painter, boring, rigid and with no real sense of palette. There are some early ones, early masterpieces. But there are plenty of unknown or half-known English painters that are better.

VR: *Are you thinking of Stanley Royle?*

BA: I wasn't. That was an unusual manifestation of Irish stupidity about Leech. I revealed the signature [of Stanley Royle on *The Goose Girl*] in sensational circumstances at the time.[13]

VR: *You have been researching The White Stag Group; can you tell me something about that process?*

BA: The White Stag group came to my attention really through

working on Mainie Jellett. She had an association with Gerard Dillon. She was the person who opened his first Dublin exhibition. He was a friend of Basil Rákóczi. There's some evidence to suggest they were lovers. But Dillon wasn't a member of the White Stag Group. The White Stag Group was mainly Kenneth Hall and Basil Rákóczi. Others like Patrick Scott were attracted to it by the dynamism of the two main people. Kenneth Hall's family was a British-Irish one, not an Anglo-Irish family. His mother was Irish, his father a mathematician responsible for a maths primer, which made a lot of money. Kenneth went off to be an artist, which his father didn't want and so Kenneth didn't get any of the money. He went to London and started the White Stag Group in 1939. It was pacifist. The white stag is a symbol of peace. The Irish association was established through the figure of Lucy Wertheim, who ran a gallery in London in the '30s. She was Christopher Woods' dealer. She gave money to Rákóczi and Hall to help them to paint. She had in her possession some very fine examples of Kenneth Hall's work. He was something of a favourite of hers and these paintings remained in the Wertheim family until she died. They were then in her daughter's collection. No one understood anything about Kenneth Hall. His greatest work was done in Ireland between 1939 and '45. He committed suicide in 1946. He was depressive, he was gay, he had this love affair with Basil, who was bisexual and very active emotionally and sexually. Kenneth Hall couldn't take that. He is the great painter of the White Stag Group.

They seemed to represent Modernism. They came out of Surrealism and in that sense came close to Jack Yeats, who in some sense is an unremarked Surrealist. Surrealism of the kind exemplified in Max Ernst's work directed the thinking of the White Stag movement. It began to disintegrate when Kenneth Hall died and Basil left Ireland after the Second World War. Steve Gilbert went and joined the Cobra movement. It had broken up by 1950. Basil continued to be quite a powerful painter. He went to Paris. He was preceded there by a woman called

Jacqueline Robinson, who helped me with my film on Jellett. She ran a dancing academy in Paris. She had a collection of Basil Rákóczi. She had a lot by way of being a guardian of Basil's work for Basil's grandson. Basil's son [Tony] had committed suicide. She had an early love affair with Basil. She married a Frenchman.

I got access to two collections, I bought from her and I bought from the Wertheim family collection. She had the *crème de la crème*, she had masterpieces by Kenneth Hall.

Nano Reid and Norah McGuinness exhibited with Lucy Wertheim. I had a collector here and he said, 'I'm not very interested in the White Stag Group'. After seeing Kenneth Hall he said he would have to have to review his thinking about the White Stag Group. There has been that obscuring of the White Stag. They vanished. Gerard Dillon, Daniel O'Neill, Arthur Armstrong and others moved in to become the painters of the '40s and '50s and established a new Irish school. Patrick Scott has disowned his association with the White Stag Group. He wants to be an original artist, not a group artist.

I have works by other members. As in the case of Mainie Jellett, I am not a group collector. I wasn't interested in Evie Hone, I always thought the association with Evie Hone damaged Mainie Jellett. Hone is a derivative painter and only found her voice when she began to do stained glass.

VR: *What art history and criticism are you writing now?*

BA: I'm no longer writing art criticism in a regular way. I feel in a sense that this is letting down a community towards which I had a nurturing and protective attitude 40 years ago, when painters and sculptors were unfairly neglected, treated with a kind of lofty disdain and told to learn from international influences. As a critic I was always fiercely supportive of the new and the experimental as well as of the older artists who had been sidelined or ignored. My most serious writing in the field of art history was based on the principles of rediscovery and reassessment. I don't think that approach is needed today. And I think

a new art historical comparative study of criticism then and now would discover a major difference between the vitality and energy of art critics in the 1960s and the 1970s, and the articles of record and notice which represent the much cooler criticism of today.

This is not to say I am bowing out. Only a short while ago I bought an oil painting by an Irish artist who lived and worked with Henri Matisse, leading up to that brief and glorious time when Matisse was one of the Fauves. My excitement at this acquisition is still a very real part of my interest and enthusiasm for Irish art. More recently still, I bought a work of sculpture by Rosamond Praeger. It too has had the same effect. I no longer feel the need to write up such discoveries. And in fact the whole world of art historical writing has been overwhelmed by detail, cross referencing, footnotes and academic correctness. The pure expression of what one sees with one's eyes, absorbs with all the material advantage of experience, and then judges in terms of a philosophical aesthetic, is what concerns me now.

In conversation, Dublin: 26, 27 September 2003, 26 November 2004; Cork: 17 June 2005.

1. Tinney, D. (ed.), *Jack B. Yeats at the Niland Gallery Sligo,* Sligo 1998. Nora Niland, born in County Galway in 1913, became County Librarian in 1945 and in 1955 established what later became The Niland Gallery, comprising 49 pictures by Yeats, and the [W.B.] Yeats Summer School in 1960. The loan exhibition of 60 Yeats paintings in Sligo in 1961, organised by her, was the greatest collection of Yeats shown in Ireland since 1945. She died in 1988.

2. Arnold, B., *Jack Yeats,* London and New Haven 1998.

3. Arnold, B., *Orpen Mirror to an Age,* London, 1979.

4. Arnold, B., *A Concise History of Irish Art,* London, 1969.

5. Arnold, B., *Mainie Jellett and the Modern Movement in Ireland,* Yale, 1991.

6. IMMA and Arnold, B., *Mainie Jellett 1897-1944,* Dublin 1992.

7. Arnold, B., *Swift: An Illustrated Life,* Dublin, 1999.

8. For an account of *The Taking of Christ* (1602) formerly attributed to Honthorst, see Benedetti, S., *Caravaggio – The Master Revealed*, Dublin, 1992.

9. *A Singer at the Wedding, The Song of the Nightingale, The Muted Swan* and *Running to Paradise* are novels by Bruce Arnold.

10. Arnold, B., *Haughey: His Life and Unlucky Deeds*, London, 1993.

11. Kennedy, B., *Dreams and Responsibilities*, Dublin, 1990.

12. Denise Ferran's major publication for the 1996/1997 Leech exhibition at the National Gallery (which travelled to Belfast and to Quimper, Brittany) is *William John Leech, An Irish Painter Abroad*, Dublin, 1996.

13. 'On the opening day of the William John Leech exhibition in the National Gallery of Ireland, 22 October 1996, I attended a press preview, and, in the light of controversy over *The Goose Girl*, I inspected the bottom corners of the painting in search of a signature. I discovered remnants of two names, including the letters, 'EY' and 'LE'. These are part of the signature of the man who is now widely regarded as the author of the work, Stanley Royle ...' Arnold, B. 'The Goose Girl Controversy' Ch. 32 *The Spire and other Essays in Modern Irish Culture*, Dublin, 2003.

Barrie Cooke in Amsterdam 1962.

Barrie Cooke

Barrie Cooke was born in Cheshire in England in 1931, and went to live in America with his American mother, Gladys Judge, and English father in 1947. He was educated at Harvard University, obtaining a BA in art history in 1953 and attending Skowhegan School of Painting and Sculpture in Maine during the summers. He came to Ireland in 1954 and has had regular one-person exhibitions, notably with Ritchie/David Hendriks from 1962 to 1988, and since then with Kerlin Gallery. Three major exhibitions stand out: The Douglas Hyde Gallery retrospective in Trinity College, Dublin, in 1986, which travelled to Belfast, Cork and Limerick, ClaoClo in the Haags Gemeentemuseum in The Hague in 1992, and the 2003 Barrie Cooke a Retrospective, which travelled from the RHA to Sligo. He has three daughters and four granddaughters.

VR: *Barrie, you've been very involved in some key developments in the arts here for 50 years.*

BC: I wasn't involved in Clare. I found my own voice in Clare. I was ten years there. I *was* very involved in Kilkenny and also in Sligo.

VR: *Were you aware of Dorothea Lange's photography project[1] or the Arensberg and Kimball study of Clare?[2]*

BC: Arensberg, yes. He had recently studied Kilnaboy in County Clare. Lange, no. Arensberg was remembered by everyone, he'd been there a few years before. There was a book called *The Irish Countryman*,[3] I got it on the internet for six quid. It was out of print. It was reprinted in the University of Mexico in 1987 and I have two copies of it. My original I lent, it's gone.

There was an extraordinary woman in Clare, Luba Kaftanikov. I got the cottage through her. I was terribly lucky with the cottage. The River Fergus was in front, five minutes away, the Burren was at the back, ten seconds away. She knew any intellectuals who came to Clare. She had been Yeats' secretary very briefly and had a couple of letters. Luba's mother was from Donegal and her father was Russian.

VR: *Do you know the name of your own maternal great-grandfather from Donegal?*

BC: He was Judge, a Quaker who ended up in Philadelphia.

The first painting I made in Clare was of Luba. I found it recently. If ever I had a show of portraits – I've done about 25 – that would be one I'd have in. My parents settled in Bermuda but I wanted to get out of Bermuda as fast as I could. So I painted every single one of my parents' friends for about five quid each.

I went to university in America for four years. I had a letter from Professor Jack Sweeney in Harvard when I came to Ireland. I came to Dublin on the boat. Jack gave me two addresses; one, Niall Montgomery the architect's, and the other Seamus Delargy's; he was head of the Folklore Commission. Niall Montgomery was a Joyce expert and an architect. He was very good at restoring Georgian buildings.

VR: *He restored the eighteenth-century stables of Kilkenny Castle which became Kilkenny Design Workshop and shop, didn't he?*

BC: Yes. I phoned Niall. He was helpful. I said 'I want a motorbike' and I got one for five quid.

Seamus Delargy was on holiday in Kilkee. He was a bit of a fisherman. When I arrived in Dublin I asked which was the best tackle shop. As luck would have it, one of the directors of the shop, Garnett and Keegans, was J.R Harris, a lecturer in entomology at TCD and author of *An Angler's Entomology*. I said 'I want the finest dry fly river in the country'. Dick, as he was called, took me seriously and made a cross on a map. 'This is the River Fergus at Kilnaboy, the best dry fly river in Europe.' I got on my motorbike and went across country to Kilkee. In Kilkee I said to Mrs Delargy that I was a friend of Jack Sweeney. The Delargy house was full. I said it didn't matter; I'd sleep on the floor. The next day, Delargy brought me to the Burren and to the River Fergus. We saw the trout rise. That was the exact spot near Kilnaboy that Dick Harris had said was the best dry fly river in Europe. Delargy introduced me to Luba and I stayed with her. I found the cottage within three days. I stayed for two years.

Ireland changed with the introduction of the calor gas cylinder. I think it made a huge difference to countrywomen, to women who collected sticks or brought in the turf. It freed people, they had more time. Television, the dry battery, the calor gas cylinder; a lot changed in the time I was in Clare. Larkin said sex happened in 1963.

Most of the country people in Clare had never met a foreigner except the Arensbergs. My wife Harriet came from New York city.

Barrie and Harriet Cooke.

When Harriet came over, I went to Cobh to meet the boat. It was a helluva job. I left the motorbike in Corofin. There was a cattle fair – you know what cattle will do to a village. It was shit all over. Standing beside my motorbike was a feeble fellow called Jack, an innocent fellow. He started to stroke the bike. It was a Norton 500 cc, single cylinder. I sold it for £5 and I saw one advertised recently for £5,000. It is now a vintage machine.

Harriet and I were asked by the parish priest would we do sets for a Christmas play and as a thank you, we got a turkey and ham. They were too big for the pot oven, so the pub keeper, Bofie Quinn, cooked the turkey and the ham. We couldn't carry them both back on the motorbike – it took two trips.

I've walked every inch of the Burren. I've walked in the middle of the night under a full moon. I was like a goat. I couldn't do that now, I'd have no ankles left. We moved to a house with electricity, running water and a Stanley stove. Even I realised that having a child without water would be difficult. We moved twelve miles from Corofin.

My parents helped. My father was a businessman and he loved animals. But at that time if you were middle class you couldn't be a zoo keeper. He took over the family business in edible fats. Matthew Smith's brother Harold was a good friend of my father [in England] and stored a lot of Matthew's work. They were the first good things I saw. I went to boarding school in England when I was seven. I've forgotten the name, I think I've deliberately obliterated it. I've spent most of my life getting over it. I went to Wrekin College in Shropshire for about a year after that. You were taught that every emotion you have, you squash. I think that's why I had difficulty. Painting was the only thing I could let go with.

When I came to Clare [in 1954] it was very poor. At that time no artist in Ireland lived in the country. Professor Jack Sweeney, who gave me the letter of introduction to Delargy, built a house near Corofin. He was the only one who didn't laugh when I said I wanted to be a painter. To build the house he sold

a big Picasso – he had two. He had Klee, Yeats, Picasso, Gris. They were left to Máire, and given to the National Gallery of Ireland [in 1987]. There was a newspaper heading 'Paintings given to the National Gallery ... Picasso ... Gris ... Cooke ...' I had done a portrait of Máire in thanks. They framed the letter. I wrote 'Dear Professor Sweeney, I would like to paint your wife in thanks ...'

James Johnson Sweeney's nephew, Seán, was in Harvard with me. Harvard were very good to me. They gave me a single room, even though I couldn't afford it. Painting in a room shared with five room-mates was driving everyone mad. They had no art school then.

VR: *James Johnson of* Rosc *fame was the brother of Jack?*

BC: Yes. I met Ted Hughes through Jack. Jack was primarily a literary man. He bought two paintings of mine. They were easily the best things I'd done.

When Dromoland [Castle] was bought, the owners asked me to restore the paintings. The really hot stuff had already been sold. I restored about 100. I tended to underclean, I just took the varnish off. I remember going over every day. Some had been in the wine cellar and they had to be dried first. There was a period when I *had* money and I got a car for my wife.

VR: *Tell me about your contacts with artists on the Irish scene.*

BC: Brian Boydell[4] was my first friend here. I met him fishing on the Fergus. I asked him to tea; it was tea at the turf fire and a deck chair. Later we stayed with him and Mary. I caught my first salmon with Brian. Brian was one of my first portraits. I know all their kids. Cormac just phoned to say he couldn't make it to the opening [Fenton Gallery, Cork, 29 April 2004]. Rachel [Parry] was in England. Patrick Pye was a very early friend. Through Patrick I met Camille [Souter] and Frank [Morris]. They were living in [37 Upper] Mount Street. We remained very close friends.

Through Patrick and Camille and Frank [in 1960] we founded the Independent Artists.[5] Camille and Frank and Michael Byrne and Noel Sheridan and Charlie Brady and others.

I was still in Clare. We'd all been refused by Living Art, except Camille. It was an alternative to Living Art. Our first show was in Baggot Street. Guinness gave us a barrel of stout. Two people could show more than others; it was by lots. Camille was one and I was another. It was ten pieces, I think. We used to go up and down Baggot Street. We got drunk quite a lot. We used to sing 'A Cooke in every home ...' Frank was a lovely person. He was teaching in St Columba's. He taught Michael Warren. Charlie Brady was around.

Barrie Cooke and Patrick Pye, c. 1961.

VR: *Charlie Brady came from New York to Ireland shortly after you.*

BC: Yes. James McKenna was involved but finally I resigned from Independent Artists. It became too political.

Someone at the first show with the Independents or was it Living Art came up and said, 'Patrick Collins wants to meet you'. I was hugely chuffed. He was a great figure, he liked my work and he brought David Hendriks to see it. That's how I started with David. I was 28. I was beginning to find my way. I never left David. When he died [in 1983] Vincent Ferguson took it over and Blaithín de Sachy ran it. Liadin, my daughter, said, 'Look Dad, you're loyal to David and David is dead'. That was when I went to Kerlin. David was a very remarkable guy and I liked Vincent but it was not the gallery it was with David. People like Patrick Scott and Norah McGuinness I only got to know later. Norah ran the Living Art.

In Corofin there was a woman called Audrey Douglas,

godmother of Anne Madden. One day in Clare I saw this apparition coming across the field, she was blonde and gorgeous. She and Louis [le Brocquy] hadn't started then. Louis was always very kind. He was the king of art in Ireland. Pat Scott was way up there. At Hendriks there was George Campbell, Arthur Armstrong, Gerard Dillon and Patrick Collins. They were all older. I didn't like their work that much, except Collins'. Paddy Collins' [work] I always loved. He hardly ever drew but he was a great draughtsman. I have three drawings he gave me. We used to go on the batter together. In his studio in Fitzwilliam Square his stuff was all over the floor. I hate when people come into the studio and say 'can I have these?', but they were being walked over. He came down and stayed with us in Clare. The idea was that he was getting off the booze. I was so touched when he came to the opening in the Hyde[6] [in 1986]. We hadn't seen each other for ten years.

VR: *You travel a lot from your Irish home – you went to Kokoshka's School of Seeing shortly after arriving in Clare?*

BC: I hitchhiked to Salzburg. I had enough money for two weeks. Kokoshka gave me free tuition, free lodgings and free food. He let two of us paint in oils at the end.[7]

VR: *Do you see a connection between Yeats and Kokoshka who came to Dublin to see a friend's show in Waddington's in 1950?*

BC: Kokoshka said to me one day, 'There are only two painters in the world, Morandi and Yeats'. It was saying a lot. Picasso, Matisse, Miro were alive then. Kokoshka had met Yeats. I don't think Yeats was influenced by Kokoshka or Kokoshka by Yeats.

VR: *Your painting of Knocknarea, that Yeatsian landmark, seems unburdened by cultural baggage. Is it inspired by the Yeats in any way?*

BC: When I was in New Zealand I painted Tekapo lake. It was like painting Glencar or Knocknarea; you almost couldn't do it. They said, 'how the f— did you ever do it?'. I said 'Why not? everyones' eyes are different'. I *am* going to do Ben Bulben. At the moment I can't but I will. There is a pile of stones on top of

Knocknarea. Reputedly Queen Maeve in her armour is [buried] standing upright, facing Ulster. In 1955 I took a hammer and chisel and made my own stone circle in Clare, I didn't tell any one. About twenty years ago I took Seamus [Heaney] there. When I was in Clare I became immersed in [W.B.] Yeats. I'd just mown the lawn one day, and up came a guy with big hair. 'My name is Yeats,' he said. Brian Boydell had sent him for a kitten. I had a Siamese cat, who had kittens. I thought he was a ghost. It was Michael Yeats.

VR: *Did you sustain your links with the American art scene?*

BC: I couldn't afford to go to America. I had a show in New York after I moved to Quin. I still have friends in Harvard.

My parents came over; first to the cottage with no water, then to the one eight miles away, with running water and electricity. For the first show I had with David Hendriks [in 1962] my name was in the window. My mother came over from America by boat. When she saw my name she thought everyone in Dublin must know about it. I was glad she had seen that. My photo was in the paper. My father died shortly after that.

VR: *When you had your first show in Cambridge, Massachussetts in 1953 how well did you know the Abstract Expressionists?*

BC: I was a student, I graduated in '53. My teachers were violently against this Abstract Expressionist thing. There was a big Abstract Expressionist show in the Fogg and on the next floor down there was a figurative show of older artists. This was conscious. The Abstract Expressionist stuff was hardly seen as art at all, but I couldn't leave it alone. I remember seeing [Pollock's] *Blue Poles* [1952] in Betty Parson's [Gallery] in New York. It didn't sell. That was a show you went to see. I was knocked out by it. I was a student. I didn't understand it but I loved it.

I loved de Kooning then and I love de Kooning now ... the paintings were incredibly violent when they first appeared. Now they're delicate and lyrical and more like Monet. I discovered he loved Soutine, one of my first passions. Much later I discovered he loved Rubens.

I never met any of these guys except David Smith and Motherwell. Motherwell was the educated one and distrusted by them for that.

VR: *Do you think painting in Ireland[8] been strongly influenced by Abstract Expressionism?*

BC: All painting is influenced by it. I happened to see it earlier. Basil Blackshaw and Louis would say they made their own way. I don't think they'd have done what they did without Abstract Expressionism. I don't think any painterly painter would.

Camille is a good example. We've discussed this. The Achill paintings were, I think, influenced by Pollock. She says Pollock is finally a decorative painter because he has no subject. The Achill paintings are about Achill.

Patrick Heron had a belief that people like Alan Davie were on their own. He did go to America at the right time, as did Lanyon.

It had almost too much effect; all over the world there are hundreds of bad dribbles. Diebenkorn's early figurative paintings are as interesting as the later ones. He was scorned because he was figurative.

My teacher was Jack Levine, he valued figuration.

Sam Francis went to France. America was very zenophobic, and he wasn't liked for that. Once Abstract Expressionism was the main currency, art had to be made in America. He was ill thought of; the work was too 'tasty'. They believed you had to be tough, masculine – the Abstract Expressionists. Sam Francis is first generation. It's only in the last twenty years that Cy Twombley has become a major figure. Joan Mitchell, another very good second generation Abstract Expressionist painter, worked in France. Grace Hartigan made a whole bunch of paintings in Ireland in the '50s.

French people insist that Tachisme started at the same time as Abstract Expressionism. Guys like Fautrier and Dubuffet and the Cobra were justified in saying they were not influenced by Abstract Expressionism. They were right after the War, they were separate.

There's a second generation in Holland, as there is in America. There's an abstract expressionist kind of Tiepolo-like ceiling in the Mauritshuis. It's superb. Rudi [Fuchs] took me there. Ger Lataster did it. It's listed in the catalogue, but you wouldn't know about it. It's the whole ceiling.

VR: *Tell me about going to Kilkenny.*

BC: Sonja [Landjweer] had a studio in Amsterdam. It was along the Amstel. Amsterdam is as nice a city as you can find, but I missed the weeds. It was very difficult to come back. I thought everyone would shoot me but no one could care less. I went first and Sonja came four weeks later. I'd left the car with the Boydells. I got the car and went to Calary to see Frank and Camille. The house was bitterly cold. Camille seems impervious to cold. It became too late to go back. Frank was a very gleeful kind of guy. He said, 'You can sleep on the sofa and wrap up in the curtains or in the spare room but there is someone there already' ... a lady who was eight months pregnant! About a year ago I met the lady. She said, 'I shared a bed with you, you don't remember; it was in the Morrisses.' We hadn't spoken.

VR: *Did you live in what is now the Grennan Mill Craft School?*

BC: Yes, but not at first. We lived in Kilkenny city in a row of cottages with an outside tap and an outside toilet. I ran a pipe from the outside tap into the kitchen. It was difficult to wash nappies. The only luxury was the Magdalen Laundry next door. I used to bring the laundry and collect it, there were these smiling nuns and happy looking girls. We didn't have a clue. Kilkenny was one of the worst of the Magdalen Laundries.

Through Peggy Butler we met Stanley Mosse and he knew all the millers. Pilsworth had owned the house we lived in. We paid £3,000 for the house. We could have had the whole island for another £4,000. It had sixteen acres. We couldn't get them when we had the money. We sold the house and moved to Jerpoint. That gave us enough to finish Jerpoint. That was 1971.

The mill building is now the Craft School. My daughters Julia and Áine went there. Liesbeth Fonkert taught weaving in

the school. There was a wonderful head of the VEC, [Brendan Conway], who gave George [Vaughan] the freedom to do what he wanted. I taught art history once a week there for about two years. I taught about artists that I like and not much about artists I don't like. Dates you can look up in a book. I was quite tough. I locked the door and students were on time after that. I met some of them after and they said the art history was one of the best things they did. There's a guy here in Cill Rialaig who came up to me and said he attended a lecture I gave in Kilkenny.

VR: *It must have been very exciting to participate in the Kilkenny Design enterprise, through Sonja?*

BC: The Design Workshops were terrifically important to Ireland.[9] Sonja was asked to set up the ceramic section. Basil Goulding, Gordon Lambert and David Hendriks knew how good Sonja was. We were living in Holland; it seemed a godsend. She was very well known by the Danish who were involved. They were setting up Kilkenny Design in Kilkenny rather than in Dublin. That was a sensational thing to do in itself.

VR: *Yes, Kilkenny's population was only 12,500 then. Who did you see as the main players?*

BC: Basil Goulding, then Stanley, then Margaret Downes were on the board. Basil forced his directors to have paintings in their offices. Basil was the only serious collector that was ever here. He was a sir and he was rich. Some have become big collectors since then. Bill Walsh, who worked for the Export Board as general manager, was the main force. He was the first CEO. *Córas Trachtála* were the export board. Bill was a tough person. He was a bit daunting. His desk was slightly raised off the ground. He would say 'sit down'. He was a Napoleon. If you stood up, you'd be undaunted. He was a fisherman. I borrowed his boat once and kept it rather too long! He came and asked me for it and I was out fishing in it. Jim King, who worked for GPA; he was an early person.

I did a 15 foot high sculpture in four sections with 'plates' on rods. Sonja fired it. It was the biggest sculpture I ever did.

We didn't know where to store it, no one understood it. It's completely destroyed now. Kilkenny Design paid for the glue and the boards. I used eight by four sheets of block board covered in plaster. That was done in Thomastown. I hadn't done the bone boxes. About fifteen years later for Bank of Ireland in New York I did a mural of plates fastened on rods.

VR: *How would you evaluate the impact of the Scandinavian report?*

BC: Despite all the rows, it was fruitful. Design in Ireland was appalling up to then. Design was something you didn't even budget for. You got it all out of a book from Italy. A guy called Bertel Gardberg, a Finn was very important. He was KDW design director in the '60s. The designers were all in their twenties. They picked brilliant young designers.

VR: *Can you remember other people who impressed you?*

BC: There was a Danish textile designer who died of cancer. There was Richard Eckersley, the graphic designer. He left. Tony O'Hanlon was his assistant, he lives in Galway. He's married to another graphic designer. Helena Ruuth, the textile designer, is very good. She lives in Wicklow. Rudolph Heltzel is one of the ones who stayed. The wood turner Maria Van Kesteren trained a lot of wood turners in Kilkenny.

Kilkenny became a place where craftspeople settled. Simon [Pearce] set up a big glass place in Bennettsbridge. Keith Ledbetter was a technician and he took over. Simon's a bloody good technician too. Simon was like Nicky Mosse, he had to be doing things all the time. Nick employs about 80 people. Simon married an American and went to Vermont. His stuff is all over the place.

More and more people began to come. Sonja welcomed that. She wasn't a serial potter. Sonja was an early member of *Aosdána*. She had bins of broken pots, she had to smash them because people were taking them. Sonja is closer to Lucie Rie and Hans Coper than to Leach, who made series. She was extremely important to my work.

Bit by bit they set up the stables as workshops. They bought Butler House, Lady Butler had lived there. It was for

visiting designers and storing Basil's collection. The County Council were going to sell the collection which Basil gave to Butler House and to Kilkenny Design Workshops. Susan Mosse and I raised hell about this. We said you can't sell gifts. It was given to Butler Gallery.

Peggy and Hubert had started a small film society in the '40s. It was where the shop is now.

VR: *You'd known them since your early days in Kilkenny?*

BC: Brian had said you must call and see Peggy and Hubert Butler.[10] I called and liked them both very much. Peggy was the main mover around the Kilkenny Art Gallery Society. She wanted me to join KAGS. I was cautious. I said I might not give a talk. She said, 'You might not be asked'. That was typical of her. Hubert was a man of great distinction. I'd say, 'Do you know such and such a person? meaning 'have you read them?' and he'd say, 'I don't know them that well but ...' He was quite well known in a small circle of writers. Myles na Gopaleen came down to stay with Hubert and Peggy in Maidenhall. He was a terrific drinker. Hubert wasn't a drinker at all. Myles was very fond of Hubert and Hubert was very fond of him. William Trevor you'd expect. Hubert was close to Elizabeth Bowen. I met Francis Stuart in Maidenhall.

I had a dream that I painted Hubert. I tried to paint from the dream but it didn't work. I do all my portraits from life. I wish I could do landscape from life. When I went to Kilkenny I made Burren paintings. I don't take photos any more. My memory of colour is more accurate than a camera. I did some drawings of Peggy. [*Peggy Butler 1, 11 and V*, 31 October, 1996]. She died about a week after that. I've given them to the Butler Gallery.[11]

VR: *What was the relationship between Kilkenny Art Gallery Society (KAGS) and the Butler Gallery?*

BC: The Pennefather Collection had some very nice paintings, a couple of Laverys, Hones, Osbornes. It was the basis. KAGS had no premises. Finally when they restored Kilkenny Castle we got the

OPW to give us a space [The Modern Gallery in 1976], largely through Peggy. Much later it was called the Butler Gallery. Dorothy Walker came down from Dublin and said, 'Why on earth didn't you make it all into one large room?' I like the small rooms. I did a lot of work with the collection. I fought to keep money for purchases. It's a very nice little collection. We had very little money so we bought small things. At the time there was no public collection of contemporary art in Ireland.

For an early show [in 1978] in the new Butler Gallery Sonja and I did a show called 'Fur Feathers and Fibre'. It's still remembered. The stuff was stored in the National Museum, well preserved in glass cases. We were given carte blanche. We took about a 100 pieces. It took a long time. Sonia knew an anthropologist from Holland, an anthropologist of some distinction. We took him to Dublin and he couldn't believe what he saw. He said it would have a special museum in Holland. They took it from the glass cases and put it in boxes. It hasn't been seen since. I'd love to see it out in the open. Maori feather capes, a magnificent South American chief's costume made from beetles wings, with a helmet and a breast plate. Stunning. Superb. Cook's second mate on his second voyage had been a TCD man, that's how the collection was in Dublin.

VR: *We must talk more about shows you curated, as we would say today, but let's stay with the Kilkenny story for a while.*

BC: George Vaughan and David Lee, organist at St Canice's, and I started Kilkenny Arts Week. There was Ramie Leahy, a great enthusiast. The same people as started the Kilkenny Arts Week [in 1974] started the Butler. They were all very devoted. The major show of the year in Butler would coincide with Arts Week. It's so hard to get people to come from Dublin. It's two and a half hours. The County Council refused money the first year. The second year they offered £25 or it could have been £35. St Canice's was the centre. The acoustics are wonderful.

We had extremely good people coming for nothing. We hated that. We completely let each other go, we wouldn't dream

of interfering. I did the visual arts part of Kilkenny Arts Week and Sonja ran the craft side.

[In the early days] Seamus [Heaney] and I did the literature. He knew lots of writers. You had to have people who knew the writers because you couldn't pay them. The readings took place in Kytler's Inn. We had Thomas Kinsella and Robert Lowell. He stayed with us for two weeks.

When we started Kilkenny Arts Week we didn't have the Butler. An early show was Patrick Scott and it was in the dining room of Kilkenny College, where Swift went to school. Only in the very beginning was there an Irish artist. We didn't have any money. There was no IMMA and the Municipal [in Dublin] was doing nothing. I got the idea of having foreign artists who hadn't shown in Ireland. The second or third artist [in 1976] was Robert Andrew Parker – he's in Ballinglen now.

I was in the *Rosc* '84. Bert Irvin was in it and so was Bill Woodrow. I liked Bert's work in *Rosc*. Bert and I both liked Turner. We were at a collector's dinner and he started quoting Turner's 'It's a rum thing ...' and I finished it ... 'this art'. Through Bert we got John Bellany [in 1987]. He was a terrific drinker and so was I. He was a great admirer of Beckmann, so was I. He did a portrait of me.

David Nash was very interesting. I was in New York at a show of English sculpture, an IBM show. A year later I saw the same show in London. I thought 'this is it' for the Kilkenny Arts Week show. I got his address in Wales and he had a show in Kilkenny [in 1982] and then the Hyde – I was on the board of the [Douglas] Hyde then. He opened a Steiner school because he was so impressed with the one my daughter was going to. He gave us two pieces [*Branch Cube, 1981* and *Family Tree*] for the Butler Gallery collection. I interested Pat J. Murphy and so David was in *Rosc* '84. I asked David Nash about another artist and he said 'what about Richard Long?' I went to Bristol and said to Richard, 'If you have any doubts ask David Nash'. Long hadn't been in *Rosc* when I asked him to be in the Butler.

There was the Gillian Ayres show. Three months before a show by a well-known English sculptor he cancelled, he couldn't come. I had a friendship with a girl who knew Gillian. I asked her to introduce me to her. A lot of people would have been offended at being asked at such short notice but she was very nice and unaffected. She said, 'Yes, they are in crates, there has been a British Council show in India' [in 1991]. She and her children came and stayed with the Mosses, Nick and Susan.

Beuys came down. I'd written to him in Germany. D'Offay hated the idea. Beuys was big enough, he would have done it. I'd known Beuys through Dorothy Walker's efforts to set up a university. Stanley showed Beuys around.

I never went through dealers. They don't particularly like their artists showing in small cities like Kilkenny. But Susan and Nicholas Mosse were very generous with their hospitality. Artists could stay as long as they liked. It was through Susan that we showed Ian Hamilton Finlay [in 1989] and Sol Lewitt [in 1993].

We showed Sidney Nolan [in 1983] but not during Arts Week. We showed a wonderful Australian artist called Fred Williams. I saw the work in New York and we worked and worked to find him. He was dead. His wife was in England. Shell had bought his paintings and we got them [in 1988].

I met Bill Woodrow through Rosemarie Mulcahy.[12] She's very expert. I hadn't realised how expert. Seán [Mulcahy] did a mirror piece for Susan.

I was in *Rosc* and Bill was in Rosc and we became friends. Bill had a wonderful show in Butler [in 1986 and 1997] after he had been in *Rosc*. Susan later commissioned a piece from him.

Bill had fished a little as a child. He fished with us. I met Richard Deacon later and he said, 'Bill's fishing all the time now'. Stanley gave Bill a wonderful stone trough, it was three tons weight. I found canisters where Julia, my daughter, lived in Thomastown. They were tossed aside – they had been full of lethal stuff, but they were gorgeous. I showed them to Bill. I warned him to wash them very carefully. He made a wonderful

piece [*From Time to Time*, (1988)] out of them, with gold liquid. It was so heavy he couldn't get the trough back to England so I said, 'Why don't you leave it with us?'. It's part of the Butler collection now.

When I moved here [to Sligo] I said to Bill, 'You've got to make me a weather vane, every fisherman has to have a weather vane'. He arrived with my hat made in steel and True (North), Deep (South), Far (East) and Wild (West). He is a master at repairing things. The first thing Pauline says is, 'What have you got for Bill now?'. I always wait for Bill to come and repair things. I stay with them in London. He had to give up the cutting in steel, partly because he got too good at it and partly because he got tennis elbow. Artists hate getting too good at things. Bill now does bronzes.

VR: *You put a lot of time and money into travelling: used you get Aer Lingus artflights through the Arts Council or what?*

BC: Yes.

There's an American artist called Turrell. Liadin showed me his work, she'd seen it at Barbara Gladstone's gallery in New York. I'd never seen anyone use light like him. I went down to Poitiers to see the piece he'd done under water.

I met a wonderful woman, Dominique Truceau, in Poitiers. She did the catalogue *raisonné* of Turrell. I made some erotic drawings in Holland in 1962, about twelve, after seeing Rubens' oil sketches. I never exhibited them, except with her, in an exhibition of erotic art; Eros, C'est la Vie. There were three artists. There was a chair by Mona Hatoum with a heart made of pubic hair. Dominique had a funny accent. 'Would you mind so very much if we used some of your erotic drawings on 100,000 condoms?' she said on the phone one day. It was for Aids fundraising. I was delighted. I gave them around to everyone. Why someone with such eyes in Poitiers? She had absolutely *carte blanche*. She was part of the L'Imaginaire Irlandais 'do'.[13] Fergus Martin and Vivienne Roche were in it. I wasn't in the exhibition which went to San Francisco, it was younger people.

I wrote to Turrell in Arizona and didn't hear from him and then one night at around three o clock in the morning he phoned. We talked for about two hours. I told him I had never seen anyone since Turner use light the way he did and that Turner had never been to Ireland. It turned out that his wife had Irish connections and he was buying an island here. I knew Susan Mosse would be the other person who understood the work. She and Nick went over and saw Turrell. They brought over a lovely piece. Ciarán Benson and Liadan and I were there looking at it. The light was wonderful. It was so blue. And when you then saw the black of night ... Jim [Turrell] asked me would they like it and I said I thought they would. The Butler Gallery were cross. They thought it belonged to them, but I know he gave it to the Mosses. Nick had paid to have it remade over here.

VR: *It was an intense level of involvement by committee members in Kilkenny then, with people like Richard Eckersley whose posters advertised Arts Week so beautifully also serving on KAGS. Would you talk more about the various committees, Barrie?*

BC: Peggy, Paddy Friel, George Vaughan and Susan Mosse were the core Butler Gallery committee when I was there. As Peggy got more and more unable – she was a very powerful chair – we used to meet at Maidenhall. Hubert was indirectly involved, but only very indirectly. He died a year or two before her. Peggy was about 90. Here were we young people and we hadn't done much, she kept us going. I remember her saying, 'Old age, you know, isn't for cissies'.

We had constant battles with the Arts Council because the committee stayed on. They stayed on because there were very few people to do the work. We were all on both committees. At the beginning, Paula McCarthy, visual arts officer at the Arts Council in the '70s, loathed Peggy and Peggy loathed her. We had to go up there and see them. I sat Peggy at one end of the enormous table in Merrion Square and Paula at the other. I said, 'Now you're 20 feet apart, you are going to have to shout at one another' – thus ensuring that they wouldn't. Very slowly they

became friends. We always had to battle with the Arts Council. Without the Arts Council, though, we couldn't have had an Arts Week or a Butler Gallery. But it was very hard to get across that Kilkenny was not the Florence of the South.

At first three-quarters of the audience for Arts Week was from outside Kilkenny, now it's the other way around.

VR: *It's now an enormous economic boost to the area. I think they got something like 60,000 visitors in the ten days this year.*

BC: When I moved here I'd been on the Butler so long they said, 'Keep in touch'. I'd seen paintings by Peter Doig, I got his address and he sent me some catalogues. I took it for granted that they would show him, but Susan was the only one who went with it. The other day Natalie [Weadick] said, 'Guess who we are having; Peter Doig', and I said, 'What a pity, you could have had him for nothing ten or twelve years ago' – I was slightly irked.

Susan left the committee shortly after I moved here. Susan's taste was much more intellectual than mine. She had been a student of Sol Lewitt. Ian Hamilton Finlay's show was hers. Sue Finlay, his ex wife, helped Susan to make 'Kilfane', that wonderful garden. Ian Hamilton Finlay didn't come – he very rarely goes away. Susan has one of his lettered pieces in her garden.

We had a celebration for 25 years of Kilkenny Arts Week [in 1999]. Everyone came, except Ian Hamilton Finlay, an American, and Hockney. Richard Long couldn't. He had a show halfway across the world. We all met again and some people had never met before.

VR: *In a sense all this fabulous volunteerism preceded the current professionalisation of arts administration.14 Butler Gallery has had administrators since 1982, hasn't it?*

BC: The first administrator was Bernie Kiely.

VR: *The artist?*

BC: We tried to get an arts person. We're old friends. She now lives in my old house in Thomastown. The second person was Shirley

Lanigan. At the time she knew very little about art, but she was a very good administrator and learnt a lot about art.

VR: *What about the directors of the Douglas Hyde which opened in 1978?*

BC: Murph. was a terrific director. I've always been an admirer of John Hutchinson. A lot of what he shows is a little too refined but there are surprises, like the Marlene Dumas show. When he told me he was going to have a show of Lieb with just one piece I said, 'Come on, you're a minimalist but one piece ...' But he was right. I saw a corridor of beeswax in France by Lieb.

For many years I'd say to John, 'You have to go and see Paul Mosse'. I put Paul Mosse up for *Aosdána* but he was refused. I think Paul is maybe one of the best painters in the country. The work doesn't reproduce in photos. Stanley was the key of the whole thing in Kilkenny. Tanya is a very good sculptor and stonecutter. Of his five children, only one is not an artist.

VR: *Stanley Mosse had himself trained as an artist, as well as being a founder member of KAGS and frequent chairman.*

BC: Yes. Anya Van Gosselyn had a little gallery over a shop in Wicklow Street. Paul was showing there. We were at the Hyde with the Millers. I wasn't on the board then. I asked John had he seen Paul's show and he said he hadn't. I tore into him. I had no right to. 'You've really screwed up Paul's chances of ever having a show here,' said Nick and Noreen. But being John, he went down to Kilkenny the following week. A lot of people would have been offended but John has a big heart. He gave Paul a show in the Hyde [in 1997].

VR: *You were very involved in the shows in the Hyde also.*

BC: Two things I regret – the sheela-na-gig show which was well under way in the late seventies, and the Beckmann. George [Dawson] disliked Beckmann. He has never been shown in Ireland. I was not a student of Beckmann's but I had friends who were. Alex Katz and a few others were in his class. I used to stay with them. Beckmann had taught at Brooklyn. He taught by using black paint on students' canvases, with his wife Quappi as

interpreter. So there were lots of 'Beckmanns' on the wall. He never learnt English. He spoke a little but very little. I couldn't understand a word he said.

The sheela-na-gig show was halfway there. George hated it. If it wasn't for George,[15] though, there wouldn't be a Douglas Hyde Gallery. George was a very powerful chairman; we had our rows. I didn't realise that you 'trade' on boards. He would give in on some issues. I think I came on the board through the Arts Council. I did push for an Ed Keinholz show. And I succeeded. George had run a gallery in TCD library. I hate that upstairs in the Hyde, but George thought you should be able to see the whole lot in one go. It was like the old library. Paintings should be seen individually, not all in one go. I think I was the only artist on the board then, now there's Alice Maher and Michael Warren, I think. Seán McCrum was education officer [from 1977 to 1982]. Seán supported the Beckmann too. There was Douglas Palmer, a palaeontologist on the board too. Douglas was a great supporter of the sheela na gig show. Roger Stalley was on the board. There were twelve sheelas in the National Museum that had never been shown and they agreed for them to be shown. I went down with a torch to see them in storage. Seán arranged to get some cast through the Ulster Museum.

I contacted Aleschinsky, a friend of Jorn in Cobra. Jorn knew all about them. Saura was interested in the show. In the Tate there was a de Kooning just like a sheela. I never met de Kooning, but I was terribly impressed. I wrote to his dealer to ask for a drawing for the show. The dealer Fourcade said de Kooning knew nothing about the sheelas. He said, 'I am almost certain de Kooning will give you a drawing for the show.' So there was de Kooning, Saura, Jorn, Aleschinsky and me. Aleschinsky was going to make special pieces. I've still got his letter. We got about twenty altogether.

I started making sheelas in Kilnaboy. I saw the one about 100 yards from the cottage. I did some in Holland. No one was serious about them then. At that time historians were embarrassed. Now there is a pub in Sligo called Sheela na Gig. When Seán left it

fell through. I was living in Jerpoint and one day I met a young Danish archaeologist, Jorgen Anderson, a student of P.V. Glob who wrote *The Bog People* [*Iron-Age Man Preserved*]. Anderson wanted to write a book on the sheelas in French – *Les Femmes Sauvages d'Irelande*. He wrote the first book, *The Witch on the Wall*. There is a church in Herefordshire near Wales where there is a dateable sheela. They say that they never appeared on churches before the eighth century but things were moved around. What I used to do was go to the National Library. I'd learn from the periodicals.

There was said to be one near Fethard. Sonja and I went down and spent two days looking for it. It was covered in ivy. Six months later I took Nuala Ní Dhomnaill down to see it and it was gone. It had been prised off the wall. There is one in NIHE, it came from a school-teacher's garden, I think. The Hunts got hold of it. They had an extraordinary house. I only met them once, they were friends of friends. She had a really Austrian pet name like Putsy [Putzel]. He[16] made a deal I think with Bunratty. He found the furniture for it, it was period, but not necessarily Irish and there was a flat there for him. He was half collector and half dealer. He had to sell in order to buy. The whole collection was left to the children. John made the Hunt Museum. He [and his sister Trudy] gave it to what was then the NIHE in Limerick.

VR: *Tell me about your involvement with the Model Arts and Niland Gallery here in Sligo.*

BC: Seán McSweeney and Sheila had lived in Sligo for years, about ten years, before me. They were extremely hospitable. Sheila took over the Model School. The west had nowhere north of Limerick that had a contemporary collection. They said, 'We've got to save this place.' It was empty, leaking and bitterly cold. It had no money. It was run as a gallery, on a shoestring. It was involved with local things. They brought in people like Dermot Healy. It was entirely Sheila's doing. Their daughter Orna was quite important too. Without Seán and Sheila, it wouldn't have happened. They asked me would I go on the board. Sheila left,

she'd been in charge. Jobst Graeve was the first director, a very good one. Jobst left. He'd have to deal with the architect. It obviously needed a lot of money. We got funding from Northern Ireland, and the EU; quite a lot of money. It was constantly damp. It needed a new roof. The new roof was the first requirement. Then came the possibility of a further two million, partly EU, partly County Council. The drawback there was they wanted a say. It was a good little board. Then it doubled. I was on the board for eleven years.

The Niland Collection was created by Norah Niland. It was rather like Pennefather's. Donal Tinney was the librarian on the board. They wanted the Niland Gallery collection as part of the new gallery. Was it going to be the Model or the Niland? In the end it was called both. There are some very good Yeats in it. It's not as varied as the Pennefather – it has Tuohy, Lamb, O'Sullivan, Hone, terrific watercolours by Hone, and Paul Henry who is much better than his wife [Grace Henry] and better than he is given credit for.

The Pennefather is the core of the Butler. I insisted it was a growing collection. Peggy was so proud of the Pennefather collection. It was enough. But she didn't put her foot down. Once a collection is never added to it becomes moribund. So I insisted it would be a growing collection. I wanted all the money from sales to go for purchases. I think that still happens in Butler, but I don't think it's true of the Model and Niland. I'm on the selection committee for the Model and Niland. The big three-D piece by Paul Mosse is one of the best things.

VR: *There's your own* Knocknarea 1 *[2001].*

BC: I'm delighted it's there, but if you're on a board you're often the last person to be bought. There's a Seán McSweeney in the hall. He was commissioned to do it. We got a Pat Hall.

The architect got an award. But there is a maximum weight capacity of two tons for sculpture and there's no access for work bigger than six feet across. The Tony Cragg show was the inaugural show [in 2000]. Two sculptures we couldn't have

in it – they were too heavy. Tony Magennis' truck was too wide to go through the space she designed. His van methodically knocked down all the lights as he drove in. The atrium is quite nice, but it should be possible to have sculpture there. I was at a board meeting and I said, 'Surely she knew it was an art centre?' Everyone laughed. The lavatories now; we had to take them out; you'd have to be extremely thin, bulimic, to get in. They're fixed now.

One of the problems in contemporary galleries is that they are, almost without exception, architects' delights[17] but they never ask artists. At the opening someone asked me did I want to meet the architect but I didn't. There were two wonderful rooms we managed to keep. Dermot Healy ran *Force Ten* from there.

VR: *Haven't you painted his portrait?*

BC: Here it is.

VR: *Your literary portraits are quite something.*

BC: I did one of Ted [Hughes], here it is. He came over fishing. The weather was awful, so I said, 'You better pose'. Two years later he came over again and posed. John McGahern is a neighbour – he's about three-quarters of an hour away. He lives about fifteen miles from where he was born. His portrait took months and he was very patient. Finally I came back from New Zealand and I finished it without him. Typically he said, 'Without me? Thank God.' Nick [Miller's] portrait of him is the best portrait he's ever done. It's in the Model and Niland.

Some portraits are done very quickly. Nuala Ní Dhomnaill was done in one day, Dermot in two days.

I've about ten portraits in my studio, the only ones exhibited are of Seamus [Heaney], of [John] Montague and now Dorothy [Cross]. I did one of Mary Coughlan [*Portrait of Mary Coughlan at Baggot Inn* (1989)]. I love red hair.

VR: *The* Siobháin McKenna *(1964) hanging in the National Gallery is another portrait of an eminent red-haired woman.*

BC: It was one of the ones I did without knowing the person. I'd seen her and her lovely red hair. Pauline Bewick lent me her studio in Ballsbridge. Siobháin was one hour late arriving. I said,

'Supposing the curtain didn't go up for an hour' and she said, 'Oh my God'. She was only five minutes late the next time. The Arts Council bought it. Sitters always get first pick. I went to Holland shortly after that one of Siobhán. I've done Camille, she loathes it. Who cares? I don't! Dorothy's mother was at the Fenton Gallery opening and Dorothy told me that her mother didn't like the portrait. She was terrified when Dorothy was swimming in the Antarctic, and the portrait reminded her of that.

After I met Sonja we decided not to see one another for a year. So I painted her from memory and showed them. Perhaps I should never have shown them. That was about the early '60s. They were mostly sold in America. It was around the time I painted Siobhán. I did almost nothing else. I wrote a lot under one called *Hair*. TCD got it and I asked for it back, in exchange. I have it at home. I had the drawing. I have all the drawings.

VR: *Were you going to put it into the big retrospective last year?*[18]

BC: Yes, but there were about 30 or 40 paintings which couldn't be traced.

VR: *Are you interested in the* ut pictura poesis *concept – a good poem is like a picture and vice versa.*

BC: No. I've been very fortunate to have close writer friends – Ted and Seamus and Montague. Seamus and I have only known each other for 25 or 30 years. We've never had any trouble communicating. Poetry is very physical. Sounds are real the way colours are. They construct a poem. A poet is more exposed than a painter. There's a high attrition rate for poets.

We talk about art. I know a little about poetry and they know a little about painting. Poets will talk about their work to me. Seamus and Ted became great friends, nothing to do with me. Seamus is one of the very few people I would talk to about my work. Most painters don't talk about their work. One time when painting Lough Arrow I had a lot of trouble. I asked Camille in. She said, 'It's not red enough'. She was right. It's one of the very few instances. My children and hers were brought up together. I've known her since 1954.

VR: *You and she were in the original* Aosdána *group?*

BC: There were 89 of us who were told [in December 1981] that we would be members, who didn't have to get voted on. It was only later that there was a vote. On the first day [14 April 1983], we had lunch in Trinity and crossed over to the Bank of Ireland, with guards stopping the traffic. I was walking with Pat Scott and I said, 'Let's do it again, this will never happen again'. Thomas Kinsella and John Montague wouldn't join. John has since joined.

There was the meeting in the Bank of Ireland. Garret FitzGerald and Charlie Haughey were sitting beside one another. Garret was Taoiseach. The peculiar thing about Charlie Haughey is that he is the only politician to do anything about Lough Sheelin. He did the tax exemption for artists and he did *Aosdána*. It's the envy of everyone, especially in France. It's not perfect, but I think it's a good thing, I really do. It became political. I'm lucky that I can manage without the *cnuas*. The *toscairí* are the spokespeople. You've got to live in Dublin to be known. I was an oddity then, living outside Dublin.

An existing member would contact an existing member and say, 'I think so and so should be on, what do you think?'. At one *Aosdána* meeting someone went against someone, the work was too avant garde. I grabbed the microphone and spoke up. I didn't know the artist then; I'd seen the work.

There was a 'do' for *Aosdána* [in June 2004]. The President gave a party in Phoenix Park. It rained, but she gave a very good speech. She kept saying, 'The whole point is to enjoy yourselves'. We artists had time to talk to one another. She had a fair bit on her mind; I think Bush was arriving next day.

VR: *The* Aosdána *idea was to honour artists but also to give a small means tested stipend.*

BC: I made a decision in the late '60s that I couldn't live by painting alone. I either taught for two days or grew vegetables. I did the latter, although I did do a certain amount of teaching, mostly block teaching. I'd rather dig. We lived almost entirely on what

I grew. We had a cow, it took two hours a day to milk her. I had a neighbour who shared the milk and shared the milking. It took Sonja the same amount of time to make the milk into cheese.

VR: *Did the fishing provide an important part of your diet?*

BC: No, not really. Nowadays I mostly put them back. In Kilkenny I was fishing one day and I saw a milky substance coming out of a pipe from a housing estate. It was sewage fungus. If you look at sewage fungus, it is like cotton wool, or beautiful cirrus clouds. It's beautiful yet it's horrible. I'd done *Death of a Lake, Lough Sheelin.* It's in Los Angeles. Rudi Fuchs did a beautiful catalogue for the show in Holland [in 1992]. Many of the other pollution paintings were in it. I did smaller ones. A very few of them have been bought privately, they've nearly all been bought up by museums, except the one Maurice Foley has. I have some still, they go to shows. There are ten Lough Arrow paintings, only one is sold. The people in Barry's Tea bought the one of the red dead upside down fish [*Lough Arrow Algae, Fish* (2002)].

At the end of the '60s no one knew what eutrophication was.

At the end of the '60s, beginning of the '70s, they were going to be mining for uranium in Kilkenny. Planes went back and forth, they were mapping. Uranium is found between granite and limestone. They were making bore holes. I was going to the creamery to get hen food and food for the cow. Sonja and I made a list of questions. We distributed them to farmers. We had a meeting. Ten people came. The miners had an office in Grague with a brass plaque, we eventually found that. They were one of the biggest mining companies in the world. Finally they didn't mine. At the last meeting there were about 200 people.

About fifteen years later I met a young geologist and asked him did he know about uranium mining in Ireland. He did, he said they were going to mine in Kilkenny but there was huge local objection. That was Sonja and me.

VR: *So it made you think it was worth trying to stand up for issues which concerned you?*

BC: I was very, very active indeed, but not in terms of painting. Painting doesn't change people's minds, it's a non-communal activity, it's nothing to do with the community. It's elitist, it's a very serious activity. I don't think it can be used to convince people. There has been too much talk about art being socially involved, which it isn't.

Matisse used to go to friends who were in hospital and bring them paintings. He said they could only do them good. I've done projections for the cancer hospital; the whole idea is to let the patients see what I see. The *Godbeam* series came out of that.

You don't influence people directly. Painting is not for nothing. Seamus [Heaney] and I talk a lot about this. [The poet] Milosz, a great friend of his, was deeply involved in politics. Beuys was very political, but his work was primarily about himself. *Guernica* (1937) is mostly about Picasso's own nightmares. They happen to be overheard. Primarily it's not a political painting.

The Lough Arrow Algae series came about not because I thought the paintings could convince people but because I was deeply concerned. I love water and hate to see it made sick. If water dies we die too; it's as simple as that.

About three weeks ago a woman left a message that the Heritage Council wanted a painting of mine for a poster. We decided on the one with the dead upside-down red trout *[Lough Arrow Algae, Fish* (2002)]. They wanted another for the brochure[19] *Irish Water*. They have an event called 'Water Week'. I said no royalties. I gave them a choice. I never do but this time I did. They are using two inside [*Sphaerotilus and Algae* (1990) and *Sewage Outlet* (1993)] and the one on the poster on the cover. It's very nice to have some enthusiasm. It's the first time that anyone like that has paid any attention. They did it so professionally. I've seen the proofs. They've got the titles right. The brochure is extremely intelligent. It's for the layman. The Heritage Council person, [Beatrice Kelly], had seen the retrospective [in 2003].

VR: *You'd left Clare ages before the Mullaghmore controversy, but didn't you get involved?*

BC: Absolutely. I contributed money. I was active. A lot of people were active. People like Lelia Doolin. What shocked me was that Declan Kelliher, whom I'd known since he was a baby, was the leader of the the pro interpretive centre group. I took it for granted that Declan would be on my side. He and Mary have a B and B right on the edge of the Burren, in Kilnaboy. I wrote and said, 'Let us not break up this old friendship'. But I never had a reply. P.J. Curtis, son of the blacksmith who had the cure, said he was hated by lots of people and will be for generations. The Mullaghmore 'do' split the community. It will take a long time to heal. Everyone is afraid, everywhere, of offending their neighbour.

I would always approach the Burren from the Mullaghmore side. It's so breathtaking. I took Ted Hughes out and we lay in a slot in the rocks and watched geese fly from the top of Slievenamon. Imagine building a jacks and an interpretive centre on that site! OPW and Clare County Council just thought they could. Thank God the road is full of holes now, buses can't go. They managed to spend a huge amount of money in a very short length of time, something like two days, thinking that having spent that amount, the centre was a *fait accompli*. They built the car park and the jacks. But they were made to take it down, every last fragment. They had a centre already in Kilfenora. And in Corofin. Have it there, it doesn't have to be on the spot, on Mullaghmore. The people objecting weren't objecting to an interpretative centre. They were objecting to it being on *that* spot. People like David Bellamy were against it, conservationists all over the world were – botanists, zoologists. The gentians are all over the Burren, there's a bed in Kilnaboy. They grow close to the rocks in the grass. They have a more intense blue, cobalt blue, than I've ever seen anywhere else in the world.

In Jerpoint the OPW were putting up a jacks and we thought they might make a mess so we wrote. A couple of people came and said it would be unobtrusive, it would be of local stone. And it was good. Paddy Friel did a good job in Kilkenny Castle and in Golden. The OPW do do good work.

VR: *Did you go to Dorothy Cross' Stabat Mater in the slate quarry in Valentia Island the other day?*

BC: Yes. I had awful trouble getting tickets. Camille came. It was seven and a half hours for her.

VR: *She drove from Achill?*

BC: From here it was about seven hours for her. You forget all those peninsulas.

VR: *It was bad luck having an outdoor event in what must be the wettest August in years.*

BC: We were okay. We were all prepared. The singers and musicians might have been in trouble but they were okay, they were all right. But it was absolutely beautiful. What happened was the rain came through behind us, you saw the flood lights and you saw the rain through the floodlights. It was really stunning. They were all wearing mining costume. Camille said they had to, by law. I thought it probably was that Dorothy was told by law that everyone had to wear hard hats and she said 'Great'. I thought the orchestra possibly weren't loud enough. There were about two or three hundred people there. All the locals thought there would be loads of room but the tickets were sold out ages ago. So they had a free dress rehearsal on Wednesday [18 August 2004]. I didn't see any other artists there. Noelle Campbell Sharpe was there. I thought Anne and Louis would be there. I rang them and they said it was about three hours away. There were lots of opera people there. The free rehearsal was not only for locals on Valentia but here in Ballinskelligs.

The quarry is very isolated.

VR: *Isn't it a 1954 Marian shrine?*

BC: The Madonna is way up. There's a pelican right bang on the floor in front of you. It's a really kitsch pelican, all shiny black with two big eyes. I think it must have been there already. It's a symbol of sacrifice. There's a central steel affair. Dorothy has a video which starts at the back and comes forward. Have you seen Viola's *St John of the Cross*?

VR: *Only on a television screen.*

BC: I saw it in Saatchi and Saatchi. We had a Bill Viola exhibition in the Hyde about twenty years ago.

You know it's Pergolesi's *Stabat Mater*. It's very even, there's no climax. The grotto is huge. It's triangular shaped. Dorothy said we might be better going up further, way up high. There were rows of seats for the old and infirm. I said, 'We can't have those, they are for the old people', and Camille said, 'We are older than most of those people', so we sat down. We had taken folding seats. There's a counter tenor and a soprano. There are only two singers. There's a trumpeter, he tunes up. He plays something that sounds quite modern. There are about eight violins and a couple of cellos. The musicians are all wearing hard hats and yellow mining jackets. Suddenly the music stops. The screen which has a Gwen O'Dowd – type image, a dark hole – comes on. It changes into scenes of mining in that quarry. There's water and grinding and very loud engineering sounds. The two singers walk around, almost like Dante and Beatrice. Camille thought it needed some sort of connection, I'm not sure. I think it works. It gradually comes forward and is right in front of you. I think that's very effective.

What a woman Dorothy is. To have organised all this was something. She was doing something on the island and saw the grotto and said, 'I have to do something with this'.

VR: *Yes indeed. This is a great set up here in Cill Rialaig, isn't it?*

BC: I like Noelle Campbell Sharpe. She's quite genuine. She's quite an achiever. What happened was that the ruins were going to be knocked down and an interpretative centre was going to be put in, the road widened and bus tours organised. She fought and retained the cottages and turned them into artists' cottages. There are five of them now. She's going to do a couple more.

There have been writers. Paul Durcan stayed. There was a famous *seanchaí*, who died a short time ago and there's going to be one cottage for books and things, where people can meet. As it is now you meet through borrowing sugar and that sort of thing. People are very hospitable.

There's a sign on every door: 'No admittance. Artist at work.' A woman came along when Camille and I were having supper and just walked in. 'Can I have a look around?' she said. I said 'No'. 'Oh, you're having a meal' she said. I said, 'I'm afraid it wouldn't be any different if we weren't'.

Artists don't work – that's what people think. I've had business people come to my studio. 'I was in the area', they would say. I'd say, 'Next time I'm in Dublin I'll call in.' 'Make sure you make an appointment,' they would say. I'm afraid Camille was nicer to the lady than I was. It's quite conscious that there are no sign posts here. No one is supposed to come. There are no names and no numbers. It's quite consciously without a phone. If you have a mobile, that's fine.

There have been over a thousand people working here. They are all nationalities. They are very helpful. For instance, I needed drawing pins, I didn't bring enough. Noelle found them and brought them to the house. I got three lots, she told other people I needed them and they arrived. She herself lives about five minutes from here, on another road.

VR: *Did artists advise her on the requirements?*

BC: Bill Woodrow was on the board of the Tate Modern with Nick Serota.[20] He invited people – painters, sculptors, artists – every week to give ideas. That's very unusual. Bill said that nine out of ten times there was nothing of importance; but every so often something of real importance would come up. Serota was there as director of the other Tate, Tate Britain, when Tate Modern came in.

I don't know who asked him but he came over to sit on the board of the Hyde when we were appointing a new director. He was the outside person, others were board members. He came to a show I had in London, he wrote after it. He's a very efficient museum man. According to Bill, when the new Tate came in, he was an excellent chairman. I don't really like Tate Modern that much. The Louise Bourgeois in Tate Modern disappears.

I haven't seen Frank Gehry's Bilbao. I have a couple of friends who went to see it. One thinks it's an abomination, two think it's a wonderful space. There's no doubt about it, it's put Bilbao on the map. It's a beautiful building. There's one room in the museum where a Serra is perfectly sited.

The new space in the National Gallery here is an abomination. The stairway is gross, the actual hanging space is much too small. We ran into the president of the RHA, Carey Clarke. 'Isn't it wonderful?' he said. But I was shocked. I just didn't say 'Yes it's great'. In that huge Albert Speer, Mussolini-like area going up to the ceiling you can't hang anything. There's an appalling walkway between galleries. It shows you could have twice the space. Those cubicles for paintings are not big enough – you can't have big paintings there. We saw the American show[21] there.

There are lots of objections to the Crawford Gallery. But as far as galleries go, it's far better. So is Sligo. The two really good old galleries in Sligo were the keystone. Thank God they are still there.

VR: *These Cill Rialaig cottages are very nice, very simple.*

BC: There's the kitchen, with a refrigerator and a cooker. Upstairs there's the bedroom. There's a place to work just here in the living room.

VR: *The concept is a bit like Ballinglen, except your studio is in your cottage here.*

BC: Or Annaghmakerrig. Tyrone Guthrie was responsible for Annaghmakerig, but without Peggy Butler it wouldn't have happened. She was his sister. She was very devoted to him. He left it on condition the arts councils North and South joined to run it. Juliet Crampton, Peggy and Hubert's only child, worked very hard for it.

The first part of Bernard Loughlin's book[22] is very fascinating. His wife was a wonderful cook. When Annaghmakerrig started [1981] there was a jury. You'd send slides. It took ages, so Bernard became boss. He made all the decisions. He was an interesting guy.[23]

Peggy met Hubert because Hubert was at university with

Tyrone and Tyrone brought his sister to meet Hubert. Peggy was so funny. There was a big 'do' at Annaghmakerrig which Jack Lynch was attending. She said to him 'Haven't I seen your dear face somewhere before?' Lynch apparently had just the right answer.

VR: *Did you become involved in Church art recently?*

BC: It wasn't that at all. I have an old friend and my granddaughter was christened in St Moling's Chapel, Borris, with his granddaughter. The church was built in 1800. It is fairly ornate. It was Catholic. It is now Church of Ireland. The man who owns it, Andrew Kavanagh, said it was a very odd thing that it was built in 1800 at the height of the Penal laws. It is not really ornate enough for a Catholic church but too ornate for a Protestant one. It has a beautiful ceiling. When I saw it I immediately thought it needed a Tree of Life. The church was attached to the house. You had to go through the kitchen to get to it. His mother thought it would be better to separate it from the house, for reasons of paying rates. The wall began to be damp. They had it examined and restored. It was re-plastered from the outside, using lime-plaster. About two years ago I first saw it. I have been making drawings ever since.

Finally it happened. My *Tree of Life* is painted directly onto plaster using acrylic. The man's daughter's boyfriend was my assistant. His name is Paul Roche. He is a video artist. He was a very good assistant. I couldn't have done it without him. After each brushstroke practically, I had to climb down and see it and climb back up again. We used brushes tied to long sticks. The scaffolding was on wheels. He wheeled me around. I did it in about ten days. I thought it was finished. Andrew had a day arranged for the launch. Seamus Heaney was to read a poem. Kerrie Hardie wrote a poem specially for it. Malcolm Proud was to play Bach. Norah Ring would sing Schubert. One of my daughters would read from the *Book of Genesis* and my grand-daughter Kathleen would read from the *Book of Revelation*. Then I went to Portugal with my daughter. I saw a sixteenth-century Iznik Turkish plate in the Gulbenkian

in Lisbon. It made me want to change it. I began to do drawings. I was going to come straight home, but we could not get tickets for five days. When we got back she took my suitcase and I took the train to Boyle, slept for two hours and drove to Carlow. Meanwhile I had phoned my friend Andrew and said, 'Please can you erect the scaffold?'. It's by far the biggest thing I have done. It is 30 feet wide by 15 high. It looks a bit like my *Knot* paintings. I was very excited.

In conversation, Cork, 30 April; Sligo, 29 June; Cill Rialaig, 21 August 2004; 9 November 2005

1. Lange spent a month in Ennis in 1954. She took 2,400 photographs. See Mullins, G., *Dorothea Lange's Ireland*, with text by Daniel Dixon, her son, Great Britain, 1996.

2. Arensberg, C. and Kimball, *Family and Community in Ireland* Cambridge, Mass. 1940.

3. Arensberg, C., *The Irish Countryman*, New York, 1934, reprint, 1968.

4. Professor Brian Boydell (1917-2000) the noted composer and musicologist was also a painter. He served on the Arts Council from 1961 to 1983. When he first served he was the only practising artist on the Council.

5. In 1983 during an exhibition of Independent Artists at the Douglas Hyde there was a tape of previous shows. See Carlisle, A., 'Independent?', *Circa No. 11* July/August 1983, pp. 14-16. This exhibition was shown in the Butler Gallery also that year.

6. Dunne, A., *Barrie Cooke*, Dublin 1986.

7. Gandon Editions, *Profile 10, Barrie Cooke,* Kinsale, 1998. (Interview with McMonagle, N.).

8. Meany, J., 'Alanna O'Kelly, Barrie Cooke and Cecily Brennan in Conversation', *Circa No. 14* January/February 1984 pp. 21-23.

9. Merchant, N. and Addis, J., *Kilkenny Design: 21 years of Design in Ireland,* London and Kilkenny, 1985.

10. Hubert Butler (1901-1991) was at St John's College, Oxford, with Tyrone Guthrie (1900-1971), actor, director, and theatre manager, who was knighted in 1961. 'When my father died in 1941 I came home with my wife Peggy to live in Bennettsbridge. There was the Kilkenny Arts Society through which in 1952 we started the first Kilkenny Debate ... there was the KAGS, which after

the death of the founder, George Pennefather, fell on evil times. It had a new and splendid revival when Lord Ormonde gave Kilkenny Castle to the nation on 12 August 1967 and a spacious and well-planned art gallery was developed from the kitchen premises on the lower ground floor. My wife, Peggy, is its secretary.' p. 19 Hubert Butler 'A Fragment of Autobiography' in *The Sub-Prefect Should Have Held His Tongue and Other Essays* edited and introduction by Roy Foster, London, 1990.

11. Lanigan, S. (ed.), *The Butler Gallery Collection Kilkenny*, Kilkenny 1999.

12. Mulcahy, R., *Spanish Paintings in the National Gallery of Ireland*, Dublin 1988 and *Philip II of Spain*, Dublin 2004.

13. The festival of contemporary Irish art and culture which took place throughout France in 1996.

14. Nunn, J., 'Sunny South East', *Circa*, no 31, November/December 1986, pp. 21-2.

15. George Dawson's Collection, now in Trinity College, was shown in Butler Gallery in 1985.

16. Hunt, J., *Irish Medieval Figure Sculpture*, 2 vols. 1974.

17. See Tipton, G., (ed.) *Space Architecture for Art, Circa* 2005

18. *Barrie Cooke: A Retrospective*, RHA Gallagher Gallery, Dublin, 11 September-26 October 2003 and The Model Arts and Niland Gallery, Sligo, 7 November-30 November, 2003.

19. The Heritage Council, *Irish Water*, 2003.

20. Serota, N., *Experience or Interpretation: The Dilemma of Museums of Modern Art*, London 1996.

21. American Beauty Painting and Sculpture from the Detroit Institute of Arts, 1770-1920, National Gallery of Ireland 12 June-1 September 2002.

22. Louglin, B., *In the High Pyrenees: A New Life in a Mountain Village*, Dublin, 2003.

23. Byrne, M., 'Forty Questions about Annaghmakerrig', *Circa*, no. 28, May/June 1986, pp. 37-8.

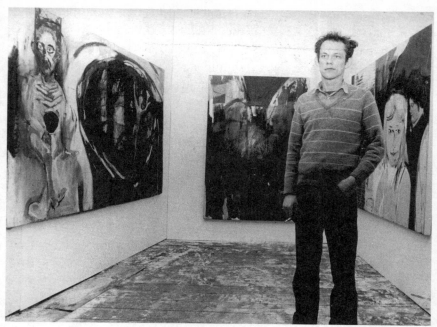

The young Brian Maguire at an exhibition of his work.

Brian Maguire

Brian Maguire was born in Bray, County Wicklow in 1951. From 1968 to 1969 he attended Dún Laoghaire Technical School and from 1969 to 1974, he attended the National College of Art in Dublin. Since 1981, he has been exhibiting nationally and internationally. He has taught in prisons and hospitals and has served on many boards, including the boards of the Project Arts Centre and IMMA. He is Professor of Fine Art in the National College of Art and Design. He has three sons and is married to Jenny Haughton.

VR: *Brian, we hope to discuss your sense of art's place in the wider community, and the emphasis you put on its practice by the marginalised but may I start by asking you, what did your parents think when you said you were going to be an artist?*

BM: My mother was very clear. The class we came from didn't have artists – art was a job for the landlord's children. My father was quieter. He never forced his opinions. He would take you for a drink. He believed people should stand their own height. He was not a tall man. It doesn't matter what you do, your own will support you. They came to the first exhibition and he bought.

VR: *What did he buy?*

BM: He bought a portrait of an actor, who, like me, had latent violence in his personality. My Dad is gone now. I was with him and drew him afterwards. I just missed my mother's death – I drew her after. It is a very valuable experience. The most obvious thing is that you look at them. With my Dad I had brought the drawing equipment to the hospital. He looked so awful I wouldn't do it. A peaceful look came to him when he died. That night I went back to the hospital and drew him. When a person dies their body contracts, so there is movement. My mother moved while I was drawing her. I experienced delight at the thought she might be alive. The idea of sitting with your dead is important. It's a very sensible way of saying goodbye and expressing respect. You see it after paramilitary deaths. People sit with the body; the comrades sit with the figure in the house. We lived a kind of internal exile. My mother, Kathleen O'Sullivan, was orphaned in Wexford and raised by nuns. My uncle Lar was some kind of relation on my mother's side. He was a civil servant. When I was young he used to come and sit on the bed and talk about the Napoleonic Wars. He brought the Napoleonic Wars to 6 Florence Road, Bray. The house was privately rented, so it was neither council nor private. A townland was essential. No townland's people connected with my mother as we grew up. My father was from Fermanagh, the townland is called Aughindiagh. Everyone that crossed the door into our house in Bray was from that townland in Fermanagh. It was as if we grew up in a place we weren't in ... In Fermanagh I understand the family was called the Phelie Maguires. There were so many Maguires on that mountain that the Christian name defined the family. Each successive

generation has a Felix, Phelim or Phelie as a male child's name.

Things got confused over time. My son Phelie was vice captain of the Irish hockey team in the European Under eighteen Championship Cup. The team was predominantly Northern Irish and Protestant.

When I was small my Ma was ill and Peggy Leslie, who worked with my Da in Murdoch's hardware store, took me at weekends and summers. She became like an aunt. Peggy was a Protestant. There was never any sectarianism in our house in relation to Protestants or Catholics or class or race. The Queen was over Peggy's tap but out of affection for me, she came to vote for official Sinn Féin. I painted her very early on.

VR: *The Maguires were lords of Fermanagh until the Ulster Plantation. Did your Dad talk about that?*

BM: Only in the humorous claim that we descended from a bishop, a Catholic bishop. Historical violence had a different importance for me. When I was around twelve or thirteen the news-reel film *Mein Kampf* was shown in the cinema in Bray. It was made of news-reel which the Allies had turned into the story of the rise and fall of Hitler. My painting may have come from that film. I can remember the wooden wheelbarrows of corpses. It was for over eighteens in Bray. I was far too young to go, but still you know, this film was shown to German school children by the Allies. I was mitching from school so I couldn't talk about it at home then. Later, I asked my father about what they knew. For him, it had all been condensed to a single image of a German officer pushing a six-year-old girl into a gas chamber.

We all get marked by some experience as we grow up. Seeing that film established for me macabre interest. I'd never seen naked people before. These things establish interest. It was the biggest crime of the times. It has been matched in recent times with crimes in Africa and in Cambodia. It seemed to me that one had to address it.

Jack Lynch, the comic actor, gave me Primo-Levi's *If This Be A Man* in the early '80s. By reading the accounts of

the survivors I became interested in accounts by the perpetrators. Nobody does anything others are not capable of. Recently, I made the journey to Auschwitz when I was working nearby. That was when the Iraq war was starting. I was with the artist Philip Napier. We were walking just where the trains pulled up in the centre of the complex. I was talking to the lady guide about the impending war in Iraq. She said, 'People are worse than animals'. Other than that comment she came across as the middle-aged museum interpreter, but I always remember the venom with which she said 'People are worse than animals'.

I did make a print in Cork of a piece of text which was an extract of the speech Himmler made, in which he clearly admitted the extent of the crime.

VR: *You went to art college directly after school.*

BM: I've talked at length about that in an interview I did with John Hutchinson.[1] Very briefly there were two aspects to the College. The first was the heavy wrapping that is always around things, the wrapping of the times, 1967 to 1969, a period when authority was being challenged nationally and internationally on a daily basis. Secondly, the location of the College was in the stables of Leinster House, which houses the government. We were going in the side door. We saw TD's daily. When we occupied the building the army arrived in. When students occupy a college the police might come along normally. The context for us was political. The training was quite deficient, quite traditional and academic, whereas other more modern forms of art education were about.

VR: *In Dún Laoghaire, which you first attended?*

BM: Yes. Trevor Scott was working there for a day a week. Diarmuid Larkin, Seán's father, was there. Within a year he gave over to Eoin Butler, who taught my class.

VR: *Where is he working now?*

BM: He is professor of art in St Pat's, Drumcondra. If ever the phrase 'I did the state some service' is appropriate, it's for him. He worked as an educator and came back and did a practice-based postgraduate degree at NCAD.

VR: *Did you get your diploma?*

BM: Yeah. The process of revolt was one the authorities sought to repress, using threats of expulsion, actual expulsion, and lawyers. I was suspended. Then there was a rationalisation of courses and we presented for final exams [in 1974]. One student, Bill Whelan, took a stand. He showed only four large paintings of skeletons, one each for the people who had been cast aside by the system and who weren't sitting for the exams. One examiner came across a notebook of Bill's drawings and insisted he be given the exam on the strength of the drawings in the notebook. There was Bill, Paddy Gillan, Mick Cullen, Dympna Cullen, Robert Armstrong, David Kavanagh, Charlie Tyrrell, Gene Lambert, Joan Thornsley and Cecily Brennan. Students were supported by staff, Alice Hanratty, Charlie Cullen, Charlie Harper and Paul Funge.

I want to try and describe how as a young student I became involved with the anarchists. The Springboks rugby team came to Bray and we protested against apartheid in South Africa. I was beaten by the police. I was politicised by that beating. I came under the influence of Seamus Costelloe, who was later founder of IRSP. He was murdered in Dublin in 1975, at the North Strand. He recruited me into Sinn Féin. I was eighteen. We began to study Marxism and anti-colonialism. When I went to the college the books of Bobby Seale and Paolo Freire became available and I took to a left-wing view.

VR: *Was art college a boozy, buzzy world?*

BM: It certainly was. Remember it was 1968 to 1974. All the free love and drugs arrived into Ireland from America but Guinness already had a place. The idea of experiment arrived all right. But the idea of separate generations – which is now there – wasn't there in my youth. There was a *detente*. My father drank at the top of the town and I drank on the seafront in Bray, and occasionally we drank together.

VR: *Was this a period of great personal struggle?*

BM: Every human being has a little struggle, if not more than one,

and we have different ones at different stages. A personal struggle can't be great. There is a necessity to keep your own counsel in relation to some personal issues. There are things that I won't talk about. We all have our skeletons. The reason for not talking is not through shame or a desire to hide from one's past. It's to do with the purpose of disclosure. I cringe when I read about someone being allowed into another person's personal space in the newspapers. There's a voyeurism that makes my blood crawl when I hear people parading their family, their private sexual life in public.

People say, 'He shows his paintings, what's he talking about?'. The point about paintings is that they are imaginative. They may draw on biography but they are not the truth, they are a fiction.

VR: *Would you elevate the truth of art over the truths in the media?*

BM: Remember one of my heroes would be Claud Cockburn, another Robert Fisk. There are ethical oppositions. The news media is one form of telling stories. We might regret its dumbing down, but it doesn't mean that this is the only way it can function. There have been efforts at creating news media not controlled by multinationals in America. There are always contradictions. There was a strong poem by Anthony Cronin published on the front page of the *Irish Independent* over Christmas. It's not a paper I read, but the poem wasn't put down on the corner, [where the Sunday poem usually is], it was right on the front page. It was a very important work which questions morality. It was looking at the relationship between the mass murderer and God. It was to do with the Holocaust.

VR: *How do you bring your ideas to bear on the teaching, now that you are professor of Fine Art at NCAD?*

BM: I've found in College in some departments a complete welcome for the idea of the repositioning of art in terms of public art and its social element. There is sincere opposition elsewhere. The job in Fine Art became available and it seemed to me that the connection between my early twenties and my late forties was there. Given that I was so strident in my youth, as a student

activist, as part of the collective campaign to improve the college, I felt I should look at the opportunity. It was clear from the interview that I was not expected to abandon my practice. I had been teaching in prison for fifteen years. I wanted to stop. There's a limit to the length of time one can work in any institution – I needed to stop. I'd been on the board of the Project [Arts Centre], on the board of IMMA, I'd set up the Portlaoise Project and worked in other prisons. I had worked in an administrative and policy-making capacity. The job seemed do-able. Colm [Ó Briain] came two years after me.

VR: *Did your time and his on the Project board overlap at all?*

BM: No.

VR: *Would you see the art world as a microcosm of the 'real' world?*

BM: The DNA is the same. But the main difference is between the public sector and the private world. In the 'real world' you work in or on someone else's project or they on yours. You both choose each other, whoever's in charge. In the public service you work on the film but you don't choose the crew. I've done what I set out to do in college.

The targets were to support the development of Social Sculpture in the curriculum, to break down the barrier between college and the community in Thomas Street – one of the last working-class communities in inner city Dublin – and to internationalise the position of the College in Europe. Formal engagement with the community is in the third year of the curriculum. Research proposals have been signed up with Northern, Central and Eastern Europe. I wanted to re-establish Erasmus participation, sending students to Eastern and Central Europe, where societies are at points of change. I wanted to make working artists central to every student's experience, and to support staff as working artists. I've kept my own practice up. I think there are very few practising artists in leadership positions in art colleges in Ireland. The targets have each been met at this stage. We have the highest Socrates participation in Europe. The other aim is to bring postgraduate opportunity to twenty per cent of

the students. Post-graduate opportunity was there but it wasn't taken up by 20 per cent of the students and it now is.

Over 30 artists contribute annually to the curriculum from outside the College. The theory of education is that the education should be as close to art practice as possible.

Recently talking to social workers about their emotional responses to their work, they became defensive and said it was only a job. Art is never only a job. It is about changing the world's perceptions.

We brought sixteen students to the World Social Forum and the World Parliamentary Forum in Port Legro – they both happened at the same time. We also brought them to visit the descendents of the slave community in Quilombo, where the grandson of a runaway slave received us in his family home, fed us and led a discussion around slavery in Brazil. Art students are expected to research by engaging in ongoing research. They are not expected to research by going to documents of those who have been researching before them. In that way this meeting was the closest you could get in contemporary life to looking at slavery. In Brazil, we also visited a settlement of the world's largest social movement – MST. I engaged in talks with their culture and public affairs officials, through translators. MST is like the Irish Land League, using direct action to take back land.

VR: *Did you see the Salgado exhibition,[2] in Cork? It includes photographs of MST activity.*

BM: No, but I am familiar with his work.

VR: *There is a central ethical concern in your own work.*

BM: The very early work was like a personal history. By the next stage I'd been involved in politics. In 1969, I joined official Sinn Féin, which became the Workers Party in 1982, and then the Democratic Left, then merged with the Labour Party. I am now a member of the Labour Party. The only kind of philosophy that made any sense to me was existentialism. Without political action and the solidarity that brings, existentialism leads to isolation and loneliness. I've gained more from

engaging with politics than politics has ever gained from me. I've worn a number of hats through that process. At one stage I painted pictures that were self critical. These were shown in the Douglas Hyde, in a show curated by Pat Murphy.[3] Donald Kuspit wrote the catalogue from a psychoanalytical point of view.

VR: *Do you usually work from life when working on the figure?*

BM: Yes, for portraits like the *(UVF) Excombatants* [1999] for example. No, for the rest. Memory acts as a filter and edits. I try to find the single image which carries the whole story.[4]

VR: *I see you as a history painter.*

BM: Yes. That is very natural, a Marxist view leads to that.

VR: *Stardust Memorial (1995) in the Hugh Lane was painted long after a nightclub fire killed 48 young people who failed to get out of locked doors on St Valentine's night in 1981.*

BM: For a long time Christy Moore's song ['They never came Home'] which was banned, was the only song about the Stardust tragedy. Butterfield took an action against the song and it was banned. 40,000 records had to be recalled and recut. The new song 'Another Song is Born' (1985) was about writing songs with the High Court at your back. At that time, this song was the only memorial to those kids. The painting was a gift to the Hugh Lane. It takes liberally from *Macbeth*. The coffins move to the GPO. It was the biggest tragedy that ever hit the city. It has just happened again in Argentina, where there are 90 kids dead.

Brian Maguire and Christy Moore.

VR: *The huge South American painting Memorial (1998) is probably your major history painting.*

BM: The murder of these prisoners was

the biggest killing of prisoners since 1945 – the massacre of the 111 prisoners admitted by the government, which the local priests maintain was a massacre of 400; 50 per cent of the men in Pavilion 9. If you machine gun each cell as they did and kill the wounded, the chances are 400 get killed. The scale of the painting is related to the scale of the subject. It was painted here in the studio [in Sandyford]. It's about empathy. When I was a very young boy and learnt about war I used to think about the last man killed on the last day of the First World War. The last man goes back to the first man. It was the idea of the unfairness of it all.

I went and talked to the eyewitnesses in the prison, the officers, then the survivors, then I got all the media pictures I could. The tone of the emotion of the work came from the conversations. A survivor, still a prisoner in Carandiru, painted a picture of the massacre. We both used the same structure. We both built the picture around the corridor. I had met him early in 1998. We went back for the *Bienal* at Sao Paolo in 1998, and I showed him my work and he showed me his.

There was a film of the massacre. The film had everything in it, except the moment of death. It's a very good film. Whoever made it decided to leave the deaths of the prisoners low key.

VR: *Was there a response from the families?*

BM: No, remember it was shown in the *Bienal*. There was huge press around it, but it focused on the work with the children in the *favela*.[5]

VR: *It's in IMMA now, isn't it? Eoin O'Brien from Cork, gave it under the Consolidated Taxes Act (1997).*

BM: Eoin offered it to the State. He is a very strong collector of my work. He is connected with Fenton Gallery in Cork. That's why I went from Vangard to Fenton. I've been with Kerlin since 1991. I was with Hendriks, it closed. I'd left the Lincoln, they'd given me my start.

VR: *Do you sell well now?*

BM: Most of the paintings are sold. There is some work in the

museums in the South and in museums in Holland and Finland. I've no work in the museums in Northern Ireland, or England or America. There have always been a small number of people who have collected my work. It is very common for artists to have individuals who collect the bulk of their work over time. The Kienholzs, Michael Traynor, Christy Moore, Michael Feeny, Tommy Tish and Eoin O'Brien have all acquired a number of works.

VR: *Did you do any Irish work equivalent to the memorial for the Brazilian prisoners?*

BM: I did do one small work on the hunger strikers. But I admit I found it easier to go to a foreign place and get involved, not having the same language, using interpreters. My distance from the complexity succeeded in keeping clarity. Here I made a series of works about the war in the North, including *Republican Graveyard*. I showed it in the Kerlin.

When I was leaving Long Kesh after teaching, an IRA man gave me two things, a photo and a book. I had painted this man. The gifts were an explanation of why he was in jail. The photo was of his brother's grave. There were four young men from Armagh buried there, two hunger strikers, two killed in action. I took the photo home and painted from it. The painting had everything. It explained what was going on. While the youth of the South emigrated, in the North the graveyard became the central cultural icon.

Recently I did work which referenced the US.

VR: *You mean When Love is Buried in the Attic, the exhibition dedicated to Lucas Johnson, at Fenton?*[6]

BM: Yes.[7] Lucas was a close friend, an artist from Houston, Texas whom I worked with in the '90s. My way of working is to rent a room for two or three months. I did that show in Paris. You need to get away from the phone and ordinary life. It breaks concentration. This show was concerned with the massive use of force against families by the US military.

VR: *You work fast.*

BM: Yes, particularly in the prison portraits. You only have people

for two hours at a time. A lecturer at College said of me, 'You paint pictures of prisoners and sell them in the Kerlin', which is nonsense. 90 per cent of the portraits belong to the prisoners. Somebody reviewed the Hugh Lane Show[8] and said I'd borrowed the pictures back from the *favela* to show them. If he had looked properly at the drawings he'd see that while they were of the same people, they were not the same drawings.

In the Kerlin show of 2002 I used the same strategy as in the South America painting. It was a way of looking at the Provos by proxy. I have a complex relationship there. Some of these people have been my students when I taught in the jail(s). I've grown to respect them. If you don't respect your students they are not going to learn anything from you. While there are rules about teaching in jail, don't be surprised by friendship. On the other hand I wanted distance. Except in exceptional circumstances, I didn't address issues people in prison were concerned with, in my own work, when I was working in prisons. That was the only boundary. If I could address an issue and it was supportive of them, I'd go ahead. I was still engaged in politics. I continued to work politically. I didn't close myself off politically.

The thing about art is that it is a very sacred business. You cannot mess around with it. I remember trying to paint propaganda work while studying in College and not being able to. You either take on work completely or you don't do it at all. There are no half-measures, you have to give yourself to it completely. Christy Moore wrote the song about this – about how you can't write a song looking over your shoulder. If you're working in jail with people, you don't shit on them when you go home. That maybe was the reason I avoided painting certain things. There is some work so dense only I could see what it came from.

VR: *Have you had good relations with the Arts Council?*

BM: Yes. I always applied for the Arts Council grants and some applications were successful. Michael Kane nominated me for *Aosdána* [in 1985] and I had the *cnuas*, which is half an industrial wage, means tested. It made up for the absence of a market here.

There will always be a small market for some work but there was an absence of market for all work then. That was about twenty years ago. My Michael was just born. It enabled me to borrow. I built this studio in 1991. I had the studio on 59 Mountjoy Square, with Padraic Ó Faoláin, up to then.

VR: *Education in prison has become a big thing in Ireland over the last twenty years. You've worked in prisons in Belfast, Cork, Dublin, Kildare and Limerick and were involved in starting the first Irish Artist-in-Prison scheme – in '87?*

BM: The first scheme was set up by the Arts Council; by Medb Ruane, and by Kevin Warner in the Department of Justice. The British Council director, Harold Fish, asked how many of the prisoners were doing degrees. Of the 64 provisional IRA prisoners I knew in jail, in Portlaoise, 62 were doing degrees. The Open University is an English institution. It provides the validation. To my knowledge, no Irish university offers that facility to Irish prisoners. NCAD on the other hand has managed a course in Portlaoise Prison. In the setting up there was Noel Sheridan, and the Department of Justice and the Head of Faculty in College, Campbell Bruce. My recollection places Noel at the heart of it.

VR: *The Arts Council have been involved with various forms of community art since the mid '80s, haven't they?*

BM: Yes; it may have begun with artists in schools or the special projects grant, where an engaged audience is part of the work. Artists-in-Prisons was the one I was involved with. I was on the pilot project and developed the Portlaoise Project.

I think there has been a change in the way government departments work. Now universities are being asked can their departments work together. The Arts Council is more willing to work with the College now. At one time they needed to be sure they weren't funding a project which had funds from some other government department. The Arts Council was providing an artist in each prison say for three weeks, maybe more. Using the model of the visiting artist in college, we were able to put four or five artists in prisons for twenty weeks.

I always wanted the prisoners' work to be shown at the highest level. Using museums to present the work gives the work the best platform. We did two shows from Portlaoise Prison, before Barbara [Dawson] did the ten-year survey [*Inside/Out*]⁹ with me. When they showed the prisoners' work, the Hugh Lane made a statement of ownership of the art in the Irish prison system. Up to then it was shown in libraries. Renoir's *Parapluies* was taken down and the prisoners' work went up. The citizen's duty is to own its prisons and its prisoners. The Hugh Lane made a unique move in that direction.

VR: *You brought your own work into the prisons, to show the students there?*

BM: Every year in September I did a show of new work in Portlaoise. The NCAD teachers, including Teresa McKenna and Mick O'Dea and I, brought all sorts of stuff in; animals, plants, flowers. Prisoners germinated plants in water from stems and grew flowers in the windows of the jail. They collected pigeon droppings to provide fertiliser. You'd get an enormous busy Lizzie coming out of a jar.

VR: *At the most fundamental level, who do you paint for?*

BM: I was severely challenged once in Portlaoise Prison by a young man, Colm Lynagh, he became an artist during his period of incarceration. He challenged me on this issue. Who was I painting for? Was I working for de Rossa and the Brits? In his view de Rossa was close to the Brits. It was a rigorous confrontation. When I came back in the afternoon he showed me a wild drawing. It depicted me painting *Roadside Assassination*, being overlooked by Pronsias de Rossa and a British and Irish soldier, while I was dressed in a top coat, no trousers and with 30 shillings on the ground. I was mixing the paint with the blood of a man shot by the Brits. I looked at it and said, 'I paint for myself, I don't paint for anyone'. He immediately accepted this and we've since become close friends. That was the day I was put on my mettle to say what I painted for. I see the role of the artist to be an individual witness. It's both your freedom and

your limitation. As an individual you are not threatening, this gives you access. It enabled me to make a relationship with the UDA in Belfast while simultaneously working with Republicans in the late '90s. These men's beliefs are opposite. Because you are an artist and only represent yourself you have freedom. It has a downside; you don't get to do much.

VR: *Do you think the Peace Process has brought much change?*

BM: I haven't seen a single change in East Belfast. Investment hasn't arrived there. But the Peace Process doubled the GNP in the Irish Republic. When the fighting stopped, there wasn't really a Peace Process. It seems to be war by peaceful means. Certainly a lot of the moves by the British Government at local level were designed to destroy both the Republicans and, in other ways, the Loyalists.

VR: *Given that you were working on a residency in Long Kesh during the formation of the Peace Process, that is an interesting view. Today, 28 July '05, is a very historic day. How do you feel as we listen to the news that the IRA will destroy their arms?*

BM: It makes me sad – the cruelty. People paid such huge prices. Whatever faults and crimes can be laid at the feet of the IRA are nothing to the governments' faults all those years. The responsibility of government is to provide peace. Successive governments really failed.

I've always taken the opposite position. Remember the joy of the first cease-fire [in 1994]. The song 'Waltzing Matilda', as sung by Ronnie Drew, is ringing in my ears.

Conversely, today is all about the future. It is a brilliant day. There is a possibility of peace. In the past the IRA always dumped the arms. Now they are destroying them. But my immediate response was one of sadness.

VR: *Concerns other than the aesthetic really do buoy up your art.*

BM: I had the honour and pleasure to introduce an Australian artist, Wolfgang Zinggl, in NCAD with the words, 'The aesthetic isn't anywhere to be seen'. The aesthetic is not the essential ingredient. Empathy is the primary tool in making art. There was a big dispute when I arrived in the College, between myself and academics

who had worked in London. It centred on my lack of interest in the art critical debate, and in the understanding of art history as a tool to assist in making art. It was an approach I had no interest in. For me the political debate, the political struggles are more important, and political history more important than art history or criticism. McEvilley noted that I'd forgotten more art history than I know. What he is saying is that I am like an outsider. I operate according to the approaches of Outsider art but have arrived at that position from the inside. I have never read an art magazine in order to move forward with my work. I've read numerous history books and political tracts and engaged in political work. Poetry and literary criticism help me to move forward. At one stage I was isolated in Dublin and I went to Francis Stuart as a mentor.

VR: *Works like Holbein's* Christ Makes it to the Rockies *(1991) trampoline off art history, though. Maybe it's the vocabulary of Christian art that enables you to work at many levels, metaphoric, etc. more than art history in general?*

BM: You put down a mark for what you believe in. You can say 'doing this thing makes a measure of hope'. I hold to that Joycean concept of the general being held in the particular. The expression of the particular in real time and space is the starting point. In any picture there is always some line, some series of lines, taken straight from the real world. The mood of the painting is taken from the mood in life. The ideology is a bigger thing, it is something which supports you. It is possible to go into an emotionally fraught situation and be secured by having an ideological position. You are then not overcome by the situation. You know why the poverty is there. You sing as well as you can.

VR: *What then about the aesthetic?*

BM: I've always had the view that the aesthetic is the respect for the subject. You make the painting as beautiful as possible.

VR: *Can we talk about artists you've been close to, like Paddy Graham who painted[10] you, and Ed Kienholz?*

BM: Paddy has a very warm strong personality. He has always made

wonderfully aggressive paintings, really powerful paintings. He helped to sort me out at one stage. I owe him enormously in professional and personal terms. We were close for a number of years. Then I was very isolated. We meet occasionally now.

The Kienholzs were my closest friends in the art world for fifteen years. I first met him in 1983. In 1981 he showed in Dublin. I had seen the work in Dublin. I was just knocked over by it – it was the best I'd ever seen. It was an attack on false intelligence, an identification of social insanity. I got his number in Berlin and decided to call him. He told me to come round. When I called he said, 'I'm going to the hardware store to buy a screw driver'. Whatever way I behaved in the store when he was buying the screwdriver I got asked in for coffee. He asked me had I any examples of my work. I had. He bought *Roadside Assassination*, *Young Man with Submarine Gun*, *Prison Suicide* and *Self Alone* over a ten-year period. These were very tough works. He bought around twenty works. No institution at that stage would touch me, as I'd only been working for four or five years. When the Wall came down he thought about leaving Berlin. He and Nancy bought a school house in Idaho. It was partly a private museum and partly a storehouse for works. The top floor was studio space. There I met Mike Shannon and Lucas Johnson. Both artists have died since.

The work Kienholz made that changed things in America wasn't the *State Mental Hospital*, it was *Illegal Operation*. It's a blob of a figure, some enamel bowls; it's an illegal abortion. It's horrific. It was included in an exhibition in Vienna of 50 works that changed the world. It is to be shown in the Pompidou in March 2006. It was reckoned that his work did a lot in changing the views on abortion. Kienholz had worked in a state hospital.

The work Kienholz showed in the Hyde in 1981 is about the person's dream. Two figures, one person, identical figures, are in bunks, one on top of the other, with an eclipse of the moon. The bottom man is so depressed he couldn't imagine anything except where he was. He had a wet sodden body.

Kienholz's friendship was very important in the '80s and '90s.

Michael Kane was a father figure in the world I entered. Recently while inspecting rental homes in Galway I've had the pleasure of getting to know Brian Bourke. The Lomberg Art Award is an art award for mental institutions and we are judges. Artist Eddie Cahill has been a close friend since his release from prison eight years ago, also Colm Lynagh.

VR: *What are your sources for* Figure Silenced *(1991) in the Crawford Gallery?*

BM: *Figure Silenced* has a number of sources. One is a paraplegic man, Stephen Walshe. Up until they reach sixteen years of age, paraplegics go to school. They're normal, going to school. But at sixteen, they leave school and don't go anywhere, they go into the wheelchair. The busy structure of their life suddenly stops, just as their physical life is coming into play. The level of anger this produces is the source for *Figure Silenced*. If no one listens to you it doesn't matter how loud you shout. He is screaming. He is in pain. How can you question it if anyone turns to drink in those circumstances?

The initial connection with myself was in Sandymount Rehabilitation Centre. Gene Lambert organised artists to work with the disabled in the Year of the Disabled. I got two grand to go in there. I've had to make money in what is loosely called teaching. Somewhere along the line I got the idea that if I went in with good paints, good paper and good brushes something would happen. In some places, in Bayview Hospital in New York, for example, I made the portraits and the women under my direction made work, and both works were shown in the Whitebox Gallery in Chelsea, New York. In Belgium I did that too but then I took their work and recreated it as a lithograph. I do them with Jacques Champfleury in Paris. He did Micheal Farrell's, I met him through Jenny [Haughton]. It used to be my work and the patients' work. Now I've put the work together. I wanted to make an artwork that could go into the community and the hospital simultaneously, so that clients and visitors in

hospital would see an image they are familiar with from the library and vice versa. This is a value of the print edition.

VR: *These projects are publicly funded, I presume?*

BM: Yes. Belgium is a state sponsored per cent for art scheme. Jimmy Durham, the native American-Indian artist, was participating in a project when I was working in Poland, and he told the Belgians about me. I had never merged my identity with the patients' before. It's a collective endeavour now. Other projects I self-fund and try to raise grants to support them or use the proceeds of sales to support them. My biggest support is the Ulster Bank, through ordinary loans.

VR: *Giving voice to the marginalised is one of your great interests, isn't it?*

BM: It is true I tend to focus on people whose voice is marginalised. The mentally ill, the homeless, the powerless are at significant times the doctors of the community. They heal the community from its arrogance and its avariciousness. For me, the best example of this is the acceptance of the mentally ill within the social fabric of Geel in Belgium, set against a fear of and aggression towards the mentally ill in some local areas in Ireland.

The project down in Galway is to seek information on the various people in the Galway region who died having accessed the services for the homeless. The method used is to talk to people who are accessing these services today. I was speaking with Kevin about his friend who had died. A social worker asked him did he know the

Brian Maguire and Jenny Haughton.

dead man's brother, who had made a lot of money in the building game in England, and did he ever work for him. Kevin hopped up and proudly said, 'I never worked for any man'. I thought quietly, 'This is this man's achievement'. We can all see different things in this. What I saw was this man's commitment to that over a lifetime.

One recent project in Brazil which looks at this in a specific way is titled *Apagados*. *Apagados* means erasure. It was the term used by the military in South America during the dictatorships in the '70s and '80s, to describe the disappeared. One of the first to lose identity is the kidnapped. People with metal illness disappear. Then there's the homeless, who have no identity by virtue of homelessness. The people who go to prison lose their identity. There are people who are charged with crimes, found innocent, but lose their identity through the process.

There are people who have survived this process to become leaders. *Ocas* magazine is a magazine which is mostly written by leading academics and intellectuals in Brazil and sold by homeless people. Unlike *The Big Issue* which is like an ordinary magazine, it remains an intellectual magazine. That way you can begin to have practical debate. I painted these people who sold the magazines and I went on demonstrations against the killings of homeless people in August '03 with them. This year I went to Brazil before the end of term and came back on Christmas Eve.

VR: *With the shopping?*

BM: Yes, with the shopping – Italian starters. I like cooking for a lot of people. I cooked a four course meal for 50 healthy young people for my son's twenty-first. It was Italian.

When I was twelve I worked under a merchant navy man in Bray during the summers. By the time I was fifteen, I was working in the restaurant, cooking. As well as teaching me the fundamentals of cooking, which is to measure nothing, cook by sight, he taught me how to swear. I learnt bad language from Pat Shine, as well as how to cook. I'm delighted.

I did a video about eating, during a residency in Portlaoise with Rehab [in1997]. It was quite revolting. Someone in Moore's Restaurant is eating and drooling. There is a contrast between the utter beauty of women cooking breakfast and the grotesqueness of the character eating it. I'm the guy eating the breakfast.

VR: *Do you think you can ease people's pain?*

BM: Maybe, by noting it. Recognition is important to individual identity and self image.

VR: *What is the relationship between the personal angst and the public concern?*

BM: Mannix Flynn has done a lot of work in relation to this. I believe that when my generation was young, 40 years ago or more, the language that was available to us to describe abusive touching, for example, didn't exist. There wasn't a language in which sex was discussed. Priests talked about beating girls in bushes and shooting boys with air guns. Later I gathered that this was our sex education. I believe that the removal of language in this area created both the opportunity for abuse and the cover for it. What I am talking about here is a private knowledge that I have from growing up. How I couldn't talk about anything. The private is a result of the public. This is a good example of a lack of public concern giving rise to personal angst. It's not the other way around. When you try to wade through all the pain, you travel from the private to the public. The Rolling Stones and the Beatles gave access to a language of feeling.

VR: *Wasn't Mannix Flynn speaking in Venice at the architectural Biennale with architects O'Donnell + Tuomey, who did the conversion of Letterfrack Industrial School?*

BM: He was. Mannix had written about the events that took place in the Letterfrack buildings.[11] By coincidence these architects had worked with my prison paintings in the Irish Pavilion for *11 Cities 11 Nations*, in Lenholden in Holland, a joint collaboration between architecture and artists throughout Europe. Their structure which houses my prison paintings was shown in IMMA when it opened in 1991 – the *Pavilion*[12] was shown in the courtyard.

VR: *Can we discuss differences between your approaches and art therapists'?*

BM: When I was studying I knew Noel Browne. He talked about reading a painting. I told him I'd been taught to read pure colour through the Bauhaus systems [in Dún Laoghaire]. The way the psychologists worked was very similar. Over 35 years later I am working with patients in Belgium in the OPZ hospital in Geel. I don't give instructions about how to do the painting. This created the possibility to do anything. That was why they liked me coming. They say it makes them feel free. I'd give a subject; a room or whatever, on the first project. Then it would be a significant man or a significant woman. I'd devote 30 per cent of the class to speaking about each work. So early on they learnt that if they did something it would be measured publicly. I always use English and I use translators. English is widely spoken. It's about communication. The therapy is the normal therapeutic value of inter-personal communication and work.

VR: *That sounds different[13] to the way formal art therapists use art. They use less verbal language, I thought.*

BM: There is a wide range of work methods employed by therapists. There is the diagnostic method, which limits the role of the therapists. Therapists have real interest in the model of the artist. In 2002 I delivered the keynote address to an American art therapists' conference in Chicago. The invitation arose from their interest in a free interpretation of the role of the artist.

VR: *And in College, do you speak much to students about student work? I know many students rate your lectures and talks very highly.*

BM: In art colleges, the normal teaching method is that the teacher goes into the studio and says 'tell me what this is about'. I prefer to say 'I'll tell you what I see, and then you can tell me'.

VR: *Do you admire IMMA's community work?*

BM: The work IMMA does I'm aware of and support. IMMA had a lot of contradictions when it was set up. It had one view that it was more important what was thought of it in America than in

Dublin, and another that it was more important what was thought of it in Inchicore than elsewhere in Dublin. I think the strength of the work outlives all that. When Declan [McGonagle]'s future came into question, I supported him as vociferously as possible.

VR: *What do you see as the function of a museum?*

BM: When I was on the board of IMMA it had a number of functions which were very clear. It has to make a collection of Irish art. It had to secure what was important in Irish art. It had to be bigger than the nation state. It had to be part of the evolving definition of what art is. It did do that, by collecting work which is termed Outsider Art, using the same process of collecting as with ordinary work. It had a role in generating new views on old stories. The curation by Declan of the John Heartfield exhibition was very interesting. Declan came out of a nationalist tradition in Northern Ireland. Here was a critic of nationalism. In Berlin, I'd seen Heartfield's work shown in cases like butterflies, now it was up on the wall in IMMA.

IMMA wouldn't sell its autonomy to a donor, no matter what the sum. Decisions remained with the Museum. The independence of the Museum is tied up with the independence of the director. The appointment of the director is most important and the defence of that was very important. IMMA has an understanding of its location as national. I've given as many lectures around Ireland [under the National Programme] when the collection has travelled, as I have in the Museum. It has in-depth relations with some locations. It doesn't address the masses. It sets out in its National Programme to give the maximum message to an admittedly small number of people. The development of its community aspect, the way of working in the community where audience is not passive, is a new way of working. IMMA was at the forefront of this. Some people saw the community aspect as add on. In fact it was cutting edge, as it is in art practice everywhere.

VR: *Your wife, Jenny Haughton [who is Anne Crookshank's niece] was very involved in the setting up of Temple Bar.*

BM: She was. She was 25 and signed a lease for 16,000 square feet, in the centre of Dublin. We got married shortly after. I don't know which decision was the more reckless. But I will say this: I would be in serious trouble if I strayed in this interview into our private life.

In conversation, Dublin, January 3 and 28 July 2005; Cork 18 June 2005.

1. Hutchinson, J., *The Irish Times*, 17 August 1982.
2. Exodus by Sebastian Selgado was a Cork as European Capital of Culture 2005 exhibition, run by Triskel Arts Centre and shown in 21 Lavit's Quay. (Children by Salgado was also organised by Triskel and shown in Triskel in 2005).
3. Brian Maguire, Paintings 1982-1987 at the Orchard Gallery, Derry, 3 February to 26 February and the Douglas Hyde Gallery, Dublin, 13 April to 13 May, 1988.
4. McAvera, B., 'Tales from the Big House', *Irish Arts Review*, Winter 2003, pp. 64-73.
5. McEvilley, T., *Casa da Cultura Brian Maguire*, Dublin, 1998.
6. Fenton Gallery, 24 October-22 November 2003.
7. In 1993 Brian Maguire had an exhibition, American Paintings, at Kerlin Gallery, 38 Dawson Street, Dublin, and the Orchard Gallery, Derry. *Brian Maguire Paintings 90/93*, which accompanied the exhibition, had essays by Donald Kuspit and Michael Casey.
8. Inside/Out, Hugh Lane Municipal Gallery of Modern Art, Dublin 26 January-26 March 2000. This exhibition travelled to the Contemporary Arts Museum Houston, Texas.
9. Ibid.
10. *Brian in the Light of Experience* (1984) is in the IMMA collection, donated by Gordon Lambert.
11. Flynn, M., *James X*, 2003, a play addresses this. Flynn's *Nothing to Say*, Dublin, 1983 is a childhood story.
12. IMMA and McGonagle D., *The Irish Pavilion*, Kinsale, 1992.
13. Murphy, C., 'A comparison between formal art therapy and non- formal art therapy', unpublished BA thesis, Crawford College of Art and Design, 2005.

Left to right: a colleague, and Angela and Jamshid Mirfenderesky in Tehran, 1977.

Jamshid Mirfenderesky

Jamshid Mirfenderesky was born in Tehran in 1947. He received his BA in Persian Literature in Tehran. He studied philosophy at Queen's University, Belfast and received his PhD in 1975. He taught philosophy and philosophy of art in the National University of Iran, and Tehran University from 1975-1980. In 1980 he settled in Belfast with his Irish wife Angela Eastwood and their two children. In January 1984 he established the Fenderesky Gallery in Belfast. From 1990 until 1995, the Gallery has been associated with Queen's University. From 1995 until now it has been associated with and is located in the Crescent Arts Centre. Jamshid has written and published on philosophy, Irish art and related topics.

VR: *How have you liked running a commercial gallery in Belfast over the last twenty years?*

JM: There is a distinction to be made between what you refer to as a commercial gallery and the type of gallery that I run. As I understand it, a commercial gallery follows the demands of collectors and the works that seem to be selling at a given time. Commercial galleries are primarily interested in the art objects. There are other kinds of galleries that follow the career of artists and promote their works. They act more like artists' agents and try to work with artists that they represent. I think this Gallery is one of those. However, coming to your question, I have enjoyed running this Gallery for the last 22 years. I met many artists and learned a lot from them and met and became friends of many people along the way.

VR: *Are there many artists' agents' galleries in Belfast?*

JM: No, not many. Tom Caldwell's gallery, which is now run by Chris Caldwell, is an artist's agent gallery. They have been showing and developing the career of many artists for a long time and very successfully, especially in the '70s when there were hardly any galleries in Belfast. There is also the Mullen Gallery, a relatively recent gallery that has its own programme of exhibitions and represents artists associated with the Gallery. These two galleries are situated in the now fashionable Lisburn Road; in this same area there are, of course, six or seven other galleries of the kind that you refer to as commercial. They buy and sell artwork mainly on behalf of certain collectors, from local artists to well-known Irish artists to prints of Andy Warhol and prints and paintings of Sean Scully. They very rarely organise one-person exhibitions. I mentioned this distinction because the Fenderesky Gallery would not have survived without the help of certain people and the Arts Council here. I do not think that the Arts Council would have helped the Gallery if it were purely a commercial gallery. I see the function of this Gallery as not only to organise exhibitions but also to try to sell the works of the exhibiting artists. To me artists who make the works come

first; they are the backbone of the entire art world. We should not forget, as some people often do, that without them no art world would have ever existed and people like me and others like art critics, curators, art teachers, dealers and so on would not have been able to make a living. It doesn't matter what the organisation is, we should all gear towards the needs of the professional artist. Unlike the curators of some state galleries, I do not think that selling art works is degrading. We should all attempt to create a viable market for the sale of artists' works; this is the only way that professional artists can remain independent and continue to develop their works. In certain countries, for example Germany, state galleries and museums are not afraid of collaborating with private galleries to promote the works of artists they happen to show. In my experience they have been more successful in shaping public perception of art. The general public in Ireland do not care much about what is happening in state galleries. Most of the successful Irish artists come out of the private galleries, Taylor, Kerlin, Rubicon, Green on Red and the like. These galleries have done a great deal in promoting the works of many successful living Irish artists. State galleries have not unfortunately been very successful in this regard.

VR: *What kind of artist do you like to show?*

JM: We show all different kinds of art by different generations of artists. Every year we show, at least, the works of two or three younger artists for the first time, often their first one-person exhibition. We also show the works of more established and better-known Irish artists, people like David Crone, Seán McSweeney, Ciarán Lennon, Graham Gingles, Felim Egan, Clement McAleer and the like. In a way these exhibitions pay for the shows of young artists who unfortunately struggle at the beginning of their career. We have also exhibited from the very beginning installation works and more recently some video works. But I must say the main focus is on showing paintings. There are other galleries fully subsidised by the Arts Council, such as the Ormeau Baths

Gallery, the Catalyst Arts, the Belfast Exposed which exhibit a great deal of video, installation and photographs.

VR: *How do you like Ormeau Baths – do you have special memories of it when Noreen O'Hare was there?*

JM: Noreen O'Hare was a good friend of mine and a good supporter of this gallery. I knew Noreen long before she became the first director of the Ormeau Baths. The Ormeau Baths and other galleries that I just mentioned are very good galleries, they are good by any standard and they do a very vital job by showing the works of many younger generation artists who do video, performance, site specific works and the like. Unfortunately because of showing these types of works they do not get enough people in. These types of works, as we know, are not very popular. When you think of it, it is really absurd. These galleries are fully subsidised by the people but the same people don't support these galleries. I think most people don't know how to handle these types of works, they do not know where to start. I have a feeling that if, for example, video works could be related to the history of film[1] making, installations and site specific works could be seen as the continuation of sculptural works and performance art related to acting and theatre, then people would have the measure of these art forms. It seems to me that certain people who are in the business of promoting the cult of the cutting edge are adamant to separate these art forms from tradition.

VR: *Do you do catalogues for your artists?*

JM: I would love to make proper catalogues for every show, particularly theme-based exhibitions, but unfortunately we cannot afford it. I have made catalogues from time to time and still do if I feel it will be an important feature of the show. When the Gallery opened in January 1984, I really believed in providing a great deal of information on the shows and the artists. Still every show that we organise is accompanied by information on the artists and the works. In those days[2] I organised numerous public lectures and seminars on topics related to contemporary art, particularly Irish art. In the last few years this type of activity, if

you like theoretical activity, has been greatly reduced, and this is for several reasons. First of all, I am getting old and have less energy. Also intellectually I have moved away from the idea that every work needs to be explained by some kind of socio-historical or philosophical inquiry. I now see art as an object of direct aesthetic experience and an arena open to visual pleasure on the part of the viewer; no intellectual inquiry can assist such pleasure.

VR: *Were you more interested in relating art and social ideas when you opened?*

JM: Yes I was. But that was a different time. I came to Belfast right at the beginning of the conflict in 1970. So I was pretty aware of what was going on. We then went back to Tehran in 1975 and after the Iranian revolution we came back again in 1980. When I opened the Gallery in 1984 the situation was still pretty bad and most of the artists that started to show with me, the Delargy brothers, Micky Donnelly, Dermot Seymour, Jack Pakenham and the like were interested in reflecting the society in which we were living. At that time I was very interested in that type of work, it had the capacity to say something about the situation that we all shared in common. That fortunately or unfortunately came to an end. Fortunately because the situation in many respects is better now but unfortunately because at that time there was a great deal of camaraderie among the artists, as if everybody understood each others' language and they shared the same ideal. That is gone now. Apart from Pakenham, everybody else has left Northern Ireland; they all live in the Republic now and are making a different type of work. And as I said, I am now more doubtful about the impact of art on society.

VR: *Did the Celtic Tiger make you cynical or happy?*

JM: The Celtic Tiger didn't affect us. From the very beginning, when I opened the Gallery, I realised that there wasn't much connection between Belfast and Dublin. That is still the case. I have a very good relationship with many galleries in the Republic and many artists from the South. We are more interested in Dublin than Dublin in us. In the last 22 years that I have been running

this Gallery, I very rarely sold anything to collectors from the South. At the same time I don't know any serious collector from the North who doesn't buy regularly from galleries and auction rooms in Dublin. It seems we are helping the Celtic Tiger more than it helps us! Perhaps in the future the Tiger would pay something back.

VR: *I think of Mike Robinson in the Ulster Museum coming South and really encouraging artists like Marie Foley or Hugh Lorigan, and buying for the Museum on an All-Ireland basis.*

JM: That was before my time. I know Mike Robinson very well. He was extremely active and a good friend of this Gallery. He also organised an exhibition of four Irish ceramists in the gallery in 1985: Cormac Boydell, Marie Foley, Sonja Landweer and Deirdre McLoughlin. It was a great show. In those days, under Ted Hickey, the Ulster Museum was very active. He retired several years ago. Talking about the relationship between here and Dublin, since the Irish Museum of Modern Art opened in 1991, nobody has ever come up to look at any show in this Gallery, let alone buy anything. The ex-chief critic of *The Irish Times* never bothered to come up either. Aidan Dunne is much better in this respect. I hope I don't sound as if I am complaining; I am only stating the facts.

VR: *I think of Kerlin as somewhat Northern in bias.*

JM: Kerlin Gallery in Dublin opened with the exhibition of Clement McAleer, a Northern painter. And at the beginning they used to show the works of some Northern artists but not any more.

VR: *Do they show Basil Blackshaw[3] in group shows?*

JM: I don't think so. They mainly show Southern artists now and artists from abroad. They certainly have no bias towards Northern artists.

VR: *Quite a few Crawford students did postgraduate work in Belfast after the MA started in 1979 and before there were postgraduate programmes in the South. Do you ever select artists from college of art shows?*

JM: Lots of students have come up to study at the Ulster University,

including the people you mentioned. I always go to the gradu-ate shows but I have not yet invited anybody directly to have a show with us. If they are interested I give them information on how to apply for shows. We have a committee in the Gallery. They meet twice a year to look at the applications. We receive applications from all over Ireland and beyond. I like the idea of having a committee, because the exhibitions would not be all based on my decision. We also invite artists to have a show in the Gallery. You can't always rely on the applications. Apart from that we need to show the works of some established artists to attract the attention of the general public.

VR: *Have you ever offered an artist an exhibition having seen their work exclusively on slide or photo?*

JM: No, I don't think that has ever happed. When artists apply and get invited to show, I make sure I see the works before the show and in many cases I see it as my job to help to select and place them in the Gallery. With invited artists it is different. We are already familiar with the type of works that we are going to get. I only go to see the works if the artists want me to do so. I don't really make it my job to go to studios. Sometimes it can be a very difficult experience.

VR: *Do you think people associate you with a preference for abstract art?*

JM: I think the perception is that I am more interested in abstract art. This is not the case. I have exhibited and still show the works of many figurative painters, for example, David Crone, Jack Pakenham, Michael Cullen, Paddy Graham, Patrick Hall, Martin Wedge, Paddy McCann and many others. Although, I think the abstract movement was the most important movement in the last century. It brought visual art closer to music and away from literary jargon.

VR: *Do you think your Iranian background made people think you must have a preference for abstraction?*

JM: Of course, Islamic design is basically non-figurative. But going back to the Pre-Islamic period there was hardly any-thing abstract. During the Shah this was regarded as the most

important period of Iranian history. But I don't really think my appreciation of art in general came from any of these traditions. The first time that I became aware of the actual act of painting was when I saw my sister, who was taking art classes, copying the Impressionists. I was eleven or twelve at that time. In my experience of painting the issue of abstract or non-abstract is not really very important. Although this issue is very important for the artists who are making the works. In 1998 I organised a joint exhibition of paintings by Chung Eun Mo and Stephen McKenna entitled Light in Painting.[4]

The aim of this exhibition was to show the similarities between their works in terms of the basic structures of their paintings, colour and light. I wrote an essay talking about these issues. Because they looked at the same things, in the same environment and under the Tuscan and Umbrian light, their works in many respects echoed the same things, although Chung is an abstract and McKenna a figurative painter.

I like to think that what I like is also good. But what I like or dislike has no bearing on the art and does not change anything. I know by now that my opinion is only one among others, although I value it a lot and never stop expressing it. Unlike maybe some other gallery people, I do not always pretend to admire what is on show. I have a habit of discussing and sometimes criticising certain aspects of the show. People want to talk about art and let other people know what they think. Whatever they say or think at the time is extremely important for them, but we all know that we often change our views and that is a great thing. The experience of art teaches us not to be afraid to change our mind. Not very many areas of the social world allow us to do so. Art is not like science, although some people are pushing it that way. I can sit here and say whatever I feel about these works around me, but I can't express my personal feeling and opinion about the principles of mathematics or physics. The experience of art gives us an opportunity to express ourselves freely. I am a bit dubious about some art experts and even

artists who think they can judge an art work on behalf of everybody else. Beuys' idea that everyone is essentially an artist and every object, given the right context, is an art object highlights the importance of art activity in society. But at the same time it diminishes the importance of the personal experience of art.

I am not interested in seeing everything on the same level and inter-related. The distinctions are there and they have to be respected. If everything becomes a part of a wider system of language and ideas, then I think we lose the intensity of our own personal experiences. It weakens our own belief in our ability to judge for ourselves. It does not matter how flawed and inadequate our opinion could be, it is better to have one than not. The experience of different art forms, it seems to me, is now the only arena in which we can still express ourselves freely. A lot of art theory is now coming out of sociology, linguistic theory, philosophy and the like. These are all important areas of study, but they can hardly tell us anything about personal experiences. I think that matters a lot in art. I know many artists today are influenced by such theories and try to make, as it were, meaningful art. I am personally not interested in the notion of meaning in the experience of art. Talking about meaning in literature is a different thing. I value greatly the works of those artists who try hard to put something in front of the viewer with visual power to be sensed rather than being understood. The analysis of meaning can come later. Over intellectualisation of art kills its emotional and aesthetic impact and reduces the viewer from being a person to a number in the crowd. Anyway as Merleau-Ponty has put it, 'we are all condemned to meaning'. As I see it, the job of an artist is to show us a way around it.

VR: *These are Modernist ideas, what about post-modernism?*

JM: I agree what I am saying is very much connected to Modernism. I am not rejecting Post-Modernism as a whole. Post-Modernist ideas played an essential part in criticising our overblown faith in history and tradition, a great achievement. It also questioned the very idea of rationality, which is also a very important topic.

But it also created lots of problems in the areas of ethics and politics. In so far as Post-Modernism is looked upon as a very serious critique of certain aspect of Modernism, it is a force to reckon with. I just don't like its application to visual art.

VR: *Do you have a big stable of artists?*

JM: In the last ten years since the gallery moved into the Crescent Arts Centre I had 117 one-person, theme-based and group shows. Over 140 different artists exhibited. Some artists exhibited only once and some other artists have been exhibiting every three to five years.

VR: *So, how many exhibitions per annum would you typically have?*

JM: We have around seventeen exhibitions per year. Usually one artist exhibiting in gallery 1, ground floor and one in gallery 2, first floor. We change exhibitions every three weeks. We also organise theme-based exhibitions, in which, depending on the theme, from six or seven to over twenty and sometimes more artists would be invited to show. Artists from different generations with different practices. The theme of these exhibitions usually comes out of the works of the artists themselves. I just try to bring

Left to right: Richard Gorman, Jamshid Mirfendersky, Deirdre Crone, Chung Euan Mo, David Crone and Nathalie Du Pasquier at the Mirfenderesky home after an exhibition, September 2005.

them together in order to highlight an issue relevant to visual art. For example, the opening exhibition of the Gallery here at the Crescent in September 1995 was entitled, Art as the Object of Desire.[5] I invited seven artists to participate: Paintings and drawings by Patrick Hall, Sharon Kelly and Ciarán Lennon, sculptures by Graham Gingles and Alice Maher, and site specific works by Alastair MacLennan and Philip Napier. Not everybody believed that art is or even could be regarded as the object of desire, this issue was contested in the making of the works and in a short statement that I asked the artists to write.

VR: *Did you do a millennium theme show?*

JM: We did. I asked Jim Smyth who is a sociologist and a curator to organise a show. He came up with the idea of organising an exhibition of four women artists entitled, Glass Millennium; Nuala Gregory, Sharon Kelly, Mary McGowan and Amanda Montgomery. This exhibition was first shown in the Gallery and then travelled to a state gallery in Norway. There, four Norwegian women artists joined the show.

VR: *What other themed shows did you organise that you particularly liked?*

JM: In the last twenty two years I organised over 40 theme-based shows. I am particularly interested in them because I suppose I initiate them. These exhibitions are also very popular. One of these was entitled The Last Lines of Waiting referring to Beckett's *Waiting for Godot*'s last three lines, which go like:

Vladimir Well? Shall we go?

Estragon Yes, let's go

Beckett *They do not move.*

Seventeen artists were invited to participate, all interested in Beckett's works, with paintings, works on paper, installations, video and sound works. I thought it worked very well. Different from the theme of this exhibition were shows entitled Painting Household Objects and Meeting Morandi. The Household Objects exhibition was held during the international conference of art critics in Belfast in October 1997. Forty-seven artists were invited to

turn an ordinary household object into an art object. In this exhibition the idea of transformation was highlighted. An imaginative transformation of something into something else is, I think, a fundamental feature of doing art and making art objects. Without the act of transformation nothing happens. Meeting Morandi in October 2000 was more or less the same type of exhibition. Morandi had this amazing ability to transform ordinary objects into magical paintings. Thirteen artists were invited to participate, all very interested in Morandi. There were paintings, photographs, sculptures and installations by Sophie Aghajanian, Tom Beven, John Brown, David Crone, Michael Cullen, Nathalie Du Pasquier, K.K. Godsee, Willie Heron, Paddy McCann, Stephen McKenna, Nick Miller, Bob Sloan and Amelia Stein.

Nowadays art works are usually devoid of any aesthetic impact. They are less visual in character. The aesthetic appeal of art has nothing to do with generalisation, it is an extremely personal affair. When it hits you it is like the experience of intense desire or the experience of being in love. It is only in this sense that art can be life enhancing. It is in this sense that as Nietzsche puts it, 'art can save life'.

VR: *Would you find that you could often experience art aesthetically?*

JM: Not in the sense that I was trying to describe. Such intense experiences are rather rare. My basic question is not related to what is art or questions concerning the meaning or function of art but the question of where is art.

St Augustine believed that truth dwells in the inner man. I also believe that art also dwells in the inner man, in the consciousness of people historically and in the consciousness of each individual. The experience of art becomes part of one's life, part of one's consciousness of life. At the end of it all, the important thing is the experience of art for the individual viewer. Without this basic consciousness no art can be manifested. In fact the artists who make it, as it were, are more involved in the experience of art than the rest of us. All this talk about big

theories, big artists, big galleries, internationalism and so on is not very important.

VR: *What did you do your PhD on?*

JM: The title of my thesis was 'Human Death: A Phenomenological Account'. This was really a thesis about a philosophical methodology. I was trying to show that phenomenology can deal with issues such as 'death'[6] and 'dying' and similar topics related to human life, love, hope, etc., better than other philosophical methodologies. This really never left me – I am still philosophically a phenomenologist.

VR: *Was your education Western?*

JM: Academic education in Iran was, I suppose, like many different countries: mathematics, physics, geography and so on. I studied Persian literature in Tehran, where I was born. Well, that was different, very much to do with a certain cultural and linguistic background. I have a great respect for Persian mystical poetry. But my family was not influenced by traditional Iranian values, if there is such a thing, especially during the Shah. The first book my father bought for me was the trial of Socrates. He was a military man. Military technology comes from the West. When you hold a revolver in your hand you are connected to the West. Military people all over the world go through the same type of training, they kill each other with the same guns. In this sense he was very much connected to the West. My mother was a civil servant working in the department of civil defence. Her hero, believe it or not, was Napoleon. She is now living in Paris.

I started to learn classical guitar when I was thirteen. But as young people interested in politics living in the '60s in Iran, we were not only interested in what was happening in the West, Europe and the US, but we were also interested in what was happening in communist Soviet Union, in Mao's China, in India and Gandhi. We were also very impressed by Japan. After all, in that sense we were all Asian, belonging to the same continent. We were trying to learn from everywhere. So I think my education was much broader than just Iranian or Western. During the Shah,

Iran was religiously very liberal and politically authoritarian, in fact in practice it was a secular society. After the revolution, the Islamic Republic changed all that. What was started as a revolt, by millions of people, against the Shah's regime turned into anti-Western values and particularly anti-Americanism.

Of course, the American government for many years was a good supporter of the Shah's regime and as a result against any democratic movement.

VR: *So you decided not to stay?*

JM: Well, nothing was pre-planned, it happened. In the summer of 1980 my wife came back to Northern Ireland to have our second child. Towards the end of the summer I came to take them back to Iran, but just a few days before we were to fly back Saddam's army attacked Iran. So the war broke out and there was no aeroplane back to Iran for about six weeks. During this period I decided to stay. It would have been very difficult for Angela and the kids to live in Iran at that time. Angela wanted to go back. She didn't know what we could do here. She had a job there teaching English and I was lecturing too. Everything we had was in Iran. Anyway we decided to stay. The whole way of life was left behind. The only thing that I still have from Iran is the key of our flat in Tehran. The Gallery's logo represents that key. Of course, we had many friends here, and Angela's family were more than generous to us. At the beginning it was a little hard but Angela soon found a job teaching chemistry in St Dominic's in Belfast and was able to support the family. I have no regrets, I am glad we stayed. I do not have nationalistic feelings and I was not carrying any cultural baggage with me. I don't believe in either of them. Both nationalism and cultural traditions, as it were, create more problems that solve any. In Iran when we were young we believed in the power of reason and we were so-called internationalist, now I don't know what I am.

VR: *Do you follow exhibitions of Iranian artists in the West?*

JM: A few Iranian women artists and particularly film[7] makers in the last ten to twenty years have made names for themselves. Most

of these artists attack and make fun of the Iranian establishment and particularly a version of Islam which creates problems for women in Iranian society. These works seem to be exotic and impart information about living conditions in Iran. I am more familiar with Iranian film makers that visual artists. Most of these films are, to my mind, exaggerated and pretty grim. I am slightly sceptical about the types of works which seem to be made to appeal to Western audiences who, for the most part, are pretty ignorant about what is actually going on in these countries.

VR: *At what stage did you get the idea of opening a gallery?*

JM: When we decided to stay I started to teach classical guitar to a few students and also started giving some lectures on philosophy and philosophy of art in the Department of Continuing Education at Queen's. In 1983 I decided to open a gallery. I thought this is something that I can do. But we didn't have any money. Then a friend of mine, Austin Donnelly, agreed to put up the money and looked for a space. We opened the Gallery in January 1984 at the basement of 4 Malone Road in Belfast. At the time that we opened the Gallery I knew a little about art but I did not know any artist to show. The first artist that I met was Micky Donnelly.[8] He asked me to go to his studio and have a look at the works. There I also met his partner Noreen O'Hare who was also an artist and later became the director of the Orchard Gallery in Derry and the first director of the Ormeau Baths Gallery in Belfast. She became a very good friend of mine and was

Jamshid Mirfenderesky at the opening exhibition of the Fenderesky Gallery, 4 Malone Road, Belfast in 1984.

very helpful to me. Unfortunately, a few years back [in 2002], she died of cancer.

VR: *Who was in your very first exhibition?*

JM: We opened with the paintings of Micky Donnelly, prints and drawings of the Mexican artist Alfonso Monreal and four sculptures by Carolyn Mulholland.

VR: *Was there a shortage of galleries in Belfast?*

JM: The Ulster Museum and the Arts Council Gallery were there and also the Tom Caldwell Gallery. Kerlin opened a few months after us. I do not know whether there was a shortage of galleries or not, what I know is that we were very lucky. We received the help of many friends and some people from the art world. Ted Hickey was at the time the keeper of art in the Ulster Museum; he became a very good friend and a supporter of the Gallery. Also Brian Ferran, who was at the time visual art officer at the Arts Council and later became the chief executive of the Arts Council, was very helpful to the Gallery, particularly when we were in the process of becoming associated with Queen's University. In 1990 the owner of the building at 4 Malone Road wanted us to leave the premises. A couple of months after closing the Gallery, I received a telephone call from Queen's University. It was the late Professor Roy Wallis who was at the time a pro-vice chancellor at Queen's. He asked me if I would be interested in running a gallery if he managed to provide spaces within Queen's. I said yes. The Gallery opened in October 1990 at 5 Upper Crescent. We were there until July 1995. Then Queen's wanted to renovate the building so we had to move out of that place. While Queen's was looking for another space with the help of the Arts Council, Jim Smyth, who was at the time the chairperson of the Crescent Arts Centre, invited me to go to the Crescent. With the blessing of the Arts Council, particularly Donnell Deeney, who was at the time the chairperson of the Arts Council, the Crescent refurbished three spaces for the Gallery. That is where we are now.

VR: *That was a lot of support, implying appreciation of what you do.*

JM: The great thing about this is that they helped the Gallery because they were interested in visual art and also they saw it as their social function. I never asked them to do anything for the Gallery. I am sure these people have helped other people too.

VR: *It's nice to see that people genuinely work to promote Irish art.*

JM: It is absolutely vital. Certain key figures have always been important in the development of any form of art in society. People with interest, with vision and power to bring other people to their way of thinking. Lots[9] of people are interested in Irish art and its development, but still I think we are not particularly good at promoting our own artists abroad, like Germans or Americans or even the English have done in recent years. It seems to me most of our curators shy away from Irish artists. They don't seem to be good enough for them. I personally get the same pleasure in looking at a good painting by Ciarán Lennon,[10] Felim Egan, Basil Blackshaw, David Crone and the like, as when I look at a good painting by Cy Twombly or Gerhard Richter.

We don't have to look far to see good things. Some people talk about so-called international art and international artists as if they are far superior to the artists living and working here. In fact, I don't believe that there is such a thing as an international artist or international art. There are some artists who are internationally well known; Picasso or Matisse are internationally well known. Among contemporary artists there are very few who can reach to this level. Incidentally, I know Pat J. Murphy has been very active in supporting Irish art and Irish artists in Dublin. I think he was also the chairman of *Rosc*. Those were great exhibitions. Nothing like *Rosc* has happened since.

VR: *I suppose they were mainly to show us great art from elsewhere.*

JM: That is true. But they also showed the works of Irish artists side by side. I think we have to be careful when we use the term Irish art. What does it really mean to do Irish art? It is very difficult to define this term. At the end of the day it doesn't really matter. What is important is that we should support what is done

and developed here, both for the sake of the artists who work here and also for the sake of the society in which we are all living. The only person I know who becomes close to the definition of Irish artist is Seán McSweeney. He was born in Ireland, his subject matter is specifically about the Irish landscape, bog lands, pools, etc., and his painting technique could be traced back to some of the paintings of Jack B. Yeats. Many other works which are made here have nothing to do with the Irish natural or cultural environment.

VR: *What desire drives people to collect?*

JM: Well to start with you must have money to collect, the desire alone is not enough. But I think there are basically three things, first the desire to possess the art object for yourself, secondly to collect art gives the collector a certain social prestige and it is also good fun and thirdly buying Irish art has become a good investment. I know a lot of people who on and off buy something, but serious collectors are rather rare. To me a serious collector is a person who knows about what he or she is buying and usually they buy a good example of artists' works, whether young or established. Some people are very quick to buy the works of an established artist for investment but it takes them ages to buy a young artist's work. That is why young artists who really need the financial support are usually struggling. As a result many of them give up working.

VR: *Are people not collecting a mix of Irish and non-Irish art?*

JM: Most of the serious collectors that I know are specifically interested in Irish art. Some of them have a better collection of contemporary Irish art than many local museums. To buy the so-called international art you have to pay a lot more and you usually don't know where it leads you.

VR: *You mean you can't follow the art scene closely enough to buy discerningly without a lot of money, unless you are where the art is being produced and circulating?*

JM: In buying art you must be very focused. If you really want a good collection you must know what you are doing. Buying the

so-called international art is fine if you have plenty of money and a lot of time. Otherwise you don't know where you are going, so you rely on other people's advice which is not a good idea. Apart from that it is not a bad idea to put something back into the society in which you live. I believe any gallery belongs to the society in which it operates and it has a duty to cater for and connect with the general public. I also see it as a duty of the collectors to give priority to the artists and the galleries of their own society. Otherwise, in search of the international dream, we all go down together.

VR: *Who are your typical collectors?*

JM: Apart from what I refer to as serious collectors, a typical collector is a person who cannot help himself buying art. Not really very dissimilar from a typical gambler, except in buying

Some of the exhibitors at Two Living Generations of Northern Art Irish Art at London Art Fair 1985 and Fenderesky Gallery, 1985: Left to right: front: Diarmuid Delargy, T.P. Flanagan, Basil Blackshaw; middle: Fergus Delargy, the late Lynne Davies-Jones, Micky Donnelly; back: Bob Sloan, Neil Shawcross, David Crone, Brian Ballard.

art, if you know what you are doing, you can also make money. Sometimes I feel people buy an artist's works as if they are putting their money on a horse. Younger people buy more art now than before. There are more women that see the shows (three to one) but more men buy art, I would say (ten to one). I don't know if that is significant or not. One thing is for sure: if the art market were left to women it would definitely go down!

VR: *Do you talk much with the people who come in?*

JM: I always encourage people to say whatever they want about the exhibitions. Nowadays, the social arenas in which people can freely express themselves become more and more restricted. There are many art experts now who often come between people's experience of art and the art works. You have to communicate with people on an individual basis. Talking about art is a form of interpersonal psycho-analysis. I talk to people about my own experiences and am interested to know what they think. If you challenge people on their moral standing, they might get annoyed with you but they usually cope with it. If you challenge them on matters related to telling the truth, they can also cope with it, but if you challenge them on their aesthetic taste, they will hate you. That is why I think art and aesthetic experiences of all kinds are extremely personal and vital for our well-being.

VR: *Do you talk art politics?*

JM: No I don't. I am not interested in the politics or socialisation of art. I am interested in just the opposite. I would like to reduce all the big ideas about art, society, culture,[11] history and the like to the level of individual and personal experiences. I think that is where art functions best.

VR: *And what about the politicians?*

JM: Well, that is totally beyond me. There are two groups of people that I usually try to avoid: politicians and journalists.

VR: *Have you found that Belfast has become safer and more prosperous? The Peace Process has changed many people's attitudes to going to Belfast.*

JM: Maybe. But the safety has nothing to do with the Peace Process. I have been living in Belfast now for over 30 years. I have never felt my safety was in danger. The Peace Process has not yet shown economic results.

There is no big investment here yet. The average unemployment here is still far greater than many parts of the UK. We have been waiting for improvement in the last 30 years; hopefully it wouldn't be like waiting for Godot.

VR: *Have you experienced any racism in Ireland?*

JM: I am sure racism does exist here, particularly against Chinese and recently the black community. When I came to Belfast in 1970 there were very few foreigners living here. So we were a bit of a novelty. Now there are a lot of people living here from all over the world. I like that but I am sure some people hate it. I have never personally experienced racism, or perhaps I did and I didn't notice it. Sometimes as foreigners we are very sensitive to other people's reactions against us. I remember any time a Mexican friend of mine didn't get his pint quickly, he blamed the bar man for being racist. I was sitting in a taxi in Belfast a couple of years ago. The taxi driver asked me where have I come from. I said Iran. He asked how long have I been living here. I said about 30 years. He said, well, we all have come from somewhere. You are a young immigrant and I am an old one, we have been living here for about 300 years. I liked that. I have never been interested in the idea of race, which is purely a cultural construct and genetically a fiction. I don't like the ideas of culture and cultural identity either. These concepts that are now taken so seriously in society and in the art world create more problems than solve any. To me, one's culture is like a name or an address: we can change them if we want to, and often we are better off to do so.

In conversation, Belfast, 15 August 2005.

1. Mirfenderesky, J., 'Semiology in the Cinema', *Film Directions* Vol. 6, no. 21, 1983.
2. Mirfenderesky, J., *GPA Exhibition of Ulster Art in the '80s*, Gallagher Gallery, Dublin, 1988.
3. Mirfenderesky, J., in Mallie, E., (ed.) *Basil Blackshaw*, Belfast, 2003.
4. Mirfenderesky, J., *Light in Painting: Chung Eun Mo/Stephen McKenna*, Belfast, 1998.
5. Mirfenderesky, J., *Art as the Object of Desire*, Belfast, 1995.
6. Mirfenderesky, J., 'Concerning Paul Edward's Heidegger on Death A Criticism,' *The Journal of the British Society for Phenomenology* Vol. 13, no. 2, May, 1982.
7. Mirfenderesky, J., 'Towards the Essence of Cinema', *Film Directions*, Vol. 2, no. 16, 1982.
8. In 1992, Jamshid Mirfenderesky wrote the catalogue essay 'Micky Donnelly' for the exhibition at the Orchard Gallery in Derry.
9. Mirfenderesky, J., *The Fifth Province: Some Contemporary Art from Ireland*, the Edmonton Gallery, Canada, 1991.
10. Mirfenderesky, J., *Ciarán Lennon*, Belfast, 2003.
11. Mirfenderesky, J., 'Art, Culture, Politics', *Fortnightly Magazine*, no. 408, 2002.

Mary Cloake. Photo by Alan Betson. Courtesy of The Irish Times.

Mary Cloake

Mary Cloake was born in Cardiff, Wales, in 1961. She was educated in Rosslare National School, Wexford and Our Lady's Convent, Cardiff. She took a BA in Trinity College in 1984 and an MA in Dublin City University in 1993. From 1989 to 1993 she was arts officer in Dundalk. In 1993 she became regional development officer at the Arts Council/An Chomhairle Ealaíon and from 1997 to 2004 she was development officer there. In September 2004 she was appointed director.

VR: *Mary, how are you approaching your task as director of the Arts Council?*

MC: The clue to how a state or a group of people can help develop

the arts is contained within a cultural milieu. It's important to take a considered view on what can and should be changed, on what interventions are appropriate, and on what has its own momentum.

If you look at something like public expenditure on the arts, and see how the arts appear in early education, you could say that levels are higher in Europe than here. But you can never take a crude comparison, because circumstances are often different. At a micro-level, there have been a number of high quality projects in schools, where artists are brought in. Many have been funded by EU money. People wonder about pilot projects. There are spotted high-quality ones around the country. But they often don't work when they are replicated, because we often don't have adequate account of the context. Initiatives will work if we have a fundamental awareness of where we are. I strive for an understanding of milieu.

In rolling out the canvas of how to proceed I try to see it in the continuum of the future and the past. How we position ourselves in history and in the world, to move it on a bit, is important. A real travesty is to see the same mistakes made again and again, because we haven't learnt the lessons.

VR: *There's the old cliché that the only thing we learn from history is that we learn nothing from history.*

MC: The benefits of being from the culture resonate with my own experience, but people who come into the culture from outside often spot the anomalies. Changing your context is very important, too.

VR: *Could you explain how you developed these views?*

MC: Where I'm from, Curracloe in Wexford, there has always been a pattern of migration. I was born in Cardiff, and my own experience is of a migratory culture. I went to school in Cardiff, on and off. We came home finally when I was sixteen. You are quite formed by that stage, but there were periods before that when we were living in Wexford. In school in Cardiff there were many more formal opportunities to study the arts than there were in Wexford, at that time. We would go to concerts, to plays

in Stratford-on-Avon and that kind of thing, from school. Back in Ireland the provision in the formal education system was less organised. There were many opportunities for instrumental tuition but they would be extra curricular. But the main difference is that the type of involvement was very different. The arts were much nearer to you here. In Wales then, you were anonymous in the audience. When we'd come home to Ireland the music was everywhere. In pubs the traditional music was all around; when you are sixteen, music in pubs is really accessible. It was all much closer in Ireland. You felt closer to the process of performance.

When I came back from Cardiff I used to see the situation in Wexford with different eyes. I saw it from the outside. Comparing both places, I decided quite early on to make a career commitment in the arts. It grew from having two different experiences of the arts. The migratory experience can be difficult and it was through the arts that I was able to deal with it. The arts are common to the diaspora. They can give you a universal language.

VR: *Were both your parents Irish emigrants to Cardiff?*

MC: In the late '40s or early '50s, my parents both emigrated from Wexford separately, while they were single. When they decided to get married, they came home to Adamstown parish church. That was 1954. Because they'd been living in what was considered a big modern city, Cardiff, my mother's dress code was quite shocking in Wexford. She wore a trouser suit. My father told me people would turn around on Main Street, Wexford, and stare. She was the first person in the parish to wear a white wedding dress then. It was one she borrowed from a friend in Cardiff.

Unfortunately there are no photographs of the actual wedding. The photographer didn't have a film in his camera. It was a pity because that particular group at the wedding would never be together again. My parents did pose for a formal photograph later. After that, my mother became an inveterate documenter of weddings. She was a very early user of the cine camera. She had

a Bell and Howell cine camera. President Kennedy came to Wexford in 1963 and there is a film of me in my mother's arms, at the railway station, with President Kennedy in the background.

VR: *The tragic death of Wexford Festival Opera's chief executive, Jerome Hynes,[1] at the age of 46 has shaken everyone.*

MC: He was a very active member of the Arts Council and an extremely efficient arts administrator, a role model of efficiency. He carved the path of the arts administrator. He was one of the people who gave credibility to the concept. He was very knowledgeable and experienced. He helped. He was a leader. Before Jerome, there was scepticism about managers and their value. The artistic director was looked to; the fortunes were tied to the artistic director. His ability to establish the value of the arts manager is visible in Druid and Wexford. He is sadly missed at the Arts Council.

VR: *Did the Wexford Festival Opera, which began the very year the Arts Council was founded – 1951 – mean anything to you when you were a schoolgirl?*

MC: Yes. At school in Wexford we did our own opera. I was eleven, maybe twelve, when I first went to the Wexford Opera. We went with the school. The school visit to the dress rehearsal was a thing we did every year. It was a full dress rehearsal.

Through going to a performance of [Britten's] *The Turn of the Screw* in Wexford it took root in my consciousness. In the Arts Council we're in the house of Sheridan le Fanu [70 Merrion Square]. You can hear him sometimes; in the summer evenings you can hear the floor boards moving on the ground floor. When I'm working late in the Arts Council and feeling spooked, Peter Quint looking through the window is one of the images that comes back. After seeing that performance, much later I read Henry James. I also saw the old film version of the story and found it very frightening.

VR: *Have you read fellow Wexford man Colm Tóibín's* The Master *[2004]?*

MC: Yes. A good thing about it was that it sent me back to Henry

James. It's really interesting seeing the success of so many writers from Wexford. I heard the other day that now that the Man Booker prize has gone to a Wexford man [John Banville] statistically the probability of it going to another is unlikely. It is a shame for Colm. His writing about Wexford is very well observed. Last summer a friend and I went to re-trace the steps of the characters in *The Heather Blazing* and *The Blackwater Lightship*. We did a little odyssey. His next novel will be the third in that trilogy.

VR: *He read a very touching piece on* This Week[2] *about his time at St Peter's in Wexford as a boarder, remembering a place that was safe for him then, only to find out later that boys were abused there.*

MC: We have been working on child protection guidelines. We worked in partnership with the Department of Health over two years. We are in discussion with arts organisations, particularly in areas like theatre. Any youth area would be an area of risk. When *The Ferns Report*[3] came out the Cabinet expressed grave concern about children at risk in the public sector. We were able to describe the guidelines we had drawn up. Gaye Tanhan was working on them. It is something that has been a concern with us for a long time. We were planning the partnership project with the Department of Health for eighteen months before starting.

VR: *On a more positive note, John Banville's winning of the Man Booker 2005 prize for fiction must have made you very pleased, not only as a Wexford person but as Patricia Quinn's former colleague.*

MC: I was very pleased. I read *The Sea* immediately after it was published, even before the publicity went out so I didn't know in advance it was about Wexford. But the first sentence made me recognise Rosslare, where I went to school. I can't be objective therefore, but I am absolutely delighted.

VR: *It's also good to hear that the Artists' Development programme in Wexford are beginning to set about training young singers in the early stages of their operatic careers.*

MC: What I'd say about Wexford is that it is a watershed that they are doing this. There are good choral traditions around Wexford. The arts officer there, Rosaleen Molloy, was a choir mistress in her previous life. It is crucially important that potential is realised. Whatever we need to do to realise it, we must do. As a society we must give that serious attention.

VR: *Do you follow contemporary opera?*

MC: Most recently I saw *The Bitter Tears of Petra Von Kant* [by Gerald Barry] in London in September. It was shown for one night only [27/05/2005] here, in the National Concert Hall. Opera is much maligned as an elitist art form. In the east coast of Ireland opera is not necessarily elitist. If you look at the Wexford Opera and the fact that people wear black tie – that may be less elitist than not wearing black tie. It's perhaps more provincial, from one point of view. It's like people wearing their best clothes to go to a wedding.

One of the really good initiatives we've taken this year is that we've partnered with RTÉ, and they've made a recording of their concert productions. So the CDs of *The Bitter Tears* will be on sale at the ENO in London. It was an unusual opportunity, but budgets were all fixed and we didn't know if it was possible. Anyway we did it and that's great. Sometimes you can take a leap in the dark in what seems an instinctive way, but instinct is based on ways of reading the situation that we don't necessarily verbalise.

VR: *What did you do at college?*

MC: Philosophy and economics in Trinity. My MA was in Communications and Cultural Studies.

Teachers in religious orders have been huge patrons of the arts. When I went to the national school in Wexford the band mistress was a nun. I learnt the piano for fifteen years, from the age of five to twenty, and I stuck at it, even when the decision was mine, but it didn't work. I did play the piano accordion in school bands. Music education is something I've always been committed to. It's a travesty that people have to go outside school time to avail of it.

VR: *The situation in the School of Music in Cork, where lessons have*

to be held in hotel rooms, is shocking, given the school's contributions to music education in the Munster region.[4]

MC: Kathleen Lynch TD asked us to make a comment on it. We need to think about that.

Arts development through inspired individuals happens everywhere. How do the teachers do it, year after year, with all the new children coming in? When I was working in Dundalk, there was a gifted violin teacher, Fr McNally. Constance Short said he gave the schoolchildren outstanding opportunities.

An example of how an intervention can make a change is Dermot Dunne. He plays the accordion in the classical tradition. In 1993 he entered the Young Musician of the Future competition, just before doing his actuarial exams, and won. It's a really generous award. It meant he could go to eastern Europe, where accordion playing in the classical tradition, and other traditions, is strong. He was heading into being an actuary and this award came. The award was initiated by RTÉ in the '70s.

The popularity of opera is related to traditional interests in music, and there is the popularising influence of the media. Radio and television have popularised opera. Eve O'Kelly at the Contemporary Music Centre would say that there are 80 Irish operas not yet produced.

VR: *Maybe Wexford will put on a few: little-known operas are their thing.*

MC: Maybe.

What interests me particularly about Barry's work is the way it can recognise, like Fassbinder [whose 1972 film is adapted in Barry's *The Bitter Tears*] the melodic and operatic opportunities within the popular narrative. Fassbinder's films were made as commercial films. There's something about moving between art forms that does fascinate me. Technology now means that we have access to many different art forms which might have been inaccessible in the past.

VR: *What do you say to the argument that the electronic will be the nemesis of the authentic?*

MC: I see the new media, not simply as technology for reproduction, but as media in themselves. You need to look at the ontology of each art form. The nature of each art form is different. With literature, it's immaterial what copy of a book you read. In music, there can be an infinite number of performances, but in the visual arts most objects are not repeatable. I don't think virtual expression can ever replace the experience of the real thing. But if you look at theories of progress, they see us as adapting our sense of the authentic.

VR: *There is also the argument that events in cyberspace can conserve the authentic – that cyberspace saves as well as disseminates and displaces.*

MC: Should they limit the number of visitors to Venice? That sort of debate is fascinating. We do want to conserve some of our heritage for future generations. The management of that ambition would partly depend on how much wealth a country had. Italy would have a different approach to Ireland. They have reproduced [Michelangelo's] *David* on the Piazza Signoria and the original is in the Accademia in Florence. That works well.

VR: *Casts to the same scale are one thing, but what about all the thousands of different sized* Davids *for sale on the walk back to the railway station in Florence?*

MC: Are we saying that one reproduction is OK for conservation purposes but not thousands for commercial purposes? Walter Benjamin has debated this.[5] I had a reproduction of *David* which was very precious to me. When I saw the original, I was really disappointed in myself as a viewer. Whether the piece is reproduced or not might woo you into looking carefully or not. But you could say that our visual culture has progressed and that pieces like *Mona Lisa* or *David*, really important at the time they were produced – in terms of light and shade or the figure – have served their purpose now.

Getting back to artists moving fluidly between popular culture and more traditional high art forms, take a writer like Gerry Stembridge – he's had plays in the theatre, satire on radio and

popular pieces on television. I think that's going to be an integral part of artists' practice.

VR: *John Montague wrote in a review[6] in* The Irish Times *[that Padraic] 'Fallon's many radio plays belong to a period when a poet might nearly make a living from the medium or at least broaden their audience.'*

MC: That's interesting. That's the continuum.

The Arts Council would see itself as investing in the person reflecting on their craft, doing that difficult interesting work of being an artist. If they can bring that ability to popular media, it's a great public benefit.

VR: *Overlaps between film and video art or theatre and performance art are the subject of much debate.*

MC: Yes.

One of the biggest audiences for an episode of *Eastenders* was when Dirty Den was killed. I watched the episode and thought it worked well from the dramatic point of view. When I saw the credits I saw that the person who co-wrote the episode was Gaby Chappie, a serious writer from Cambridge with a formal theatre background. She had crafted a perfect episode of *Eastenders.* When I see a popular programme on television I make a note of who's writing and watch for the crossovers. These good writers here develop a sophisticated audience for drama. I would say never underestimate audiences. There are very sophisticated audiences for film, television and music.

VR: *Developing and sustaining theatre audiences is nonetheless a problem, and venues are struggling to keep going.*

MC: I am determined to get theatre and the performing arts firmly on the agenda. There were five weeks of world-class theatre in Dublin recently; three of the Dublin Theatre Festival and two of the Fringe. Very few of the plays will be seen outside the main centres. One of the things that has come through in our consultation is that there is a need for touring. Touring is really expensive. Travel, accommodation, public liability and employers' insurance make it very expensive. There has to be enough

money in the system to make it feasible. The reason companies are asking receiving venues for large guarantees is that it is expensive to tour. To take an overview of touring, we have commissioned a paper from Jane Daly. There are three touring scales, large, medium and small but they are not necessarily proportionally different. There are economies of scale. Because so few companies are touring now, it is hard to establish true costs. Not every company is committed to touring. The costs to the venue and to the touring company have to be given equal weight. The production company is dependent on the venue to create audiences and to market. It's a symbiotic relationship.

VR: *And venues who wish to produce must be facilitated?*

MC: In Ireland the larger organisations have been under supported for many years. When the money wasn't there the larger organisations didn't grow. The structural problems arose partly because funds weren't there to invest. With our successful economy, we need to invest in and become proud of our institutions. Fiona Shaw said that when she went to study drama in London, she was influenced as an artist by the existence of thriving institutions. For a country to sustain itself, it has to have a sense of its own worth. That issue is understood. The arts are a way of defining and sustaining a country in its sense of self and a country's attitude to the arts is, in part, defined by its attitudes to its institutions.

VR: *This summer it was hard to be proud of what unfolded in the Abbey.*[7]

MC: Media comment suggests that we need small dynamic organisations and some medium ones and that we need a diversity. But we also need big organisations which are solid, which employ people, which allow artists to work on a large scale, which give audiences an opportunity to see spectacle and which have responsibility for mentoring smaller organisations.

VR: *The complicated ownership of and responsibility for the Abbey must have made leadership hard up to very recently. Fiach Mac Conghail's appointment[8] may boost confidence. But withdrawing*

financial support can be like withdrawing oxygen – and the 2003⁹ Arts Council cut to the Abbey may have been costly and destructive in the long run.

MC: The real problem about 2003 was that the arts community didn't know how to cope. There hadn't been a real cut for ten years. The arts community were used to a relatively stable funding environment. That was why the world collapsed. It was a major setback for big institutions like the Abbey, and for smaller ones. And we don't know about the organisations that didn't emerge at all, due to those cuts. Stability of funding is essential. We still don't know why there was such a huge cut to Arts Council funding. When there has to be a draconian reduction in public spending, grant-aiding bodies like the Arts Council are targeted. Their expenditure is considered to be discretionary. The case we need to make to government is that funding is not discretionary. Once it's given on a year-by-year basis and we don't know from one year to the other what it will be, we are in a difficult situation. In the network of venues around the country, there's a basic human and physical infrastructure in the arts that has to be allowed to exist. Some festivals like Kilkenny or the Dublin Theatre Festival are not just about celebration, they are important points of culmination of artistic activity. We have a number of smaller organisations who took the brunt of the 2003 cuts. But it can seem more expedient to give a large organisation like the Abbey, for example, a cut and it's always suffered from that. A ten per cent cut of five million is 500,000 less to the Abbey. It's very tempting to give five organisations that ten per cent between them. That's always been the way – it brings us back to the question, 'Are we going to look after our large organisations?'.

VR: *We are cited as being the most dynamic economy in Europe but you are concerned about how little some actors earn.*

MC: It is interesting that the annual income of an actor is €5000. It is shocking that gifted and educated people earn as little as many actors do. 75 per cent of people in theatre have third-level

qualifications, while 25 per cent of the general population have. Theatre is a well-educated sector whose levels of remuneration could be expected to be on a level with other people who are highly educated and constantly training. There is a big commitment in what actors

Mary Cloake, Berlin, c. 1990.

offer. In the National Poverty index, measurements of poverty include whether people can afford to buy presents for friends and family. Or go on holidays. 23 per cent of the population at large cannot afford to go on holidays. In theatre, over seventy percent cannot afford to go.

It's a dilemma. It's not going to work to say that every theatre company must pay a minimum wage. The typical genesis of a theatre company would be that people get together at college. Costs of productions are met and anything extra is divided. Making it illegal to do that wouldn't help. The main institutional theatres do offer reasonable rates to actors, and offer premium rates for stellar performers. It's somewhere in between the start up of a company and the institutional structure that needs to be addressed.

A major disadvantage is how actors are sometimes treated by the social welfare system. There needs to be more sensitivity to the nature of actors' work as seasonal. Twenty is the average number of weeks an actor works per annum. When they are in down times, they can be under pressure to take up work that is not theatre related. Many social welfare officers are very generous in their approach, but many are less so. Our Council member, Rosaleen Linehan, for example,

would say her situation has always been sensitively treated.

VR: *You have led[10] a well-publicised campaign to retain the 36-year-old tax exemption on earnings from their art by artists.*

MC: This week [7-11 November, 2005] we are inviting members of the Dáil and Seanad for breakfast briefings at the Arts Council. Depressingly, some said that the pressure we've been able to bring to bear at political level on this issue has been inadequate. There are so many sectors who can make an impact when they lobby. Artists are really bad at advocating for themselves. We have asked people to make public statements. But they are often reluctant because they are afraid they will be attacked by the press for campaigning for the retention of something they themselves are benefiting from. Michael Mulcahy TD, a back bencher, said he would give us one or two out of ten for the impact of our campaign.

VR: *I think the brochure[11] prepared jointly by the Sculptors' Society of Ireland, the Association of Irish Composers and the Irish Playwrights and Screenwriters Guild is and impressive, making the point, that artists represent only .03 of people who benefit from the 25 tax incentive/relief schemes in operation.*

MC: It is very good. David Kavanagh and Toby Dennett and John McLachlan have done very good work. We at the Arts Council cannot make a strong enough case on our own. It's much more convincing when artists do it themselves.

VR: *I think I saw in* The Times *that the holiday homes tax incentive lost €315 million to the exchequer,[12] presumably over the nine years it has been in operation.*

MC: And often those holiday homes are a blight on the land-scape. I'm pleased with the delegation that is going to the Minister for Finance, Brian Cowan, on Monday morning [14 November] to argue further for the retention of the tax exemption for artists on their work. Eugene O'Brien, author of 'Pure Mule', a series on RTÉ 2, is coming with the accountant and us. He is from Offaly. He has had a successful first play in the Abbey. The television series is set in

the midlands and shot in Banagher, County Offaly, Brian Cowen's constituency. Banagher benefited to the tune of a million euros from the shoot.

VR: *Good luck. With 90 per cent of artists earning less than the industrial wage from their art, removing the exemption could lead to the need for other forms of State support?*

Could we talk a little about the idea of 'national' – a national theatre, for example?

MC: There have been generations of critics, academics, directors, actors and journalists up there on the stage talking about this. It's been really interrogated. The interrogation shifts. The current situation in the Abbey is about who owns the Abbey, who is it for and is there a match between who owns it legally and who owns it morally. You could ask those questions about many organisations. If you look at the role of the National Theatre at the beginning [1904], it was to create the nation. We had many decades of theatre about economic poverty, isolation and imaginative wealth.

Have you read Brian Fallon's *An Age of Innocence?*[13]

VR: *Brian is another past pupil of St Peter's College in Wexford. I found it a fascinating counter argument to the usual view of the pre- and post-war period in Ireland as philistine and insular.*

MC: Irish society has changed. Is it the Abbey's role to examine that and say through their repertoire, what does it mean to be Irish or live in Ireland now? National can be in contra-distinction to international, and is that what we want? Perhaps the role of the National Theatre is to juxtapose what comes out of Ireland and what is going on in theatre elsewhere. In the past year in the Abbey we had visits from four major European companies to the Abbey. This international dimension to the Abbey's work may be one that is likely to grow.

VR: *Should the Abbey still be with the Arts Council, whose client it has been for 30 years, or should it be a national cultural institution like IMMA, or more recently, the Crawford Gallery?*

MC: There are pros and cons to being a national cultural institution.

Certainly there is stability in being one. But is there as much room for growth? I think the cultural institutions perform really well, and are very good. It depends on the art form. If it's a collection based institution, I think it's different to a national theatre. Being able to take an overview of the national theatre relates to the theatre all over the country. In theatre there is a kind of porous relationship, where people go into the Abbey, bring ideas with them – in acting, design, production, directing, etc. – refine that expertise and then bring that expertise elsewhere. The national institutions often have responsibilities outside of Dublin.

This debate started with the Richards Report in 1976.[16]

VR: *Was that the report which pointed out that in 1976 only four venues outside Dublin, and only three theatres in the whole country were Arts Council funded? Twenty years later there were about twenty venues and twenty theatres funded by them.*

MC: Thirty years later it is very different. One of the early steps then was sending the arts on tour. The Arts Council had touring exhibitions; they were the touring agency set up to disseminate the arts around the country. In the '80s there was more of a move to look for the indigenous, distinctive voice all over Ireland.

If you want to standardise, you have to respect the distinctive and the local. Druid in Galway is the quintessential theatre example. In Sligo there's the Model and Niland. That came from the work done by Seán and Sheila McSweeney, with Norah Niland's collection and their interest in the contemporary coming through in a very individual way. We want to say 'How do we make *this* work', rather than 'What should we put here?'. The distinctive voice coming through was linked to capital development when Michael D. [Higgins] came in. Development has been expedited by funds of different kinds, not just EU investment. What we need now is for each area to be able to find their *metier*. Each area may be different and we want to create space for new projects to come through.

VR: *Do you find it vaguely bizarre the way everyone fought for arts*

venues, and now they are there and must be supported, but a lot of the creative energy is going towards non-official venues?

MC: It was always going to happen. The marginal, the outside, the alternative is always going to be of interest to artists. But it can be a bit frustrating, because there is a network of more than twenty art centres that are under resourced.

VR: *Another ironic turn of events is that NCAD and Crawford College are under threat of being sent to suburban campuses, just as there are mature art centres, etc., available for them in their city locations.*

Have you enjoyed your participation in Cork as European Capital of Culture 2005?

MC: The programme has attracted much public debate and that's good. That means people are involved. It is really interesting to see what can happen from a focused investment. Cork 2005 would say it wasn't enough. Enabling work on a large scale like *The Merchant of Venice*, produced by Corcadorca, is exceptional. How can we now build on the financial and creative investment and decide what elements of the good work can be continued into the future? Typically with Capital of Culture years, a lot of the resources are used for projects, for one offs. The arts organisations have grown and learned from experience – they now need opportunities to work at this level.

I travel around, going to Kilkenny Arts Week and to Cork, and participating in events there and elsewhere. That's very important to me.

VR: *Planning always has to be easier when you are relating it to experience of a milieu, as you were saying earlier. Can we talk about the three-year plans, the Arts Plans that the Council began in the mid 1990s and were cast aside recently in dramatic circumstances?*

MC: The first plan was linked to EU development. The common agricultural policy, the National Development Plan, and each element of government had to have a plan. There was a culture of planning. That first plan was very all-inclusive. The Arts Council asked for submissions and tried to address everything.

For the next plan we had twelve goals and it was a much more refined process. Then after that we had six goals in the third plan. Where we are now is that we believe rigid planning doesn't work in the arts. By their nature the arts are fluid. And funding is uncertain. We need a strategy, not a plan.

Resources are always less than the ambition. Closing the gap between them is strategy. Strategy in the arts has improved; by working with the local authorities and other partners on the ground, the ideal of partnership has been refined and this is the basis of our strategy.

VR: *Do you look much at how neighbouring Arts Councils operate?*

MC: In Ireland we are often cited as being halfway between America and mainland Europe in terms of arts policy. In looking at Britain,[15] some of the issues are similar but the political context is sometimes quite different. For example, there has been an emphasis on 'instrumentalising' the arts to make them work towards social and economic goals. A further difference is that in England, Scotland and Wales the National Lottery funds really changed the Arts Councils there. The lottery funds were subcontracted to the Arts Councils to distribute, with criteria, in the 1990s.

VR: *You worked with the Welsh Arts Council on a cinema research initiative recently?*[16]

MC: Yes. We have different cinema-going patterns. People in Ireland go to the cinema more than in any other country in Europe except Iceland, with a per annum frequency of 4.5 visits. But what we have to see in terms of choice is limited to mainstream cinemas. That initiative was to broaden what was available, so that people would have more choice.

Peter Tindall, the director in Wales, is from Dublin. He learnt to speak Welsh, as it's a bilingual post.

VR: *Impressive. A nurturing of traditional art forms is a special feature of the 2003 Arts Act.*

MC: There is a special committee, the committee for the traditional arts. There's a policy issue that needs to be addressed. We have three years to get the traditional arts policy right. In this time,

we have an opportunity to ask, does this work, does that work? The Arts Council is in a unique position. It is a policy body and can consider a variety of views.

VR: *I think the Report[17] defines the traditional arts very narrowly. Why would stone carving not be considered as a traditional art, for example?*

MC: That's an interesting view.

VR: *It seems to me that since the Arts Act of '73 and the changes the NCEA brought about in third-level art education in the mid-1970s, the Arts Council and the art colleges have run alongside one another like parallel lines which never meet. The narrow definition of the traditional arts to exclude forms like stone carving may be one of the results of that. Could the shortage of film education[18] until recently, despite the fact that film came under the Arts Council's remit in '73, be seen as a result?*

MC: Maybe the same could be said of architecture.

VR: *The Arts Council's existence affects what art is and how its practice develops.*

What do you see as good in the 2003 Arts Act?

MC: It's very much of its time. The 2003 Arts Act was acknowledging the creation of a department for the arts. It's a formalising of the role of a minister. The really good thing is that it values the arm's length policy. There were other options available.

It secures the value of an arm's length policy and endorses the value of peer involvement. The Council is drawn from the arts community and other key stakeholders who represent the public interest in the arts.

When the arts become a grass roots issue they can become very attractive for politicians. Direct control can be attractive to them. The Act was a vote of confidence in the Arts Council. What needs to be clear is the role of the minister. It's being described as a policy-making role. There could have been a tension but the idea of special committees to advise the Arts Council creates a good structure. It is an acknowledgement that policy is best made when it's made by experts. The special committee is drawn from

the Arts Council and the arts community and makes recommendations to the Arts Council on policy. The Arts Council's independence is acknowledged in the Act, and in theory it could work very well. The Arts Council's independence in accepting or not accepting the recommendations of committees is secure. The arts are an important portfolio in a minister's remit. We have a cabinet post to make the case for the arts at the cabinet table.

VR: *Did you work in the Arts Council in the days before there was a minister with a cabinet post?*

MC: No. 13 January 1993 was the day Michael D. Higgins was appointed and that was the day I went for my first interview [as regional development officer]. The interview panel had just heard the news and were asking what did it really mean for the Arts Council. A new Council was appointed by Michael D. in April 1993, with Ciarán Benson as chair.

VR: *Isn't it interesting that the three ministers for the arts so far have Atlantic constituencies? Michael D. in Galway, Síle de Valera in Clare and John O'Donoghue in Kerry?*

MC: Colm O hEocha was the president of Galway University and Arts Council chair when I went in. I was there for his last meeting.

VR: *Síle de Valera is not going forward for re-election, they say.*

MC: Síle as Minister for the Arts had a great commitment to education. She championed the cause of the arts and disability. There were great strides made in putting the arts onto the agenda of the disabled lobby. She had many achievements. When she was in opposition, she asked a parliamentary question about Arts Council funding. She ensured that in the Fianna Fáil manifesto there was a commitment to funding the first Arts Plan in full, and subsequently when she was minister, this became a reality. It had been a three-year plan. Based on available resources, it was extended to five years. The new government in 1997 committed to deliver in four years. So the plan went from being a three-year plan to being a five-year plan and back to being a four-year one.

VR: *Adrian [Munnelly] was your first boss at the Arts Council?*

MC: Yes. Patricia [Quinn] came in November 1996.

VR: *He too had great commitment to education, even before he began his directorship in 1983.[19] But would you say his work with local authorities was his big achievement?*

MC: Adrian worked very well with local authorities, basing his work on a very clear strategy, which recognised that the Arts Council was never going to be big enough to provide comprehensively for the arts around the country.

VR: *The first local authority arts officer came in when Adrian was director – in Clare in 1985. Is the arrangement that the local authorities pay half the salary of the arts officer and the Arts Council the other half?*

MC: There are 34 local authorities and there are now 32 arts officers. We part-fund about fifteen. Dublin city and county and Cork city pay their own officers, so do some other local authorities. Local authorities have a thorough understanding of what is needed locally to develop the arts.

VR: Was *the 1973 Arts Act giving the local authorities power to spend money on the arts having effect by Adrian's time?*[20]

MC: In 1993 the Arts Council did a short document on capital development and programmes for the arts. It showed that arts infrastructure in Ireland was poorly provided. The appointment of a minister was a very important departure point. The possibility of money becoming available for capital development in the arts became a reality. For the visual arts, one of the ideas the Arts Council was trying to promote was that there should be four or five exhibition centres around the country with international standards of curation and display; major visual arts venues. We wanted a balance between working with what was already there and supporting the creation of new venues. Limerick was already there. The Model and Niland in Sligo wasn't, it was a gleam in the eye of a few people. The idea that our own artists could be international artists followed the idea that there could be world-class art spaces.

The strategy to build political support for the arts was

based on the assumption that serious public investments in the arts would only be made, if all around the country local politicians would be hearing all the time about the needs at grass roots level. The strategy in the Arts Council at that time was to build up political support for the arts. The arts needed to be represented by a political voice. The appointment of a minister in 1993 showed that that strategy worked. The regional policy is the one that worked in getting that message home. The arts were really under-funded. The more people on the ground who are interested in the arts and the more people campaigning for more money, the more the message comes through. The arts were put on the political map then.

VR: *The 1987 Programme for National Recovery was hugely important, wasn't it? That year, the White Paper* Access and Opportunity: A Cultural Policy *made the arts part of government policy.*

MC: That was Adrian's strategy. He was really focused on the goal of getting the arts on the political agenda, on building political support through grass roots and local communities. He wanted to have the country peppered with arts organisations and centres. If you look at a map of organisations funded by the Arts Council in 1984 and ten years later, you'd see that it wasn't just about regional access. It was also about building up grass roots support to put the arts on the political agenda. The Arts Council's role is to lead. Public policy follows.

VR: *Patrick Little, TD, the first director/chair in 1951, had tried to have country-wide support for the arts – he perceived rural Ireland to be the heart of Ireland, but the next two directors went more for what was perceived as elitist support for work of quality.*[21]

MC: Yes. There are a couple of important principles the Arts Council has to take on board in everything it does. The first is diversity, the need to support enough types of work to ensure that the best work will come through. In times of scarce resources, it is tempting to look at core organisations and to focus grant aid on a narrower range of work and consolidate. But that's a luxury we can't have. We have to have a core principle of diversity

when patronage comes from the public purse. The second core principle is to spread the decision making in order to have a range of perspectives. That could ameliorate what could be a monolithic position. The local authorities are a good example of decision makers who help spread the decision-making process. There are different people in local authorities all over the country making decisions. We encourage organisations to get funds from other sources, so that other sources have an influence. The box office in theatre and the performing arts is important. People are choosing and that's an influence.

VR: *What about decisions in the visual arts?*

MC: On our panels for artist's awards we have peer assessments, that is independent assessment from peers, who make recommendations to the Council. We rotate membership among a wide group of people. An important portion of our money is spent in that way. The influence of the funder, the Arts Council, should be wide ranging, and reflect the range of practice.

In the visual arts, for example, there is a person with a policy overview, the visual arts specialist. But, for example, if a gallery comes in with an exciting programme and wants funding, there would be four staff taking negotiated, considered views, before making recommendations to Council. With twelve people on Council, that's sixteen people. The arts sector has grown to the point where one person having the necessary kind of knowledge is not enough. There is a visual arts specialist, but also a team with other relevant specialisms, for example, a public art specialist and staff with relevant knowledge of venues and local development. The model of an officer, for example, like Oliver Dowling, is difficult to replicate in this environment

We will never have another Oliver Dowling, someone who has been with the Arts Council on and off since the late '60s, who knows the visual arts from the commercial end as well as the subsidised end. He knows it from organising exhibitions. He has an encylopaedic knowledge. He is always travelling. He knows a range of artists, from people starting up studios in garages to the

most eminent. Impossibly large boots to fill.

VR: *Is the individual visual artist who is not part of a studio group a vulnerable species?*

MC: Last year we turned down 1,000 applications for funding from individual artists. It is a waste of good ideas. It is a resources issue. But with available resources we have to make sure that writing good proposals is not the only basis for supporting individuals. For some artists, writing a good proposal is a challenge, because it is not what they do best. We plan to introduce new types of awards that are based on track records. We might say, here is a three-year bursary for you to develop your ideas, so that the artists don't have to re-apply in June and January.

VR: *Sounds good. Before becoming regional development officer in the Arts Council, you'd worked with a local authority?*

MC: I was Dundalk UDC arts officer. On my first day in the job the chair of the arts committee came in and said, 'There are three things I want to make clear. One, we make the decisions around here, not you. Two, don't do anything to compromise public morality and three, we don't want to have anything to do with modern art.' Tom Bellew was his name, he is unfortunately deceased. There is a road in Dundalk named after him. After a while he was the most supportive and the most adventurous councillor. He would always lobby for money for the arts. We had our first nude painting in an exhibition when he was there. I think that was by Cliodhna Ryan, it was student work and very good. We would take over PMPA's office each year and show student work. They would sponsor the exhibition and give a prize. They lent us their window; it was a high street window. In the Town Hall we cleared out the basement and whitewashed it and used it as a gallery. Tom Edlin was the branch manager at PMPA, he was very good. Dundalk always supported the arts. In 1973 it was the first local authority to implement the Act. Oscar Wilde spoke in the Town Hall in Dundalk and all the fit-up companies,[22] Anew McMaster's and all of them, were there.

VR: *The fit-up companies, which within a generation had declined*

from twenty to five by the mid 1960s, were honourable prede-
cessors to the modern touring company, weren't they?

MC: Yes, they were.

VR: *What do you know about the fate of the P.J. Carroll collection*
in Dundalk?

MC: I have been talking to Enrique Juncosa about that. IMMA is
very open to the collection having a special relationship with
Dundalk. There is no question of IMMA colonising the collec-
tion. The large commissioned sculptures shouldn't be moved
from there, that's without question. There is a question mark
about the core of the rest of the collection. A couple of ques-
tions include having the entire collection stay in Dundalk. The
cigarette factory is now an institute of technology. Some of the
pieces could not withstand the wear and tear involved. IMMA
are open to having a rotating number of works or a section of
the collection in Dundalk. If Dundalk could provide a space,
they would let them have them back.

VR: *It was a tax incentive donation, wasn't it?*

MC: Yes, I think it was a tax incentive donation. Carroll's are paying
for the restoration of many of the works.

VR: *If the museum is a pivotal centre in contemporary society, then*
relocating the art to a capital city museum[23] is more regrettable
for people in Dundalk than it is exciting for IMMA, perhaps.

MC: The museum and gallery have become alternative anti-secular
spaces where people go for spiritual space and improvement.

VR: *The nineteenth-century drive to form museums had that*
improvement agenda. The penitential discomfort of many muse-
ums still conveys that nineteenth-century authoritarianism.

MC: Yes, the Matthew Arnold idea of civilising through art experi-
ence had powerful appeal. Ideas of improvement as a main pur-
pose of art can be dangerous though. Involvement with art is
about perspectives. The arts give you perspectives on the world.
Understanding the perspective of, for example, the anarchist
can be equally important. I would say art-as-improvement is
not a tautology, as they hoped in the nineteenth century. Art

can make people more critical. The arts communicate, they don't contain. If you look at the Pearse poetry and 1916 or Rupert Brooke's poetry, it is about blood sacrifice. The arts communicate value and deal with identity. They can help in cultural diversity situations. They can help in society's unity and society's diversity. That is why public money goes to the arts.

VR: *The Council's art collection, begun in 1961, is still a fine one.*

MC: We did a review of the collection, in 1997. Belinda Loftus and Sarah Finlay did it, after Sarah left. It wasn't published. It's a good solid bit of work. The Glucksman exhibition in Cork [*Four Now*, May '05-October '05][24] is the most recent opportunity we have had to reflect on the collection. The reasons the Council collected were varied. The main reason always has been in support of the artist, rather than collecting to create a survey of a period.

I miss the William Scott from my office. It's on loan to the Glucksman. One of my favourite exhibitions ever was the William Scott in the Guinness Hop Store [in 1986].

VR: *Do you have a favourite twentieth-century artist?*

MC: One of my favourite pieces is the Rothko Chapel in Houston. I've only seen it in reproductions but I plan to go. I think the paintings have a sense of the sublime. I love them.

VR: *Scott and Rothko were mates. Kathleen Bridle, Scott's teacher when he was a young teenager, was another of those amazing individuals who change the course of people's lives.*

MC: Yes.

VR: *There were Council members who loved contemporary Irish art and collected very well for the Council. Perhaps from the artist's point of view the bursary system is just as good now?*

MC: Their purchasing policy was of its time and quite biased, but they would have had good reasons for that. The collection was put together over time, with the purpose of supporting the individual artists. It became very eclectic. The collection was informed by what the market was doing. If other people are buying, we don't need to. When the main purchasers were institutions and the big work was being sold, we'd look at smaller

work. We'd try to complement the market. The market is strong now, I understand, but there is work that is not being bought-new media work, ephemeral work.

A new approach we've agreed is to start buying again, but instead of the buyers being staff or Council members, we appoint a curator for two or three years. They form an approach and put on an exhibition. There will be a series of mini steps, coherent steps that will reflect the curator's work in collecting for the Council. It doesn't matter if they have a preference for one kind of work or another. One person's view is important. Otherwise it's corporate buying. Quality goes without saying. It has been very ad hoc and this will bring a new perspective. The principle of having a turn over in curatorship is important. The approach will be contemporary. The Council hasn't been collecting recently and in taking a step back into the collecting arena, it's important not to be ad hoc. We want to start with a minimum purchasing budget of €100,000.

VR: *How do you view per cent for art money being used to start an institutional collection?*

MC: Each case has to be taken on its merits. It can be a good way to start a collection. Whether it's better to buy or commission depends on the circumstances. What you need is good, informed expertise, usually a panel. If an institution is at the early stage of implementing a per cent for art scheme, purchasing can be a way of building confidence. A commission offers the artist a chance to respond to the space. Once you lose that chance, it never comes back.

VR: Aosdána *is the most contested form of Arts Council support. You are a supporter.*

MC: There is no question but that *Aosdána* was a good idea at the time [1981/1983]. It remains very valuable.

If you go back to the mission statement, it was to give the artist a voice in society, and to honour and support the artist. When Salman Rushdie's *Satanic Verses* was banned, *Aosdána* made representation against the fatwah. *Aosdána* taking a view on relevant situations can play a very important role, and present

the voice of the artist. Artists are people who have interesting perspectives on society. Very often, it comes through in their work but sometimes it's important to speak as a group too.

It can be confusing to look at *Aosdána* from outside. There's the honorific side and there's the financial side. The honorific element is about valuing the artist in society. It is the artists who decide who become members. Peer assessment is one way of deciding who becomes a member, and there are always pros and cons. What constitutes a peer is something that comes up if you are setting up a committee.

But *Aosdána* is a labyrinthine process of selection. If we were to address the gaps, like the support becoming available to the interpretive artist, the singer or the actor, would we look at keeping the honorific separate from the financial? I do think there are gaps in *Aosdána*. The exclusion of choreography is a real issue. We did have a choreographer put forward this year, not elected; put forward. It was an important move. At this stage *Aosdána* has symbolic value.

VR: *What does it cost in relation to the overall Arts Council budget?*
MC: It costs about €1.5 million, our budget is about €60 per annum.
VR: *Issues of leadership in Irish art are immensely interesting.*
MC: One of the reasons we funded the Clore leadership programme, headed by Chris Smith and Dame Vivienne Buckley, with whom we discussed how Irish people could participate in the programme, was to develop leadership. It's just been awarded to Fergus Ó Conchubhair. He's a dance artist, performing in a contemporary idiom. He's from Rinn in County Waterford and he's an Irish speaker. He competed with a very high calibre of candidates. You have to have people who can come back and be in places of leadership. We've put €40,000 into that programme, so that we can have people with that kind of experience available. Fergus, like many artists, has a portfolio career. Dance performing careers are not that long and artists need to look at their later career. We don't spend a lot on leadership. This is a big investment in one person's leadership.

VR: *Mary has been an auspicious name in Irish political leadership: the only women presidents were called Mary; there is Mary Harney, the first woman Tánaiste and Ministers Mary Coughlan and Mary Hanafin.*

MC: It might be that they are first borns.

VR: *Are you a first born?*

MC: Yes.

VR: *Would your name be related to your birthday? When is that?*

MC: In May.

VR: *Do you remember having May altars?*

MC: Yes. There was a statue of the Blessed Virgin and the covering on the altar had to be one of those cotton or linen cloths with worked edges, maybe broderie anglaise or lace. There would be primroses and bluebells and aquilagea in the vase or jam jar. Ours was upstairs on the landing and I was responsible for it.

VR: *Yours is a very interesting generation, born into Lemass' Ireland, participating in the older and newer Irelands simultaneously at a young age.*

MC: I remember us in the very early days saying the Rosary at night. It dwindled to once a week and then maybe to saying it coming home in the car from Granny's.

It was easier for me to consider applying for the post of director because Patricia had been director. Having a woman director wasn't something that much point was made about. Once any initial surprise about a woman being a leader is over, people usually forget about it as an issue. Now it is compulsory to have 50/50 men and women on boards. It is six and six on the Arts Council.

There is a high proportion of women in the arts. It would be an anomaly if women weren't in leadership roles in the arts. The fact that you need gender equality written into legislation says it's not quite to be taken for granted. The child care debate has become very political because women are working outside the home and cannot relinquish that working life.

In local authorities, there have been breakthrough appointments. Martina Moloney is county manager in Louth. Anne

McGuinness in Westmeath is coming to the end of her seven-year tenure as county manager.

But the symbolic value of Mary Robinson[25] was very important. She opened a lot of doors.

In conversation, Dublin, 13, 28 July, 11 November 2005.

1. Jerome Hynes (1959-2005) died at the Theatre Royal in Wexford on 18 September. When Druid Theatre Company was founded by his sister Garry Hynes, Mick Lally and Marie Mullen in 1975, Jerome began working for them, at first casually, but by 1981 was their full-time administrator. In 1988 he became MD of Wexford Festival Opera. He was appointed vice chairman of the Arts Council in 2003 and chaired the committee for Traditional Arts. He was on numerous boards, including Business 2 Arts.

2. RTÉ, 30 October 2005.

3. Judge Murphy's *The Ferns Report* on clerical child abuse in the diocese, was presented to Government in October 2005.

4. It was reported in *The Irish Times*, 9 July, 2005 that construction on the long-awaited Cork School of Music, to cost €60 million could be completed by September 2007. The 3,361 students have been attending classes in eighteen different locations around the city since 2004.

5. Benjamin. W., 'The Work of Art in an Age of Mechanical Reproduction' in *Illuminations*, London, 1970.

6. 9 July 2005.

7. The Abbey overspent significantly during its centenary year, 2004, when it toured widely, and a stabilising grant of €2 million was made available by the Arts Council, partly to reduce the deficit and partly to finance a programme of change.

8. Theatre and film producer, curator and commissioner Fiach MacConghail (*b.* 1964) was appointed director of the Abbey in 2005. He succeeded Ben Barnes, who was artistic director. When John O'Donoghue TD became Minister for Arts Sports and Tourism in 2002, he appointed Fiach Mac Conghail as his arts adviser. Tony Sheehan succeeded him.

9. In 2003 government funding to the Arts Council was cut by 8 per cent, which, when adjusted for inflation, became a cut of 11.6 per cent.

10. *The Irish Times*, 29 March 2005.

11. *Artists' Tax Exemption: Know the Facts Understand the Question State your Position.* 2005.

12. In *The Irish Times*, Mark Hennessy wrote on 12 October 2005 that under The Seaside Resort Scheme introduced by the rainbow government in the 1996 Finance Act, as the pilot Tax Relief Scheme for Certain Resorts, and later extended, €315 million was lost to the Exchequer in taxes, through the tax incentives around the building of 5,000 homes in fifteen targeted towns.

13. Fallon, B., *An Age of Innocence, Irish Culture, 1930-1960*, Dublin, 1998.

14. Richards, J.M., *Provision for the Arts*, Dublin, 1976.

15. Pearson, N., *The State and the Visual Arts: A Discussion of State Intervention in the Visual Arts in Britain 1760-1981*, Milton Keynes, 1982.

16. *The Cultural and Economic Trends of Cinema in Ireland and Wales*, Dublin, 2004.

17. *Towards a Policy for the Traditional Arts,* Dublin, 2004.

18. Filmbase in Curved Street, Temple Bar, Dublin, and Dún Laoghaire Institute of Art and Technology provide courses.

19. Adrian Munnelly was Education officer at The Arts Council/An Comhairle Ealaíon from 1979 to 1983.

20. Mulderrig, M, (ed.), Kennedy, B.P. in *The Regional Development of the Arts in Ireland*, Cork, 1995 Conference Report, pp 27-32.

21. Kennedy, B. 'Four Decades of the Arts Council/An Chomhairle Ealaíon', *Irish Art Review Yearbook* 1990/1, pp. 115-125.

22. *Reeling in the Years*, RTÉ, 5 August 2005.

23. Putnam J., *Art and Artefact: The Museum as Medium*, London 2001.

24. Four Now, a joint exhibition of the Collections of the Arts Council/An Chomhairle Ealaíon and the Arts Council of Northern Ireland, curated by Sarah Glennie, and artists; Susan MacWilliam, Isabel Nolan, Dan Shipsides and Joe Walker.

25. Mary Robinson, née Bourke, *b.* 1944, in Ballina, County Mayo, lawyer and member of Seanad Éireann from 1969-1989 and of the Labour party from 1977-1985, was from 1990-1997 the first woman president of Ireland.

Index